AMERICAN ART tile

1876—1941

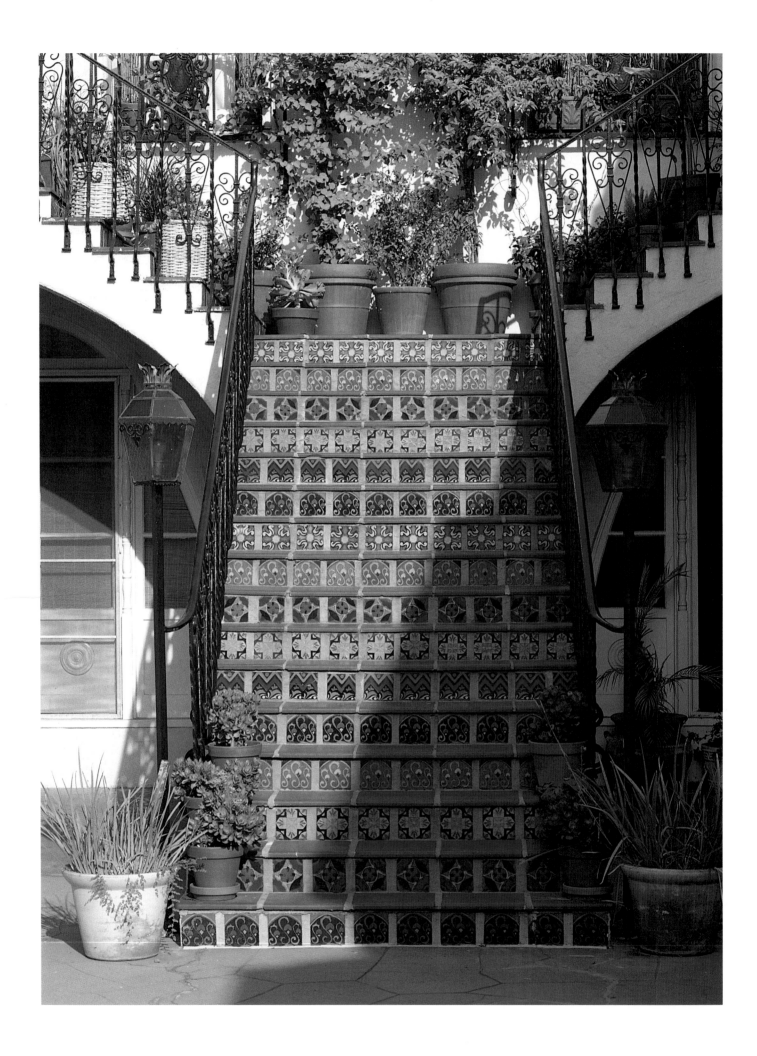

AMERICAN
ART tile
1876–1941

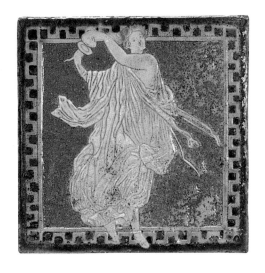

Norman Karlson

RIZZOLI
NEW YORK

First published in the United States of America in 1998 by
RIZZOLI INTERNATIONAL PUBLICATIONS, INC.
300 Park Avenue South, New York, NY 10010

Copyright ©1998 by Michael Friedman Publishing Group, Inc.

Library of Congress Cataloging-in-Publication Data

Karlson, Norman.
 American Art Tile / Norman Karlson.
 p. cm.
 Includes bibliographical references.
 ISBN 0-8478-2098-X
 1. Tiles—United States—History—19th century.
 2. Tiles—United States—
History—20th century. I. Title.
NK4670.7.U5K37 1998
738.6'09773'09034—dc21 98-10731
 CIP

American Art Tile
was prepared and produced by
Michael Friedman Publishing Group, Inc.
15 West 26th Street
New York, New York 10010

Editor: Sharyn Rosart
Art Director: Jeff Batzli
Designers: Maria Mann, Jennifer Markson, and Paul Taurins
Photography Director: Christopher C. Bain
Production Manager: Camille Lee

Color separations by Fine Arts Repro House Co., Ltd.
Printed in Singapore by KHL Printing Co Pte Ltd.

Page 1: Grueby Pottery, Boston; page 2: Santa Monica Brick Co., Taylor Tilery; page 3: Frederick Hurten Rhead

ACKNOWLEDGMENTS

I would like to thank Joe Taylor of the Tile Heritage Foundation for being the keeper of tile information, and Riley Doty for knowing the location of every tile in the State of California.

I want to thank my wife, Shannon, who had to do all other work while I researched and photographed for such a long time.

I also want to thank Craig Sanemitsu, Douglas Karlson and Susan O. Castrence for the endless pages of copy and Richard Moreno for the endless aid with photography.

I would like to thank the following people and institutions, who were so kind as to loan tiles from their private collections:

Lyman Allyn Museum, New London: The Tile Club, by Winslow Homer; New Jersey State Museum: J.L. Rue Pottery Stove Tiles; Bill Bilsland III: Iowa State, AET, Rossman, Rushmore; Carol Ann Carlton: Broadmoor; Stephen Davis: Charles Owen: Carol Doty: Grueby, Franklin, C. Pardee, Rookwod, AET, Van Briggle, Gladding McBean, Monaco, L.A. Pressed Brick, Brayton Laguna, Pomona, Malibu, Woolenius, Muresque: Riley Doty: San Jose Mission, Catalina, West Coast Tile, Claycraft, AET, Woolenius, California Art Tile, Kraftile, Muresque, Handcraft, Solon and Schemmel, Solon and Larkin; Mike Duff: Paducah, WACO, Gladding McBean, Santa Monica, Malibu, Tudor, Calco, AET, Catalina, Hispano Muresque, Claycraft, Batchelder, California Art Tile, Handcraft, Woolenius, Kraftile; Arthur Goldberg: John Bennett, Hartford Faience, Raritan; Jim Graham: Chelsea Keramic, Dedham, Mueller, Moravian, Enfield, Star, Flint, Pewabic; Jim Jaffe: Malibu Aztec; Allan Lutting: G.E.T.; Stephanie Lynn: Steiger Terra Cotta, Halcyon, California Faience, Waldrich; Bernice Lyon: Star, International, Trent, Providential, Mueller, Beaver Falls, Robertson, Franklin, Weller, AET, Zanesville Majolica, Ohio Encaustic, Hamilton, Cambridge, Kirkham, J.B., Owens, Empire, Mosaic, G.F. Brunt, Wheatley, A.E. Hull, GET, Standard, Kensington, U.S. Encaustic, America Art Clay, Flint, L.A. Pressed Brick; Clark McLean: Matt Morgan; Steve Peterson: Newcomb; Sarah Price: Pauline Art Pottery, Roblin; Seymour Siegal: Boston Terra Cotta, Raritan, Owen and Peirce, Old Bridge, International, Robertson, C. Pardee; Stan and Rilda Webb: University City

Following is a list of all the kind people who helped me piece together the history of art tile in the United States:

J. Richard Abell, Cincinnati & Hamilton County Public Library, Cincinnati, OH; Francisco Acosta, New York, NY; Carol R. Alper, Wolfsonian Foundation, Miami, FL; American Olean Corp. Lansdale, PA; Sister Justine Apfeld, Brussels, Belgium; Max van Balgooy, Homestead Museum, City of Industry, CA; Rick & Elizabeth Baratta, South Africa; Doris P. Beach, Columbus, OH; John Beroud, Santa Monica, CA; Bob Bettinger, Mt. Dora, FL; William M. Bilsland III, Cedar Rapids, IA; Chris Blanchett, Tiles & Architectural Ceramics Society, England; Dorothy L. Blosser, Dalton, OH; Barbara Boyd, Glendale Public Library, Glendale, CA; Marsha Bray, Missouri Historical Society, St. Louis, MO; Mrs. M.

Buessow, Historical Society of the Tarrytowns, Tarrytown, NY; Burrowes Mansion Museum, Matawan Historical Society, Matawan, NJ; John Cable, Canton, OH; Dennis Caffrey, Los Angeles, CA; Donald H. Calkins, Lakewood, OH; Carol Ann Carlton, Englewood, CO; Damaris Chapin, Abbot Public Library, Marblehead, MA; Joan Chernoff, Newburgh Free Library, Newburgh, NY; Bill Clark, Bayonne, NJ; Doug Clements, Cleveland, OH; Barrie D. Coate, Los Gatos, CA; Walter Cornelison, Bybee, KY; Rev. Roger Croteau, Goffstown, NH; Dean Cunat, Crystal Lake, IL; Annette W. Curtiss, Mid Continent Public Library, Independence, MO; Mrs. Ben Davies, Pittsburgh, PA; Stephen Davis, M.D., Wayne, NJ; Carl Deimling, Bolivar, OH; Ulysses S. Deitz, Newark Museum, Newark, NJ; Barbara Dickenson, Public Library, San Jose, CA; Darlene Dommel, Golden Valley, MN; James Harrison Donahey, Walnut Hills, OH; Carol Doty, Oakland, CA; Toni & Tom Doyle, Malibu Lagoon Museum, Malibu, CA; Mike Duff, San Raphael, CA; Gail Dunham, Mayfield, KY; Michaela Dzurisin, Manitowoc, WI; B.A. Elder, Mason City Public Library, Mason City, IA; Joan Elliot, Jackson County Historical Society, Independence, MO; Sarah Ellison, Matawan Historical Society, Matawan, NJ; Ron Endlich, Seattle, WA; Jack Feingold, New York, NY; Susan Finkel, New Jersey State Museum, Trenton, NJ; Erin Foley, Minneapolis Public Library, Minneapolis, MN; Norma Friday, Columbus Metropolitan Library, Columbus, OH; Elizabeth G. Fuller, Westchester Historical Society, Elmsford, NY; Anne & Julia Fulper, Fulper Glazes Inc., Yardley, PA; Joan Gardner, Middleburg, VA; Bill Gates, Ohio Historical Society, Columbus, OH; Eleanor M. Gehres, Denver Public Library, Denver, CO; David Gifford, Old State House, Little Rock, AR; Charles H. Glatfelter, Adams County Historical Society, Gettysburg, PA; Arthur F. Goldberg, M.D., Closter, NJ; Mrs. Lee Goldman, Berkeley Historical Society, Berkeley, CA; Jim Graham, Washington, DC; Gordon Gray, Princeton, NJ; David Greenberg, Santa Monica, CA; Charles S. Griffen, Hartford Public Library, Hartford, CT; Karen Guido, Sunnyvale, CA; Anna Haldeman, San Marcos, CA; Barbara D. Hall, Hagley Library, Wilmington, DE; Jim Handley, Los Angeles, CA; M.K. Harris, Minneapolis Public Library, Minneapolis, MN; Norman Haas, Quincy, MI; Barbara Jean Hayes, Coos Bay, OR; Virginia Heiss, Indianapolis, IN; Wilbur Held, Claremont, CA; Ed Henderson, St. Louis, MO; Helen B. Henderson, Burrowes Mansion Museum, Matawan, NJ; Jeffrey Herr, Cultural Affairs Department, Los Angeles, CA; Isa Hidalgo, Miami, FL; A.G. Hinz, American Olean, Olean, NY; Ed Hobert, Laguna Beach, CA; Jim Jaffe, Santa Monica, CA; Lewis Jaffe, Philadelphia, PA; Angel & Jack Jeandron, Keyport Historical Society, Keyport, NJ; Edna L. Jones, Washington, IA; Brian Kaiser, South Gate, CA; Rama Karamcheli, Ohio County Public Library, Wheeling, WV; Christopher Karlson, Los Angeles, CA; Charles D. King, Kenton Public Library, Covington, KY; Teresa L.M. Klaiber, New Concord, OH; Bob Klinges, King of Prussia, PA; Irene Knops, Fresno, CA; Vance A. Koehler, Moravian Pottery & Tile Works, Doylestown, PA; Joe Koons, Riverside, CA; Eugene R. Kosche, Bennington Museum, Bennington, VT; Barbara M. Kramer, Boston, MA; Charles W. Kraft, Piedmont, CA; Tamara Kuenz, Philadelphia Museum of Art, Philadelphia, PA; Jerry Kunz, San Francisco, CA; Reta Larson, Portland, OR; Charlotte Laubach, Malibu Lagoon Museum, Malibu, CA; Tom Layman, Iowa City, IA; Alan Lutting, Grand Ledge, MI; Rebecca Lintz, Colorado Historical Society, Denver, CO; Mary Ann Ludwig, Rocky River, OH; Stephanie Lynn, Los Angeles; Marion County Public Library, Indianapolis, IN; Glenn Mason, Long Beach, CA; Elaine Massena, Westchester County Archives, Elmsford, NY; Kim McCall, Historical Society of the Tarrytowns, Tarrytown, NY; Adrianne G. McConville, The Carnegie Library of Pittsburgh, PA; Tony McCormack, Atlanta, GA; David R. McFadden, Cooper-Hewitt Museum, New York, NY; Jane McHale, Pewabic Pottery, Detroit, MI; Victoria & Clark McLean, Tampa, FL; Terry A. McNealy, Spruance Library, Doylestown, PA; Judith A. Meier, Historical Society of Montgomery County, Norristown, PA; Frank Mendola, Orange County Historical Museum, Orlando, FL; Jim Messineo, Boston, MA; Becky Middleton, Spencer County Public Library, Rockport, IN; Diane Michener, Salem United Church of Christ, Doylestown, PA; Susan Montgomery, Newton, MA; Christine Morgan, Abbot Public Library, Marblehead, MA; Virginia Moshen, Matawan-Aberdeen Public Library, Matawan, NJ; Ruth Neuendorfer, Historical Society of the Tarrytowns, Tarrytown, NY; Elizabeth Orsburn, Casa Dorinda, Santa Barbara, CA; James Stuart Osbourn, Newark Public Library, Newark, NJ; Coralee Paull, St. Louis, MO; Brenda Pearson, Iowa City, IA; Victoria Peltz, Rocky River Public Library, Rocky River, OH; Steve Peterson, Studio City, CA; Douglas G. Pinnell, Syracuse, NY; Michael Pratt, Portland, OR; Sarah Price, Pineville, LA; Hilda Pritsker, Dallas, TX; Don Quick, Roanoke, TX; David Rago, Lambertville, NJ; C. Carlton Read, Delaware River Port Authority, Camden, NJ; Richard W. Reeves, Free Public Library, Trenton, NJ; Glen Rile, American Olean, Lansdale, PA; Ron Rindge, Malibu Lagoon Museum, Malibu, CA; Jeanne Roberts, Historical Society of Pennsylvania, Philadelphia, PA; Rick Roe, Denver, CO; Lee Rosenthal, San Francisco, CA; Joe Sacco, Chicago, IL; Donna Schleifer, New Brunswick Free Public Library, New Brunswick, NJ; Alesandra M. Schmidt, Connecticut Historical Society, Hartford, CT; Steve Schoneck, St. Paul, MN; Roy W. Schweiker, American Olean, Lansdale, PA; James Shepherd Jr., Syracuse, NY; Seymour Siegel, M.D., Ocean Side, NY; Dick Sigafoose, Jackson, TN; Michael Sims, Zanesville, OH; Dan Smith, Pittsburgh, PA; Margaret Curtis Smith, Sherman Oaks, CA; Malvina Solomon, New York, NY; D. J. Stearn, Woodstock Public Library, Woodstock, NY; Billy Steinberg, Los Angeles, CA; Bill Stevenson, Detroit, MI; Nelda Stone, Laguna Beach Public Library, Laguna Beach, CA; William W. Sturm, Oakland Public Library, Oakland, CA; Mary Suess, Milwaukee Public Library, Milwaukee, WI; Lisa Taft, Walnut Creek, CA; Phyllis Taylor, Barberton Public Library, Barberton, OH; Regina Taylor, Hermosa Beach Historical Society, Hermosa Beach, CA; Stephen E. Towne, Indiana State Archives, Indianapolis, IN; Kenneth R. Trapp, Oakland Museum, Oakland, CA; Susan Tunick, Friends of Terra Cotta, New York, NY; Tom Turnquist, Englewood, CO; Sharron G. Uhler, Colorado Springs Pioneer Museum, Colorado Springs, CO; Ignacio Villeta, El Museo del Barrio, New York, NY; Mary Ann & Steve Voorhees, Santa Rosa, CA; George G. Walker, Manchester, CT; Marilyn Walkins, Anderson, IN; Stan & Rilda Webb, Silverdale, WA; Michael Wentworth, Library of the Boston Athenaeum, Boston, MA; Jim Whitfield, Colorado Springs, CO; David R. Wilder, Iowa State University, Ames, IA; Helen M. Wilson, Historical Society of Western Pennsylvania, Pittsburgh, PA; Winterthur Library, Winterthur, DE; Helen Harris Witte, Memphis, TN; Martha Wright, Indiana State Library, Indianapolis, IN; Adam Zayas, Moravian Pottery Works, Doylestown, PA; Pat Zudeck, Museum of Fine Arts, Boston, MA

CONTENTS

Beaver Falls Art Tile Co., *Beaver Falls*

Robertson Art Tile Co., *Morrisville*

Moravian Pottery & Tile Works, *Doylestown*

Enfield Pottery, *Enfield*

Franklin Tile Co., *Lansdale*

Robert Rossman Co., *New York, Beaver Falls*

OHIO 67

Weller Pottery, *Zanesville*

American Encaustic Tiling Co., (A.E.T.), *Zanesville*

Mary Louise McLaughlin, *Cincinnati*

The Pottery Club of Cincinnati, *Cincinnati*

Rookwood Pottery, *Cincinnati*

Matt Morgan Art Pottery Co., *Cincinnati*

Zanesville Majolica Co., *Zanesville*

Ohio Encaustic Tile Co., *Zanesville*

Hamilton Tile Works, *Hamilton*

Cambridge Art Tile Works, *Covington, Kentucky and Hartwell, Ohio*

Kirkham Art Tile & Pottery Co., *Barberton*

J.B. Owens Pottery Co., *Zanesville*

Mosaic Tile Co., *Zanesville, Ohio and Matawan, New Jersey*

Wheatley Pottery, *Cincinnati*

J.H. Strobl Tile Co., *Cincinnati*

A.E. Hull Pottery Co., *Crooksville*

Stark Ceramics, *East Canton*

Cowan Pottery Studio Inc., *Cleveland, Lakewood, and Rocky River*

Unitile, *Urichsville*

G.E.T., *Zanesville*

Sparta Ceramic Co., *East Sparta and Canton*

Standard Tile Co., *Zanesville*

CENTRAL STATES EAST OF THE MISSISSIPPI 103

Louisiana

Newcomb Pottery, *New Orleans*

Mississippi

George Edgar Ohr, *Biloxi*

Kentucky

Bybee Pottery, *Bybee*

Kensington Art Tile Co., *Newport*

Paducah Pottery, *Paducah*

Alhambra Tile Co., *Newport*

West Virginia

Wheeling Tile Co., *Wheeling*

Indiana

U.S. Encaustic Tile Co., *Indianapolis*

Columbia Encaustic Tile Co.,
 National Tile Co., *Anderson*

Overbeck Pottery , *Cambridge City*

American Art Clay Co. (AMACO), *Indianapolis*

Illinios

American Terra Cotta and Ceramic Co., *Terra Cotta*

Northwestern Terra Cotta Co., *Chicago*

Midland Terra Cotta Co., *Cicero*

Abingdon Potteries, *Abingdon*

Michigan

Flint Faience and Tile Co., *Flint*

Pewabic Pottery, *Detroit*

Wisconsin

Pauline Pottery, *Chicago, Illinois and Edgerton, Wisconsin*

Susan Stuart Goodrich Frackelton, *Milwaukee*

Continental Faience and Tile Co., *South Milwaukee*

CENTRAL STATES WEST OF THE MISSISSIPPI

124

Arkansas
Niloak Pottery, *Benton*

Texas
San Jose Pottery, *San Antonio*

Missouri
Winkle Terra Cotta Co., *St. Louis*
University City Pottery, *University City*
Ozark Pottery, *Location Unknown*

Iowa
Shawsheen Pottery, *Billerica, Massachusetts, and Mason City, Iowa*
Iowa State College, *Ames*

Minnesota
The Handcraft Guild of Minneapolis, *Minneapolis*

North Dakota
University of North Dakota, School of Mines, *Grand Forks*

South Dakota
Rushmore Pottery, *Keystone*

Colorado
Van Briggle Pottery and Tile Co., *Colorado Springs*
Broadmoor Art Pottery and Tile Co., *Colorado Springs*

Washington
Waco Art Tile, *Clayton*

NORTHERN CALIFORNIA

136

Steiger Terra Cotta & Pottery Works, *South San Francisco*
Roblin Art Pottery, *San Francisco*
Halcyon Art Pottery, *Halcyon*
Arequipa Pottery, *Fairfax*
Cathedral Oaks, *Alma*
California Faience, *Berkeley*
Solon and Schemmel, "S & S", *San Jose*
California Art Tile Co., *Richmond*
Walrich Pottery, *Berkeley*
Muresque Tiles, *Oakland, California, and Denver, Colorado*
Handcraft Tile, *San Jose and Milpitas*
Woolenius Tile Co., *Berkeley*
Kraftile Co., *Niles*

SOUTHERN CALIFORNIA

154

Pacific Clay Products, *Los Angeles*
Los Angeles Pressed Brick Co., *Los Angeles, Santa Monica, Richmond and Alberhill*
Kirkham Tile & Pottery Co., *Tropico*
Pacific Art Tile Co., *Tropico*
Western Art Tile Co., *Tropico*
California Tile & Terra Cotta Co., *Tropico*
Tropico Potteries, *Tropico*
Batchelder Tile Co., *Pasadena, Los Angeles*
California China Products Co., *National City*
Wade Encaustic Tile Co., *Vernon*
West Coast Tile Co., *Vernon*

FOREWORD

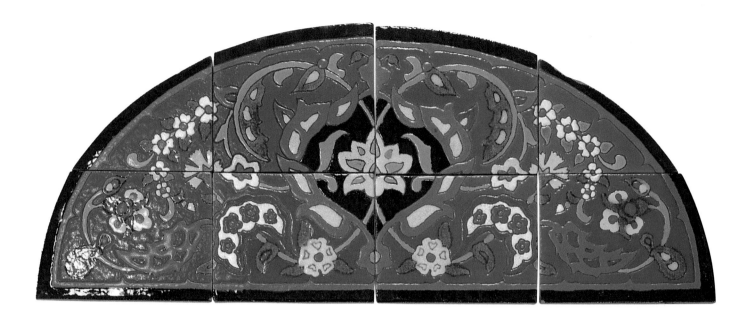

IN 1962, I PURCHASED SOME HAND-PAINTED FLOOR TILES IN FLORENCE, ITALY TO REPLACE THE VINYL IN MY KITCHEN. THE TILES were engaging, featuring the blue-and-white interlocking patterns typical of decorative work from the Amalfi coast.

Prior to installing them in my house in New York, I used them in a photograph for the *Ladies' Home Journal*. From that single photograph, I received some five hundred reader inquiries asking where to buy the tiles. Noting the interest, I promptly began a two-year search for tile makers in Europe. After a short buying trip in 1964, I opened a small tile shop in the basement of my photography studio, and called it Country Floors.

Soon I was taking photographs half the day and promoting tiles the other half. I also developed a passion for collecting antique ceramic tiles. To reestablish my photography career, I moved to France. There I found myself making photographs part-time and visiting factories the rest of the time. I found old tiles in flea markets, auctions, antique shops, and in the archives of old tile factories. This growing collection was shipped to New York and stowed throughout the store and warehouse. Eventually, I assembled them all for the Cooper Hewitt Museum's tile exhibit in New York in 1980. At that time my interest was mostly in European tiles.

In 1984, I married Shannon, also a tile aficionado. We settled in California, where she said wonderful tiles were made in the twenties and thirties. She was right, and before I knew it, I was enthusiastically collecting American art tiles.

In the United States, the first commercially produced tile was made in 1876 by Samuel Keys of the Pittsburg Encaustic Tile Company. The firm's first important tiles were used in some of the floors in the capitol building in Washington, D.C. Other tile makers may have preceded Pittsburg Encaustic, but none made salable products.

By the time the American tile industry was barely twenty years old, at the turn of the century, U.S. companies were displaying and winning medals at almost all of the international shows in Europe. In those days, the ceramists would come to work at a factory, bringing their own assistants and their own glaze formulas. When they left one factory for another, they took their secrets with them. As you read you will find a very tangled order of ceramists moving from one factory to another. Many companies were run by English emigrés (such as Samuel Keys) who worked in the eastern U.S. in Massachusetts, New York, and

New Jersey. From the East many tile makers moved on to Ohio, the Midwest, and California. As they migrated across the country, their tile designs evolved from Victorian English in style to revealing a very American character, which often came to be mixed with a Hispano-Mooresque style in the southwest and on the West Coast.

As I delved deeper into the world of American art tile, trying to discover more information about the tiles and artists who created them, I found very little had been written about the tile makers and their products. As I did more and more research, I rediscovered many little-known potteries and factories. It was possible to interview only the children and sometimes only the grandchildren of these tile makers. Old tile catalogs proved to be rare, and the catalogs of some potteries that we know existed simply never surfaced in my searches. But finding an old catalog is a treat, as it often makes it possible to identify unmarked miscellaneous tiles!

The search for old tiles can be gratifying and frustrating. I have covered every area flea market, as well as all of the antique malls, antique shops, and estate sales. Over the years, I have amassed hundreds of tiles. It became somewhat embarrassing arriving home from a sale with armloads of tiles, so if Shannon was at home, I would leave the boxes in the car. When she was out I would scurry them in just as she did with her shoe purchases. It was so satisfying to log them in and identify an unknown example. I still have many tiles in boxes that I have labeled "INCONNU" and wonder if they will ever be identified.

Antique tiles have now come of age and are very collectable. More articles than ever are being published about them. In Healdsburg, California, the Tile Heritage Foundation, established by Joe Taylor and Sheila Menzies, publishes a tremendous amount of invaluable new information.

Today, tile is experiencing a major resurgence in popularity. Why is this happening? It's for the same reason the Arts and Crafts Movements started at the turn of the century. People have grown disenchanted with vinyl, linoleum, formica, and other plastic conglomerate materials. They want to see the mark of an artist's involvement. Handmade, handmolded, and handpainted ceramic tiles are inviting and tactile. They beg to be touched and are visually appealing. The surface can be magical from one glaze to another. The art can be as sublime as the artist or artisan's ability.

I have written this book to share my passion and research with the growing ranks of tile enthusiasts, and it is my hope that this book will go some of the way toward addressing the lack of information available about this important American art form. Enduringly beautiful, many wonderful tiles can still be seen in their original installations, a number of which are pictured through-

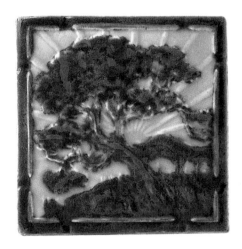

out this book. (See page 205 for information on these installations.) The information in this book was gleaned from a variety of sources, ranging from old catalogs to personal interviews, and as a result, the amount and depth of information varies from one pottery to the next. Dates are necessarily approximate, as I extracted them from city directories, incorporation documents, and other historical records, with plenty of variance from one source to the next. I want to extend a warm thank-you to all the people who helped me in amassing tiles and information, and I take full responsibility for any inaccuracies that may have crept into the book. I welcome clarifications and new information on the potteries mentioned herein (and any others of which I may not be aware) and would appreciate hearing from other collectors and enthusiasts.

Norman Karlson
P.O. Box 769
Hollywood, CA 90078

INTRODUCTION

AMERICA HAS BEEN EXPERIENCING A GROWING INTEREST IN COLLECTING ART AND ANTIQUES OF THE TWENTIETH CENTURY. An educated and somewhat affluent public, in search of both beauty and a piece of their past, have moved beyond the more traditional collectibles favored by their parents, whose early American furniture and European china this generation grew up with. Today, the focus has shifted to designers and producers of more recent fame. In particular, decorative objects and furniture from the Arts and Crafts Movement in America have become hugely popular.

The Arts and Crafts movement has proven to be a popular field of collecting for at least two reasons. First, the Mission aesthetic straddles the nineteenth and twentieth centuries, the last period of American antiques, yet it also forms part of the foundation on which modern design was based. There is also its romantic recognizability factor because it was, after all, the furniture of many of our grandparents and the rustic camps of our youth.

Most of the attention has been directed toward Arts and Crafts furniture, with its warm, dark finishes, straight simple lines, and no-nonsense approach to design. But recent decades have seen a broadening base of collectors for other art of the era, such as hand-wrought copper, decorative ceramics, and the subject of this book, art tile. Those wishing to create an Arts and Crafts interior may use furniture to form the skeleton of their home, but such an environment needs be fleshed out with the decorative arts. Many Arts and Crafts-style homes were outfitted with tile, from the monochromatic to the breathtakingly colorful, by important makers such as the Rookwood Pottery of Cincinnati, Ohio and the Grueby Pottery of Boston, Massachussetts.

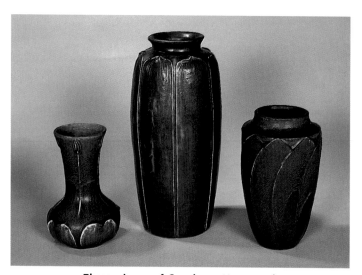

Three pieces of Grueby pottery, each with tooled and applied leaves.

Collecting art tile is therefore a natural part of living in an Arts and Crafts home. Homeowners fortunate enough to have a fireplace often take the plunge and actually set precious antique tiles in cement, recreating the look of a Stickley bungalow. Most of us, however, mount our decorative tiles in fine frames and hang them on walls or rest them on plate racks, elevating their status to a finer art.

Advanced art pottery collectors also naturally gravitate towards art tile, and such interest has accelerated in the last decade. After all, the medium is the same, the decorative elements and techniques similar. And there is a direct link in that many of the finest tiles were produced by some of the most famous of America's art potteries.

Rookwood, for example, produced art pottery for about 75 years, setting the standard for quality and consistency. Artists painted floral designs and scenes onto the surfaces of vases, developing expertise in design technique and glazing. In 1900, Rookwood won a gold medal at the Paris Exposition.

While most potteries came to fame with their world-class holloware, their entry into tile production around the turn of the century greatly enhanced the quality and prestige of this fledgling American industry. Of particular interest is their architectural faience, a heavier-bodied ware used to grace building façades, fountains, and fireplaces across the country.

The Grueby Pottery matched Rookwood's importance in producing a vibrant and revolutionary ceramic. With rich, vegetal matte glazes over organic, handthrown forms, such pieces seem more harvested than crafted. The organic naturalism of these pieces was often enhanced by modeling or applying stylized leaves and flowers. Grueby dabbled in tile production prior to 1900,

but it was not until 1907 that the pottery pursued this venture with vigor, utilizing the same rich glazing and design elements, and resulting in some of the finest tiles in the land.

It is not hard to see why dedicated collectors of such artware will usually include plaques or tiles in their portfolio. For a collector seeking to define an aesthetic, the absence of such an important aspect of a favored company's work would be a glaring omission.

Once the collector has begun to notice tile, it is but a short leap to the collecting of other fine tile work. The Moravian Pottery and Tile Works of Doylestown, Pennsylvania, is one good place to start. Henry Mercer and his staff there produced a great many high-quality tiles for years. Mercer influenced the designs, techniques, and guiding philosophies of many of his contemporaries, with his hands-on purist approach to tile making, the hand-pressing of unusually-shaped brocades, and mosaics of medieval imagery.

Emest Batchelder, who produced fine and inventive art tile in his suburban Los Angeles, California workshop in 1915, equalled Mercer's high standards by hand-molding thick tiles. These were impressed with stylized designs of knights on horseback, Dutch peasants, and West Coast landscapes. Another of Mercer's admirers, Joseph Dulles Allen, set up shop in nearby Enfield, Pennsylvania. The products of these three companies are often similar enough to be confusing to all but the expert eye.

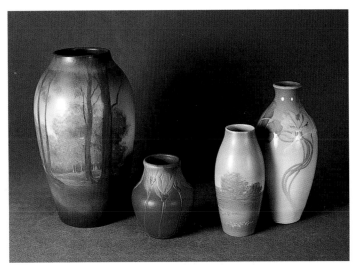

A variety of vases by the Rookwood Pottery Company of Cincinnati, Ohio.

Though little art tile was produced during the years of World War I, the industry enjoyed a rebirth during the 1920s and '30s as part of the postwar building boom. Existing production facilities, such as the American Encaustic Tiling Company and the Beaver Falls Tile Company, were adapted to meet the demand for the hand-made or faience look; thick tiles with stylized images in the Arts and Crafts vernacular. Such tiles were ultimately mass-produced, often with rustic characteristics added, such as built-in irregularities and postproduction aging. Many new tile companies were started just before the Great Depression (of which only a few survived), producing both plain and decorated faience tile, including Franklin, Mueller, Flint, and Mosaic.

Today, tile collectors often don't realize (or mind) the difference in technique and quality between the early, more labor-intensive approach of such artists as William Grueby and Henry Mercer, and the later, made-to-look-old product by those who followed. Prices are set by supply and demand and, while Grueby tiles will probably always be in a class by themselves, a large, pretty Tudor landscape panel will command a higher price than just about any Moravian tile of comparable size. The market for antique art tile is very much in its infancy, slowly catching up to the rest of the Arts and Crafts collecting groundswell. Hidden tile treasures still lurk aplenty in this country, and enough tiles and information should be uncovered in the next decade to encourage further research. What remains to be seen is if other authors, with the same focus and conviction as our friend Noman Karlson, become equally available.

Suzanne Perrault and David Rago

UNITED STATES POTTERY

Bennington, Vermont 1855–1858

NORTON & FENTON 1844–1847

THE BENNINGTON POTTERIES CONSISTED OF TWO FAMILY POTTERIES, ONE OWNED BY THE NORTON FAMILY AND THE OTHER BY Christopher Webber Fenton. The two were combined only briefly, from 1844 to 1847.

The oldest of the two was the Norton Pottery, established by Captain John Norton and William Norton in 1793. In 1823 John Norton turned the pottery over to his two sons, John Jr. and Luman, and the name of the pottery was changed to John Norton and Sons. Luman, an experienced potter, was manager, followed in 1841 by his son Julius.

Christopher Webber Fenton was born in Vermont in 1806, the son of Jonathan Fenton Jr., also a potter. Christopher had married Julius Norton's sister Luisa in 1832 and joined the pottery in 1844. With Fenton's influence the factory began making Rockingham and a variety of other pottery. The firm's name became Norton & Fenton.

In 1849, after a half dozen reorganizations and name changes, the company became Lyman Fenton & Company. Fenton received a patent for his Flint enamel glaze, in which metal oxides were actually mixed into the glazes to produce a wonderful speckled effect.

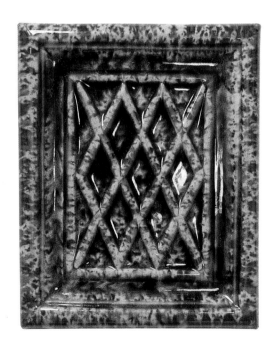

In 1853 the name changed once again, to the United States Pottery Company. It was, with 200 employees, the largest pottery in the country at that time. That same year, the company produced and installed inlaid tiles at the Crystal Palace Exhibition in New York. The tiles were ten inches square, white, inlaid with variegated colors, featuring a center decoration and American flags in each corner.

In 1855 United States Pottery was incorporated. Unable to recover from its financial difficulties, the United States Pottery Company closed its doors in 1858. During the period from 1844 until his pottery's end in 1858, Christopher Webber Fenton probably produced the widest variety of pottery in America.

IN 1866 ALEXANDER WILLIAM ROBERTSON ESTABLISHED A POTTERY AT THE CORNER OF WILLOW AND MARGINAL STREETS IN Chelsea, Massachusetts. In 1867, Hugh Cornwall Robertson, Alexander's younger brother, joined the pottery (which became known as A.W. & H.C. Robertson). The two men were then joined by their father James, and the firm was renamed James Robertson & Sons. Hugh brought with him artistic skills. Some other well known artists employed were J.G. Low (future owner of Low Art Tile Works), Franz Xavier Dengler, and G.W. Fenety.

In 1876 Hugh attended the Philadephia Centennial Exhibition and became enamored of Chinese ceramics and French Bourg-la-Reine slip decorated faience, of which the pottery soon began to produce its own. In 1877 the pottery introduced Chelsea Faience, for which the company is most remembered. This ware was characterized by relief modeling glazed in soft, rich colors. The decoration was either carved, impressed, or applied. Along with vases, many tiles and large relief plaques were made, modeled mostly by Hugh or his sister-in-law Josephine Day. The subjects included floral and geometric motifs, fable characters, portraits of literary figures, and even reproductions of famous paintings. The company also developed the first tile press during this time.

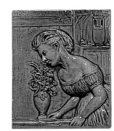

In 1880, James Robertson died, and in 1884 Alexander moved to California, leaving Hugh in charge of Chelsea Keramic. Hugh continued with his glaze experiments, in particular attempting to reproduce the Sang-de-Boeuf or oxblood red glaze. This, coupled with Hugh's neglect of the operation of the pottery, caused its total financial failure in 1888.

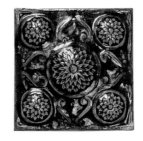

In 1891, a group of Boston investors reformed the company as Chelsea Pottery U.S., and installed Hugh as manager. Crackleware, based on another Chinese ceramic process that Hugh had rediscovered, was put into production and became the mainstay. In 1895, due to unsuitably damp conditions at the Chelsea plant which adversely affected the kilns, the factory was moved to Dedham, Massachusetts, and was thereafter known as the Dedham Pottery.

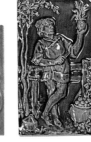

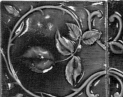
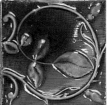

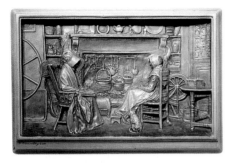

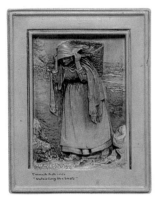

JOHN GARDNER LOW WAS BORN JANUARY 10, 1835, THE FIFTH GENERATION OF Lows in Chelsea. Artistically inclined from childhood, he studied painting in Paris under scenic painters Thomas Couture and Constantine Troyon from 1858 to 1861. Returning to the United States, he exhibited his work at a one man show in Boston. He married Charlotte Jane Farnsworth in 1861 and the following year a son, John Farnsworth Low, was born.

John Gardner worked as a scenic painter until 1873, when his need to effect a more gainful living sent him back to ceramics. He worked for James Robertson at the Chelsea Keramic Art Works for a year, and attended the Centennial Exhibition in 1876, which he found very inspiring. In 1877 he founded the J. & J.G. Low Art Tile Works. The factory was located at 948 Broadway, at the corner of Stockton Street. After almost two years, he fired his first successful kiln.

Within a few months after the start of production, Low tiles won the silver medal at the Cincinnati Industrial Exposition. In 1879, Low won the first prize, gold medal, at the exhibition at Crewe conducted by the Royal Manchester, Liverpool, and North Lancashire Agricultural Society in England, beating established English manufacturers. Almost overnight, this little known Massachusetts company, which had rushed to produce tiles in time to ship to the exhibition, found itself elevated to a prominent position within the tile industry.

Many awards were to follow, including the bronze medal from the American Institute in New York in 1880, the silver medal at St. Louis in 1881, the gold medal Republique Francaise at the Exposition Universelle, Paris in 1889, and an award from the American Institute of New York (for their soda fountains) in 1891.

In 1878 George W. Robertson joined the firm as a chemist and glaze expert (twelve years later he would establish Robertson Art Tile in Morrisville, Pennsylvania). John Gardner's father retired in 1883, and his son, John Farnsworth Low, joined the company, at which time the name was changed to J.G & J.F. Low Art Tile Works. William H. Grueby was employed at Low around 1880, prior to founding his own company.

Arthur Osborne, an Englishman, joined Low in 1879 and became the company's best known artist and modeler. He is credited with designing the majority of tiles produced by Low. His most renowned tiles were his "plastic sketches," rectangular ceramic plaques as large as twenty-four inches. The

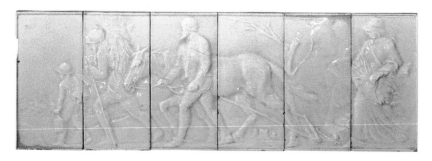

subjects varied: farm animals; farm workers; and portraits, especially older faces. Some motifs were drawn from mythology. The "plastic sketches," most signed with an "A" inside an "O," sold as framed art in galleries across the U.S. and Europe.

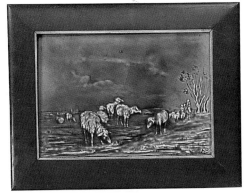
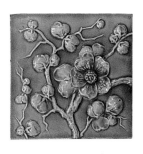

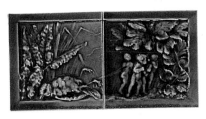
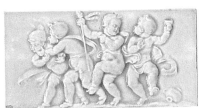

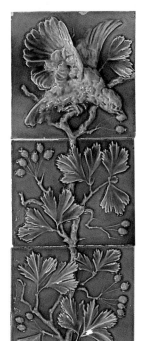
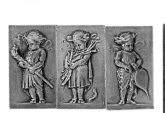

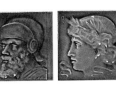

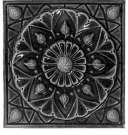

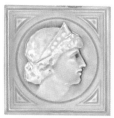 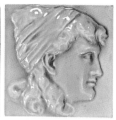

 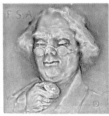

 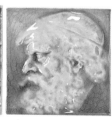 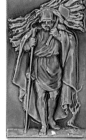 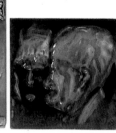 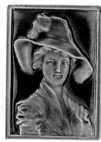

The company's most important products were relief tiles made mechanically by the dust method. These tiles featured portraits, flowers, plants and geometric patterns. They were made for mantels, stoves, wall coverings, wall art, and soda fountain installations. The company also produced tiles made and marked for other companies, such as Conway Cabinet Company, J.S. Conover & Company of New York, and The Henry Dibble Company of Chicago.

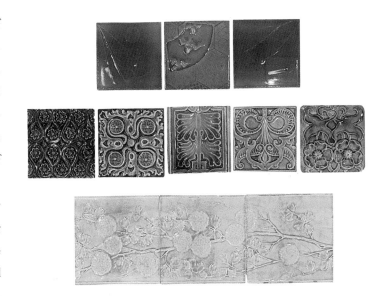

Another popular line of products produced by Low were "Natural Tiles." These were made by impressing leaves, grass, flowers, or even fabric into soft clay. A piece of tissue paper was then applied and another tile was placed on top. When these were pressed together and separated, there remained a convex and concave pattern. The deeper indentations held more glaze, resulting in darker color. This process was patented by Low on February 18, 1879.

During the company's life, only two catalogs were published, one in 1884 with thirty plates and one in 1887 with fifty plates. The book, *Plastic Sketches*, was published in 1882 and again in 1887.

Production ceased in 1902, the company was liquidated in 1907, the same year John Gardner Low died. Today, part of the plant, a brick building, still stands, a monument to one of the nation's greatest tile works.

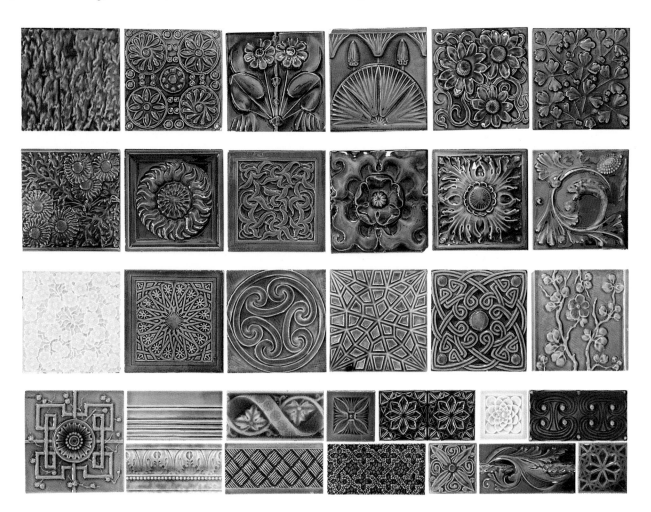

BOSTON TERRA COTTA COMPANY

Boston, Massachusetts 1880–1893

THE BOSTON TERRA COTTA COMPANY WAS ORGANIZED IN 1880 AS THE SUCCESSOR TO THE BOSTON FIRE BRICK COMPANY.

The Boston Terra Cotta Company manufactured architectural and decorative terra cotta and faience-glazed terra cotta for interior and exterior use. Notable installations of the company's work included glazed terra cotta in the corridors of the Charlesgate and the Adams House in Boston, and architectural terra cotta in the Barnum Institute of Science and History in Bridgeport, Connecticut. James Taylor, called the father of American terra cotta, was superintendent from 1876–1885.

Boston Terra Cotta was managed by Fiske & Coleman Company, and associated with the company were Eugene R. Atwood and William H. Grueby in the production of architectural faience (prior to Grueby founding his own Grueby Faience Company in 1894). Boston Terra Cotta was sold to Perth Amboy and New York terra cotta companies in December 1893, and the business was liquidated.

GRUEBY POTTERY

South Boston, Massachusetts 1898–1911
ATWOOD & GRUEBY 1891–1894
GRUEBY FAIENCE CO. 1894–1909
GRUEBY FAIENCE AND TILE CO. 1909–1920

WILLIAM HENRY GRUEBY WAS BORN IN 1867 AND, AT THE AGE OF THIRTEEN, BEGAN A TEN-YEAR APPRENTICESHIP WITH THE J. & J.G. Low Art Tile Works. In 1890 he struck out on his own to produce architectural faience at Revere, Massachusetts. Unfortunately, the company failed almost immediately. Undeterred, he formed a partnership the following year with Eugene R. Atwood, called Atwood & Grueby (a division of Fiske Homes & Company, Boston), which produced architectural ceramics and glazed bricks.

In 1894 Grueby formed the Grueby Faience Company in the old Atwood & Grueby plant at 164 Devonshire Street, South Boston. Three years later the company was incorporated with Grueby as manager, and George Prentiss Kendrick as designer.

1897 was a turning point: the company introduced its first matte glaze. Although the glaze is often attributed to Grueby, matte glazes had been produced prior to 1897 by Rookwood, Chelsea Keramic, and Hampshire Pottery. After

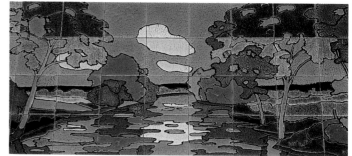

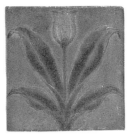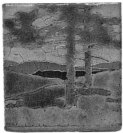

winning one silver and two gold medals at the Exposition Universelle de Paris in 1900, Grueby's name became synonymous with its matte green glaze, in shades of cucumber, melon, and leaf. Many firms imitated the glaze by various means, including chemical formulas, firing techniques, acid washing, and sand blasting. By 1906 there were over a dozen makers of matte green, including Wheatley Pottery, Van Briggle, TECO, and Pewabic.

Other awards for Grueby quickly followed. In 1901 the company received a gold medal in St. Petersburg, Russia. That same year Grueby pottery was shown in the four rooms of Gustav Stickley furniture at the Pan American Exposition in Buffalo. In 1904 the pottery received the grand prize at the Louisiana Purchase Exposition in St. Louis as well as the highest award in the exposition at Torino, Italy.

Grueby's matte-glazed pottery became a symbol of the Arts and Crafts movement. It was sold throughout the United States and Europe by Gustav Stickley, Tiffany & Co., and Marshall Fields, to name a few.

Grueby pottery was often decorated with forms of leaves and flowers. After the pot was thrown, but while it was still in a soft state, the decoration was incised. Then a very thin, rolled, spaghetti-like clay was applied to the incised groove so it became part of the body of the piece. On tiles, the design was sometimes applied through the use of tube-lining, in which a thin strip of soft clay was applied to the tile surface using a pastry bag. This raised line would separate the different colored glazes that were applied. Often, the Grueby glazes were so thick that they obliterated the clay line. The pottery had many imitators, but Grueby tiles, which were the mainstay of the company's production and finances, were so unique that successful imitation was rare.

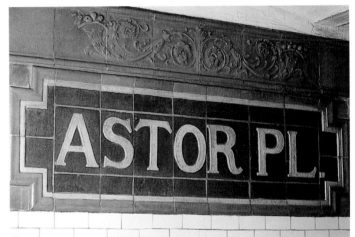

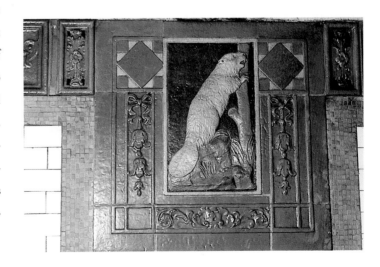

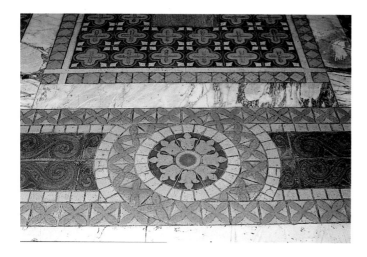

In 1898 the organization was divided into two divisions: art pottery and architectural faience. Art pottery was marked "Grueby Pottery," while architectural ceramics were marked "Grueby Faience."

Designer George Kendrick left Grueby and was replaced in 1901 by architect Addison Le Boutiller. In 1908, Karl Langenbeck was hired as superintendent of Grueby Faience.

In 1907 Grueby Pottery was incorporated as an independent company. Grueby Faience Company went bankrupt in 1909, and William Grueby took his formulas and designs and formed the Grueby Faience and Tile Company. This new firm produced only architectural faience and tiles, which were marked "Grueby Boston."

Production at Grueby Pottery ceased in 1911. Grueby Faience production continued until 1919, when the company was purchased by Calvin Pardee of Perth Amboy, New Jersey. Production continued in Boston until about 1920, when the administration was transferred to New York and the tile making to Perth Amboy. William Grueby died in 1925 at age fifty-eight.

Grueby tiles were used in many important installations. Perhaps the most accessible are those made for Manhattan subway stations. These can be seen at Astor Place, Bleecker Street, and 28th Street on the Lexington Avenue line (1904) and at Columbus Circle on the Broadway/7th Avenue line.

Some other notable installations include the paneled floor of the crossing in the Cathedral Church of St. John The Divine on Amsterdam Avenue in New York City, and thirty-six panels painted by C.G. Voorhees in 1908, depicting scenes along the Delaware Lackawanna & Western Railroad in what was the station in Scranton, Pennsylvania, and is now the Royce Hotel.

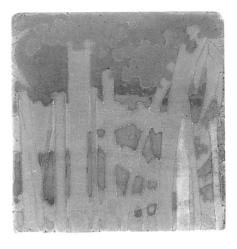
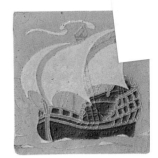

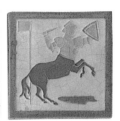

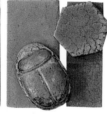

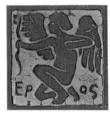

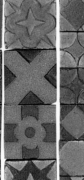

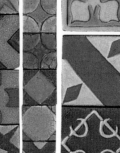

HARTFORD FAIENCE CO.

Hartford, Connecticut 1894–1991
ATWOOD FAIENCE CO.

THERE IS LITTLE HISTORICAL RECORD OF THE HARTFORD FAIENCE COMPANY, EXCEPT SOME REFERENCES FOUND IN OLD ADVERtising and city directories. The Atwood Company existed as early as 1860, and later became the Atwood Faience Company. In 1894 it was incorporated as the Hartford Faience Company. Faience tiles were produced between 1901 and 1912.

During these years the company made a wide range of both common and decorative tiles. These included painted and heavy relief tiles, murals, signage, shaped tiles, glossy and matte tiles, cornice tiles, and glazed architectural terra cotta. These were used on building facades, subway stations, fireplaces, mantels, and wainscotting.

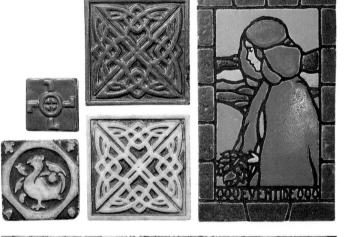

In 1902 Clarence E. Whitney was president and remained at least through 1929. Fred L. Bishop was the general manager and also a director. From 1917 through at least 1928, the factory was located on Bartholomew Avenue and the corner of Hamilton Street.

In 1905 the company started making electrical porcelain, which continued until the company closed in 1991.

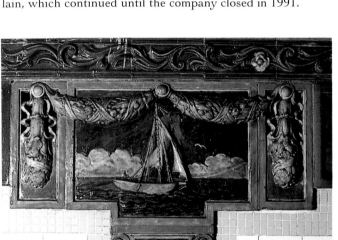

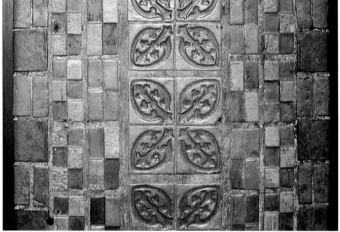

DEDHAM POTTERY
Dedham, Massachusetts 1895–1943

AFTER RESCUE AND RESUSCITATION FOLLOWING ITS 1888 FAILURE, THE CHELSEA POTTERY MOVED TO DEDHAM, MASSACHUSETTS, in 1895, and became known as the Dedham Pottery. Hugh Cornwall Robertson continued to manage the plant, and was helped by his son William A. Robertson.

Dedham was best known for its crackleware, which was primarily dinnerware, vases, small animal figures, and tea tiles. These were handmade in molds and hand-decorated with blue glaze. Over the years Dedham produced more than sixty patterns of border decoration, mainly featuring animal and flower motifs. The most well known of these was a rabbit, which became the company's logo. The tea tiles either matched the border decorations or had larger images of animals or florals centered on the tile.

Dedham's pottery (250,000 pieces ultimately were produced) became very popular, and was sold in stores such as Tiffany & Co. in New York. In 1908 Hugh Robertson died and William became head of the pottery. William had suffered severe burns to his hands in a kiln explosion a few years earlier and was not able to design or model any pieces. Most of the pottery produced after 1908 was based on Hugh's previous designs.

William Robertson died in 1929, and his son J. Milton Robertson continued to manage the factory until April, 1943. Subject to a shortage of skilled artisans and hurt by increasing production costs, the factory closed. The inventory of both Dedham and Chelsea were liquidated through Gimbel's Department Store in New York City in September, 1943. J. Milton Robertson died in 1966, ending an eight generation line of Robertson potters.

MERRIMAC POTTERY
Newburyport, Massachusetts 1897–1902
MERRIMAC CERAMIC CO. 1902–1908

IN 1897, THOMAS S. NICKERSON ESTABLISHED THE MERRIMAC CERAMIC COMPANY IN NEWBURYPORT, MASSACHUSETTS. THE pottery's first products were drain pipes, florist ware, and glazed tiles. The following year Nickerson formed a partnership with W.G. Fisher and expanded production.

Five sets of Merrimac tiles were shown at the Society of Arts & Crafts Exhibition in Boston in April 1899. These, listed in the exhibition catalog as "Enameled Tiles," were a lettered fireplace head-piece designed by W.G. Rantoul; three tile panels, for dado or fireplace; a panel of various decorative tiles; enameled coats-of-arms; and small lettered tiles designed by Nickerson.

The company began to shift its production to art pottery around 1900. In 1902, the name was changed to Merrimac Pottery. Merrimac's accomplishments were acknowledged with a silver medal at the 1904 Louisiana Purchase Exposition in St. Louis.

In 1908 Nickerson sold the Merrimac Pottery to Frank A. Bray, but the plant was destroyed by fire in October of that year and never resumed operation.

MARBLEHEAD POTTERY

Marblehead, Massachusetts 1904–1936

THE MARBLEHEAD POTTERY WAS ESTABLISHED IN 1904 BY DR. HERBERT J. HALL AS A THERAPEUTIC TREATMENT CENTER FOR his mental patients. Dr. Hall envisioned a self-sufficient crafts village in which rehabilitated patients could support themselves and the sanitarium through the creation and sale of their wares. The pottery was set up in an old barn at 12 Goodwin's Court, Marblehead. Charles Binns recommended that Alfred Baggs, a promising young student, be hired to set up and oversee the pottery. Alfred Eugene Baggs (born in Alfred, New York, on October 27, 1886) had begun his studies with Charles Binns at Alfred University in 1903. By 1908, the Marblehead Pottery was producing about 200 pieces a week.

Dr. Hall soon realized that ceramic modeling placed too great a strain on his patients and he separated the pottery from the therapy program, turning the pottery into a completely commercial venture, its profits benefitting the sanitarium. The pottery proved popular with Marblehead tourists.

The pottery's wares were characterized by simple, classic shapes, muted matte glazes, and excellent craftsmanship. Vases, tea and mantel tiles, and bookends were produced. Those that were decorated typically used stylized floral, animal, nautical, or geometric motifs.

In 1915, Dr. Hall moved his sanitarium to Devereaux, Massachusetts, and Baggs became owner of the pottery, which he moved to larger quarters at 111 Front Street. Under Baggs, the pottery received many accolades, including the J. Ogden Armour prize at the 1915 exhibition of applied arts at the Art Institute of Chicago; the Arts and Crafts Society, Boston, medal in 1925; the Charles F. Binns medal, 1928; and the first prizes for pottery at the Cleveland Museum of Art, 1928, the Robineau Memorial Exhibition in Syracuse, 1933, and the National Ceramic Exhibition in Syracuse, 1938.

Baggs began dividing his time at the pottery between supervising in summer and teaching in winter. From 1925 to 1928 he assisted a former classmate, R. Guy Cowan, at the Cowan Pottery in Rocky River, Ohio. In 1928, he was named chairman of a new Ceramic Design Department at Ohio State University. Dwindling sales of art pottery and Baggs' increased absence from Marblehead forced the pottery to close in 1936, although the shop that sold its wares may have remained open until 1939 or 1940. It is estimated that more than 200,000 pieces were produced by Marblehead Pottery. Baggs remained at Ohio State until his death in 1947.

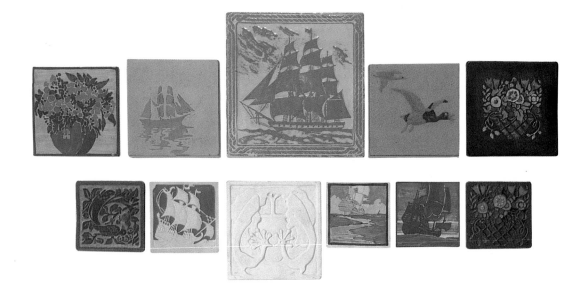

THE SATURDAY EVENING GIRLS CLUB WAS ORGANIZED AT BOSTON'S NORTH BENNETT STREET INDUSTRIAL SCHOOL TO HELP poor teenage girls from predominantly immigrant families. The club sponsored music classes, a glee club, dances, lectures, and crafts. In 1906, to provide some income for the girls, a pottery class was added.

Mrs. James J. Storrow, a member of the board of managers of the school, became the pottery's patron. A ceramist was hired from the Merrimac Pottery, and by 1908, the pottery was producing.

The pottery operation soon ran out of room and moved to a larger building at 18 Hull Street, where it occupied the basement and rear of the first floor. Edith Brown, the director, lived on the top floor. The building was next to Boston's famous Old North Church of Revolutionary War fame. This history inspired the Saturday Evening Girls Club to market goods sold at their store, "The Bowl Shop," under the name "Paul Revere Pottery."

Over the years, about 200 young women were members of the Club, although only about fifteen worked there at any one time, producing both Paul Revere art pottery and decorative tiles.

By 1915 the pottery had again outgrown its space and a new building was constructed at 80 Nottingham Road in Brighton. The staff was increased to about twenty.

Edith Brown died in 1932 and the pottery went into a decline and closed in January, 1942. Mrs. James Storrow, the Saturday Evening Girls Club's great benefactor, died in 1944. Unlike the Newcomb College Pottery, the Club was never a financially profitable organization.

The tiles produced during the pottery's thirty-six years of operation were quite diverse, ranging from pictorial series (Paul Revere's ride, Columbus' ships, the buildings of old Boston, the Mayflower) to animal and floral motifs, round plaques, and murals (some of which were signed by Edith Brown). While the tiles were still soft, incisions were made in the plastic clay to separate the colors that were applied afterwards. Most of the tiles were dated and initialed, but there are no records extant to link the initials to specific individuals.

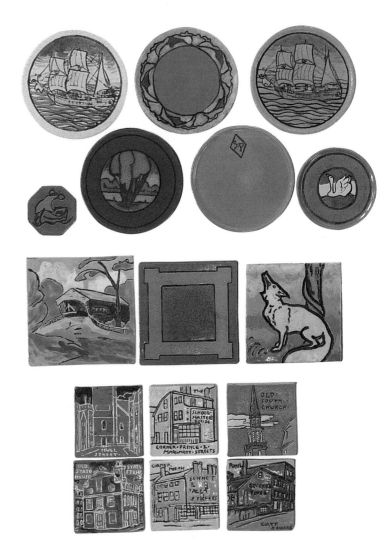

UNION PORCELAIN WORKS

Greenpoint, Brooklyn, New York 1886–c. 1928

WILLIAM BOCH AND BROTHERS c. 1844–1864

SMITH AND LOCKWOOD 1864–1869

THOMAS C. SMITH AND CO. 1869–1888

THOMAS C. SMITH AND SON

SOMETIME BETWEEN 1844 AND 1854, THREE GERMAN BROTHERS FOUNDED THE WILLIAM BOCH & BROTHERS PORCELAIN FACtory in Greenpoint, Brooklyn, New York. It was located at 300 Fifth Street (which later became Eckford Street). Between 1861 and 1863, the company was purchased as an investment by a New York architect, Thomas Carl Smith. On a trip to Europe in 1863, Smith visited some porcelain factories, which piqued his interest in this industry. Upon his return to the United States, he enlarged the plant. The company went through several name changes within the next few years. In 1864 it became Smith and Lockwood; from 1864 to 1869, Thomas C. Smith & Company; from 1869 to 1888, when Smith's son, C.H.L. Smith came into the firm, the name changed to Thomas C. Smith and Son; in 1888, it was incorporated as the Union Porcelain Works.

In 1865 the company developed the first true hard porcelain white ware produced in America, and the following year it became the first American pottery to use underglaze decoration. It was during this period that the factory produced its finest wares, some of which can be found in museums today. Notable artisans associated with the factory included Karl Mueller, chief designer and modeler, and J.M. Falconer, a prominent decorator.

The focus of Union Porcelain Works' production was fine decorative porcelain as well as restaurant china. The company also produced both thin and thick hard porcelain tiles with underglaze decoration. These, the factory claimed, were the only tiles made in America that could withstand the heat of a fireplace. The tiles were decorated with griffins and other designs for mantels and wainscotting. Overglaze painting was also used. Union Porcelain's office had a series of panels illustrating the ceramic processes used in the pyramids in ancient Egypt.

In 1900 C.H.L. Smith succeeded his father. The company continued production until shortly after the death of C.H.L. Smith in the late 1920s.

JOHN BENNETT POTTERY

New York, New York 1876–1883

JOHN BENNETT WAS BORN IN ENGLAND IN 1840. HE TRAINED FIRST AT STAFFORDSHIRE POTTERIES, AND LATER WORKED FOR Henry Doulton. By the time Bennett arrived in the United States and opened a studio at 101 Lexington Avenue in New York, in 1876, he was already a very accomplished pottery decorator.

His high-priced pottery, called "Bennett Ware," was sold at many fine stores across the country, including Tiffany & Co. Bennett Ware was characterized by simple, unencumbered shapes adorned with underglaze painting. The decorative subjects were usually boldly painted plants and flowers in strong colors, often outlined in black against brightly colored backgrounds. In addition to pottery, Bennett produced six-inch tiles using the same underglaze technique. His work could have been influenced by William De Morgan and William Morris (and possibly Persian or Turkish painting).

In 1878, Bennett taught classes in pottery decoration at the New York Society of Decorative Art (relinquishing the post a year later to Charles Volkmar). In 1879, Bennett moved his studio to 412 E. 24th Street, where he remained until he retired to his farm in West Orange, New Jersey in 1883. The father of thirteen children, John Bennett died in 1907 at the age of sixty-seven.

THE TILE CLUB

New York, New York 1877–1887

THE TILE CLUB WAS ESTABLISHED BY TWELVE ARTISTS IN 1877, A TIME WHEN AMERICAN ARTISTS WERE NOT HELD IN HIGH regard. Eager both to have some fun and make a name for themselves, the artists hoped that they could do both by painting decorative tiles. The twelve founding artists included the painters Winslow Homer, Arthur Quartley, Julian Alden Weir, and Robert Swain Gifford; the English architect Edward Wimbridge; illustrators Edwin Austin Abbey and Charles Stanley Reinhart; sculptor William Rudolf O'Donovan; writer and art critic Earl Shinn; painter and journalist W. M. Laffan (who later owned the New York Sun); writer and painter Francis Hopkinson Smith; and an amateur, Walter Paris. Eventually thirty artists became members. Young and poor when the club was formed, most of these artists had made successful careers for themselves by the time the club disbanded ten years later.

The Tile Club met on Wednesday nights in members' studios. The members painted on eight-inch white tiles, generally in a monochrome blue. The artists considered the tiles secondary to their regular work, and didn't take them too seriously. Still, these pieces, extremely rare today, faithfully reflect each artist's style and subject matter: Winslow Homer's tiles depict beach scenes with people; Julian Weir's feature small portrait heads.

There were no membership dues or restrictions of any sort, except that any profits made from the tiles were to be used solely for the club's entertainment. The members regularly went on inspirational sketching excursions. On the most lavish of these

trips they rented and redecorated a canal boat and went on a three-week sail up the Hudson. Indeed, the artists gained a good deal of notoriety as members of the Tile Club and were often referred to by nickname in the press, which frequently featured articles on the club's madcap undertakings.

In 1881 Edwin Abbey allowed the club to use the first floor of his rented house as a meeting place. In 1887, the artists published the Book of the Tile Club, which illustrated their work. It was the club's last venture, possibly a way to liquidate the club's funds. By this time, most of the artists involved were famous in their own right.

Other artists who became members after the twelve founders included: George Henry Boughton, William Gedney Bunce, William Merritt Chase, Frank Duveneck, Arthur Burdett Frost, George Willoughby Maynard, Francis David Millet, Alfred William Parsons, Augustus Saint-Gaudens, Napoleon Sarony, John Henry Twachtman, Elihu Vedder, Stanford White, Frederick Dielman, Gustav Kobbe (musician), Dr. L. Lewenberg (musician), Antonio Knauth (musician), William C. Baird (musician), W.A. Patton (writer and journalist), Charles Truslow (lawyer), Heromichi Shugio (art director).

CHARLES VOLKMAR

New York, New York 1879–1914

MENLO PARK CERAMIC CO., *Menlo Park, New Jersey* 1888–1895

VOLKMAR KERAMIC CO., *Brooklyn, NY* 1895–1895

VOLKMAR & CORY, *Corona, New York* 1895–1896

CROWN POINT POTTERY, *Corona, New York* 1896–1900

VOLKMAR POTTERY, *Corona, New York* c. 1900–1903

VOLKMAR KILNS, *Metuchen, New Jersey* 1903–1914

BORN IN BALTIMORE IN 1841, CHARLES VOLKMAR WAS THE SON OF A PORTRAIT PAINTER AND ART RESTORER. AS A YOUNG man Volkmar moved to Paris and studied under sculptor Antoine-Louis Barye and painter Henri Harpignes, and apprenticed with Theodore Deck and Haviland Limoges.

Volkmar returned to the United States in 1879 and established a pottery in Greenpoint, Brooklyn. Using the underglaze slip method of decoration he had learned from Limoges, Volkmar made vases and tiles depicting pastoral landscapes and barnyard scenes. Fireplace tiles produced under Volkmar's direction were shown at an exhibition of the Salmagundi Club in 1880. In 1882 Volkmar moved the pottery to Tremont, where he continued to produce plaques, tiles, and vases with pastoral scenes applied in the underglaze slip method.

Volkmar moved to Menlo Park, New Jersey, in 1888 and opened the Menlo Park Ceramic Company in partnership with J. T. Smith. He used opaque glazes and low relief lines to define compositions, instead of the high line reliefs commonly employed at the time.

In 1895 Volkmar returned to New York and opened the Volkmar Keramic Company at 39 Greenpoint Avenue, Brooklyn, producing art tiles and household ceramics, primarily in a Delft-inspired style. The same year, Volkmar and artist Kate Cory established another pottery, Volkmar & Cory, in the Corona section of the Bronx. The designs produced here were similar to those of Volkmar Keramic — Delft-style American scenes in blue underglaze on a white background. What distinguished these pieces from typical Delft wares (imagery aside) was a greater amount of detail and texture than the traditional Dutch ceramics. The work produced at Volkmar & Cory won a gold medal at the 1895 Atlanta exposition. By late 1896, however, the partnership was dissolved. Volkmar continued the pottery alone as Crown Point, and then Volkmar Pottery.

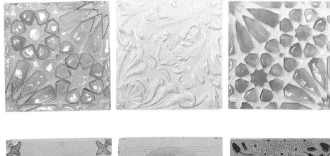

In 1903 Volkmar and his son Leon established the Volkmar Kilns, Charles Volkmar & Son, in Metuchen, New Jersey. Leon, born in France in 1879, studied at the Academie Nationale before opening Volkmar Kilns. The Volkmars increasingly used matte glazes, which particularly suited the new porcelain body they switched to in 1905.

The Volkmars taught ceramics in Metuchen, and in 1911 Leon left the pottery to establish Durant Kilns with one of his students, Jean Rice. Charles continued to operate Volkmar Kilns until his death in 1914.

INTERNATIONAL TILE AND TRIM

Brooklyn, New York 1882–1888

NEW YORK VITRIFIED TILE WORKS 1888–1896

BROOKLYN VITRIFIED TILE WORKS 1896–1917

INTERNATIONAL TILE AND TRIM WAS ESTABLISHED IN 1882 BY A FATHER AND SON, BOTH named John Ivory. It was located at 92 Third Street, between Hoyt and Bond, in Brooklyn, New York. The company's financial backing, management, and machinery came from England, as did ceramist Fred H. Wilde. (Wilde came to International from Maws Company in England in 1885, beginning what was to be a long and varied career in America.) Predictably, the factory produced glazed, printed, and decorated encaustic tiles in the English style.

In 1886 the English shareholders sold out to an American, John Arbuckle. Two years

later the company was sold again, becoming the New York Vitrified Tile Works. Although the company produced vitreous and semi-vitreous floor tiles, it is not known whether the wall tile program of International Tile and Trim was continued.

In 1896, A. H. Bonnell purchased the company and changed the name to Brooklyn Vitrified Tile Works. In 1917 the plant was sold at auction.

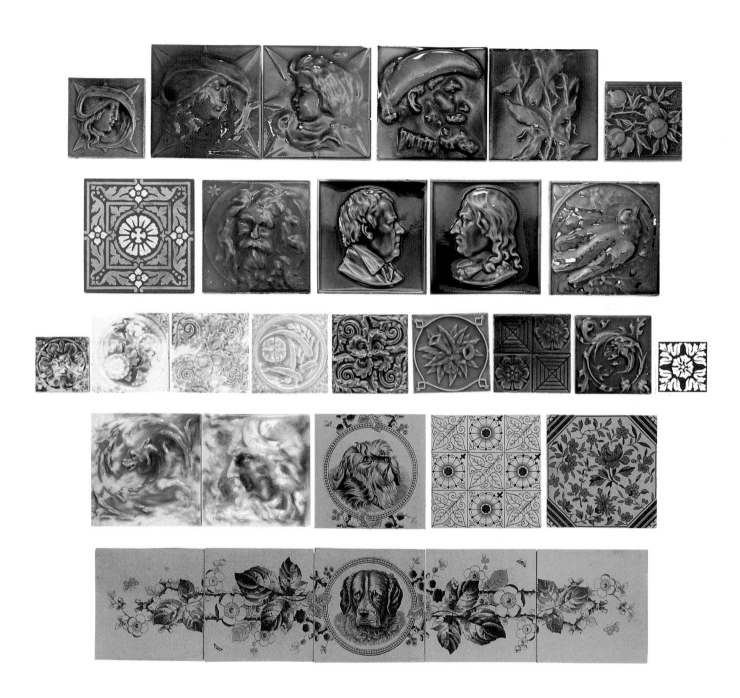

NEWBURGH TILE WORKS

Newburgh, New York 1884–1890

RAVEN-OWEN AND CO. 1885

CHARLES R. OWEN CO. 1884–1890

OWEN AND PEIRCE,

OWEN TILE MANUFACTURING CO. LTD., *Tarrytown, New York* 1890–1891

ONLY FRAGMENTARY INFORMATION—CULLED FROM CITY DIRECTORIES, TILE MARKINGS, AND A FEW DOCUMENTS—EXISTS concerning these tile factories. From 1884 to 1890, Newburgh city directories list several tile companies at the same address on Broad and Water Streets: Charles R. Owen Tile Manufacturer from 1884 to 1891; Newburgh Tile Works from 1884 to 1890; and Raven Owen & Company in 1885. ("Owen and Peirce Newburgh" is another name variation that can be found on the backs of some tiles.)

A local economic Depression in 1890 caused the company to move across the Hudson River to Tarrytown, where it settled into the old Odell and Booth Brothers plant at 155 Main Street. The company incorporated at this location in 1891 with Charles R. Owen as president.

The tiles produced in Newburgh under the various company names all have the same general style: dust pressed in deep relief, bright glazes, with floral and portrait decorations, including a well-executed head of Napoleon.

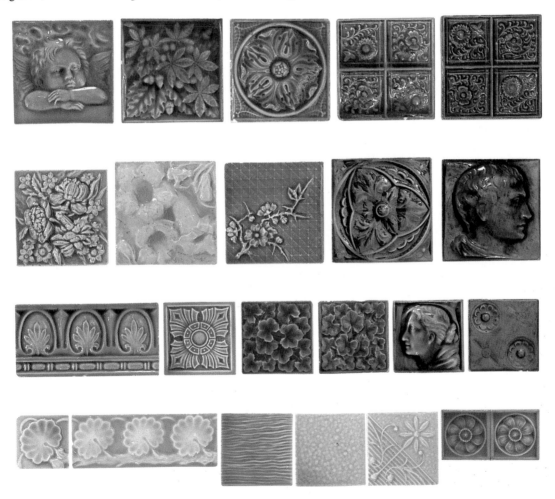

ORLANDO BRONSON POTTER AND ASAHEL CLARKE Geer founded the New York Architectural Terra-Cotta Company in 1886. It was located at 401 Vernon Avenue, Long Island City. Walter Geer was chairman of the board and Richard F. Dalton was president.

The company produced terra cotta tiles, bricks, and molded or hand-modeled architectural panels. The company introduced a white terra cotta which proved very popular, particularly in panels and bricks. New York Architectural Terra-Cotta furnished details for Carnegie Hall, the Plaza Hotel, The Gertrude Rhinelander Waldo Mansion (now the Ralph Lauren store), and the facade of 39 Fifth Avenue, all in New York.

In 1891 the factory expanded and the following year an office building (now a landmark) was constructed at 42–10 Vernon Boulevard, Queens. A second plant was constructed in Old Bridge, New Jersey. The Depression brought misfortune and the company declared bankruptcy in 1932. In 1933 both plants were taken over by the Eastern Terra Cotta Company. The original factory building in Queens was finally razed in the 1970s.

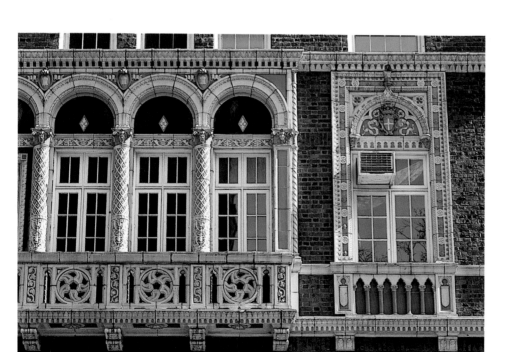

ATLANTIC TERRA COTTA COMPANY

Staten Island, New York 1897–c. 1912

THE ATLANTIC TERRA COTTA COMPANY WAS ORGANIZED IN 1897 IN TOTTENVILLE, STATEN ISLAND, NEW YORK.

In 1907 Atlantic consolidated with three other companies: Perth Amboy Terra Cotta, founded in 1897; the Excelsior Company, founded in 1894 in Rocky Hill; and the Standard Terra Cotta Works, founded in 1892 in Perth Amboy. In 1908 Atlantic acquired the controlling interest in the Atlanta Company (founded in 1895 in Atlanta, Georgia), and became the largest terra cotta company in the world at the time.

In 1912 Atlantic produced the glazed tile for the Marine Grille at New York's McAlpin Hotel. The wall murals, depicting shipping in New York Harbor, were installed between arched columns. Unfortunately this fine installation, designed by Fred Dana Marsh (the son of Reginald Marsh), has since been destroyed.

ROBINEAU POTTERY

Syracuse, New York c. 1900–1928

ADELAIDE ALSOP ROBINEAU (B. 1865) BEGAN HER CAREER IN POTTERY BY LEARNING, THEN TEACHING, THE ART OF CHINA PAINTing. In 1899 she and her husband, Samuel Edward Robineau, founded *Keramic Studio,* a design magazine for the pottery trade. Three years later *Keramic Studio* published an article by the famed French ceramist, Taxile Doat, containing the instructions and formulas for porcelain paste and glazes made by the French pottery, Sevres.

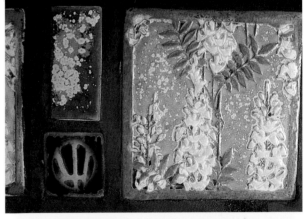

While working with her husband at the University City Pottery, Adelaide made her famous Scarab Vase, which took about 1,000 hours to complete. Today the Scarab Vase is perhaps the most well-known piece of pottery in America, and was even stolen from a museum. (Fortunately it was later recovered.) Adelaide produced only about 600 pottery pieces in her lifetime, many of which are now in museums across the country.

In 1911 Adelaide won the grand prize in Torino and, in 1915, the grand prize at San Francisco's Panama-Pacific Exposition. From 1920 to 1928 she was on the Syracuse University faculty as an instructor of pottery and ceramic design. In 1928 she retired, passing away the following year at the age of sixty-four. Although tiles were not her main interest, Adelaide did produce some extraordinary examples, such as those used on the two fireplaces in her house in Syracuse.

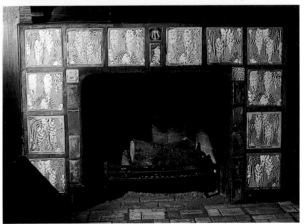

TIFFANY POTTERY

Corona, Long Island, New York 1900–1914

LOUIS COMFORT TIFFANY ELECTED NOT TO FOLLOW HIS FAMOUS FATHER, CHARLES L. TIFFANY, INTO THE JEWELRY BUSINESS, opting instead to begin his career as a painter. At age thirty he shifted to applied arts, working on glass, jewelry and metalware, and it was here that he made his greatest achievements.

Tiffany did not begin experimenting with ceramics until the age of fifty, when he set up a pottery in Corona, Long Island. Two years later, in 1902, he moved the pottery to New York City. The first public showing of Tiffany pottery was at the Louisiana Purchase Exhibition of 1904.

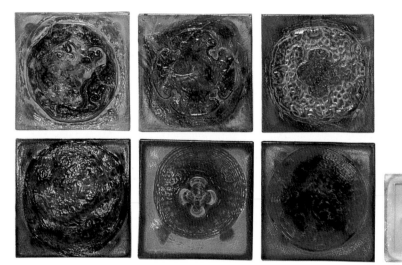

Tiffany's work, decorated primarily with floral and leafy patterns, was influenced by William Grueby (who had supplied lamp bases to Tiffany's father for use with the famous Favrile glass shades). Although they were not his main focus, Tiffany did produce some ceramic tiles, including a notable example of a 3½-inch square tile with a wild carrot blossom pattern.

Louis Comfort Tiffany died in 1933 at age eighty-five.

BUFFALO POTTERY

Buffalo, New York 1901–Present

THE BUFFALO POTTERY, A SUBSIDIARY OF THE LARKIN SOAP COMPANY, WAS ESTABLISHED in 1901 at Seneca Street and Hayes Place, Buffalo, New York, to supply premiums to soap customers. John Durrant Larkin, head of Larkin Soap, was named president of the pottery, and Ralph Stuart (a relative of Gilbert Stuart, the renowned portrait painter) was appointed head of the art department.

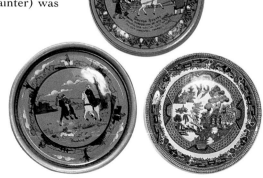

Production began in 1903. Due to its proximity to great amounts of hydroelectric power, the pottery was one of the few at the time to operate entirely on electricity. Decoration was applied by hand painting, decals, or a combination of the two. The "Old Willow Pattern," produced with decals, was first made in 1905. The most popular line was "Deldare," which was decorated by hand painting on top of a decal. This was first produced around 1908–09, and then reintroduced between 1923 and 1925. In 1932 the com-

pany produced the "George Washington Plate," using the famous portrait by Gilbert Stuart. Tiles produced were either tea tiles or wall plaques.

The pottery is still in business, known since 1956 as Buffalo China Incorporated. The company now manufactures restaurant china.

BYRDCLIFFE POTTERY
Woodstock, New York 1902–1928

BYRDCLIFFE WAS A UTOPIAN COMMUNITY ESTABLISHED IN 1902 BY THE HEIR TO A BRITISH INDUSTRIAL FORTUNE, RALPH Radcliffe Whitehead, and his wife Jane Byrd McCall. An amalgam of the Whiteheads' middle names, Byrdcliffe was located on 1,300 acres of beautiful mountainside land in Woodstock, New York. The colony's purpose was to permit its members to live a wholesome existence in nature. The colony was to be funded by the sale of arts and crafts produced by its members.

Thirty buildings were constructed, including workshops, living quarters, and a dining hall. The first workshop was a very well-equipped furniture studio. The colonists had planned to sell their furniture at Mc Creary's, in New York City, but the size and weight of the pieces made transport too difficult. The furniture shop was closed in 1905, and emphasis shifted to other crafts.

In 1903 a small pottery was established for the summer, and soon became a permanent shop under the direction of Edith Penman and Elizabeth R. Hardenbergh. The earliest work was done by hand, without a potter's wheel, and glazed in soft colors. These were fired by Charles Volkmar. In a 1907 exhibition at the New York Society of Keramic Arts, examples of Byrdcliffe pottery were well-received.

Alexander Archipenko replaced Penman and Hardenbergh when they left Byrdcliffe to set up their own pottery. In 1923 he was followed by Zulma Steele, who had been at Byrdcliffe from the beginning, except for a stint with the Red Cross in France during World War I. Steele ran the pottery until 1928, when Byrdcliffe closed. She named her pieces "Zedware."

Due to Byrdcliffe's influence, Woodstock and the surrounding area became a cultural haven of arts and crafts. Eventually, the inspiration for Byrdcliffe faded, and the colony became the Whitehead's private estate in 1928. Ralph Whitehead died in 1929. His wife took up permanent residence at Byrdcliffe until her death in 1959, and the Whitehead's son, Peter, continued on the estate until he died in 1976. Today, the property belongs to the Woodstock Guild, whose programs focus on education and theater.

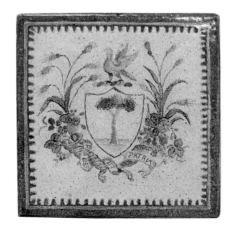 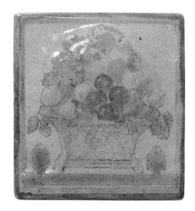

NEW JERSEY

FULPER POTTERY

Flemington, New Jersey 1899–1935

G. W. FULPER & BROTHERS 1881–1899

FULPER STANGL 1930–c. 1972

THE ORIGINS OF THE FULPER POTTERY DATE BACK TO 1814, WHEN SAMUEL HILL ESTABLISHED A POTTERY TO PRODUCE DRAIN tiles at the corner of Main and Mine Streets in Flemington, New Jersey. Abram Fulper, an employee, purchased the pottery following Hill's death in 1860.

In 1881 Abram Fulper died and the pottery was taken over by his four sons: William, George, Charles, and Edwin. The company operated as G. W. Fulper & Brothers and Fulper Brothers until 1899, when it was incorporated as the Fulper Pottery Company.

By the 1900s, William Fulper emerged as head of the pottery. Late in 1909, with the help of John Kunsman, the factory's leading potter, William Fulper introduced a successful line of art pottery called "Vasekraft." In addition to pottery, the line included tiles and other decorative accessories. These were characterized by sophisticated glazes derived from Chinese ceramics.

By 1911, J. Martin Stangl, the technical superintendent, was responsible for creating most of Fulper's famed glazes. In 1928, William Fulper died. In 1929 the pottery acquired a third plant in Trenton. The following year, the main plant in Flemingon was destroyed by fire, leaving the old plant on Mine Street.

Stangl purchased the pottery in 1930, and the company was renamed Fulper Stangl. Production of art pottery continued, but on a much smaller scale. In 1935 the Flemington plant was closed.

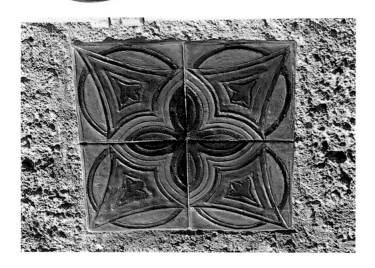

Although pottery had been under the Stangl name, the company did not officially become the Stangl Company until 1955. Stangl died in 1972 and the plant struggled on until 1978, when it finally closed.

Interestingly, the Fulper legacy has carried on. In 1984, William Fulper's granddaughters found the Vasekraft glaze formulas in the attic of the Fulper family home and started a new line of tiles using these splendid old glazes.

BURROUGHS MOUNTFORD AND COMPANY

Trenton, New Jersey 1879–1921

BURROUGHS MOUNTFORD AND COMPANY WAS FOUNDED IN 1879, TAKING OVER THE THREE-YEAR-OLD EAGLE POTTERY, which had foundered. The company's principals included H. Nelson Burroughs, his son, H. A. Burroughs, Joseph Burroughs, and Elijah Mountford.

The company employed 150 workers, including thirty decorators, to produce fine tableware, bathroom ware, and art tiles. The art tiles varied from relief patterns to painted or transfer decorations. Advertisements offered tiles "for walls, hearths, bathrooms, mantels, cabinet work, fire stoves and for general interior decoration." Burroughs Mountford won a bronze medal at the World's Fair and Cotton Centennial in New Orleans in 1884-85.

Production began to decline in 1906 and (although the Burroughs Mountford name was used until 1940) in 1921 the company was purchased by the Crane Company, a manufacturer of bathroom porcelain fixtures.

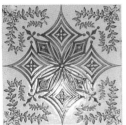 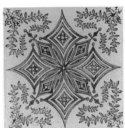 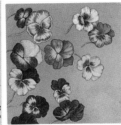

J. L. RUE POTTERY

South Amboy, and Matawan, New Jersey c. 1880–1884

AFTER LEAVING THE SWAN HILL POTTERY, JOHN L. RUE AND HIS son Isaac started the J. L. Rue Pottery in South Amboy, New Jersey. In 1880 the pottery moved to 32 Main Street in Matawan.

The firm employed thirty to forty workers, producing Rockingham ware, yellow ware, crockery, majolica, enameled bricks, and tiles. In 1884 legal suits against the pottery forced it into receivership, and the following year The New Jersey Mosaic Tile Company, directed by Bennett Kossuth Eskesen, took over the property.

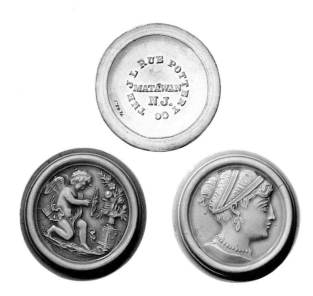

TRENT TILE CO.

Trenton, New Jersey 1882–1939

HARRIS MANUFACTURING CO. 1882–1883

THE HARRIS MANUFACTURING COMPANY WAS ESTABLISHED IN 1882 AT KLAGG AVENUE AND PLUM STREET IN TRENTON. Soon after, the name was changed to the Trent Tile Company.

Born in Quebec in 1835, Isaac Broome came to Trent as a designer and modeler in 1883. Broome had very strong artistic qualifications, including eight years at the Ott and Brewer pottery. At Trent Broome was such a prolific tile modeler that the company was able to continue producing new Broome designs years after he left the company, in 1886.

Broome was replaced by another accomplished artist and modeler, William Wood Gallimore, an Englishman with thirty years' experience in England and the United States. Despite the loss of his right arm in a shooting accident some years earlier, it was in these later years of his career that Gallimore produced his most notable work.

In 1910 the factory employed 300 persons, but by 1912 the plant had financial difficulties, and by 1916 the company was in receivership. Thomas H. Thropp purchased the foundering establishment, becoming its new manager and president. The company was revitalized under Thropp's stewardship, producing 8 million square feet of tile annually. Thropp died in 1931 and was succeeded by his son, H. W. Thropp.

In 1936 R. P. Herrold, who had been president of Mosaic Tile Company, purchased Trent from the Thropp family with a government loan. In 1939 the government foreclosed the loan and the plant was in receivership once again. The factory closed down, remaining idle until 1940 when it was bought by the Wenczel Tile Company of Trenton, which was expanding.

Trent Tile Company's most artistic work was produced in its early years when Isaac Broome and William Gallimore created their heavily modeled and glazed tiles, decorated with figures, portraits, flora, and Beaux Arts patterns. Many six-by-eighteen-inch tiles and even some twelve-by-twenty-four-inch pieces from this period were used on fireplaces, mantels, counter fronts, wainscotting, soda fountains, doorways, and as independent art panels. Iridescent, luster tiles and heavy relief tiles, which were sandblasted after glazing, were also produced. Trent Tile was well justified in boasting about the beauty and variety of its embossed glazed tiles, which were available in 118 colors and thousands of designs.

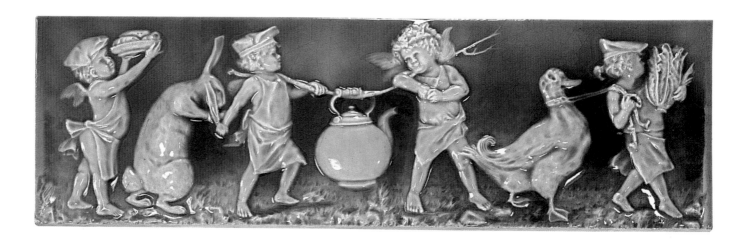

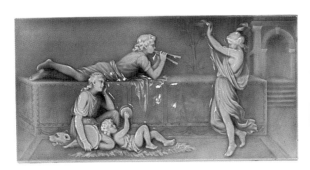
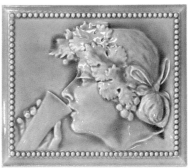

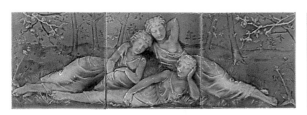
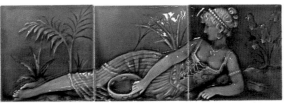

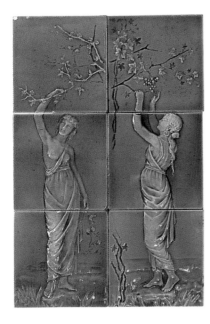
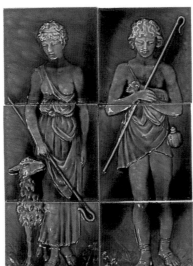
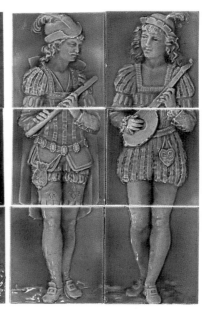

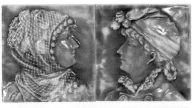
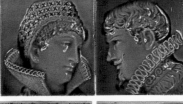
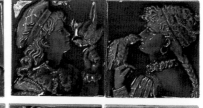

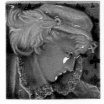
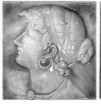
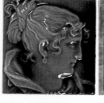

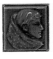
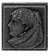
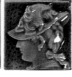
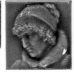

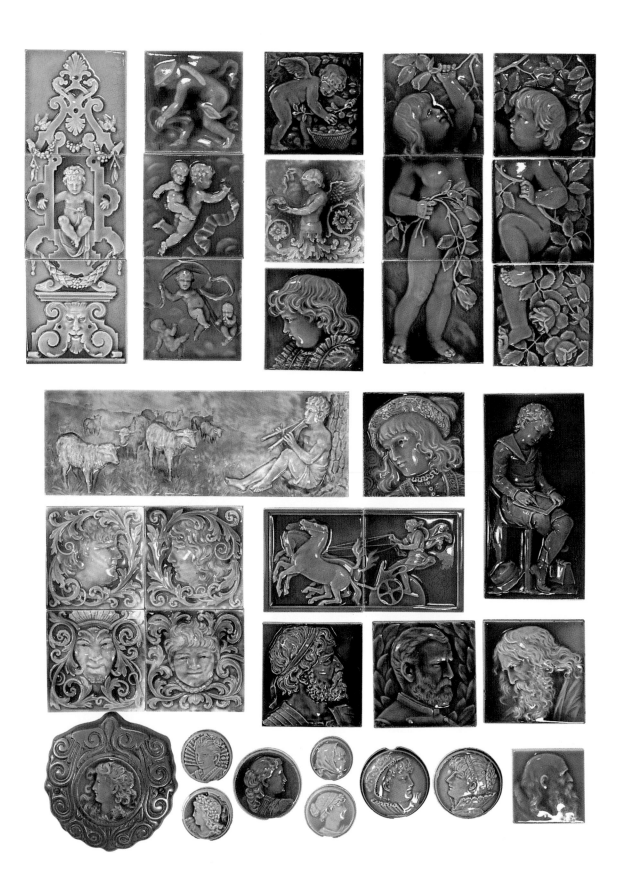

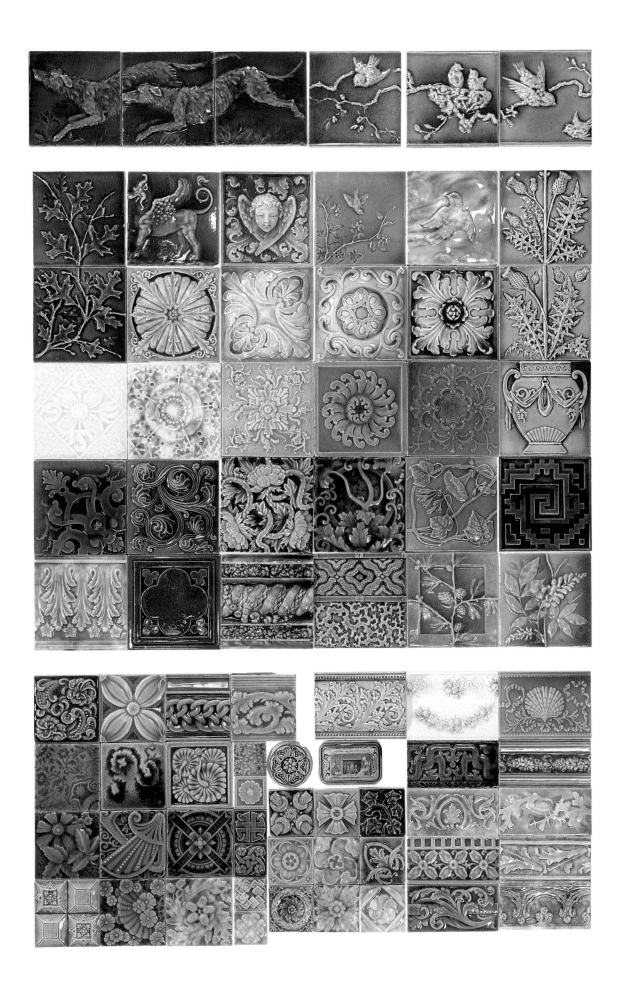

RARITAN ART TILE WORKS

South Amboy, New Jersey c. 1884–c. 1900

RARITAN ART TILE WORKS OF SOUTH AMBOY, NEW JERSEY, WAS PRODUCING TILES AROUND THE TIME THE BROOKLYN Bridge opened and the Statue of Liberty arrived from France. Raritan made well-executed, molded tiles, some of which had a concave negative mold on the back side. Subjects included portraits on four, six, and eight-inch tiles, as well as floral, vine and geometric patterns. The tiles were glazed in both subdued matte and glossy colors. Some tiles were marked "copyright by G. DeFestetius 1884, Raritan Art Tile Works, South Amboy."

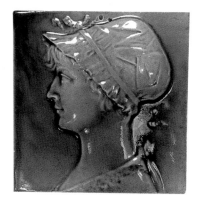

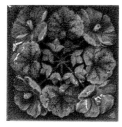
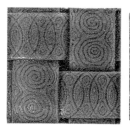

PROVIDENTIAL TILE WORKS

Trenton, New Jersey 1886–1913

THE PROVIDENTIAL TILE WORKS WAS ESTABLISHED BY JOSEPH KIRKHAM, JAMES H. ROBINSON, AND C. LEWIS WHITEHEAD IN Trenton, New Jersey, in 1886—just three years after Trent Tile was founded there. The companies manufactured similar products. The well-known designer and modeler Isaac Broome left Trent to go to Providential in 1886. As at Trent, Broome built up a library of designs that were used by Providential long after he left in 1890. Broome was replaced by Scott Callowhill, an Englishman who had gained considerable experience working at the Royal Worcester, Doulton, and Lambeth potteries in England. Callowhill's two sons, Hubert and Ronald, were also hired as decorators, along with Fred Wilde, who worked at Providential for a few months in 1900.

In 1893, Joseph Kirkham sold his shares to open his own tile factory in Barberton, Ohio. James Robinson sold out in 1900, leaving Whitehead to continue alone. When Whitehead died in 1912, the company was sold to Whitehead's wife Emma, a former concert singer, in 1913. Emma was secretary and treasurer of the company and intended to operate the plant as general manager, along with some other interested capitalists. The plans fell through, however, and the factory was dismantled soon thereafter.

Providential's tiles were white with dust-pressed, heavily molded figures, portraits, flowers, or vines painted in savory, translucent glazes. The tiles were used for fireplaces, mantels, store counters, and wainscotting. A popular line produced from 1890 to 1910 was a series of white, molded tiles with gold outlines.

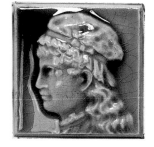

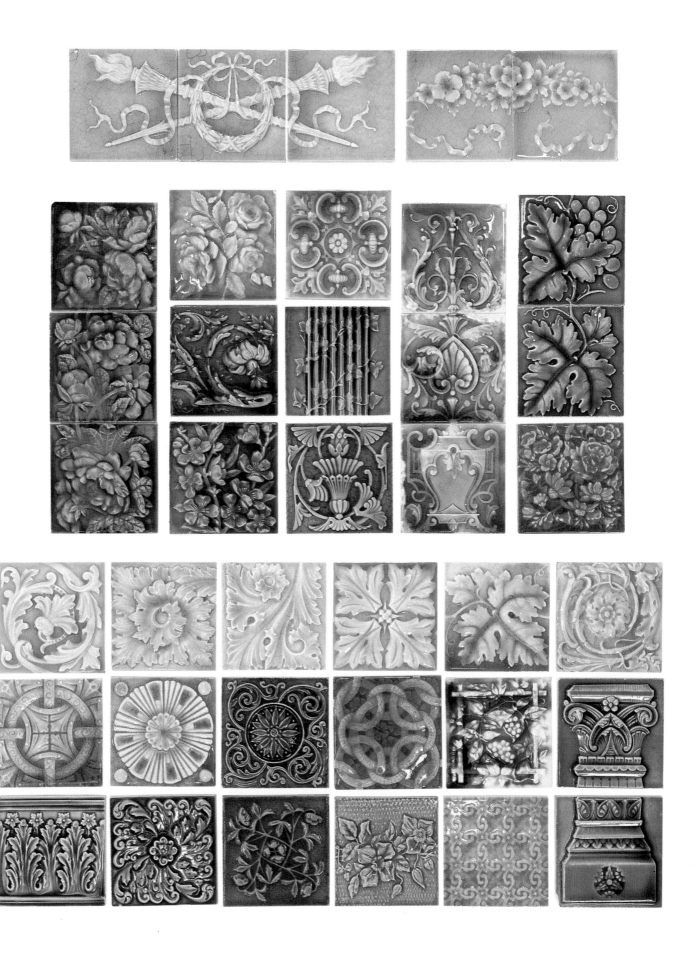

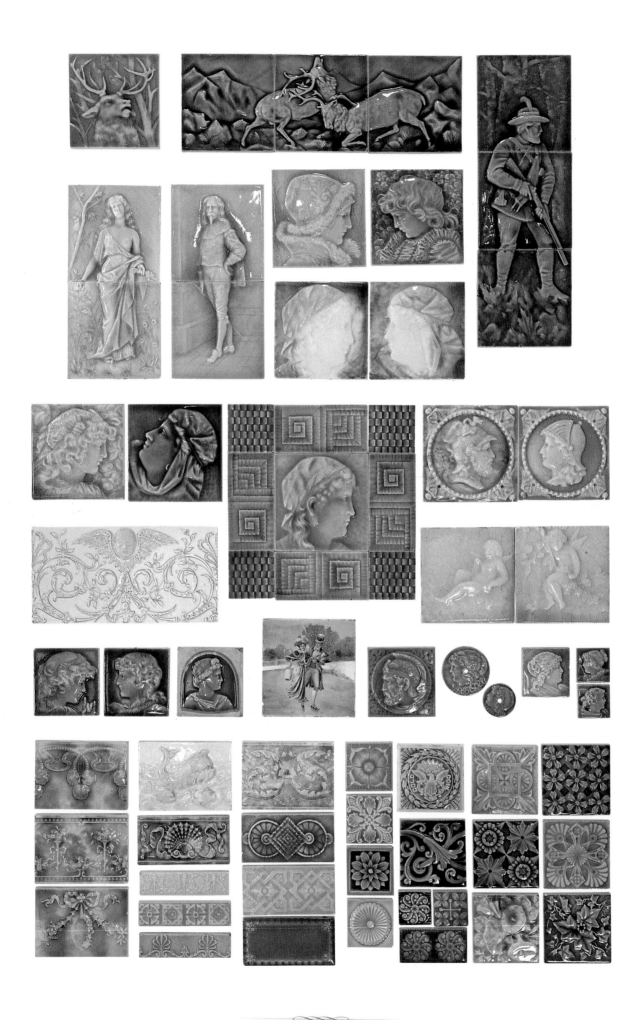

BORN IN STAFFORDSHIRE, ENGLAND, IN 1861, WILLIAM E. RIVERS EMIGRATED TO AMERICA IN 1885. AN INVENTOR AS WELL AS a ceramist, Rivers developed the cost-saving "Rivers Downdraft Periodic Kiln."

In 1890, Rivers founded The Old Bridge Tile Company in Old Bridge, New Jersey. Poorly financed, it was taken over by a bank in 1893. Fortunately, the company was quickly refinanced and reincorporated as The Old Bridge Enameled Brick and Tile Company.

After its shaky start the new company became very profitable. By 1903 the plant had 200 workers. The same year, Old Bridge consolidated with the Robertson Art Tile Company of Trenton and the Columbia Encaustic Tile Company of Anderson, Indiana, to form the National Tile Company. Old Bridge backed out of the deal after a year, however, and reinstated its former name.

In 1917 William Rivers died. Charles H. Devoe purchased River's share and became superintendent. In 1927 Old Bridge sold out to a new conglomerate, the Robert Rossman Corporation. Devoe stayed on as manager of the Old Bridge factory. After a year Devoe left Robert Rossman and started his own company in Old Bridge, selling tile to contractors from a small showroom. For his new business Devoe took the Old Bridge Tile Company name.

In its several incarnations over its thirty-seven year span, Old Bridge produced dust-pressed tiles in soft solid colors, as well as lightly molded designs with floral, garland, and Beaux Arts motifs. Often two colors were used without regard for the relief design, after the current fashion.

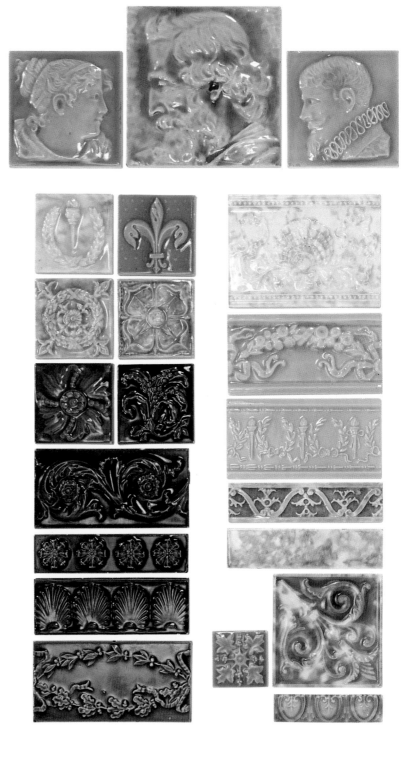

C. PARDEE WORKS

Perth Amboy, New Jersey c. 1890–1928

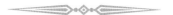

THE C. PARDEE WORKS WAS ESTABLISHED BY CALVIN PARDEE SOMETIME PRIOR TO 1893 ON PROPERTY ADJOINING A STEEL mill operated by the Pardee family. The main factory and office building had previously been owned by the members of a "free love society" and used as their domicile.

The factory closed for a few years around 1898 but reopened with the arrival of Adolf Metzner and his son Max in 1900. They had previously been employed by the Hamilton Tile Works, as well as the American Encaustic Tiling Company. In 1908 the Metzners left Pardee to start their own company.

In 1919 Pardee bought the ailing Grueby Faience and Tile Company of Boston and transferred production to Perth Amboy the following year. Pardee continued to produce Grueby tiles (as they proudly advertised), and these tiles sometimes bore the Grueby, sometimes the C. Pardee, marks. The company also began to import and distribute Royal Delft faience tiles from Holland in the early 1920s.

Ario Pardee became president of the company in 1929 and soon entered into an agreement with the Matawan Tile Company to sell Matawan tiles. That organization was called Pardee Matawan Tile Company, with B. K. Eskesen as vice president and Alfred Mathiasen as treasurer. The original C. Pardee Works closed in 1938, and the plant was dismantled.

ARCHITECTURAL TILING COMPANY (ATCO)

Keyport, New Jersey 1912–c. 1960

EAGLE TILE COMPANY 1903–1908

KEYPORT TILE COMPANY 1906–1912

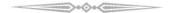

THE EAGLE TILE COMPANY, LOCATED IN THE SOUTHERN END OF KEYPORT, OFF BEER STREET, WAS ORGANIZED IN 1903 AND failed in 1908. The Keyport Tile Company was incorporated in 1906 at the same address. In 1908 The Matawan Tile Company purchased Keyport Tile, only to sell it again four years later.

In 1912 the Keyport Tile Company was purchased by Anthony Christiana and renamed the Architectural Tiling Company, or ATCO. (Christiana had previously owned the Atlantic Tile and Faience Company of Maurer, New Jersey.) Around this time Adolf Metzner and his son came to the firm after disposing of their own company. In 1916 ATCO was reorganized and incorporated. The company advertised majolica tiles, as production now included colored tiles on white or faience bodies, as well as matching faience floor tiles.

According to the Ceramic Trade Directory, in 1929 Anthony Christiana was president of ATCO and an E. F. Christiana was superintendent. ATCO was still in business in 1960, but was sold later in the decade.

 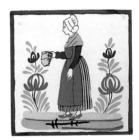

M ATAWAN T ILE C O.

Matawan, New Jersey c. 1905–1942

P ROGRESSIVE A RT T ILE 1930–1942

I N 1905 THE M ATAWAN T ILE C OMPANY WAS ESTABLISHED AT THE OLD J. L. R UE P OTTERY BY THREE D ANES FROM J UTLAND:

Karl Mathiasen (president); Bennett Eskesen; and Bennett's brother, L. B. Eskesen. In 1908 Matawan Tile purchased the Keyport Tile Company, which was operated as a subsidiary until 1912, when it was resold. That same year Charles Barker, after six years with the company, left Matawan Tile and established the Atlantic Tile Manufacturing Co.

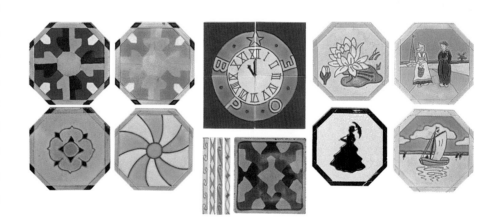

Karl Mathiasen died in 1920 and Bennett Eskesen became president. By 1928 Matawan Tile was thriving and employed 200 workers. In 1929 Alfred Mathiasen was manager.

In 1930 a small factory was built next to the main plant to produce art tiles, coasters, and Delft mantel tiles. This subsidiary was called the Progressive Art Tile Company.

Eventually Matawan combined with C. Pardee to form a selling organization called the Pardee Matawan Tile Company, which lasted until 1938 when Pardee closed. Eskesen finally sold out in 1942. The factory continued for a few more years, then was dismantled and sent to South Africa.

M. A. METZNER MANUFACTURING CO.

Perth Amboy, New Jersey 1908–1915
PERTH AMBOY TILE WORKS 1915–1930

THE M. A. METZNER MANUFACTURING COMPANY, WAS ESTABLISHED BY ADOLF METZNER AND HIS SON MAX IN 1908, AT SAYRE Avenue and Convery Boulevard in Perth Amboy, New Jersey. Metzner's associates were Thomas Atherly and Iver C. Ostergaard. Before this venture, Adolf Metzner was working at The C. Pardee Works in Perth Amboy. Earlier, Metzner had worked at the American Encaustic Tiling Company in Zanesville, Ohio, and had founded another ceramic company, the Hamilton Tile Company of Hamilton, Ohio, as far back as1883.

In 1909, Metzner and his son left M. A. Metzner to work for the Architectural Tiling Company in Keyport, New Jersey. The Perth Amboy plant became the Ostergaard Tile Works, with Ostergaard as president and August Staudt as secretary treasurer. Production shifted to floor tiles. In 1915 Staudt gained control of the company, installing himself as president, with Ostergaard as vice president, and changing the name to the Perth Amboy Tile Works.

In 1927 Staudt and his company joined in a consolidation of tile companies to form the Robert Rossman Corporation. Participants included the Robert Rossman Company, Beaver Falls Art Tile Company, Old Bridge Enameled Brick and Tile Company, and the Perth Amboy Tile Works.

In April 1928, a fire destroyed the Perth Amboy plant. This, plus the Great Depression, brought an end to the organization two years later. The Perth Amboy plant lay idle for several years before it was finally taken over by the city for back taxes.

In 1940 Staudt rented the plant from the city in an attempt to resume operations. Again, the timing was poor as the economy was shifting to a war footing, and factories were gearing up for the war effort. Staudt's last tile-making venture failed.

MUELLER MOSAIC COMPANY

Trenton, New Jersey 1908–1942

HERMAN CARL MUELLER FOUNDED THE MUELLER MOSAIC COMPANY IN 1908, AT THE OLD ARTISTIC PORCELAIN COMPANY plant on Chambers Street and Cedar Lane in Trenton, New Jersey. Assisting him were two brothers, George and James Grigsby, with whom Mueller had previously worked at the National Tile Company and Robertson Art Tile. The company was incorporated the following year with Mueller as president.

Mueller, a German-trained sculptor, emigrated to the United States in 1875 and became one of this country's preeminent ceramic modelers. His education in classical decorative art styles and firm beliefs in the ideals of the Arts and Crafts movement were the foundation for his successful career in the ceramic industry. Mueller's previous credits included establishing the Mosaic Tile Company with Karl Langenbeck.

Even with the vast amount of tile available at that time, Mueller still felt there was a great need for more artistic tiles executed in the Arts and Crafts tradition of aesthetic beauty melded with high craftsmanship.

Mueller's numerous mosaic installations included the Kelsey Memorial Building and Crescent Temple in Trenton, New Jersey; the Garden Pier and Blatt Building in Atlantic City, New Jersey; the U.S. Embassy in Tokyo; the YMCA in Harrisburg, Pennsylvania; the Ceramic Building at Rutgers University in New Brunswick, New Jersey; and the Walker-Gordon Dairy in Plainsboro, New Jersey.

George Grigsby died in 1916, and his brother died the following year. At this time, Mueller's sons, Edward and William, became part of the company. William eventually became vice president. The firm continued to produce prolifically through the 1920s and into the 1930s. The Depression, Mueller's advanced age, and the switch in popular decorative tastes to sleeker, less expensive, industrially-produced materials contributed to the firm's decline in sales in the mid–1930s. To the end, Mueller stuck by his aim to produce art tiles in the Arts and Crafts tradition. Mueller died in 1941, and the company closed the following year.

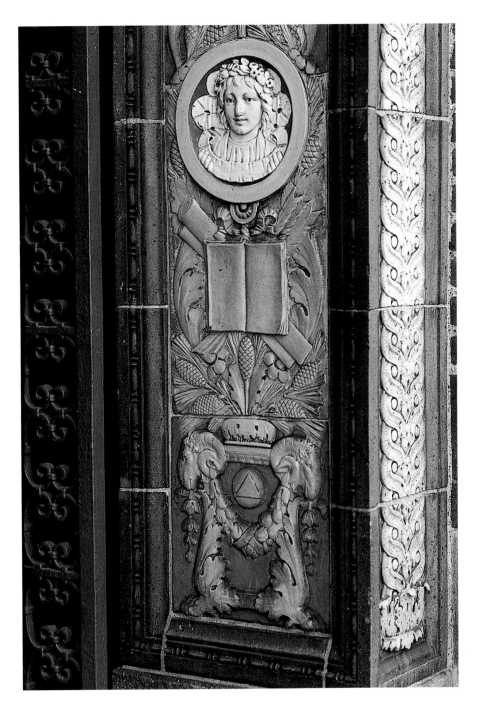

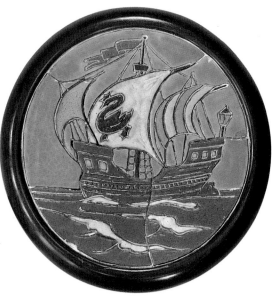

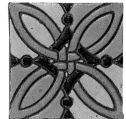

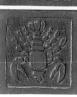

Atlantic Tile and Faience Company

Maurer (Now Perth Amboy), New Jersey 1908–1912
American Encaustic Tile Company (A.E.T.) 1912–1937

In 1908, two brothers, Anthony W. and Van Christiana, organized the Atlantic Tile and Faience Company of Maurer (now Perth Amboy), New Jersey. Adolf Metzner was employed as chemist; Van was superintendent. The modern plant, equipped with the latest machinery, was built between two rail lines: one bringing clay and raw materials into the factory; the other carrying out the finished tiles. The company produced architectural tiles, white wall tiles with all forms of trim, and faience tile for designers.

Previously, Anthony Christiana had worked for C. Pardee Works, also in Perth Amboy, and had been a salesman for the American Encaustic Tiling Company in Zanesville, Ohio. In 1912, the Christiana brothers sold Atlantic to American Encaustic and became Encaustic's eastern plant. Eventually Anthony left to purchase Keyport Tile Company (later, the Architectural Tiling Company) in Keyport, New Jersey. In 1937, the parent company, A.E.T., was liquidated and the Perth Amboy plant was purchased by the president of the Franklin Tile Company, Malcomb A. Schweiker. Schweiker continued to operate the plant as American Encaustic Tiling Company Incorporated, until it became part of a new conglomerate, American Olean Tile Co.

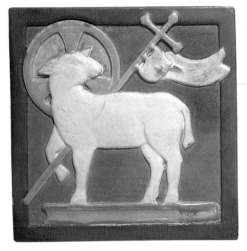 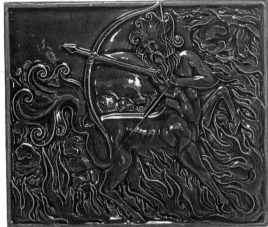

ATLANTIC TILE MANUFACTURING CO.

Matawan, New Jersey 1910–1919

THE MOSAIC TILE CO. 1919–1967

THE ATLANTIC TILE MANUFACTURING COMPANY WAS ESTABLISHED IN 1910 ON ELM AND ATLANTIC AVENUE IN MATAWAN, NEW Jersey, by Edward Barker, his son, Charles Barker (who was formerly at the Matawan Tile Company), and Herbert Gittens. The vast clay deposits in the area and its proximity to the New York market made Matawan an ideal site. The company incorporated in 1916.

In 1919 The Mosaic Tile Company of Zanesville, Ohio, purchased the plant and enlarged the factory's capacity from one to ten kilns.

In 1931, as the Depression was taking its toll on other tile factories, Mosaic was in full production, six days a week, working on tiles for the Eighth Avenue Independent Subway in New York. The following year, however, the plant either temporarily shut down or operated on a very limited schedule until 1936. The Matawan factory closed in 1967.

OTT AND BREWER

Treton, New Jersey 1871–1893

BLOOR, OTT AND BOOTH 1863–1864

BLOOR, OTT AND BREWER 1865–. 1871

BLOOR, OTT AND BOOTH WAS ESTABLISHED IN 1863 ON CLINTON AVENUE IN TRENTON, BY WILLIAM BLOOR, AN EXPERIENCED potter, with Joseph Ott and Thomas Booth. After a year, Garret Schenck Burroughs replaced Booth and the name was changed to Bloor, Ott and Burroughs. The following year Garret Burroughs died and his interest was purchased by John Hart Brewer, a highly-skilled potter who had previously run a livery stable with Joseph Ott. For several years the company continued as Bloor, Ott and Brewer. Finally, in 1871 or 1873 Bloor left and the company's name was shortened to Ott and Brewer.

Sometime between 1873 and 1875, Isaac Broome, the celebrated modeler, was hired by Ott and Brewer to prepare an exhibit for the U.S. Centennial Exposition. A twelve-inch tile portrait of George Washington against a field of stars, which Broome created for the exhibit, is an important example of his work. (Some fifteen years later, Broome designed an almost identical tile for the Beaver Falls Art Tile Company.) Broome's pottery received medals at the Exposition, and in 1878 Broome was appointed the U.S. Commissioner of Ceramics for the Exposition Universelle in Paris. Broome continued working for Ott and Brewer until 1883, when he left to join the Trent Tile Company.

Ott and Brewer, like so many other potteries, suffered from the economic depression of 1892, then endured from a potters' strike. In 1893 the firm was dissolved and the assets were sold to the firm's bookkeeper, Charles Cook.

John Hart Brewer (1844-1900) served both in the New Jersey State Assembly and in the U.S. Congress. Brewer was instrumental in organizing the U.S. Pottery Association, and later became its president.

MAYWOOD ART TILE COMPANY

Maywood, New Jersey 1892–1905

ELTERICH ART TILE STONE WORKS 1889–1892

THE ELTERICH ART TILE STONE WORKS WAS ESTABLISHED IN 1889, FINANCED BY GUSTAV L. JAEGER AND HENRY LINDENMEYER, and run by a Mr. Elterich and his son Otto. The company manufactured patented heating stoves, using tiles purchased from

other makers. Soon the company decided to make its own tiles, and engaged William E. Rivers of Old Bridge to come to Maywood on weekends as an instructor.

Fred H. Wilde of International Tile and Trim in Brooklyn was hired as superintendent in 1891. In 1892, the company was reorganized as the Maywood Art Tile Company, producing good anchor-back glazed tile for stoves, hearths, and mantels.

After a time, Maywood's management tried to dismiss Wilde, but when he took his secret formulas with him, tile production came to an abrupt halt. (At the time, glaze formulas were the property of the ceramists who developed them.) Fortunately, Mr. Bilhuber, one of the stockholders, took over as manager and rehired Wilde. Wilde then remained at Maywood until 1899, when he left to join the Providential Tile Company. (Max Metzner, Adolf Metzner's son, was hired to replace him.)

In 1905 the factory closed and was dismantled.

HARIKAN ART PRODUCTS

Matawan, New Jersey 1928–c. 1941

TILE PRODUCTS CO. INC.

ACCORDING TO HELEN HENDERSON, A LOCAL TILE HISTORIAN, TILE PRODUCTS OF MATAWAN, NEW JERSEY, OPERATED FROM 1928 to 1941. Harry J. Kahn and his wife Hannah formed Tile Products Company, Inc., also known as Harikan Art Products. After graduating from Massachussetts Institute of Technology, Harry Kahn had worked in the ceramics program at Rutgers College, at American Encaustic Tiling Co. in Zanesville, Ohio, and at the Wheeling Tile Co. in Wheeling, West Virginia. In Wheeling, Kahn had been a partner in the Progressive Ceramics Co. Kahn then came to New Jersey to work at the Matawan Tile Co., where he continued to use the mark "Pro-Cer" from Wheeling.

Tile Products Company used blanc bisque tiles purchased from two New Jersey companies, Architectural Tiling Co. (ATCO), and C. Pardee Works. At Tile Products, tube lining was applied to the tiles to create a high line surface which was glazed in various colors. The business was quite successful and lasted until Kahn went into the army during World War II.

A few years after Kahn returned from the war, he moved to Massachussetts where he worked for the Stylon Corporation.

PENNSLYVANIA

HYZER AND LEWELLEN

Philadelphia, Pennsylvania c. 1870–c. 1893

ALTHOUGH THE PITTSBURGH ENCAUSTIC TILE COMPANY IS GENERALLY CREDITED WITH MANUFACTURING THE FIRST American art tiles, conceivably Hyzer and Lewellen deserves this distinction. It may simply be that Hyzer and Lewellen's earliest tiles were not widely distributed.

An early producer of firebrick stove linings and furnaces, Hyzer and Lewellen began experimenting with encaustic tiles in 1870. After failing with plastic clay tiles, the company succeeded with tiles produced with a dust clay body. The tiles came in black, red, and buff colors with an inlaid design one-quarter-inch deep, topped with a lead glaze. Around 1870 the company also produced an underglaze decoration of a green vine border around an octagon shaped tile, triangular and square decorated tiles, and unglazed, low relief tiles with a floral design. Hyzer and Lewellen was still in business in 1893.

The pottery historian, Edwin Atlee Barber, noted that Hyzer and Lewellen tiles were strong and had very little crazing. A variety of the company's tiles are now in the Philadelphia Museum of Art collection.

PITTSBURGH ENCAUSTIC TILE CO.

Pittsburgh, Pennsylvania 1876–1882

STAR ENCAUSTIC TILE CO.

1882–1914

SAMUEL KEYS WAS BORN IN DERBY, ENGLAND, IN 1832 AND emigrated to the United States in 1862. While managing a brick factory, Keys experimented with tile making and by 1871 had successfully produced encaustic tile. His efforts earned him a certificate at the Pennsylvania Agricultural and Mechanical State Fair.

In 1876 Keys organized the Pittsburgh Encaustic Tile Company at Buff and Gist Streets in Pittsburgh, Pennsylvania. This small factory, occupying only 8,000 square feet, is often credited with being the first tile factory in America. The facto-

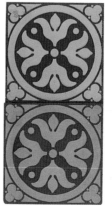

ry's wares—good, unglazed encaustic tiles, plus geometric, tesselated tiles in many shapes, sizes, and colors—were quite successful. They were used throughout the United States, notably on two floors of the Capitol Building in Washington, D.C., (better known for its extensive installations of English Minton tiles).

In 1882 the company was reorganized with new capital under the name Star Encaustic Tile Company. In 1888, the company produced the largest tile floor ever installed in Pennsylvania (42,000 square feet), at the Allegheny County Court House.

The Star Encaustic Tile Company received a medal at the World's Fair in Chicago in 1893 and another at the World's Fair in St. Louis in 1904.

The company was still listed in the Pittsburgh city directory in 1909, and is said to have been still operating as late as 1914.

BEAVER FALLS ART TILE COMPANY
Beaver Falls, Pennsylvania 1886–1927

THE BEAVER FALLS ART TILE COMPANY WAS FOUNDED IN BEAVER FALLS, PENNSYLVANIA, IN 1886 BY FRANCIS W. WALKER. Walker's artistic wife Leila, who was interested in china painting, probably steered him toward ceramics. (Indeed, Leila Walker hand-decorated many of the company's early tiles.) Walker was interested in the chemical component of ceramics, experimenting with glazes that produced attractive, non-crazing pastel colors.

In February 1887, Walker formed a limited partnership with a Beaver Falls banker, John Reeves, who then became the company's president. Beaver Falls Art Tile began by producing small quantities of plain enamel tiles for stoves and mantels, but soon expanded production to include embossed and intaglio tiles. The glazes were noted for their soft, rich colors.

By 1890 the company was also producing relief tiles. The same year the noted ceramist, Isaac Broome, left Prudential Tile and joined Beaver Falls Art Tile as a designer. Broome modeled many of Beaver Fall's best tiles. The company produced portrait, floral, and geometric tiles, as well as large relief panels for fireplaces and mantels.

By 1906, when the company was finally incorporated, demand for stove and mantel tiles was on the decline, and the company switched production to plain wall tile and moldings. To increase the marketability of his products, Walker engaged the Robert Rossman Company of New York to act as his primary selling agent. Rossman handled several imported lines of decorative tile, which allowed Beaver Falls to continue its production of a plain single line without limiting its market. When Rossman died in 1908, Beaver Falls absorbed Rossman's company, with Walker as president.

In 1927 Walker consolidated the Beaver Falls Art Tile Company and the Robert Rossman Company with the Old Bridge Enameled Brick and Tile Company and the Perth Amboy Tile Works to form the Robert Rossman Corporation. Unfortunately, the Depression forced the new conglomerate into bankruptcy in 1931. The Beaver Falls Art Tile Company plant and its equipment were sold to the Armstrong Cork Company, ending a successful forty-five year tile business. Francis W. Walker died in 1933.

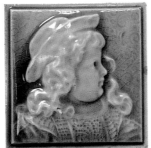
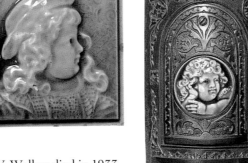
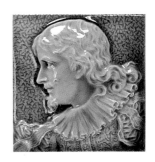

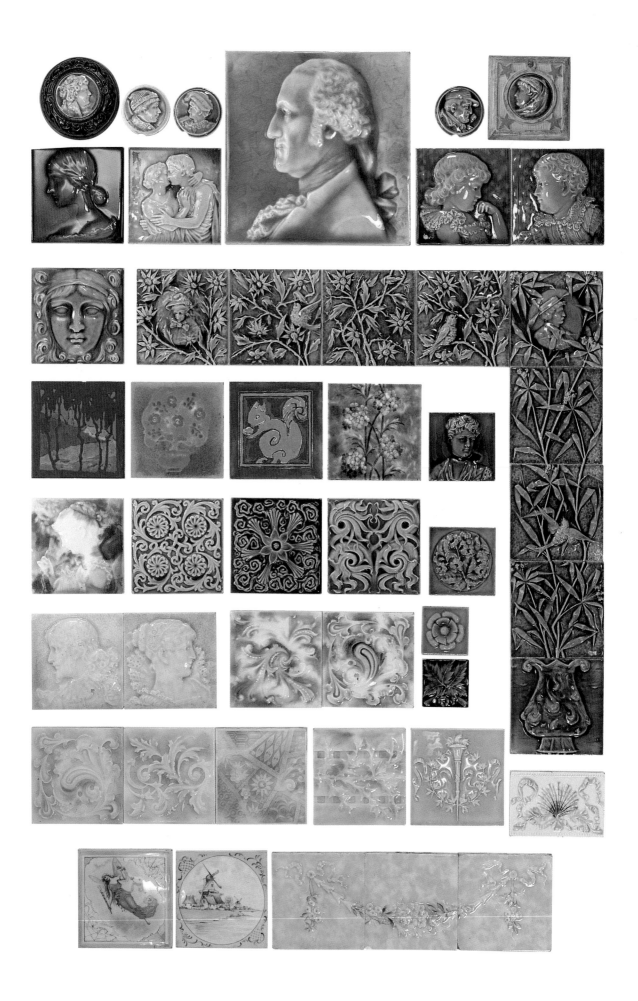

ROBERTSON ART TILE CO.

Morrisville, Pennsylvania 1890–1930

CHELSEA KERAMIC ART TILE WORKS c. 1890

ROBERTSON MANUFACTURING CO. 1930–1983

GEORGE W. ROBERTSON, A MEMBER OF THE SECOND GENERATION OF THE FAMOUS ROBERTSON TILE DYNASTY, WAS assistant manager at the East Boston Pottery from 1865 to 1871, and then was associated with the Robertson family pottery, Chelsea Keramic Art Works in Chelsea, Massachusetts. From 1878 until 1890 he worked at the Low Art Tile Works.

In 1890 Robertson moved to Morrisville, Pennsylvania, to start his own tile works, the Chelsea Keramic Art Tile Works, named after his family's former firm. Robertson ran out of money before the plant was complete. He owed money for supplies to the Trenton Fire Clay and Porcelain Company and, to settle the debt, he gave shares to the owners, W. J. J. Bowman, R. K. Bowman, and Arthur D. Forst. Forst became president, one of the Bowmans became treasurer, and Robertson became super-intendent. The company's name was changed to Robertson Art Tile, ending confusion with the original Massachusetts factory. Three years later Robertson's son James died; Robertson lost interest in his work and sold his shares, although he agreed to stay on for six months to train his successor. He left for California in 1895, at which time Forst became manager.

Fred Wilde joined Robertson Art Tile in 1900. Three years later, in 1903, Wilde left for the Western Art Tile Company in Tropico (Glendale), California. That same year, Herman Mueller joined Robertson Art Tile.

Also in 1903, Robertson Art Tile merged with Columbia Encaustic Tiling Company and Old Bridge Enameled Brick and Tile Company to form the National Tile Company. The National Tile consolidation lasted only three years before Robertson Art

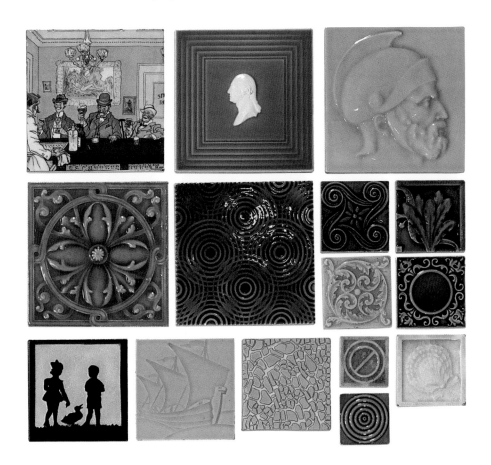

Tile withdrew and continued under its own name. Mueller remained with Robertson until 1908, when he started his own company, Mueller Mosaic.

In 1920, Forst bought out the other shareholders, and continued to run the company with his two sons. Later, the firm's name was changed to Robertson Manufacturing Company, and then to Robertson American Corporation. The company closed in 1983.

The tiles produced in Robertson Art Tile's first twenty years were highly artistic. Some were modeled in deep relief by Robertson's brother, Hugh Cornwall.

MORAVIAN POTTERY & TILE WORKS

Doylestown, Pennsylvania 1898–Present

THE MORAVIAN POTTERY & TILE WORKS WAS ESTABLISHED IN 1898 BY HENRY CHAPMAN MERCER, WHO CAME FROM A wealthy and prominent Pennsylvania family. After studying law at Harvard, Mercer went on to become an archaeologist and anthropologist and was instrumental in establishing the Bucks County Historical Society. An avid collector, Mercer was interested in early American tools, and amassed an extensive collection. He became interested in potter's tools and pottery. He liked the imagery of tiles and appreciated this popular, decorative medium.

The name Mercer chose for his pottery was in honor of the Pennsylvania German settlers known as Moravians, whom he admired.

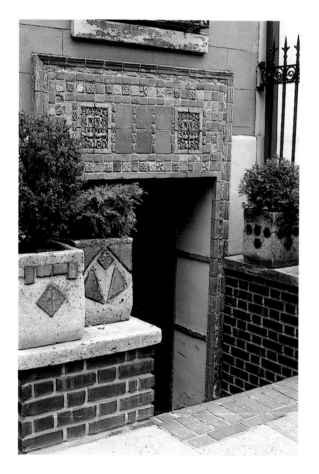

Production began in 1899, in a studio with kilns built on the family's Doylestown estate. In 1912, Mercer moved into a factory that he had constructed in the style of a Spanish mission. On the same site, he also built a mansion called Fonthill constructed of exposed concrete, then a revolutionary material for building.

All the tiles were designed by Mercer: molded tiles with images inspired by Moravian stove plates, as well as medieval European tiles.

Unlike the tiles of the other major proponents of the Arts and Crafts style, Mercer's style of representation was medieval and cartoon-like. Mercer was awarded the Grand Prize for Tiles at the 1904 St. Louis Exposition.

Perhaps Mercer's most unique creations were his mural brocades. In these assemblages the figures of the design were molded and fired separately, then assembled onto a concrete backing to create single tiles, fireplace surrounds, or even wall-sized murals. The imagery often revolved around American folklore and history, as well as animals, plants, and geometric shapes.

Mercer's tiles were used in installations both in the U.S. and around the world. Among the many sites they can be found are: Grauman's (now Manns') Chinese Theatre, Hollywood; The Casino, Monte Carlo;

Shepheard's Hotel, Cairo; Marlboro-Bleinheim and Traymore Hotels, Atlantic City; Isabella Stewart Gardner Museum, Boston; Museum of Fine Arts, Boston; State Capitol, Harrisburg, Pennsylvania; Salem United Church of Christ, Doylestown, Pennsylvania; El Museo del Barrio, 1230 Fifth Avenue, New York City.

Perhaps the most extensive installation of Mercer's work is in his own home, Fonthill. He intended his huge house to be a showplace for both the tiles he collected and produced.

The Moravian Pottery and Tile Works remained profitable throughout Mercer's lifetime. When Henry Chapman Mercer died in 1930, he willed the pottery to his assistant, Frank Swain. Operation continued on a reduced scale until Swain's death in 1954, when the estate was left to Swain's nephew. In 1956 the pottery was sold to Raymond F. Buck, who produced ordinary tiles in the plant until he closed it in 1964. The Bucks County Department of Parks and Recreation bought the pottery in 1967 and opened it as a museum in 1969. Wayne Bates, a ceramist, began to reproduce Mercer's tiles in the old tile works in 1974, using the original processes. Today, the tile works, Fonthill, and the Mercer Museum—all National Historic Buildings—are open to the public.

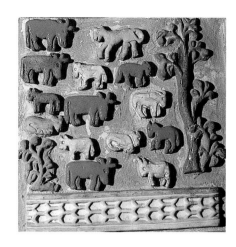

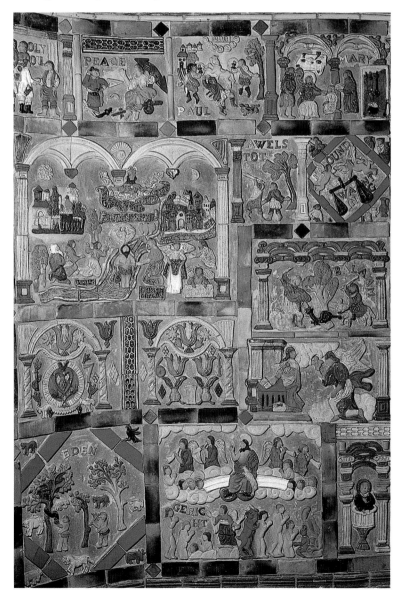

ENFIELD POTTERY

Enfield, Pennsylvania 1906–c. 1930

THE ENFIELD POTTERY WAS ESTABLISHED BY J. H. DULLES ALLEN ON A CORNER OF HIS FARM IN ENFIELD, PENNSYLVANIA, eleven miles north of Philadelphia.

In 1905, Allen, while convalescing from a polo accident, became interested in the various clays found on his farm. He ordered a small kiln and began to experiment. Success came quickly, and in 1906 the Enfield Pottery was listed as a member of the tile manufacturers' association. In 1907, Enfield Pottery won two medals at the Jamestown Exposition.

The pottery's products were quite diverse: unglazed terra cotta with deeply molded figures and designs; high-line, molded, glazed tiles; number and letter tiles for signage; and cut-out animals and designs as wall inserts. Enfield Pottery tiles are similar to those of the Moravian Pottery and Tile Works, founded eight years earlier, only fifteen miles away.

Enfield's tiles were used nationwide. Some notable installations included the Bok (Carillon) Tower in Florida; the Pan American Union Building in Washington, D.C. (where a series of profile figures of Mayan and Incan Gods, in black, was installed on the patio floor); and the Delaware River Bridge, now called the Benjamin Franklin Bridge. The Benjamin Franklin Bridge has at least seven huge Enfield tiles, depicting transportation themes such as the Santa Maria, the steamboat, the Conestoga wagon, the steam engine, the horse and carriage, and the airship Shenandoah. Interestingly, all the tiles are installed inside the bridge's four towers, and are sealed off from public view; midway through the bridge's lengthy construction, original plans for interior elevators, a trolley car crossing, and interior walkways and shops, were cancelled.

The Enfield Pottery closed around 1930.

FRANKLIN TILE CO.

Lansdale, Pennsylvania 1926–1935

FRANKLIN POTTERY CO. 1923–1935

AMERICAN ENCAUSTIC TILING CO. (A.E.T.) 1875–1964

AMERICAN OLEAN TILE CO. (A.O.) 1964–Present

BROTHERS MALCOLM A. AND ROY W. SCHWEIKER ESTABLISHED THE FRANKLIN POTTERY IN 1923 IN AN ABANDONED CANNERY
in Lansdale, Pennsylvania. Both had previously been associated with the Empire Floor and Wall
Tile Company plants in Metuchen, New Jersey, and Zanesville, Ohio. The Franklin Pottery was
named after Benjamin Franklin, one of Roy's childhood heroes, and Franklin's mottoes and
image appeared on the company's stationery. Malcolm ran the business side, while Roy handled
production and marketing. Tile production commenced in 1926, when the brothers changed the
name to the Franklin Tile Company. The first tile order was produced, sold, and installed by Roy
himself.

In 1926, Franklin Tile built and moved into a new plant. While continuing to produce wall
and floor tile, the company also made faience tiles in geometric raised-line relief, and hand-painted or decal images of colonial
figures, flowers, and animals. Franklin Tile introduced such innovations as single-fire tiles, craze-proof tiles, self-spacers, and
cushion-edge tiles. In 1927, Franklin Tile absorbed the Domex Floor and Wall Tile Company of Greenburg, Pennsylvania (a
company that the Schweikers had previously managed for J. B. Owens). In the 1930s a selling organization was formed between
Franklin Tile and the Olean Tile Company of Olean, New York: American Franklin Olean Tiles, Incorporated. Unlike so many
other companies, Franklin continued to remain stable throughout the Depression.

In 1935, the U.S. government installed Malcolm Schweiker as president and manager of the bankrupt American Encaustic
Tiling Company. Schweiker was surprised to find that A.E.T. didn't produce any "bread-and-butter" items, and had an incredibly disorganized system of production, which may explain why the company, formerly the largest producer of tile in the U.S.,
had failed. Of A.E.T.'s five plants, only the Perth Amboy, New Jersey, plant was still in operation at the time Schweiker took
over. Schweiker sold off the closed plants, and Franklin Tile's production methods were employed at the Perth Amboy plant,
which continued to produce tile under the American
Encaustic name for a while. Soon, however,
Schweiker transferred production to the larger

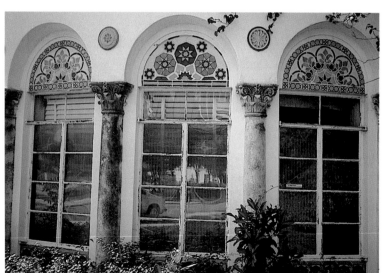

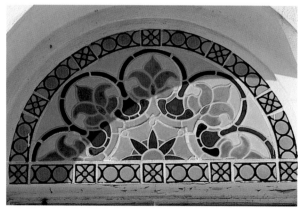

Franklin plant in Lansdale, leasing A.E.T.'s Perth Amboy factory to a manufacturer of war materiel. A.E.T.'s last remaining asset was its name, which was still listed on the New York Stock Exchange. Since it was difficult to get listed on the exchange, after the war the Schweikers decided to combine all of Franklin's assets under the A.E.T. name.

In 1958, A.E.T. merged with the National Gypsum Company as an autonomous subsidiary, and then acquired the Olean Tile Company and the Murray Tile Company to ensure a complete line of tile products. In 1964, the company's name was officially changed to the American Olean Tile Company, Incorporated, or "A.O.," as it is commonly called today. The Schweiker brothers remained at the company until they both retired in 1973, fifty years after founding Franklin.

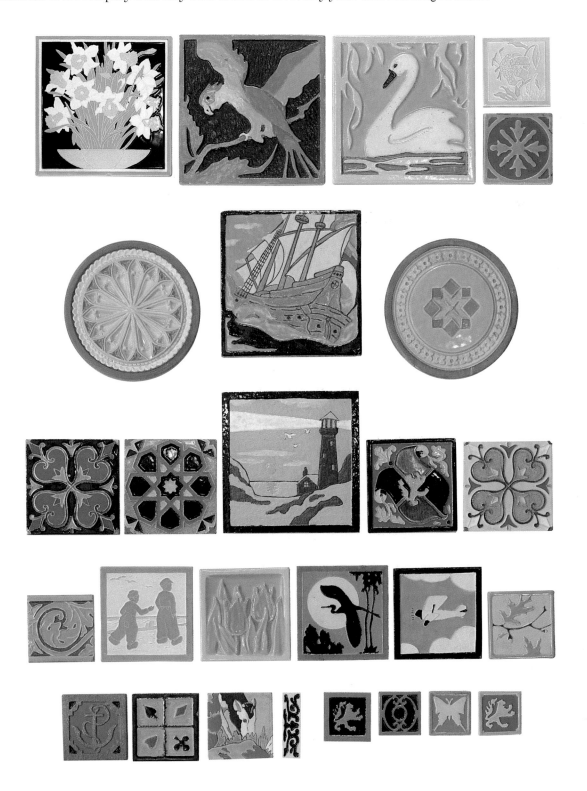

ROBERT ROSSMAN COMPANY

New York, New York; Beaver Falls, Pennsylvania 1908–1927

ROBERT ROSSMAN CORPORATION

1927–1930

ON JANUARY 1, 1908, THE ROBERT ROSSMAN COMPANY WAS FORMED TO IMPORT AND SELL TILE. ROBERT ROSSMAN WAS president, Adolf Rossman, his father, was vice president.

In May 1908, Robert Rossman died suddenly at the age of forty-six. In 1911 Beaver Falls Art Tile Company took over Robert Rossman Company and made Rossman its selling arm; the president of Beaver Falls, F. W. Walker, became president of the Robert Rossman Company. This union continued until 1926, when Walker's son, Francis W. Walker Jr., wanted to consolidate more tile companies.

In 1927, a new organization, the Robert Rossman Corporation, was formed with a $2 million loan. This new corporation joined Robert Rossman, Old Bridge Enameled Brick and Tile Company, Beaver Falls Art Tile Company, and the Perth Amboy Tile Works.

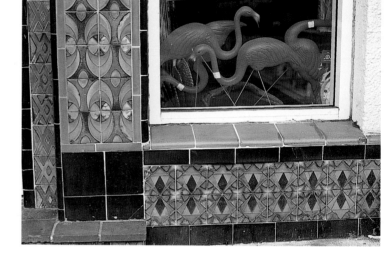

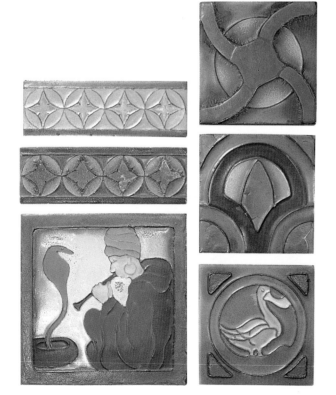

After only three years, the Robert Rossman Corporation declared bankruptcy. The Beaver Falls' factory was dismantled and sold. Old Bridge was sold to the Quigley Company to make refractory products. The Perth Amboy Tile Works lay idle for many years, until the city of Perth Amboy took over the plant to cover back taxes. August Staudt then rented the plant from the city and started a new company.

Robert Rossman's products were sold in showrooms across the country. The company also sold the tiles of Herman Mueller and imported highly decorative tiles from Seville, Persia, and Tunisia. The Tunisian tiles can still be seen in the Santa Barbara, California, Court House.

OHIO

W E L L E R P O T T E R Y

Zanesville, Ohio 1872–1948

WELLER POTTERY WAS ESTABLISHED BY SAMUEL A. WELLER IN 1872 IN FULTONHAM, OHIO, A RURAL TOWN 120 MILES SOUTH of Zanesville. The pottery made flower pots, umbrella stands, and simple jardinieres. Weller used the power of his horse (one h.p. to be exact!) to run the machinery. He used the same horse to take his pottery to market.

In 1888 Weller moved the pottery to Pierce Street in Zanesville, and in 1891 he purchased the old American Encaustic Tiling plant on Sharon Avenue as a second factory.

Weller hired a famous French potter, Jacques Sicard, who had worked with Clement Massier. Sicard developed an irides-cent luster glaze of copper, rose, blue and purple. The glaze, named "Sicardo," became quite popular. A notable example of Sicard's work—a Sicardo-glazed plaque of a woman in profile—is in the Smithsonian Institution collection. Sicard returned to France in 1907 and (as the formula went with him) Weller's production of this glaze ended.

In 1920 Weller acquired the Zanesville plants, and in 1922 the company incorpo-to lose two of its three plants in 1935, Ceramic Avenue factory. At the end of in a difficult financial position and in 1947, stock of Weller, and the factory closed the fol-

Art Pottery, giving the company three rated. The Depression caused the company although production continued at the World War II, the factory again found itself Essex Wire Company bought controlling lowing year.

Though it accounted for only a small percentage of its total output, Weller's tile production was con-siderable. In 1905 Weller produced a tile catalog featuring classical figures and relief designs modeled by Hugo Herb, while two

Weller catalogs from 1930 featured faience tiles. Weller is also known to have made tiles with Incan motifs. The company advertised that single tiles or panels could be made to order, either from designs developed by Weller's art department—which employed artists such as Levi Burgess and Hester Pillsburg—or from designs supplied by the client.

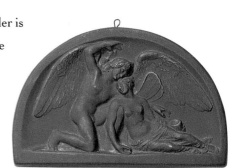

American Encaustic Tiling Co. (A.E.T.)

Zanesville, Ohio 1875–1935

Fischer and Lansing

E. H. Hall received a patent for making tile in 1874–75 and began production in the old Hallum Howson factory at the foot of South Seventh Street in Zanesville. The firm, Fischer and Lansing, was named after its two New York backers, Benedict Fischer and George R. Lansing. In 1875 American Encaustic Tiling Company (A.E.T.) was founded.

The production of encaustic tiles involves a complicated process in which powdered clays of different colors are pressed together to form a pattern or design. A notable early installation can be found in the Muskingham County Court House in Zanesville.

When Hall left the company in 1876, Gilbert Elliott came from England to replace him. A year later, George Stanberry, a mechanical engineer, took over as superintendent (from 1877 to 1909), and was responsible for producing the machinery that would mass-produce tiles as never before in the United States.

Incorporated in 1878, business increased rapidly, and the factory moved to a larger building on Marietta Road and Sharon Avenue in 1879. Glazed tiles were introduced in 1880, and embossed tiles in 1881. In the 1880s a showroom was established in New York City, at 140 West 23rd Street.

Herman Mueller brought a new range of tile products with him when he was hired in 1887. Well-trained in Nuremberg and Munich as a sculptor and modeler, Mueller produced many large relief tiles, as well as panels of female figures, mythological symbols, and portraits. Many of these were based on Renaissance motifs. He also produced intaglio-modeled tiles, portraits or scenes in which the design was carved into the tile, then glazed. The glaze darkened in the more deeply carved areas; in the shallow areas, the tones would be more delicate, giving certain tiles the appearance of a photograph.

Karl Langenbeck, a chemist who introduced many new colors into the A.E.T. line, was hired away from Rookwood in 1890. With all these new tiles, production

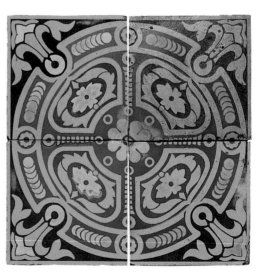

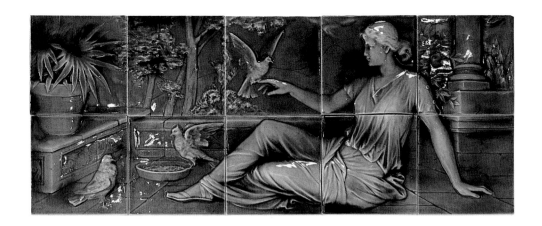

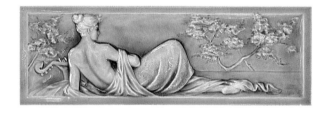

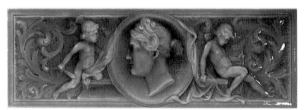

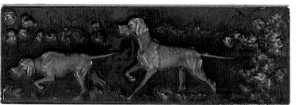

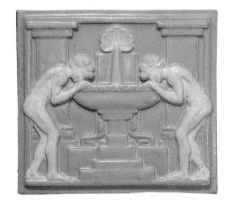

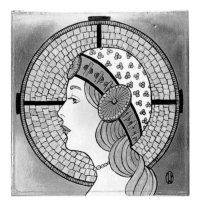

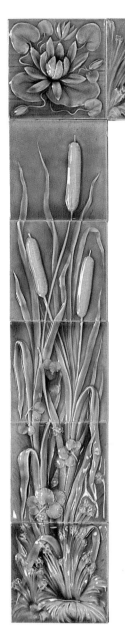

soared, and again the company outgrew its factory. To keep A.E.T. in Zanesville, the city passed a bond issue and raised $40,000 to buy land for a new factory. On April 19, 1892, the new plant opened on Linden Avenue, proclaimed by A.E.T. to be the largest tile factory in the world. William McKinley, then governor of Ohio, gave an address at the grand opening. Fifteen thousand dedication tiles, designed by Mueller, were given out.

In 1894 Mueller and Langenbeck left A.E.T. to start a new tile factory in Zanesville, the Mosaic Tile Company, which was soon to become a competitor of A.E.T. Christian Nielson, who came to the United States in 1891 from Denmark, replaced Mueller at A.E.T. and stayed until 1902.

In the 1890s A.E.T. produced a series of at least eleven printed decal tiles with designs by Walter Crane, taken directly from the original plates of *Baby's Own Aesop Fables* and *Baby's Own Opera,* popular children's books of the era. Mosaic Tile Company also produced some of the same series, although the pieces did not bear the Walter Crane seal. A.E.T. followed with William Morris patterns, also made from decals.

From 1903 to 1906, A.E.T.'s New York showroom was located at 1123 Broadway. A second factory was purchased in Maurer (now Perth Amboy), New Jersey, in 1912; a third in the Los Angeles suburb of Vernon in 1919; and a fourth in Hermosa Beach, California, in 1926. From 1914 to 1920, the A.E.T.'s showroom and office were at 16 East 40th Street in New York City, but A.E.T.'s most magnificently outfitted location was 16 East 41st Street, where they had an office and showroom from 1922 to 1935.

Cecil Jones, an English designer, arrived in the United States in 1913 and worked at A.E.T. in Zanesville. He later went to A.E.T. in Maurer, and in 1919 to A.E.T. in Los Angeles, where he headed the decoration department. Jones left A.E.T. in 1930.

Frederick Hurten Rhead came to A.E.T. in 1917, after leaving his own pottery in Santa Barbara, California. He became the director of a research department at A.E.T. Designing in a commercial environment brought something new to Rhead's style. At A.E.T. Rhead produced many new and different tile designs, including painted, molded, and cuenca pieces, as well as some pottery. Rhead left in 1927.

Leon V. Solon came to A.E.T. as a designer in 1912 and worked in New York City until 1925. Solon's brother Paul also worked at A.E.T. at the time.

However, by 1932 the company faced financial difficulties, and in 1933 both the Vernon and Hermosa Beach factories were sold to Gladding, McBean.

In 1935 the Zanesville plant closed. The government placed Malcolm Schweiker of the Franklin Tile Company in charge of liquidating the A.E.T. Company. Schweiker sold the Zanesville plant to the Shawnee Pottery Company and took over the Maurer plant. By 1941 Schweiker had made A.E.T. a profitable operation again. However, since the Lansdale plant of Schweiker's

own company, Franklin, was much larger and could handle A.E.T.'s production better, the Maurer plant was leased to a manufacturer of war materiel, and the tile equipment was removed.

At this point the only remaining asset of the American Encaustic Tiling Company was its name, which was still listed on the New York Stock Exchange. Franklin Tile and A.E.T. combined, assuming the A.E.T. name.

In the 1930s Franklin Tile Company and Olean Tile Company of Olean, New York, formed a selling organization called American Franklin Olean Tiles, Incorporated, that sold both company's tiles. In 1959, A.E.T. acquired Olean Tile and Murray Tile Company, and in 1964 the whole consortium became the American Olean Tile Company, which was commonly known to the tile trade as "A.O." In 1995 American Olean merged with Dol Tile Corporation.

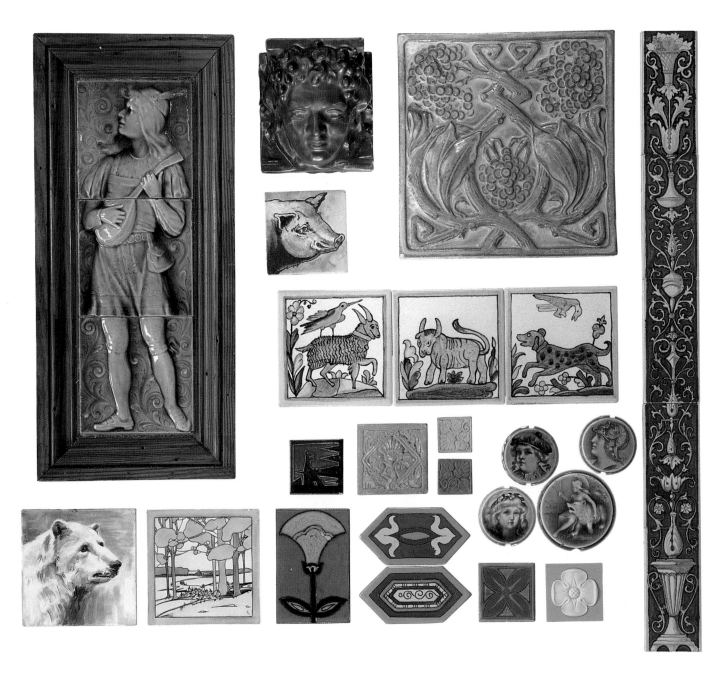

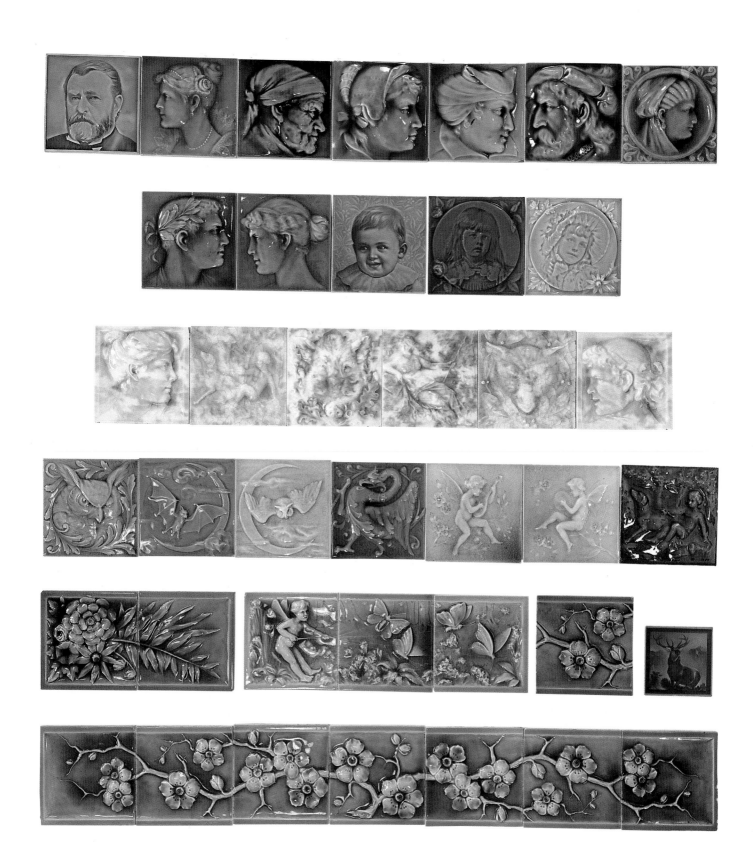

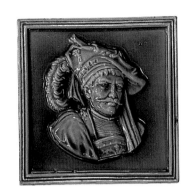
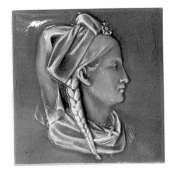

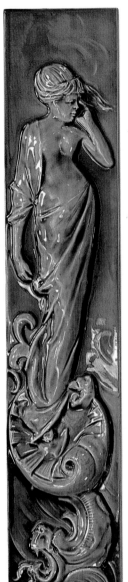
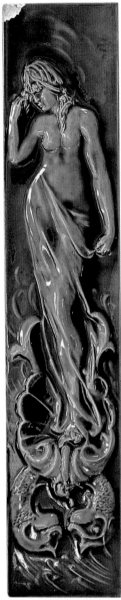
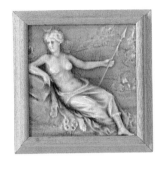

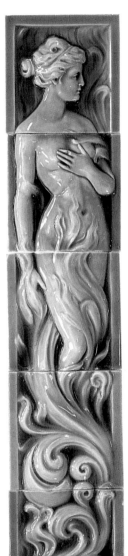
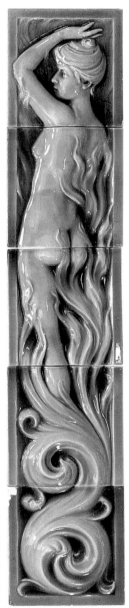

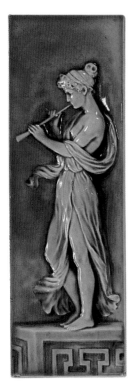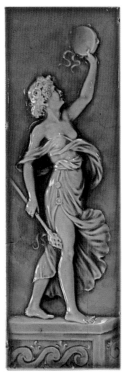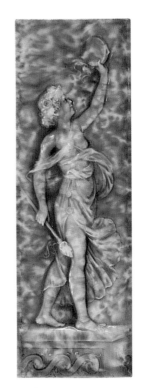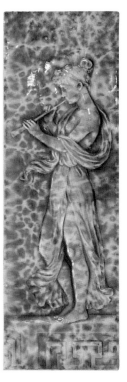

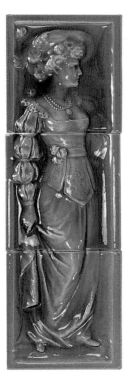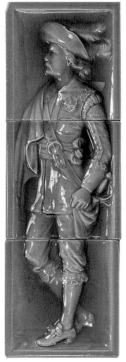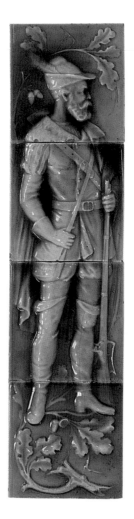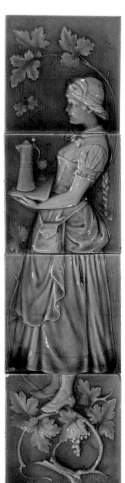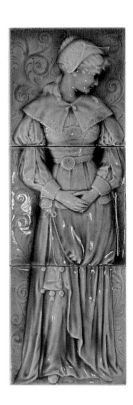

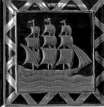

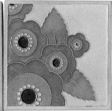

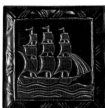

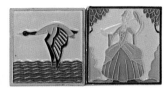

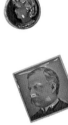
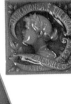
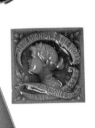

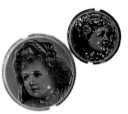

75

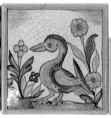

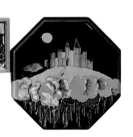

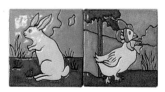

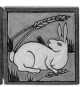

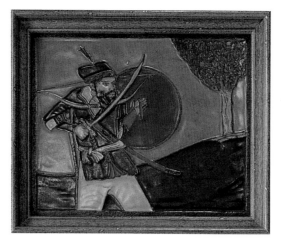

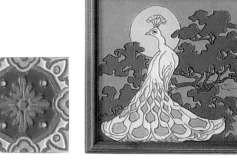

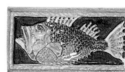
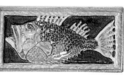

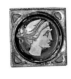

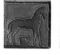

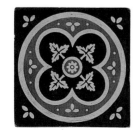
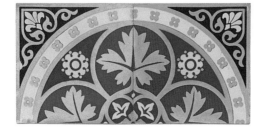
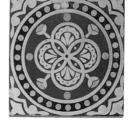

BORN IN 1847, MARY LOUISE McLAUGHLIN BEGAN HER CAREER IN CERAMICS BY CHINA PAINTING. IN 1877, WHILE experimenting at the Coultry Pottery in Cincinnati, she found that she could mix mineral paints with a white slip (liquid clay) and paint directly on greenware (a moist clay body). Prior to firing, the greenware and glaze would dry and shrink together; upon firing, the glaze would fuse with the body. This method proved successful and became the basis for many potteries' decorations, including Rookwood's (a fact Rookwood would not be willing to concede).

In 1877 McLaughlin told of her findings in a book entitled *A Practical Manual for the Use of Amateurs in the Decoration of Hard Porcelain.* Two years later she formed The Pottery Club, a group of twelve women potters that eventually expanded to twenty. Members painted ceramics in a room at the Dallas Pottery.

A feud and rivalry between McLaughlin and another Cincinnati socialite, Maria Longworth Nichols, began over invitations to join The Pottery Club. Intentionally or not, Nichols failed to receive an invitation, and a rift began among Cincinnati potters. Nichols, who had already been experimenting with pottery, founded her own group, which also met at the Dallas Pottery.

After its first year, The Pottery Club hosted a lavish reception. The event was a success, and enough pottery was sold to fund the club for a year. The Club continued these annual receptions until they disbanded in 1890. But they did have a reunion to exhibit at the 1893 Chicago exposition.

In 1880 Maria Nichols's father gave her an old schoolhouse, where she started the Rookwood Pottery. The Pottery Club rented space at the Rookwood factory, and all of the pieces The Pottery Club produced featured the Rookwood mark. However, William Taylor of Rookwood eventually felt this situation was too confusing, and had The Pottery Club evicted.

McLaughlin faced another problem. Thomas Wheatley, an artist at Coultry Pottery, had obtained a patent for McLaughlin's underglaze process and attempted to prevent both Rookwood and McLaughlin from using the process. After some litigation the courts agreed that McLaughlin had perfected the process in January, 1878, before Wheatley did in 1879.

Questions over ownership of this underglaze method arose again at the 1893 Chicago Exposition (where both Rookwood and The Pottery Club exhibited). The exposition catalog initially stated that McLaughlin had originally discovered the method used by Rookwood. William Taylor of Rookwood demanded that the statement be deleted from the catalog. When McLaughlin resisted, Nichols would not admit that previously she had sided with McLaughlin in court against Wheatley. In the end, Rookwood won the battle, and the statement was deleted from the subsequent printings of the catalog. About fifty years later, however, McLaughlin finally saw justice, as the American Ceramic Society officially acknowledged that she deserved credit for discovering the process.

From 1885 to 1895, Mary Louise McLaughlin designed tiles for Kensington Art Tile, located across the river in Covington, Kentucky. McLaughlin retired from ceramics in 1906, and died in 1939 at the age of ninety-one.

ROOKWOOD POTTERY WAS ESTABLISHED BY MARIA LONG-worth Nichols in 1880 in an old schoolhouse at 207 Eastern Avenue in Cincinnati. Nichols had become fascinated with pottery making after a neighbor, Karl Langenbeck, gave her a set of china decorating paints.

Many fine artists also joined the firm, including Ferdinand Mersman, who designed beautiful tiles for Rookwood while still at Cambridge Art Tile Works; Albert R. Valentien, hired in 1881; and ceramic chemist Karl Langenbeck, who joined the company in 1895.

In 1885, Nichols's husband (a colonel in the Civil War) died and she married Belamy Storer. The following year Storer was appointed Ambassador to Belgium and later served as Minister to Spain. As the company finally became profitable, Maria Storer left the factory for an extended honeymoon in Europe.

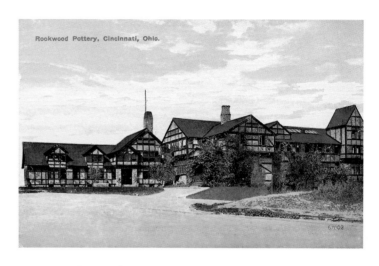

Rookwood Pottery, Cincinnati, Ohio.

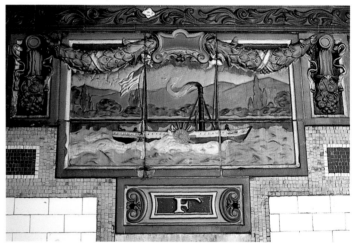

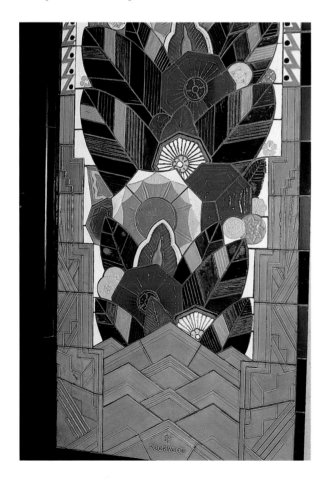

In 1889 Rookwood won gold medals at the Exposition Universelle in Paris and at the Exhibit of American Art Industry in Philadelphia. Maria Storer retired in 1890 and transferred her interest to William Taylor, who then became president. That same year the company began construction of a new plant on Mount Adams, overlooking Cincinnati, where the factory moved in 1893. More accolades were bestowed on Rookwood at the World's Columbia Exposition in Chicago (1893), the International Exhibit in Paris (1889), and the Pan American Exposition in Buffalo (1901).

In 1902 Rookwood began producing architectural tile with a matte glaze. The following year the company supplied the New York Subway System with tiles, most notably those installed at Fulton Street, depicting Robert Fulton's steamboat. Designers E.B. Cranch

and W.E. Hentschell modeled tiles that were very heavy and voluptuous, with strong, sturdy lines. Rookwood made tiles for mantels, wall panels, drinking fountains, architectural reliefs for building exteriors, and accoutrements for vaulted ceilings. From 1904 to 1950, Rookwood produced vellum glaze tiles, often sold in oak frames. Although Rookwood produced architectural faience from 1902 into the 1940s, the years 1907–1913 were the most important for Rookwood's tile production.

In 1913 William Taylor died, willing his Rookwood stock to the Cincinnati Museum. Maria Longworth Nichols Storer died in 1922. In 1928, with the Depression, the company's financial position weakened. Rookwood was forced to discontinue its most expensive artist-decorated pots, and closed the architectural tile department.

In 1941 Rookwood went into receivership. Stock was liquidated, and the factory was sold to Harold and Walter Schott and Lawrence Kyle. Production resumed for one year, when Sperti Incorporated became the owners. In 1956 James M. Smith took over, and finally in 1959 Herchede Hall Clock Company assumed ownership, sending everything to Starksville, Mississippi, including the old molds. During the 1960s, production of pottery resumed, using the marks of the 1880s and 1890s, until the factory closed for good in 1967.

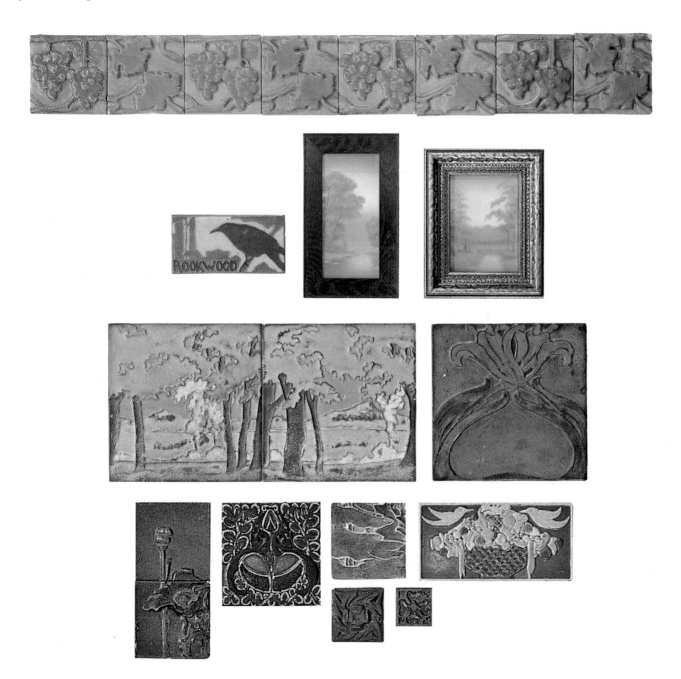

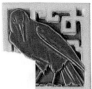
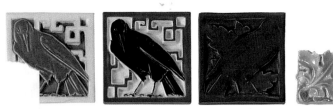
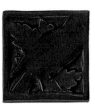

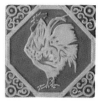
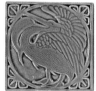

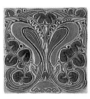

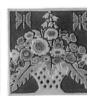

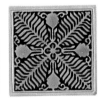
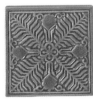
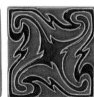
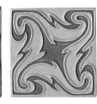

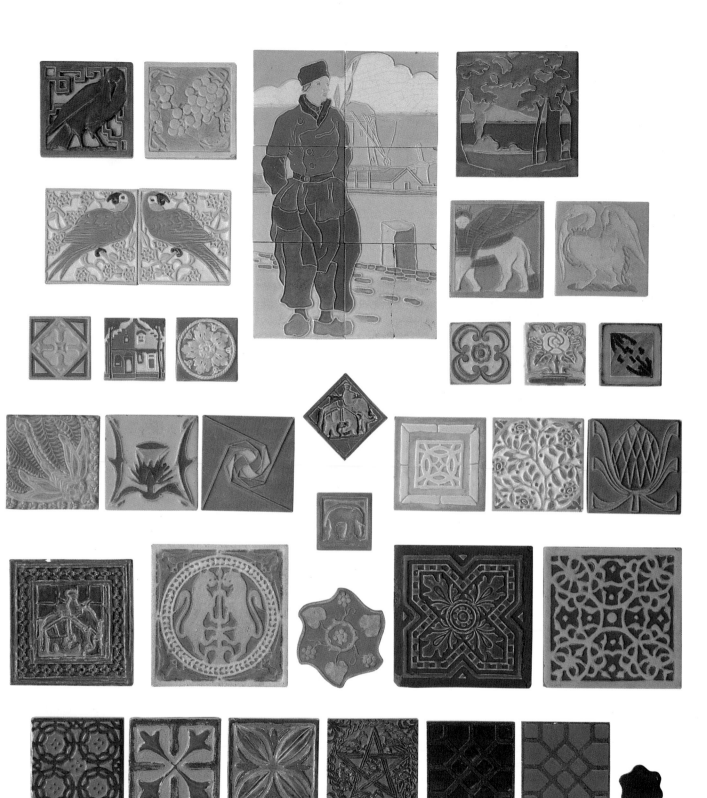

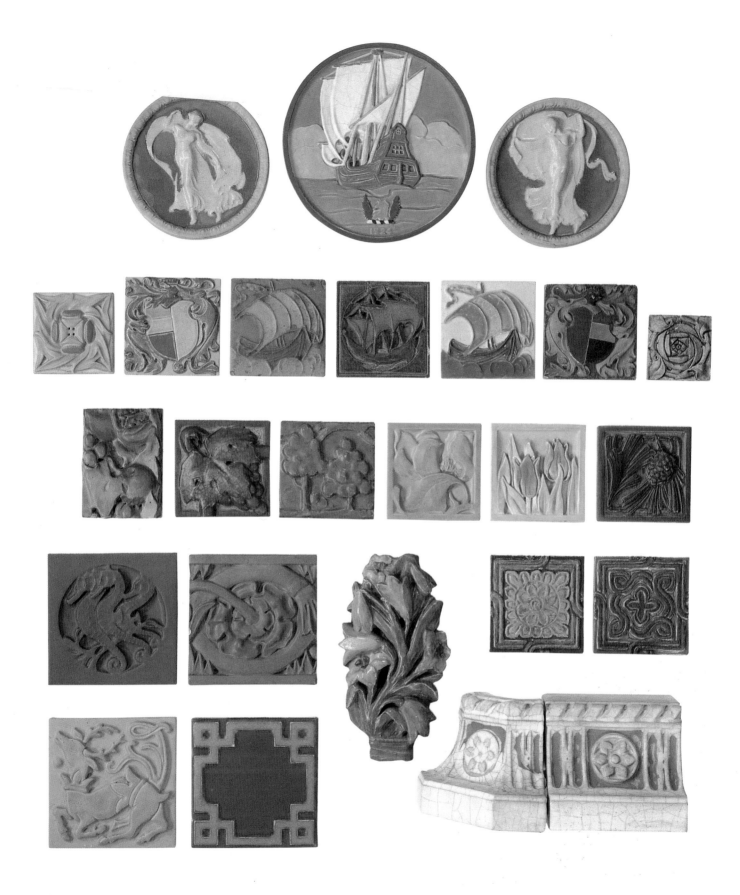

MATT MORGAN ART POTTERY CO.

Cincinnati, Ohio 1882–1884

MATTHEW SOMERVILLE MORGAN WAS BORN IN ENGLAND IN 1839. HE WORKED AS A CARICATURIST FOR PUNCH, AND ALSO worked as a scenic painter. Morgan probably gained his first experience with ceramics at a pottery in Spain. When he came to America in 1873, Morgan originally hoped to pursue a career in lithography.

In 1882, Morgan became partners with George Ligowsky, inventor of the clay pigeon. Together they formed the Matt Morgan Art Pottery Company, on Nixon Street in Cincinnati. The company produced wares with Hispano-Moresque motifs and luster glazes, influenced by Morgan's travels in Spain.

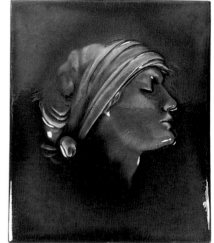

The most notable employee of the new firm was Herman Mueller, who had previously designed and modeled for the Kensington Art Tile Company, just across the Ohio River in Newport, Kentucky. In 1886, Mueller left to work for the American Encaustic Tiling Company in Zanesville.

In 1884, the Matt Morgan Art Pottery Company reorganized, but couldn't overcome its difficulties and closed the same year. Matt Morgan went back to work as a lithographer. Morgan died in New York City in 1890.

ZANESVILLE MAJOLICA CO.

Zanesville, Ohio 1882–1884

THE ZANESVILLE MAJOLICA COMPANY WAS FIRST LISTED IN THE ZANESVILLE CITY DIRECTORY IN 1882, AND WAS INCORPORATed on November 28, 1883. The pottery was established in the J. & G. Pyatt Pottery, located next to the works of the American Encaustic Tiling Company.

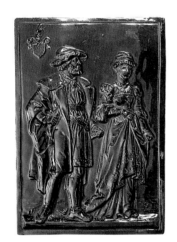

Zanesville Majolica produced very detailed tiles, modeled in deep relief and glazed in a range of colors. Of exceptional quality, the tiles bore a similarity to Swiss and Austrian stove tiles of the sixteenth century.

Tile historian Michael Sims has researched and written about Zanesville Majolica. According to Sims, the company entered its tiles in the Cincinnati Industrial Exposition in September, 1883, and won a silver medal. Matt Morgan, a judge at the Exposition, sent a personal letter to the company stating that the medal should have been gold.

In January, 1884, a fierce fire consumed the pottery. Three horse-drawn pumpers responded to the alarm, but two broke down, and the third could not manage a frozen fire hydrant. The building was a total loss. Although the structure was rebuilt in four months, production never resumed.

Due to the short life span of the company and the fragility of its creations, Zanesville Majolica tiles are quite rare today.

OHIO ENCAUSTIC TILE CO.

Zanesville, Ohio 1883–1886

SAMUEL EBERT, A TOY MERCHANT, FOUNDED THE OHIO ENCAUSTIC TILE Company in 1883. Ohio Encaustic managed to construct four fully-equipped factory buildings at Cooper Mill Road and Railroad by the spring of 1884.

Lacking professional tile-making skills themselves, in 1883 the owners hired Henry Bagley, an English tile maker, to head production. However, dismayed by the lack of other skilled workers at the plant, Bagley returned to England with his family in 1885 and the company closed in early 1886.

The principal cause of the Ohio Encaustic's failure was that no one involved knew how to produce a salable, quality product. Some surviving tiles show warping, unsquareness, cracks, iron stains, and surface pits from impure clay. If these samples are typical, it is clear that the company never succeeded in mastering the art of tile-making.

HAMILTON TILE WORKS

Hamilton, Ohio c.1883–1901

METZNER AND BIELER 1883

METZNER AND HATT CO. c.1883

HAMILTON TILE & POTTERY CO.

THE OHIO TILE CO. 1901–1909

ADOLF METZNER WAS BORN IN STUTTGART IN THE MID-1830S AND EMIGRATED TO INDIANA AROUND 1860. LIKE MANY immigrants who swelled the Union ranks during the Civil War, Metzner joined the army immediately upon arrival in this country. Metzner served in the 32nd Indiana Volunteers and saw action at Chicamauga, Shiloh, and Missionary Ridge. During the war he kept a record of events, making over 100 drawings and watercolors. Unearthed eighty years later, these works caused Metzner to be posthumously acclaimed as "the dean of Civil War artists" by art experts.

After the war, Metzner moved to Hamilton, Ohio, where he experimented with tile-making in his backyard. Following this period of trial and error, Metzner formed a partnership with a Mr. Hatt of Indianapolis, purchased the old Royal Pottery in Hamilton, and established Metzner and Hatt Company. The two men continued experimenting, but achieved little commercial success. Discouraged, Hatt left the company in 1883.

Metzner then became partners with Jacob L. Bieler, also of Indianapolis, and the firm was renamed Metzner and Bieler. Again, repeated experiments yielded few positive results. At this point, the company hired an experienced ceramist, Robert Minton Taylor. After a very short stay, Taylor too left the firm.

In 1883, the name of the company was changed to the Hamilton Tile Works. Working with his two sons, Otto and Max, Metzner struggled to keep the company alive. Then, in 1884, a new company was formed with additional capital. The president of the new venture was Dr. Wild, an old army comrade of Metzner's. Also involved were Julius Bunson (related to the makers of the Bunson Burner) and Adolf and Otto Metzner, who served as superintendents. The new company produced vivid, well-formed relief tiles which were distributed across the country. This must have pleased Metzner who, after so many years of experimenting, had finally achieved tangible and successful results.

In 1897 the company was reorganized but failed two years later. In 1901 the company was revived with new owners, and was renamed the Ohio Tile Company.

Adolf Metzner left to work at the American Encaustic Tiling Company in Zanesville, and then to the C. Pardee Works in Perth Amboy, New Jersey in 1900. He retired in 1912, and died in 1917.

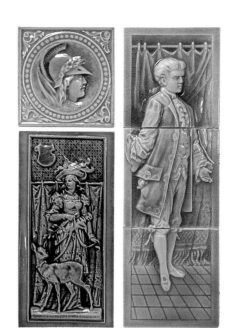

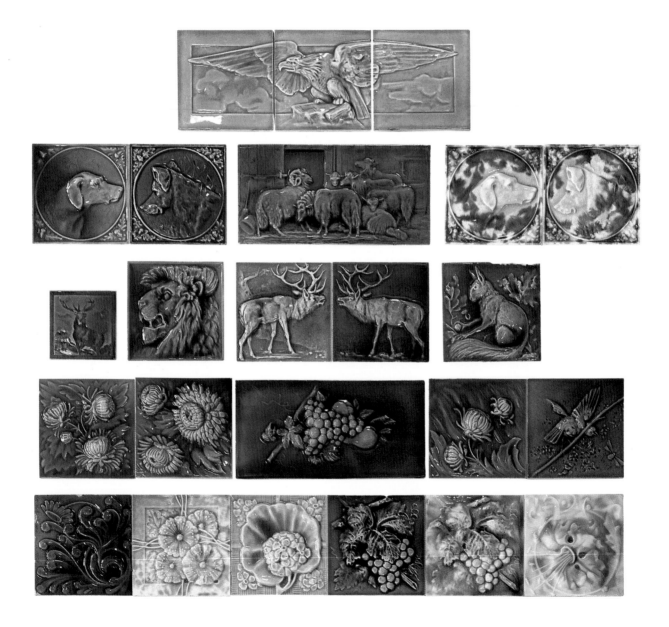

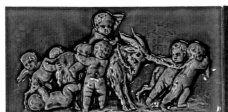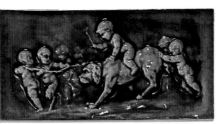

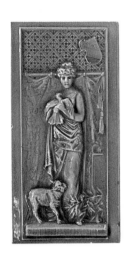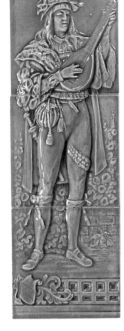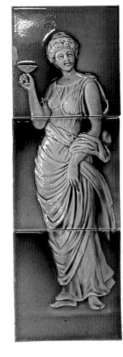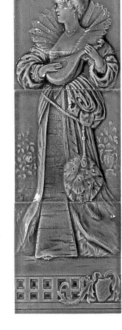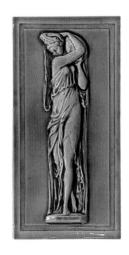

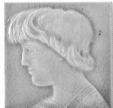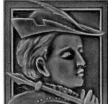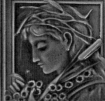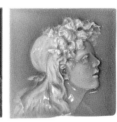

CAMBRIDGE ART TILE WORKS

Covington, Kentucky; Hartwell, Ohio 1886–1985

J. J. BUSSE AND SONS 1886–1888

MOUNT CASINO ART TILE AND ENAMELED BRICK COMPANY 1888–1889

CAMBRIDGE TILE MANUFACTURING COMPANY 1889–1985

WHEATLEY TILE AND POTTERY COMPANY 1927–1929

CAMBRIDGE WHEATLEY COMPANY 1927–1936

CAMBRIDGE ART TILE WORKS

IN 1886 J. J. BUSSE AND HIS SONS JOHN, HERMAN, LOUIS, AND J. HENRY, TOGETHER WITH HERMAN BINZ, BEGAN TO glaze bricks and make decorative tiles in the J. J. Busse and Sons brickyard at 15th and Holman in Covington, Kentucky. A primitive operation, the company mixed clay with a horse-drawn wheel. The 1888 city directory listed the company as the Mount Casino Art Tile and Enameled Brick Company. Another company, the Cambridge Art Tile Works, was established by the Busse brothers and Binz as a selling organization in 1887.

In 1889, Mount Casino Art Tile and Cambridge Art Tile combined to form the Cambridge Tile Manufacturing Company. The company produced brightly colored enameled tiles, stove tiles, and decorated tiles such as artistic faience mantel tiles and vitreous mosaics. Ferdinand Mersman and Clement J. Barnhorn, two German artists and modelers who had worked across the Ohio River at Rookwood, joined the company.

In 1927, Cambridge Tile acquired the Wheatley Pottery of Cincinnati, renaming it the Wheatley Tile and Pottery Company, and running it as a separate subsidiary producing completely different wares than Cambridge. That same year the Cambridge Wheatley Company was formed as a selling organization for both Cambridge and the new Wheatley arm.

In 1929, twenty acres of land were purchased in Hartwell, Ohio, ten miles from Cincinnati, for a new plant. The first tiles were produced in October 1929, on the day the stock market crashed. Despite the bad timing, all production was shifted to the new Hartwell plant.

In 1936 Cambridge Wheatley was dissolved, and Cambridge Tile Manufacturing Company continued under its old name. During World War II, Cambridge turned its presses to the production of compressed cereal bars for K rations, a staple of U.S. troops. Cambridge continued as a tile maker, though producing less artistic tiles, until 1985.

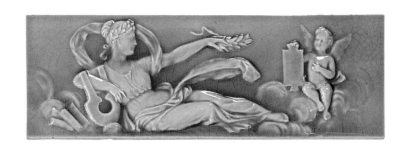

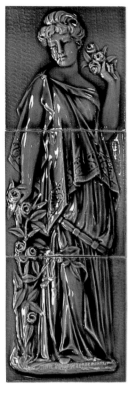

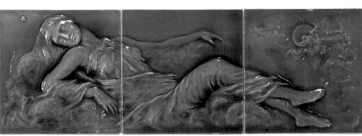

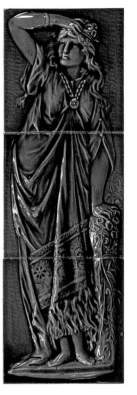

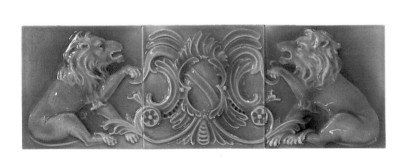

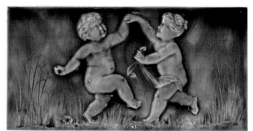

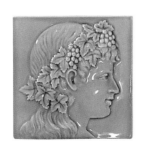

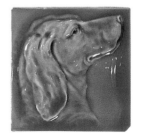

KIRKHAM ART TILE AND POTTERY CO.

Barberton, Ohio 1891–1895

JOSEPH KIRKHAM WAS BORN IN STAFFORDSHIRE, ENGLAND, IN 1845, AND LEARNED THE CERAMIC BUSINESS WHILE HE was employed at the Josiah Wedgwood Company. After coming to the U.S., Kirkham was instrumental in the establishment of the Providential Tile Company. In 1891 he established the Kirkham Art Tile and Pottery Company on Baird Avenue and Eighth in Barberton, Ohio.

Kirkham Art Tile and Pottery was one of the largest and best-equipped tile works in the United States, covering seven acres and employing 700 workers. Kirkham was superintendent and ceramist. The company's stationery indicates that all styles of ceramics were produced, including Pate-sur Pat, Samian, Palissy, Roubelle, Limoges, Vergonia, and Jasper.

In March 1893, less than two years after construction of the Kirkham factory was complete, fire completely destroyed the plant. Tragically lost was what has been described as a magnificent display ready to be shipped to the Chicago World's Fair, as well as most of the company's inventory. Attempts to rebuild the factory failed, and it was closed in 1895. Kirkham then moved to California where he started a factory in Tropico.

J. B. OWENS POTTERY CO.

Zanesville, Ohio 1891–1907

ZANESVILLE TILE CO. c. 1907

J. B. OWENS FLOOR AND WALL TILE CO. 1909–1923

EMPIRE FLOOR AND WALL TILE CO. 1923–1929

JOHN B. OWENS WAS BORN ON A FARM IN ROSEVILLE, OHIO, IN 1859. HE ESTABLISHED HIS POTTERY IN ROSEVILLE IN 1885, with an investment of $300.

In 1891 he established and incorporated the J. B. Owens Pottery Company in nearby Zanesville. The company grew rapidly, and by 1893 had sixty workers, including artists W. A. Long, J. Herold, A. Radford, Frank L. Ferrel, and J. Lessell. When Karl Langenbeck was hired as head chemist, the factory had truly become an art pottery. In 1905 Owens won four gold medals and a grand prize at the Lewis and Clark Exposition in Portland, Oregon.

That same year, Owens, whose company by now had 214 employees, decided to devote considerable effort to making tiles, restyling J. B. Owens Pottery as the Zanesville Tile Company. Owens's tiles were cheaper than others made in Zanesville. He

was seen as something of a renegade by his competitors (all members of the tile manufacturers association), who offered to buy him out. Owens accepted, and his competitors closed Owens's plant in 1907.

Two years later, however, Owens opened a new plant next to his old one, and called it J. B. Owens Floor and Wall Tile Company. In 1923 the new company was incorporated as the Empire Floor and Wall Tile Company. More expansion followed, with the construction of new plants in Metuchen, New Jersey, and Greensburg, Pennsylvania (near Pittsburgh). The Greensburg plant was called the Domex Floor and Wall Tile Company.

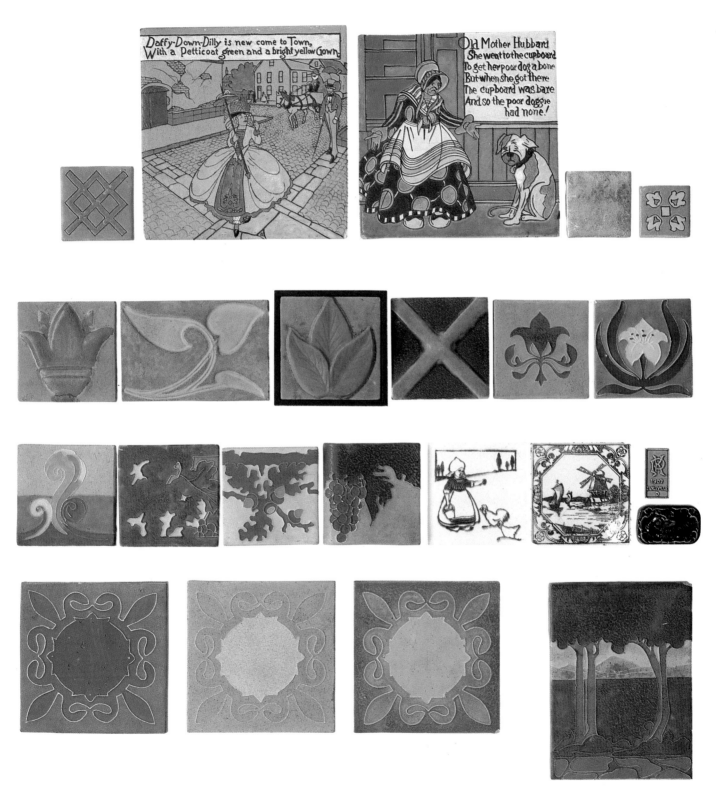

A destructive fire occurred in the Zanesville plant in 1928, but—against good advice in a bad economy—Owens insisted on rebuilding the plant the following year.

The Domex plant in Greensburg closed in 1927, and both the Metuchen and Zanesville plants closed in 1929. Owens retired to Homestead, Florida, and died in poverty in 1934 at the age of seventy-five.

MOSAIC TILE COMPANY

Zanesville, Ohio; Matawan, New Jersey 1894–1972

THE MOSAIC TILE COMPANY WAS INCORPORATED ON SEPTEMBER 4, 1894, BY HERMAN C. MUELLER, KARL LANGENBECK, and William M. Shinnick of Zanesville. Mueller, one of the finest modelers of the era and an expert designer of tile-making machinery, and Langenbeck, a chemist, both left the American Encaustic Tiling Company (A.E.T.) to start this new venture.

Cooper Mill Road in Zanesville was the site selected for the new factory. Four small brick buildings were erected and, with thirty employees, the company began making buff clay square, octagon, and hexagon floor tiles. The tiles sold well, but were far from exciting products from such an artistic and talented staff.

In 1901 the company opened the Mosaic Tile Building at 445 W. 41st Street in New York, a grand, eight-story structure with a tile facade that housed the company's showroom and offices. (The building was demolished in 1954.)

In 1903 Mueller and Langenbeck left the company, even though Mosaic was operating successfully. Shinnick was made general manager in 1907, in charge of finance, design, production, and marketing. During this period Mosaic sustained its greatest growth.

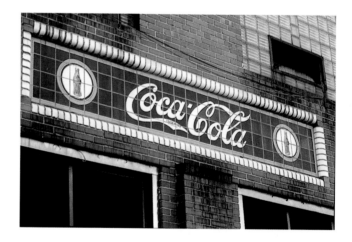

In 1918, faience tile production began. Harry Rhead, an Englishman, was hired in 1920 to supervise this new product line. That same year, Mosaic acquired the Atlantic Tile Manufacturing Company of Matawan, New Jersey. Rhead then left in 1923 to found the Standard Tile Company of South Zanesville.

During 1925–1927, Mosaic reached new heights, employing 1,250 people and producing more tiles than ever before. At this time, Mosaic and A.E.T. were very competitive, vying with each other for the title of largest tile company in the world.

In 1937 Mosaic took a financial interest in the General Tile Company of El Segundo, California and purchased it in the 1940s. It continued to operate under its own name. 1941 saw Mosaic's largest production ever. The production of faience tiles stopped in 1959. In 1967 the Marmon Group of Chicago assumed control of Mosaic Tile. Production there ended July 30. The Atlantic Tile Company in Matawan and the General Tile Company in El Segundo continued to produce plain, solid-color and a few silk-screened decorated tiles in 4¼- and 6-inch sizes. General Tile closed in 1972 and the plant was razed the following year.

Some significant Mosaic installations include two large faience decorated panels (120 feet long x 7½ feet high) for the Will Rogers Memorial at Fort Worth, Texas, which depict historical and industrial developments in Texas; Charity Hospital, New Orleans; Roosevelt Mansion, Hyde Park, New York; Henry Ford Hospital, Detroit; DePaul Hospital, St. Louis; Holland Tunnel, New York–New Jersey; and the Stevens, Drake, Morrison, and Sherman hotels in Chicago.

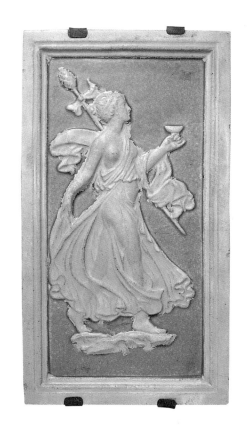

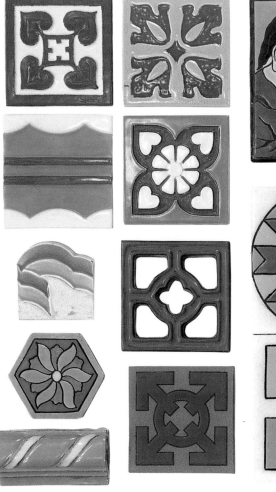

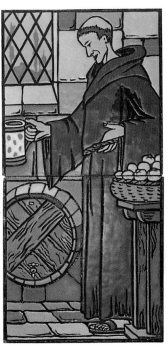

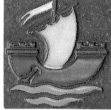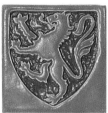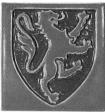

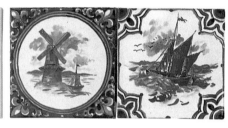

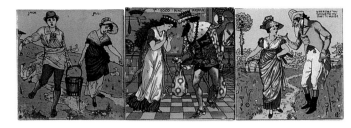

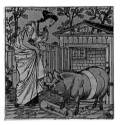

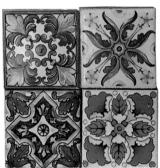

WHEATLEY POTTERY

Cincinnati, Ohio 1903–1927

T. J. WHEATLEY AND CO. 1880–1882

WHEATLEY TILE AND POTTERY CO. 1927–1932

T. J. WHEATLEY AND COMPANY WAS ESTABLISHED IN APRIL, 1880, AT 23 HUNT STREET, CINCINNATI, BY THOMAS JEROME Wheatley, six years prior to Rookwood's founding. Business was excellent; one of their customers was Tiffany & Company, New York.

Wheatley left the pottery in the summer of 1882. He moved to Zanesville and worked for Weller for some time.

In 1903 Wheatley returned to Cincinnati and started the Wheatley Pottery Company with Isaac Kahn at 2430 Reading Road. The company produced architectural ware as well as pottery. T. J. Wheatley is said to have been the first potter to successfully produce a matte green since William Grueby—though others have claimed to have preceded Grueby. The company did make unique, glazed six-by-twelve-inch wall tiles. These were often installed with scenic panels over mantels. After 1910, a large portion of the company's production was tiles. The firm of Strait & Richards was the sole distributor of Wheatley tiles.

Wheatley managed the pottery until his death in 1917. At that time, the company was manufacturing large amounts of faience tile. Kahn took over as president and brought in new capital with John B. Swift. The company moved to Swift's building at 4609 Eastern Avenue and expanded from thirty to 300 employees.

In 1927 the pottery was acquired by Cambridge Tile Manufacturing Company, and the name was changed to Wheatley Tile and Pottery Company. The pottery was closed in 1930, and all operations moved to the Cambridge plant in Harwell, Ohio. The Wheatley tile firm was legally dissolved in 1936.

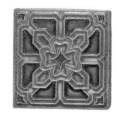

96

J. H. STROBL POTTERY

STROBL TILE COMPANY 1910–1922

J. H. STROBL, A FIFTH-GENERATION POTTER FROM A FAMILY ORIGINATING NEAR LINZ, AUSTRIA, FOUNDED A POTTERY, THE J. H. Strobl Pottery, in 1901 at 909 Depot Street and State Avenue, Cincinnati. Strobl's grandfather had come to the United States in 1851 and established a pottery in Milwaukee, Wisconsin, and his father, Frank X. Strobl, had opened a pottery in 1873 at Ripley County, Indiana, which lasted until 1883. Frank Strobl was then listed in the Cincinnati directory as a potter in 1899 and 1900.

J. H. Strobl was born in Ripley County and began his career modeling clay at his father's pottery. When he was fourteen years old, Strobl moved to Cincinnati to work for the Scott Pottery. Then, in 1901, he established the J. H. Strobl Pottery, which was incorporated in 1906. The company produced vases, bowls, loving cups, and flower baskets. During the financial panic of 1907, the factory switched attention to ornamental art tiles and architectural faience. A specialty was producing mantels in matte colors, including a version of popular Grueby green, according to architectural specifications. The company's products were sold across the United States and Canada.

In 1909, Strobl built a new, modern factory at 4316 Durham in Winton Place, a section of Cincinnati five miles north of downtown. Here, production shifted exclusively to tiles and, at the end of 1910, the name was changed to Strobl Tile Company. The company's ads in *The Mantel, Tile, and Grate Monthly* illustrated faience tiles and mantels with decorative relief-tile inserts. The company also advertised large panels depicting mountain and ocean scenes, as well as panels and tiles with Dutch motifs. These tiles were used on fireplaces, wainscotting, bathrooms, kitchens, and as wall murals. Advertisements indicate that Strobl applied color to this ware in a plastic state, which produced durable colors.

The Cincinnati city directories listed Strobl Tile Company through 1922, when the product line shifted to electrical porcelain and the company became The Cincinnati Porcelain Company.

A. E. HULL POTTERY CO.

ADDIS EMMET HULL WAS BORN IN 1862 IN MORGAN COUNTY, OHIO. IN 1905 HE PURCHASED THE ACME POTTERY COMPANY at the north end of China Street in Crooksville. Combining his old company, the Globe Stone Ware Company, and the new plant, he formed the A. E. Hull Pottery Company. The Acme Electric Company was also installed in the plant, so that power generated to light the town at night could be used to make pottery during the day. The company made basic household china in large quantities, as well as some art pottery, from 1917 until 1950. A. E. Hull produced tiles from 1927 to 1932 in solid colors, gloss and matte, as well as decorated tiles and borders. Tiles with a rounded "cushion edge" for floors, walls, fireplaces, and mantels were also produced. Hull also began to import china from Europe to sell in his outlets. In 1927 Hull converted his old Globe plant to produce tile. Tom Dunlavy was the tile designer. Tile production stopped in 1932.

In 1930 A. E. Hull died and A. E. Hull Jr. took over operations. In June, 1950, a flood brought four feet of water into the plant that reached the 2,000 degree tunnel kiln. The resulting fire destroyed the building. The factory was rebuilt in 1952 and the name changed to The Hull Pottery Company. By 1985, work was slowed to a minimum, but the pottery produced a souvenir tile marked "Pottery Lover's Reunion" for the Pottery Lover's July 1985 festival in Zanesville. In 1986 the factory officially closed.

STARK CERAMICS

East Canton, Ohio 1936–Present

OSNABURG BRICK CO. 1909–1912

STARK BRICK CO. 1912–

ENOS A. STEWART WAS BORN ON JULY 18, 1870, IN HOLMES COUNTY, OHIO. A teacher by profession, Stewart realized that he would never be able to support his family on the low income it brought him. In 1908 he purchased a half-interest in a sixty-six-acre farm that also had a clay deposit and an abandoned brick plant. Stewart hired Fred Mark to construct a kiln and a building, and to assemble the necessary machinery. The first brick was produced on January 1, 1911.

At first, Stewart taught during the day and worked at the plant at night. After three years he resigned from teaching to give full attention to brick-making. Stewart did most of the selling himself.

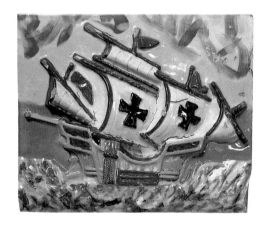

In 1909 the company was incorporated as the Osnaburg Brick Company in East Canton, Ohio; in 1912, the name was changed to the Stark Brick Company. Stark Brick formed a subsidiary called Stark Ceramics, incorporated in 1936. When the parent company was liquidated, the subsidiary continued.

Between 1931 and 1935, Russell Dawson made heavy, sculptured tiles that he called "Soft Mud Plaques," which his wife Thelma painted. The tile illustrated is ten by twelve inches. Other tiles include one illustrating "The Last Supper" (approximately eighteen by twenty-four inches), and another of a lawn bowling scene (the latter was installed in a local country club). These tiles were all made two inches thick, so that they could be installed easily into brickwork.

Stark's main products were glazed brick and hollow building brick. The company was still in business as of this writing, at 600 W. Church Street in East Canton, with John H. Stewart Jr., the grandson of Enos A. Stewart, as Chief Executive Officer.

It is the author's assumption that some of the molding equipment and perhaps staff used at Stark in the thirties came from Unitile in Urichsville, after that factory was destroyed by fire in 1927. The unique bisque in both cases has identical back marks.

REGNALD GUY COWAN WAS BORN TO A FAMILY OF POTTERS IN EAST LIVERPOOL, OHIO, ON AUGUST 1, 1884, AND ATTENDED the New York State School of Clayworking and Ceramics at Alfred, New York. Cowan built his first kiln in his backyard at 107th and Euclid Avenue in Cleveland, Ohio, and in 1913 he established Cleveland Pottery and Tile Company on Nickerson Avenue in Lakewood (a suburb of Cleveland).

The pottery's main production was pottery and figures. It also produced decorative tiles for mantels, baths, fountains, and wall plaques. One notable installation was on the floor of the Cleveland Museum of Art. (It was later removed during renovations.)

In 1917 Cowan received first prize at the International Show at the Art Institute of Chicago. Later that year, with the U.S. drawn into World War I, he joined the army and closed the pottery for the duration of the war. In 1920 Cowan moved the pottery to 19633 Lake Road in Rocky River, another Cleveland suburb.

Many artists were associated with Cowan during these years: Waylande Gregory, who modeled figures; Arthur Baggs of Marblehead; and Elsa W. Shaw, Thelma Frazier, and Viktor Schreckengost, who all made tile plaques.

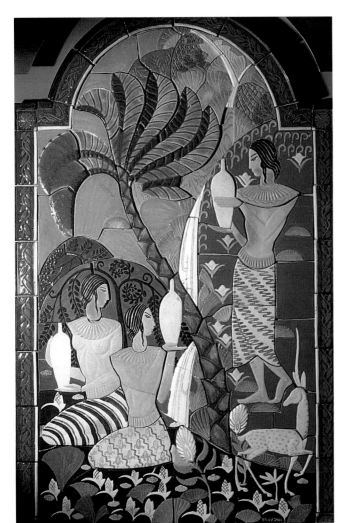

Some tiles were regular production items, while others— such as ecclesiastical decoration and soda fountains—were special commissions. Figurines and pottery were also a large part of Cleveland Pottery's production. In many cases 50 or 100 molded pieces were made, and then the mold was destroyed.

In 1927, Cowan Pottery Studio Incorporated was established, and two years later was reorganized as the Cowan Potters Incorporated. The Depression caused the pottery to go into receivership in 1930 and the Rocky River plant closed in 1931.

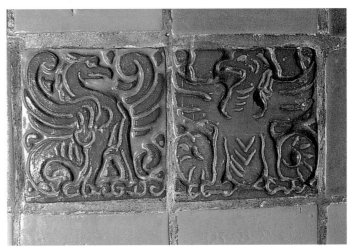

After the closing Cowan went to work at Ferro Enamel, a Cleveland pottery supplier. In 1933 he moved to Syracuse, New York, where he worked for the Onondaga Pottery Company. He continued working and teaching there until 1957, when he died at the age of seventy-three.

The Cowan Pottery Museum is located in the Rocky River Public Library in Rocky River, Ohio.

UNITILE

Urichsville, Ohio 1917–1927

UNITILE WAS FOUNDED IN 1917 BY THREE BROTHERS: JAMES HARRISON DONAHEY, A CARTOONIST FOR THE CLEVELAND PLAIN Dealer; Alvin Victor Donahey, who later became Governor of Ohio; and William Donahey, a writer and illustrator of children's books. (William Donahey's most important creation was the "Teenie Weenies," a children's story syndicated for more than twenty years in over 200 newspapers across the country.)

Established in Urichsville, Ohio, the Unitile factory produced terra cotta wall tiles in various cut-out shapes which, once assembled, produced images of people, animals, and emblems. Nursery rhymes and children's motifs were common themes.

The company also developed a technique similar to that of Henry Chapman Mercer, whereby deep grooves were cut into a clay tile. The resulting isolated sections were then chemically treated to produce a different color when fired. After grouting, these sections looked like individual tiles. In addition, Unitile produced terra cotta floor tiles in various sizes and shapes that made unique combinations

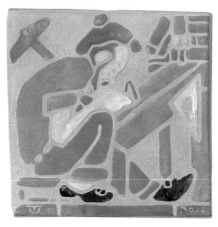

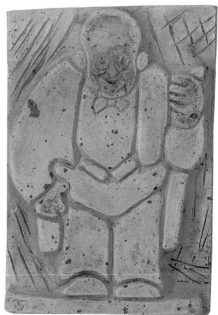

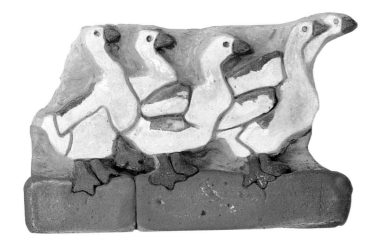

The factory employed twelve to fifteen workers and used coal-burning beehive kilns. In 1927, a fire destroyed the factory, and production ceased. James Donahey, the son of Alvin Victor, was able to salvage three railcars of tiles. These he shipped to Columbus, Ohio, where he sold them over the next two years. It is the author's assumption that after the factory was destroyed in 1927, some of the equipment and possibly some staff moved to Stark Brick Company in East Canton. Some of the terra cotta bisque made at Unitile is identical to that of the Stark bisque.

G . E . T .

Zanesville, Ohio

NOT MUCH INFORMATION EXISTS ON G.E.T. THIS FIRM PRODUCED some very fine tiles, some of which are identical to those of the American Encaustic Tiling Company, which may point to a connection between the two companies. The tiles are marked "G.E.T. Co. Zanesville, Ohio."

Tile maker Gilbert Elliot went to A.E.T. in 1876, only a year after the company was established. It is certainly possible that G.E. T. stands for "Gilbert Elliot Tile."

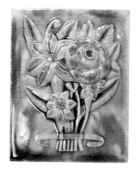

S P A R T A C E R A M I C C O .

East Sparta, Ohio; Canton, Ohio 1922–Present

U . S . C E R A M I C T I L E C O . 1854–Present

U . S . Q U A R R Y T I L E C O . 1926–Present

THE SPARTA CERAMIC COMPANY WAS ORGANIZED IN 1922 BY DAVIS CABLE, STERLING FRY, AND FRANK ESTERLY. THE COMPANY took over the East Sparta Clay and Lime Company plant and produced its first floor tile there in 1923. In 1945, the Company obtained trademark for the name "Spartan." The products were primarily glazed and unglazed mosaics for floors and walls, as well as relief-tile inserts in two-, three- and four-inch sizes. These were available in multicolored glazes for walls and partial glazes for floors.

The U.S. Quarry Tile Company was established in 1926, when the U.S Roofing Tile Company changed its name and began producing quarry tiles. U.S. Roofing had been formed thirteen years earlier. The owners were D. J. Cable and Frank L. Bean.

Cable's son Davis became the superintendent of the East Sparta plant and later went on to become president of U.S. Quarry.

The U.S. Quarry Tile Company primarily manufactured utilitarian quarry tiles (in squares and shapes), floor and wall tiles, and trim tiles. One notable installation of this material was in the Lincoln Tunnel, under the Hudson River between New York and New Jersey. The company did produce some molded relief, polychrome insert tiles in 2¾-, 4-, and 6-inch sizes.

With partial ownership of the two companies held by the Cables, Sparta Ceramic and U.S. Quarry Tile operated as parallel companies, occupying the same branch offices across the country. The two companies' 1940 catalogs were very similar in style.

In 1954 Sparta Ceramic was acquired by U.S. Quarry Tile. The new firm was called U.S. Ceramic Tile Company. Soon five plants were producing tile, and by 1960 the company was one of the largest tile producers in the U.S. In 1974, the name was changed to Spartek Incorporated, reflecting its role as a giant conglomerate working in ceramics, plastics, metal-powder products, chemicals, and tools. The company is still in business.

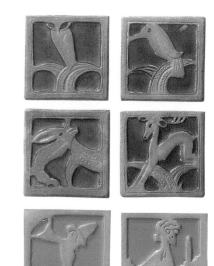

STANDARD TILE CO.

Zanesville, Ohio 1923–1943

STANDARD TILE COMPANY WAS ESTABLISHED BY JOHN M. MORTON IN 1923 IN ZANESVILLE, OHIO. MORTON, WHO HAD BEEN the superintendent of Mosaic Tile Company, was president.

During the Depression the company was able to stay in business, but operated on a very small scale. In 1935 Morton died and Ernest V. Gorsuch became president.

The firm was still in business in 1943.

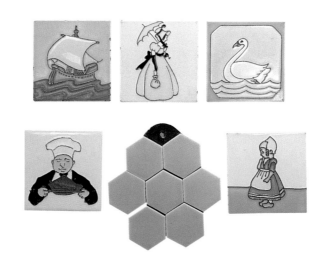

NEWCOMB POTTERY

New Orleans, Louisiana 1895–1940

THE NEWCOMB POTTERY HAD ITS ROOTS IN THE WOMEN'S COLLEGE ASSOCIATED WITH TULANE UNIVERSITY—THE H. Sophie Newcomb Memorial College—founded in New Orleans, Louisiana, in 1886. An instructor at Newcomb, William Woodward, and a few of his students organized the New Orleans Art Pottery Company as a small, independent commercial oper-

ation. In 1887 Woodward was assisted by Joseph Fortune Meyer and George E. Ohr of Biloxi, who threw pots and handled the firing, while the students decorated the pieces. This company closed in 1890 but was the forerunner of Newcomb Pottery.

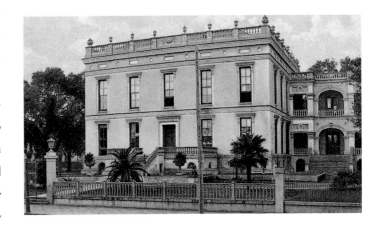

In 1894 Newcomb College added pottery to its curriculum. The following year it began production as the Newcomb Pottery, with William Woodward's brother Ellsworth in charge and Mary Given Sheerer, an accomplished artist and ceramist from Cincinnati, as his assistant. Jules Gabry (Clement Massier's assistant) and George Wasmuth threw pots until Joseph Fortune Meyer took over the job in 1896.

Some of the students were eventually employed as full-time decorators after graduation. Each piece was marked with the decorator's initials, and there are sixty-seven such initials on record. The most notable decorators are: Sarah (Sadie) Irvine, who began as a student in 1902, became a staff member, and stayed at the college until her retirement in 1952; Henrietta Bailey, who worked from 1901 until 1938; Fannie Simpson who worked from 1902 to 1929; and Leona Nicholson who worked from 1903 to 1929.

In 1902 the pottery's facilities were enlarged as the demand for Newcomb pottery exceeded its production. Newcomb's output was second only to Rookwood Pottery.

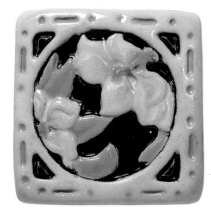

In 1910 Paul Ernest Cox, a graduate of Alfred University, was hired to solve some technical problems and reorganize production. Among other accomplishments, Cox developed a matte glaze to be used with the existing underglaze colors. In 1918 Cox made plans for a larger pottery to be constructed up the river adjacent to the Tulane campus, but he left Newcomb before it was completed.

Cox was replaced by Frederich E. Walrath, followed by Vincent Axford, Harry Rogers, and Kenneth E. Smith.

During the Depression, as with other potteries, sales decreased. Newcombe's pottery sales ceased completely in 1940.

In all, the pottery produced about 70,000 ceramic pieces—mostly vases, but also bowls, plates, lamps, and tiles. The pottery used Southern themes in its decoration, typically Southern flora and fauna, with no two pieces exactly alike.

The Newcomb Pottery received great acclaim over the years. Among the many awards Newcomb received were: bronze medals at the Exposition Universelle (Paris, 1900), at the Pan American Exposition (Buffalo, 1901), and at Portland (1905); a silver medal at Charleston (1902); gold medals at Johnstown (1907), and at Knoxville (1915); and the grand prize at the Panama International Exposition (San Francisco, 1915).

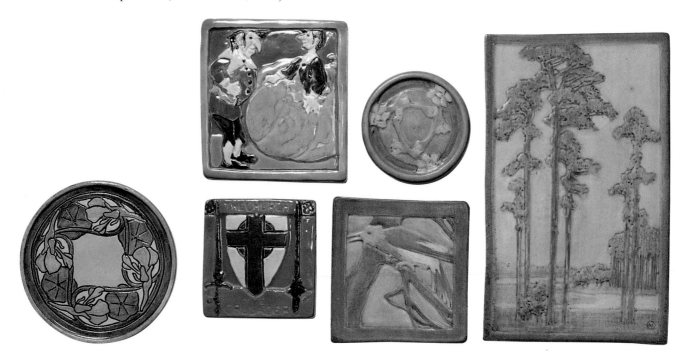

GEORGE EDGAR OHR

Biloxi, Mississippi 1883–1909

BILOXI ART POTTERY UNLIMITED

PERHAPS ONE OF THE MOST DISTINCTIVE PERSONALITIES OF THE ARTS AND CRAFTS CERAMISTS, GEORGE OHR PRODUCED some of the most outstanding and unique ceramics of the epoch at his Biloxi Art Pottery. Ironically, these pieces and their creator, known for his flamboyant personality, were reviled by his contemporaries.

Born July 12, 1857 in Biloxi, Mississippi, George Edgar Ohr was the son of a blacksmith, a trade the young Ohr performed prior to his apprenticeship in New Orleans with a boyhood friend, ceramist Joseph Fortune Meyer. Ohr left New Orleans and embarked on a two-year tour of potteries in the Midwest and East Coast. Returning to Biloxi in 1883, Ohr built a pottery with his own hands, and began producing utilitarian wares.

In 1888 Meyer again asked Ohr to join him, this time at his New Orleans Art Pottery. Ohr accepted the post, which entailed working as assistant pottery teacher to the Ladies' Decorative Art League. The League was eventually absorbed by Newcomb College. It is assumed that Newcomb asked Ohr to leave because his bawdy character was unsuited for the refined young ladies at the college. Ohr returned to his Biloxi Art Pottery where he continued his single-handed pottery production. The pottery,

which he referred to as the "Pot-Ohr-Ree," became a local tourist attraction.

Ohr created very unique art pottery: wares with delicately thin walls that were deliberately twisted, crushed, and otherwise manipulated into distorted forms. The approximately 7,000 pieces Ohr created over the years were warehoused by Ohr's family when he closed his pottery in 1909. Ohr died in 1918.

In the 1960s Ohr's stored treasures were discovered by a New York art dealer, and today Ohr's pottery commands some of the highest prices along with the most collectable Arts and Crafts ceramics. Finally, this eccentric, avant-garde potter—whose work modern scholars note as anticipating such art movements as abstract expressionism, funk, dada, and surrealism—won the recognition he deserved.

Illustrated are six coin tiles, with ribald pictograms, styled on brothel tokens and sold as souvenirs to tourists visiting the Biloxi Art Pottery.

BYBEE POTTERY

Bybee, Kentucky 1845–Present

CORNELISON POTTERY c.1883–1893, c.1930

THE BYBEE POTTERY WAS SAID TO HAVE STARTED IN 1809, BUT RECORDS DATE BACK ONLY TO 1845. BYBEE WAS FOUNDED AND run by Webster Cornelison, who was succeeded by his son, James Eli, who in turn was followed by his son, Walter. In 1939 Walter's son, Ernest, took over. Ernest was succeeded by his son, the second Walter, in 1969. Walter's sons, James Andrew and Robert Walter, are working at the pottery today.

The pottery, located in the Cumberland Mountains southeast of Lexington, Kentucky, operates in almost the same manner as it has for over a century. The clay deposit is three miles from the pottery, and the clay, which does not require any additives, is ground in an antique pug mill.

The operation had always been called the Bybee Pottery until Howard G. Selden, a distributor, registered the Bybee name in the 1920s. This prevented the Cornelison family from using the name again until 1930, when Selden went out of business. The Bybee name was then restored to the pottery.

In the span of five generations, the plant's products have shifted from salt-glazed stoneware to newer, brighter colors of molded pottery. During the 1920s and 1930s Bybee produced finer art ware in heavy matte glazes of green and blue, sometimes compared to the wares of Hampshire, TECO, and Marblehead.

The pottery's main building, made out of walnut logs, is 100 years old, and the business still continues today, after 150 years and five generations of Cornelisons.

KENSINGTON ART TILE CO.

Newport, Kentucky 1885–1893

HATT AND HATT c. 1883–1885

J. ARTHUR HATT AND HIS BROTHER OTTO W. HATT ORGANIZED A TILE FACTORY CALLED HATT AND HATT IN 1883 OR 1884, at Elm and Lowell Streets in Newport, Kentucky. Previously, one of the Hatt brothers and Adolf Metzner had formed Metzner, Hatt, and Company, in Hamilton, Ohio.

Hatt and Hatt failed in 1885, at which time Colonel Robert William Nelson (a local attorney), John Meyerberg, Otto Metzner (son of Adolf) and John Sheehy reorganized the Kensington Art Tile Company at the same address. Otto Hatt became superintendent and manager.

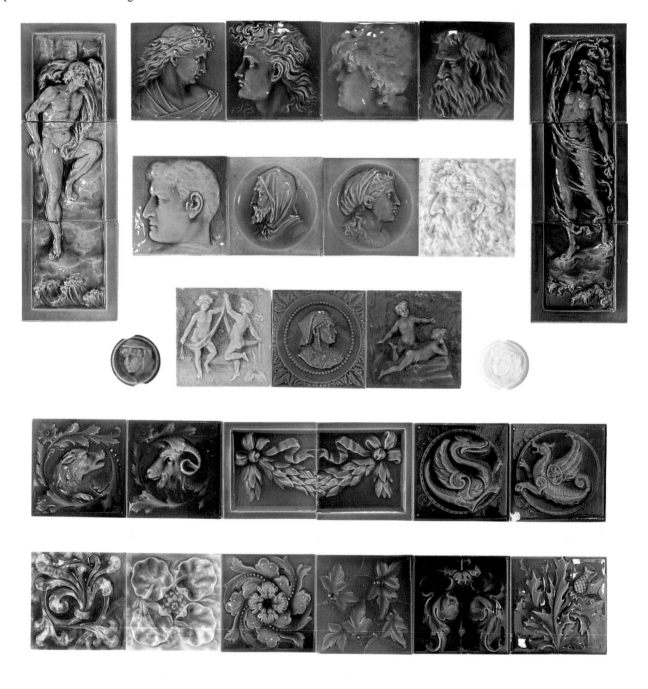

During Kensington's ten-year existence, the factory produced many well-made, dust-pressed tiles. It was particularly well-known for its portrait tiles. Herman Mueller began modelling at Kensington in 1885, and Mary Louise McLaughlin was employed as a designer.

The factory's closing is not clearly documented. The August 29, 1893 issue of *Clay-Worker* reports that Kensington Art Tile, Hamilton Art Tile, and Anderson Tile Works of Indiana had been purchased by a syndicate of Cleveland capitalists, who would relocate all three plants to Anderson, Indiana. This may not have occurred, for one and a half years later, the *Kentucky Post* of March 9, 1895, reported that all of the equipment from Kensington had been shipped to the Hamilton Tile plant in Ohio. Indeed, commemorative tiles indicate that the Hamilton Tile Works and The Kensington Art Tile Company were consolidated, with an office in Hamilton, Ohio.

John F. Sheehy, who had been the superintendent and manager since 1888, became manager of the Alhambra Tile Company of Newport, Kentucky, in 1901.

PADUCAH POTTERY

Paducah, Kentucky; Los Angeles, California 1886–1929

PADUCAH TILE AND POTTERY CO.

J. A. BAUER POTTERY 1909–Present

F. K. PENSE TILE WORKS 1929–1940

THE SON OF GERMAN IMMIGRANTS, JOHN ANDY BAUER WAS BORN IN JEFFERSONVILLE, INDIANA, IN 1856. AT AGE EIGHTEEN, Bauer was hired by a local Louisville pottery, where he worked for eleven years. During this time he married Emma Dargel.

Records show that in 1886 a "J. Andy Bauer" purchased land in Paducah, Kentucky, at 7th and Trimble Streets, and established a pottery. Because Bauer and his father shared the same name, either could have founded the pottery. Some authors credit the elder Bauer; however, directories list the elder Bauer as a plasterer, a trade he continued until his death.

In 1905 the Paducah Pottery was incorporated and the 7th Street plant modernized and expanded. Four years later, Bauer, suffering from asthma, moved to Los Angeles, bringing with him much of the equipment and sixteen workers from the Paducah plant. Despite Bauer's departure, the Paducah plant remained in operation under the supervision of Bauer's brother, George, who was assisted by a number of John's eight children.

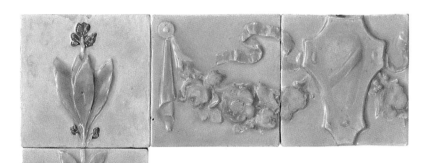

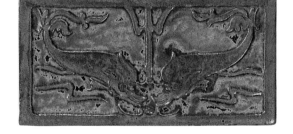

In 1909 Bauer established the J. A. Bauer Pottery on Avenue 33 in Los Angeles. The factory primarily manufactured flower pots, bowls and vases; there is no evidence that tiles were produced here.

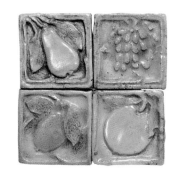

In the early 1920s, the J. A. Bauer Pottery was sold, and Watson E. Bockmon became the company's president. In 1932 or 1933, the firm acquired the failing Batchelder Tile Company plant, located less than one block away on Artesian Avenue. In 1929 Bockmon left the pottery to become superintendent of the Bockmon Tile Company, at 6300 East Slauson Avenue in Los Angeles. The J. A. Bauer Pottery continued operating until about 1958.

Meanwhile, in Kentucky, the Paducah Tile and Pottery Company was sold to F. K. Pense in 1923. Pense had previously worked for fourteen years at the American Encaustic Tiling Company. Little is known about the Depression-era activities of the Paducah Pottery except that, in 1929, the pottery changed its name to the F. K. Pense Tile Works. Company advertisements indicate that the pottery was engaged in the manufacture of mosaics, pastels, bathroom fixtures, and "Paducah Faience."

In 1940 Pense sold the factory and it was shipped to San Antonio, Texas.

ALHAMBRA TILE COMPANY
Newport, Kentucky 1901–1941

JOHN F. SHEEHY, A NATIVE OF ZANESVILLE, OHIO, WHO HAD worked at the Kensington Art Tile Company, and Otto Wolf formed the Alhambra Tile Company in 1901 at 16 East 10th Street and Monroe in Newport. Production began in 1902 with Sheehy as superintendent.

Alhambra Tile remained quite small throughout its forty-year history, producing excellent faience wall tiles as well as some roof tiles. The faience tiles were made in the raised-line method, with floral and geometric patterns in soft-hued glazes. Some tiles were marketed as "Araby Tile" and "Plastic Faience Decorated Tile." Alhambra also produced special art tiles for mantels.

In 1926 Alhambra won a first prize at the Sesquicentennial Exposition in Philadelphia.

Due to the lack of manpower and supplies, the plant closed in 1941. In 1942 the building was leased to the F. J. Derrick Brick Company for war work. On the first day of production, the building was devastated by a fierce fire. All of the tile production components of Alhambra were destroyed, which precluded any chance of reopening Alhambra after the war was over.

WHEELING TILE COMPANY

Wheeling, West Virginia 1913–c. 1960

DECORATIVE CLAY PRODUCTS COMPANY

THE WHEELING TILE COMPANY WAS ORGANIZED IN 1913 BY SAMUEL O. LAUGHLIN, WHO PURCHASED THE OLD WHEELING Pottery plant on Chapline and 32nd Street in Wheeling, West Virginia. In 1916 the company purchased another Wheeling Pottery plant one block away, at La Belle and 32nd Streets. Christian Friderichsen was superintendent, but in 1919 he left to start his own factory in Independence, Missouri.

In 1934 Wheeling acquired a third factory, on 31st and Eoff Streets. The pottery had chosen Wheeling as its location due to an inexpensive supply of natural gas—an asset in firing the dust-pressed tiles. How much decorative work was done by Wheeling Tile is not known, but a separate company called the Decorative Clay Products Company performed much of this work. A Wheeling Tile catalog states that it was the representative of The Decorative Clay Products Company. Advertisements from 1915 describe Wheeling's products as hand-made vitreous and encaustic floor tile. Wheeling Tile closed about 1960.

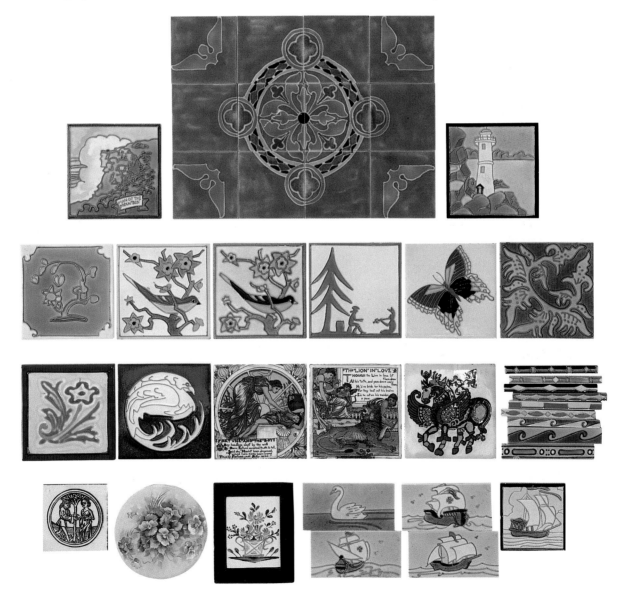

U.S. ENCAUSTIC TILE CO.

Indianapolis, Indiana 1877–1886

U.S. ENCAUSTIC TILE WORKS 1886–1932

U.S. TILE CORP. 1932–c.1937

THE U.S. ENCAUSTIC TILE COMPANY WAS FOUNDED IN INDIANAPOLIS IN 1877 AT 349 WEST 16th Street.

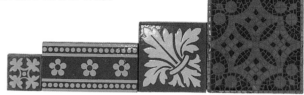

Recruiting trips to England were made to induce skilled tile workers to emigrate to Indianapolis with their families. Robert Minton Taylor, an Englishman, worked at U.S. Encaustic from 1881 to 1883. Ruth M. Winterbotham was the only known sculptor and modeler. By 1884, the factory was said to be the largest plant of its kind, with 300 employees and a capacity to produce 2 million square feet of tile per year. The company even drilled its own gas wells, and piped natural gas over twenty miles back to the factory.

U.S. Encaustic's sculptured tiles were made by the dust process, a system used to make buttons patented by Richard Prosser in England in 1840, and adapted for tile-making by J. M. Blackfield. One notable project was a special floor produced for a saloon in Fort Worth, Texas, during the 1890s. It consisted of small encaustic tiles with holes in the centers, into which ten- and twenty-dollar gold pieces and silver dollars were inserted. The floor proved quite popular. One day two workmen came in with pick and shovel, and told the bartender they had orders to put in a new floor. The two men dug up the floor tiles and the coins and hauled them away in a wagon.

In 1886 U.S. Encaustic Tile failed. The company was then reorganized by John J. Cooper and its name was changed to the U.S. Encaustic Tile Works.

In 1893 William Landers developed a matte glazed tile for use in an Indianapolis hotel. This accomplishment came five years before Grueby developed his famous matte cucumber green. Landers's matte glaze, however, was not readily accepted by the public. Landers shelved it for a time before reintroducing it in 1900.

An untimely and expensive expansion program began in the summer and fall of 1929, which was the cause of the company's failure two years later. The company was in receivership from October, 1931, until December, 1932, when a new company

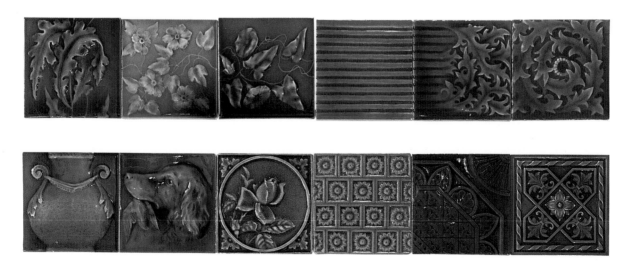

was formed: the U.S. Tile Corporation. U.S. Encaustic Tile Works was listed in the city directories until 1934. The U.S. Tile Corporation was listed at that address from 1934 to 1937.

Between 1938 and 1939, the plant and all assets were liquidated, and the property was turned into a playground.

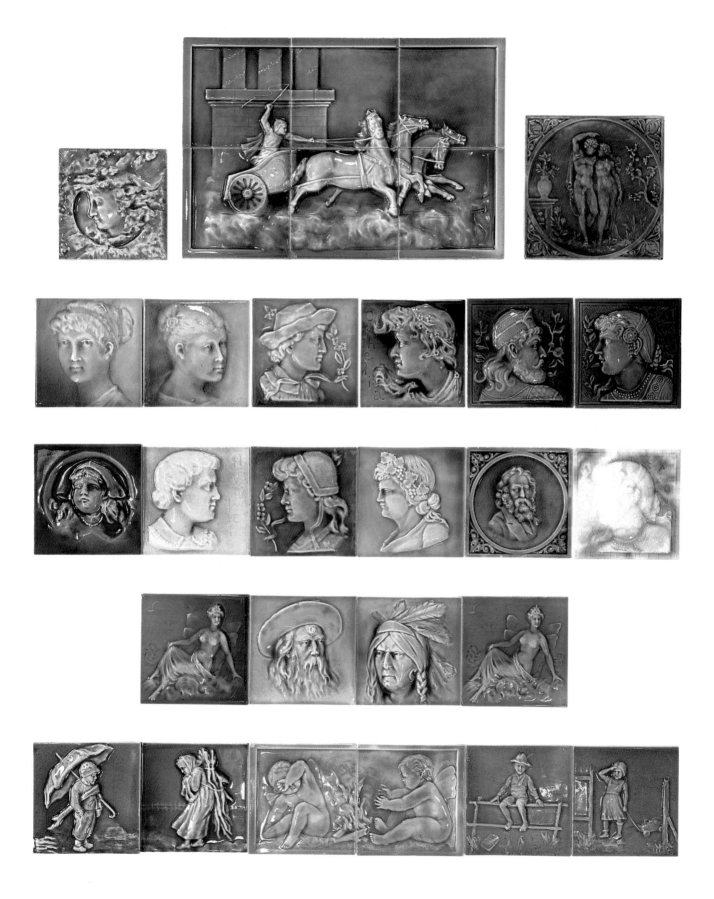

COLUMBIA ENCAUSTIC TILE COMPANY

Anderson, Indiana 1889–1903

NATIONAL TILE COMPANY

1903–1966

THE COLUMBIA ENCAUSTIC TILE COMPANY WAS ESTABLISHED IN 1889 BY B. O. HAUGH AND GEORGE LILLY AT 26TH AND Lynn Streets, Anderson, Indiana. The company manufactured encaustic floor tiles as well as glazed and embossed relief tiles — which were generally used for hearths, mantels, and wainscotting. Decorative subjects included a series of children's figures representing the four seasons, and children's portrait heads.

Initially, Columbia did not have a national sales organization, so, in 1903, the company consolidated with Old Bridge Enameled Brick and Tile Company and Robertson Art Tile Company. Together, the companies formed the National Tile Company. Herman Mueller was hired to head the design department in the Morrisville plant.

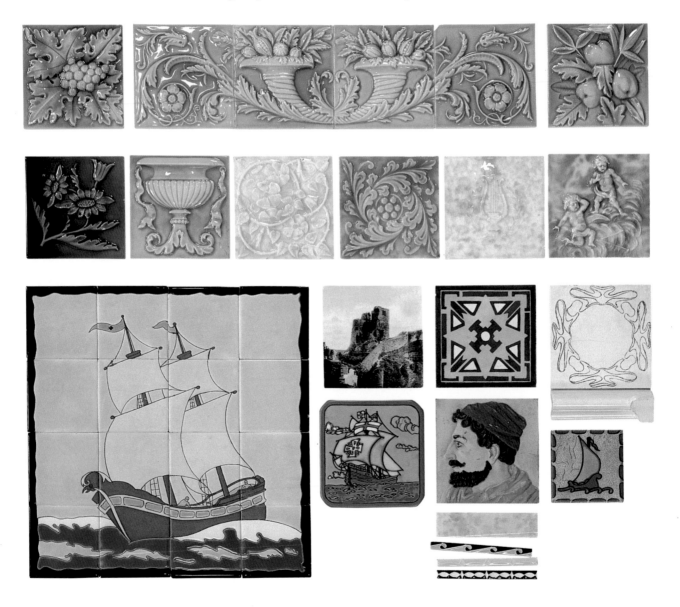

According to an account in the Bulletin of the American Ceramic Society , on May 15, 1943, the new organization opened an elaborate office on Broad Street in Trenton, New Jersey, as well as a high-rent showroom at 551 Fifth Avenue in New York. Due to this extravagant increase in overhead, the company could not pay a dividend in 1904.

Less than two years later, Old Bridge Enameled Brick and Tile pulled out of the consortium and assumed its former name. Shortly thereafter, coerced by Columbia, Robertson did the same. Left by itself, Columbia continued under the name of National Tile Company, giving up the office in Trenton, but keeping the New York showroom.

In 1927, National Tile Company became publicly owned. In 1947, the company became the National Tile and Manufacturing Company. National Tile and Manufacturing Company closed for good on October 26, 1966.

Of the tiles pictured opposite, the top two rows are Columbia Encaustic; the tiles below those are National Tile Company.

OVERBECK POTTERY

Cambridge City, Indiana 1911–1955

THE OVERBECK POTTERY WAS ESTABLISHED IN 1911 BY FOUR SISTERS: MARGARET, HANNAH, ELIZABETH, AND MARY Overbeck. They set up the pottery in their family home, with the workshop in the basement, the studio on the first floor, and a Revelation kiln in a separate building in the backyard.

Margaret (b.1863) had worked at a pottery in Zanesville, Ohio, one summer and had attended the Art Academy of Cincinnati and Columbia University. She taught in the art department at De Pauw University in Greencastle, Indiana. She died in 1911, in the first year of the pottery's existence.

Hannah Borger (b.1870) was an invalid for many years. Like Margaret, Hannah attended the Art Academy of Cincinnati. At Overbeck she was the principal designer and also did modeling. Hannah Borger died in 1931.

Elizabeth Grey (b.1875) studied at Alfred University with Charles Binns in 1909-1910. Perhaps the most technically gifted of the four sisters, she worked on the wheel, doing most of the throwing, and also made hand-built pottery. Responsible for much of the designing and decorating, she created glaze formulas, her finest being the hyacinth and turquoise glazes. Elizabeth Grey was named a fellow of the American Ceramic Society in 1936. She died the following year.

Mary Frances Overbeck, the youngest (b. 1878), studied with Arthur W. Dow at Columbia University, and also attended the Art Academy of Cincinnati. Mary was in charge of glazing, designing, and modeling (obviously, after 1937 she did everything). She died in 1955, and the Overbeck Pottery closed.

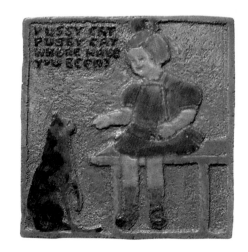

The Overbecks worked together on almost every aspect of production, with many of the pieces passing through all their hands. They made pottery, dishes, figurines, tea tiles, and plaques. Most of the pieces were carved, giving the designs a thick relief. The subjects were both floral and geometric, sometimes with animals, in both matte and glossy finishes.

The Overbeck's pieces received acclaim in exhibitions in St. Louis, Baltimore, and San Francisco, and at the Chicago Century of Progress Exposition.

AMERICAN ART CLAY COMPANY
(AMACO)

FINE ART CERAMIC COMPANY

AMERICAN ART CLAY COMPANY—ALSO KNOWN AS AMACO—WAS ESTABLISHED IN INDIANAPOLIS IN 1919 BY TED O. PHILPOT, at 353 W. 14th Street. Philpot was a pharmacist and big-game hunter. He owned a zebra (which he took for walks), two Bengal tigers, two African lions and two cheetahs.

Another pottery, the Fine Art Ceramic Company, was incorporated in January, 1921, at the same address. Fine Art Ceramic sold both utility and art ceramic ware.

AMACO produced ceramic tiles whose decoration possessed a photographic quality. Various personages—such as Pope Pius, Warren Harding, Abraham Lincoln, and Christ—were used as decorative subjects for the tiles. In 1930, American Art Clay Company began making commercial pottery under the direction of designer Jaroslov Marek, who had studied ceramics in his native Czechoslovakia. Pottery was sold at Peacock's and Marshall Fields in Chicago, at Hudsons in Detroit, and was distributed through Soovia Janis in New York.

In 1931, AMACO moved to 4717 W. 16th Street, across the street from the first turn of the Indianapolis Speedway.

AMACO discontinued pottery production in 1938 to concentrate on selling supplies such as kilns, potter's wheels, clay, and glazes. The company is still in business as of this writing.

AMERICAN TERRA COTTA AND
CERAMIC CO.

SPRING VALLEY TILE WORKS c. 1882
TERRA COTTA TILE WORKS 1885–1929
GATES POTTERY, TECO 1899–1929

WILLIAM DAY GATES GREW UP IN CRYSTAL LAKE, ILLINOIS, FIFTY-FIVE MILES NORTHWEST OF CHICAGO, AND PRACTICED law in Chicago until 1886. Gates had purchased some land in 1880 near Crystal Lake and found a large clay deposit, excellent for pottery. Gates founded the Spring Valley Tile Works on the property, a beautiful rural setting, bordering a small lake in Terra Cotta, Illinois. In 1885 Gates renamed the pottery Terra Cotta Tile Works, changing the name again in 1887 to the American Terra Cotta and Ceramic Company.

The company produced sewer pipes and garden terra cotta, as well as some architectural terra cotta and tiles.

In 1899 the company announced a new pottery would be built, called the Gates Pottery, producing high-styled, molded ceramics under the name TECO. This ware was considerably less expensive than thrown pottery; many pieces were listed at prices ranging from one to twenty dollars.

In 1900 the company exhibited ceramic pieces with a soft, silvery, matte green glaze. In 1904, the pottery won two gold medals and highest honors at the Louisiana Purchase Exposition in St. Louis. The pottery was at its peak production at this time.

Following a popular demand for green glazes, from 1904 to 1910 the company produced only matte green pottery—in 500 forms. The closing of Grueby Pottery (known for its green glaze) in 1911, marked the end of the craze for green pottery.

In 1912 American Terra Cotta produced polychrome faience tile. There were many important projects at this time. Ten terra cotta panels by Karl Schneider, depicting the life of Lincoln, were installed in Lincoln Hall at the University of Illinois at Urbana. A series of panels by Charles Francis Brown on the theme of the "Great Northwest," were produced for the TECO Inn Restaurant at Hotel Radisson in Minneapolis, Minnesota. And at the factory's offices, terra cotta panels depicting the history of the company were installed.

TECO produced tiles for fireplace facings in panels and single tiles of fruit, flowers, foliage, and geometric compositions. There were also sculpted tiles in low relief, often with a matte green glaze. Hardesty G. Maratta painted murals for TECO.

Architectural terra cotta was one of American Terra Cotta's most important products. Some notable buildings in Chicago that used the company's pieces were the Chicago Trust and Savings Bank Building, A. L. Rothchild's Department Store, Goldblat's, The Woods Theatre, and the Chicago and North Western Railway Terminal.

In 1913 William Gates was sixty-two years old and wished to retire. He turned the management over to Harry J. Lucas, who was soon replaced by John Crowe. The new management enlarged the facilities, and increased the work force to 300. Business was good and there was a backlog of orders.

The Chicago Carpenters Union went on strike, which closed down virtually all construction. The factory could not ship any goods and thus could not meet

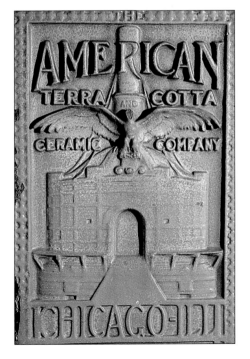

its payroll. Gates came out of retirement and asked the citizens of Crystal Lake to purchase stock in the company, which they did, keeping the company aloft.

As World War I approached, pottery sales slowed. The pottery made ceramic hand grenades for training troops. After the war, however, with many architectural projects under construction, business resumed and the company expanded, purchasing the Indianapolis Terra Cotta Company. In 1921 the company resumed production of TECO pottery, which was sold to many former customers.

Four months after the 1929 stock market crash, the Indianapolis plant closed, followed by the main plant in Terra Cotta. Ownership of the pottery was transferred to the family of George A. Berry Jr. The plant was reorganized and continued production on a small scale under the name of the American Terra Cotta Corporation. William Gates again retired to his home in Crystal Lake, this time in failing health. He died in 1935.

American Terra Cotta continued until the outbreak of World War II. The factory then shifted to processing steel products for war materiel. After the war, the production of clay products resumed on a small scale until 1966 when American Terra Cotta closed for the last time. In 1972 an unrelated company, Terra Cotta Industries Incorporated, took over the plant.

Today TECO pottery is among the most cherished wares among collectors, along with Grueby and Van Briggle ceramics.

NORTHWESTERN TERRA COTTA CO.

Chicago, Illinois 1888–1956

CHICAGO CRUCIBLE CO. 1917–1922

CHICAGO CERAMIC CO. 1922–1956

TRUE BRUNKHORST AND CO. 1877–1886

TRUE HOTTINGER AND CO. 1886–1887

JOHN R. TRUE, AND JOHN BRUNKHORST LEFT THE CHICAGO TERRA COTTA COMPANY IN 1877 TO FORM TRUE BRUNKHORST and Company at Lincoln Avenue and Wells Street in Chicago. Soon thereafter the company moved to the former Chicago Terra Cotta Company plant at West 15th and Laftin Streets. In 1883 the company built a huge new factory at 2525 Clybourn Avenue in Lakewood (a Chicago suburb). Most of the company's production was devoted to terra cotta garden pots, furniture, and statuary.

The company began to devote more energy to producing architectural terra cotta. Sample terra cotta tiles were distributed to architects and prospective clients, and by 1884 the company had over fifty commissions, including the Royal Insurance Building, the Chicago Board of Trade, and the Pullman Palace Car Company offices.

John Brunkhorst died in 1886 and the name of the company was changed to True Hottinger and Company. The firm referred to itself, however, as the Northwestern Terra Cotta Company and, in 1887, was incorporated as such.

About 1904 the company began to produce pottery similar to the American Terra Cotta Company's "TECO" line. From 1907 to 1920 Northwestern's pieces were called "Norweta." In 1920 Northwestern discontinued the Norweta line and acquired the Chicago Crucible Company, which had been incorporated in 1917. Chicago Crucible, which produced pottery, lamp bases, ashtrays, and wall plaques, was probably purchased to better compete with TECO.

In 1922 the Chicago Crucible name was changed to Chicago Ceramic Company, but it remained a subsidiary of Northwestern. Northwestern's major products continued to be architectural terra cotta, which included decorative plaques, doorway surrounds, architectural borders and blocks. By 1927 the company was the largest terra cotta producer in the U.S., and by 1929 had plants in Chicago, Chicago Heights, St. Louis, and Denver.

Northwestern Terra Cotta Company continued to operate until 1956.

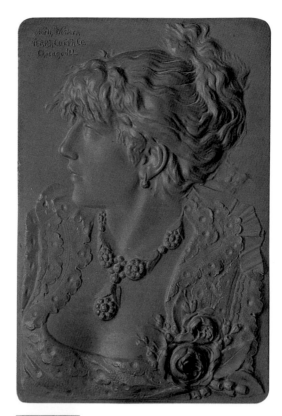

 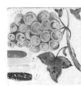

MIDLAND TERRA COTTA CO.

Cicero, Illinois 1910–

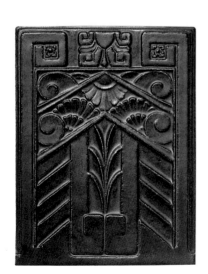

INCORPORATED IN 1910, MIDLAND TERRA COTTA COMPANY WAS LOCATED IN CICERO, Illinois (part of Greater Chicago) at West 16th Street and South 54th Avenue. According to Walter Greer's *The Story of Terra Cotta*, the company's significant installations included Municipal Pier, Medinah Temple, Sisson Hotel, and the Elks Club, all in Chicago. William G. Krieg was president until 1918, followed by Hans Mendies.

ABINGDON POTTERIES

Abingdon, Illinois 1933–1950

THE ABINGDON SANITARY MANUFACTURING COMPANY WAS ESTABLISHED IN 1908 AND QUICKLY DEVELOPED A REPUTATION for very high grade porcelain plumbing fixtures. When demand for construction materials dropped to dangerously low levels during the Great Depression, the company began to develop alternative products. In 1934, "Abingdon Art Pottery" was born.

The company hired Ralph Nelson to head the modeling department. Abingdon began to turn out over 1,000 models each year, all made of high grade porcelain. The company produced vases, candlesticks, figurines, cookie jars, flower pots, and some tea tiles. The two tiles shown here were produced in 1937 or 1938 and were called "Geisha" and "Coolie."

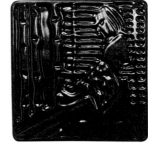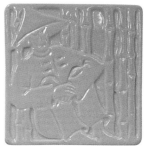

Soon after World War II ended, Japanese manufacturers began to copy Abingdon's pottery, which hurt its business somewhat. In 1947, Brigg's Manufacturing Company purchased a controlling interest in Abingdon Potteries. A fire in 1950 destroyed the art pottery kiln and art pottery was discontinued.

FLINT FAIENCE AND TILE CO.

Flint, Michigan 1921–1933

ALBERT CHAMPION, A FRENCHMAN, HAD BEEN A RACER OF MOTORCYCLES, AND AUTOMOBILES BEFORE HE MOVED TO AMERICA to manage a small spark plug factory in Boston. When General Motors bought the spark plug business and moved it to Flint, Michigan, Champion followed.

Collaborating with Carl Bergmans, a Belgian ceramic artist, in 1921 Champion organized the Flint Faience and Tile Company as a subsidiary of the A. C. Spark Plug Company and General Motors. The company was located on Harriet Street in Flint. The new subsidiary may have come about merely as a means of maximizing the capacity of the spark plug kilns.

Flint tiles were all made by hand and glazed to order, mostly using the raised-line process, though some used the inlay or embossed process. The company also produced large panels and advertised over 150 colors and more than 7,000 stock designs. Flint tiles were sturdy, well designed, and neatly executed, winning prizes at the Metropolitan Museum of Art in New York City. The tiles were used in the Palace of the President of Peru, in auto showrooms in the General Motors Building in Detroit, in John D. Rockefeller's swimming pool at his New York estate, in the Custom House in Puerto Rico, and in St. Matthew's Catholic Church in Flint.

Albert Champion died on a business trip to Paris in 1927. In 1928 the firm acquired a larger plant on Dort Highway and Davidson Road. Even though tile-making proved profitable, the factory ceased production of tile in 1933 to make more room for spark plug production.

 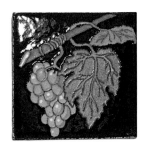

 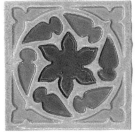 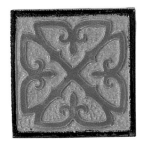 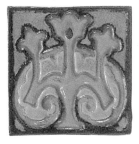

 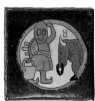

 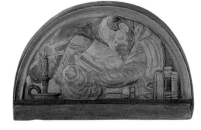

MARY CHASE PERRY WAS BORN IN HANCOCK, MICHIGAN IN 1867. IN 1887 SHE WENT TO THE ART ACADEMY OF CINCINNATI TO study china painting. At the Academy Perry met Maria Longworth Nichols Storer of Rookwood, Artus Van Briggle, and Mary Louise McLaughlin of the Pottery Club, who comprised the creative heart of art pottery in Cincinnati.

Two years later Perry opened a studio on West Adams Street, Detroit, where she decorated china and gave lessons. Her next door neighbor, Horace J. Caulkins, had just perfected a simple, kerosene-fueled kiln for firing dental porcelains. Realizing

its potential for ceramics, Perry formed a partnership with Caulkins and named their new device the "Revelation" kiln. Perry traveled across the United States, teaching china painting while demonstrating the Revelation kiln at the same time.

Perry and Caulkins rented an old carriage house on Alfred Street in Detroit and founded the Revelation Pottery. In 1903 the first order for 132 pieces of pottery, totaling $747, was delivered to Burley and Company, Chicago, an important dealer in art pottery. Mr. Burley advised Perry and Caulkins to rename the pottery in order to promote their ware properly. The partners agreed on "Pewabic," referring to the Pewabic mine near Perry's birthplace in Hancock, in northern Michigan. Pewabic is a Native American Chippewa word meaning iron or copper colored clay.

Realizing that she needed more information to operate a pottery, Perry coordinated her Revelation kiln sales trips to potteries she could study. She visited Grueby, Merrimac, and Dedham potteries in Massachusetts, and Weller Pottery in Zanesville, Ohio. Perry also went to Alfred University in Alfred, New York, where she studied briefly with Charles F. Binns.

At Pewabic Perry was in charge of glazes and designing the forms while Caulkins mixed clay and attended the kilns. The pottery also made polychrome scenic tiles, which soon took up a large

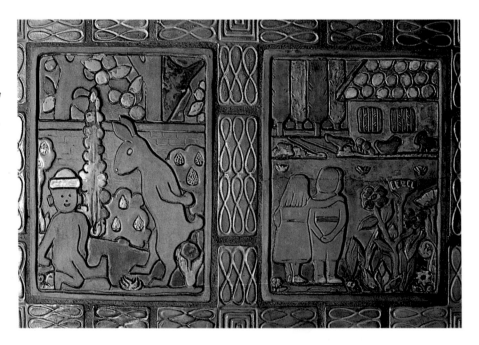

share of the company's production. In 1906 one of the architects who used Pewabic tiles, William Buck Stratton, designed a new pottery for Perry, which was built at 10125 East Jefferson Avenue in Detroit. The well-planned structure was a comfortable looking building, not at all like a factory in appearance, yet very suitable for a pottery. It was done in the English style with a brick façade on the lower section, wood beams and stucco above. The factory still exists, and is open to the public today.

In 1909 Pewabic produced a small iridescent piece of pottery. This iridescent glaze was soon recreated in many different colors including rose, gold, yellow, copper, purple, green, and Persian and Egyptian blues (which were the most popular). These glazes created great demand for Pewabic pottery, and today Pewabic's iridescent glaze pieces are the most sought after by collectors.

Pewabic Tiles were installed in hundreds of places across the United States. Notable examples include St. Paul's Cathedral (1909), Holy Redeemer Church (1920), the Public Library Children's Room (1926), and the Union Trust Building (1927), in Detroit; and the National Shrine of the Immaculate Conception in Washington, D.C. (1924–31).

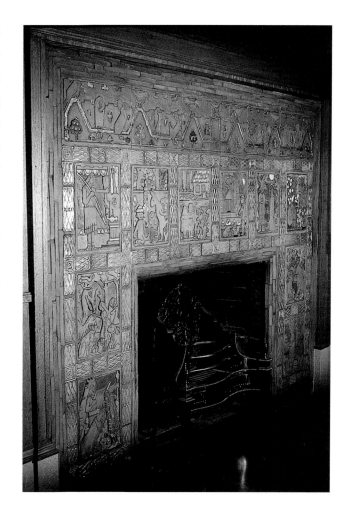

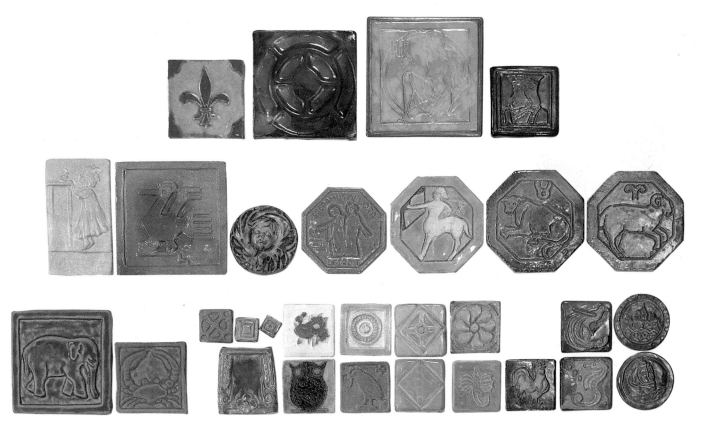

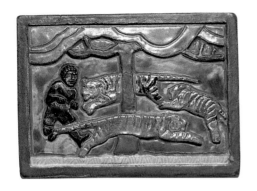

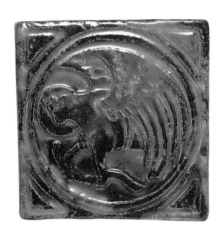

In 1918 Mary Chase Perry married William Stratton. When Horace Caulkins died in 1923, Mary Perry, now Mary Stratton, managed the pottery herself. Mary Stratton taught pottery from 1924 until the late 1940s.

Mary Stratton's health began to fail in the 1950s and many of her duties were turned over to Ella J. Peters. Still, Mary Stratton remained in control of the pottery until she died in 1961 at the age of ninety-four. The pottery remained active until 1965 when it became part of Michigan State University. Pewabic reopened in 1968 as an educational institution and museum. In 1991 the pottery became a National Historic Landmark.

PAULINE POTTERY

Chicago, Illinois; Edgerton, Wisconsin 1883–1893

IN 1880, WHEN PAULINE BOGART JACOBUS VIEWED AN EXHIBIT OF CERAMIC WORK BY SARAH BERNHARDT, SHE DECIDED ON A career in ceramics. Her husband, Oscar I. Jacobus, a successful businessman, encouraged her to study with Maria Longworth Nichols at Rookwood. In 1883 Jacobus started her own small pottery in Chicago. Jacobus sold her ware to Tiffany & Co. in New York, and Marshall Fields in Chicago.

In 1888 Oscar Jacobus discovered a good clay deposit 120 miles north of Chicago in Edgerton, Wisconsin. Oscar and Pauline purchased a house there and set up a new operation, Pauline Pottery, which was incorporated at that time. Soon, forty employees were producing vases, flower pots, candlesticks, lamps, and fireplace tiles at the pottery. The company's tile molds were designed for large-scale production, though the firm's actual tile output is not known.

In 1891 two Danish ceramists were employed: Thorwald P. A. Sampson, as artist and modeler, and Louis Ipson, who worked with molds. After one year, however, the two men left to start the American Art Clay Works.

Oscar Jacobus died in 1893 and soon afterwards the pottery closed.

Pauline Jacobus then set up one of her old kilns in her house and resumed pottery making on a much smaller scale assisted by pottery students who boarded with her. She closed her operation in 1909 and sold off most of her pottery. Two years later her house was destroyed by fire. Pauline Bogart Jacobus died in 1930.

SUSAN STUART GOODRICH FRACKELTON
FRACKELTON CHINA DECORATING WORKS

Milwaukee, Wisconsin 1883–1902

SUSAN FRACKELTON, BORN IN 1848, WAS THE DAUGHTER OF A WEALTHY WISCONSIN BANKER AND BRICKMAKER. SHE HAD EXPERimented with salt glaze stoneware and won medals at the Philadelphia Centennial Exposition of 1876 and the International Exposition in Atlanta in 1881. In 1883 she established the Frackelton China Decorating Works in Milwaukee, which produced 1,500 to 2,000 pieces a week. At the Exposition Universelle in Paris in 1900, Frackelton's ceramics won great international acclaim. Some of her tiles were stoneware with underglaze Dutch motifs, such as cherubs, windmills, and ships.

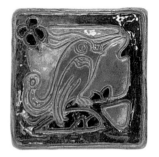

Susan Frackelton gave up pottery in 1902 when she moved to Chicago. She died in 1932 at the age of eighty-four. A good collection of Frackelton's work can be found at the State Historical Society of Wisconsin at Madison.

CONTINENTAL FAIENCE AND TILE COMPANY

South Milwaukee, Wisconsin 1925–1943

CONTINENTAL FAIENCE AND TILE COMPANY WAS INCORPORATED BY CARL VIRGIL BERGMANS IN 1925 AT 9TH STREET AND Menomonee Avenue in South Milwaukee. Bergmans, a Belgian, had previously worked at Mosaic Tile and American Encaustic Tiling Company in Zanesville, Ohio, and at Flint Faience and Tile Company in Michigan.

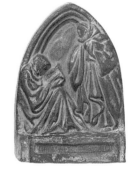

Advertising of the period promoted Continental's hand-made artistic faience, fireplaces, fountains, decorative panels, sculptured moldings, and decorative inserts used with floor tiles.

Continental is described in the 1943 Directory of the American Ceramic Society as producing the items mentioned above, and cites Bergmans as president. The 1945 Milwaukee directory, however, classified Continental as a producer of concrete products.

NILOAK POTTERY

Benton, Arkanas 1910–1946

HYTEN BROTHERS POTTERY 1895–1910

CHARLES D. "BULLET" HYTEN, THE MOVING FORCE BEHIND THE NILOAK POTTERY, WAS THE SON OF J. H. HYTEN, WHO OWNED a pottery in Boonsboro, Iowa. Advised by his doctor to seek a warmer climate, J. H. Hyten relocated his family to Benton, Arkansas, where he found a job at the Eagle Pottery which he eventually purchased, but died soon thereafter. His widow remarried and ran the pottery with her new husband (also a potter), until the couple moved back to Iowa in 1895. Eighteen-year-old Charles Hyten and his two brothers stayed on in Benton to run the pottery, which became known as the Hyten Brothers Pottery.

Charles mixed native clays of different colors to achieve marble-like multicolor swirls. He then added oxides and other chemicals to his clay, employed a slow heating process, and sandpapered the surface of the fired product. By around 1910 he had perfected this technique and produced an exquisite product called "Mission Ware." Charles Hyten patented this process in 1928.

The pottery produced an unknown number of different tiles, although the facade of the Hyten Brothers pottery showroom in Benton (since demolished) was covered with marbleized tiles. By 1910 Charles was marketing his pottery as "Niloak" (kaolin spelled backwards) and started the Niloak Pottery Company.

Charles Hyten received recognition for his accomplishments at the Arkansas Exhibit of the 1934 Chicago World's Fair. Unfortunately, as the Depression wore on, sales declined and Hyten lost control of Niloak. He continued as a salesman for the company until 1941, when he sold his remaining shares. The marvelous marbleized Niloak pottery was finally discontinued in the late 1930s or early 1940s. Charles Hyten died in 1944, and the pottery closed in 1946.

SAN JOSE POTTERY

San Antonio, Texas c. 1940–c. 1953

MEXICAN ARTS & CRAFTS SHOP c. 1982–1940

San Jose Pottery, founded in 1940 by Ethel Wilson Harris, was located in the San Jose Mission at San Antonio, Texas. Ethel was born May 27, 1894, in Sabinal, Texas to a pioneer family and moved to San Antonio before the turn of the century.

In 1931, she began her Mexican Arts and Crafts Shop in the old Lewis barn on North St. Mary's Street. Her intention was to train and create jobs for Mexican craftsmen and also to preserve the arts and crafts traditions. One of the crafts was the production of tiles and pottery.

During the Depression, she was hired by the W.P.A. to manage their arts and crafts division. Under the W.P.A. her tile panels were installed at the Alamo Stadium and along the San Antonio River walk.

In 1940, Helen, her family and shop moved to the historic San Jose Mission, built in 1720. They lived in six rooms made of four feet thick ancient adobe walls.

San Antonio, Texas, Mission San Jose. Built 1720.

Besides being custodian of the Mission, she continued to produce pottery, tiles and other crafts. Her tile motifs were often Mexican scenes, the Mission, or local southwest flowers and plants. The tiles were glazed in brilliant colors, some so bright that the Uranium Oxide would light up Geiger counters.

As a mark, she used the Maguey plant, a local form of the century plant, which she considered the most beautiful in Texas. It was used as a subject, or signature glazed on the front of tiles or scratched into the back. The W.P.A. had its own emblem.

Harris' husband was a chemist and made the San Jose glazes until he died in 1939. Ethel Wilson Harris died on September 21, 1984, at the age of ninety-one.

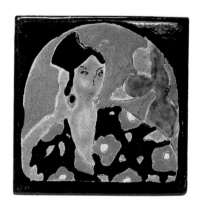

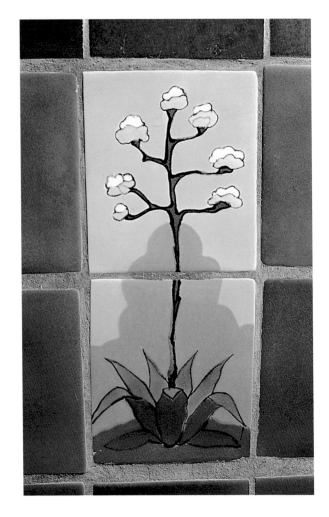
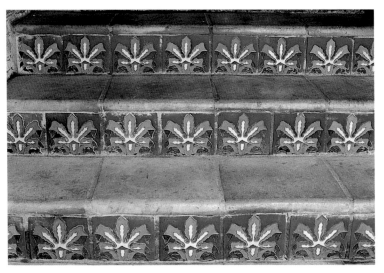

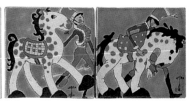

WINKLE TERRA COTTA CO.

St. Louis, Missouri 1883–1943

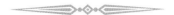

THE WINKLE TERRA COTTA COMPANY WAS FOUNDED IN 1883 AT 5739 Manchester Avenue in St. Louis by Joseph and Andrew Winkle.

Winkle produced brightly glazed ceramic tiles, although the company's basic product was architectural terra cotta. Some of Winkle's most notable projects were the Fort Dearborn Building in Chicago, the Railway Exchange in St. Louis, the Hillman Building in Los Angeles, the Dayton Building in Minneapolis, and the Rialto Building in Kansas City.

The company was listed in the St. Louis city directory until 1943.

UNIVERSITY CITY POTTERY

University City, Missouri 1909–1915

UNIVERSITY CITY PORCELAIN WORKS

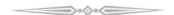

THE AMERICAN WOMEN'S LEAGUE WAS ESTABLISHED IN 1907 BY EDWARD GARDNER LEWIS TO ADVANCE WOMEN'S EDUCATION and broaden their opportunities. The People's University in University City, a suburb of St. Louis, provided a correspondence course for the League.

Lewis found deposits of pure white kaolin clay on the People's University grounds in 1903, and, after years of experimentation, came to the conclusion that this clay would produce the finest porcelain in America. In 1909 the University City Pottery was founded, with Taxile Doat a distinguished ceramist and author of "Grand Feu Ceramics," a treatise on high fired porcelain.

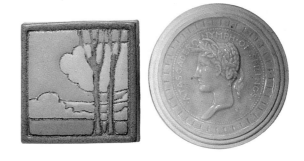

The school invited some of its most gifted students to come to University City to receive personal instruction. The Pottery Department became known for its accomplished staff: Frederick Hurten Rhead, Adelaide and Samuel Robineau, Edward and Elizabeth Burnap Dahlquist, George Julian Zolnay, William Victor Bragdon, Kathryn E. Cherry, Edward and Mabel G. Lewis, Emile Diffloth, and Eugene Labarriere. (The last two came from Europe with Taxile Doat.)

The quality of University City ceramics was outstanding. Adelaide Robineau's Scarab Vase of 1910-1911, probably the most famous ceramic work ever created in America, was created there and can now be seen at the Everson Museum in Syracuse. Ceramics from University City were shown in exhibits at the Art Institute of Chicago, the Arts and Crafts Society in Boston, and the Muse-

um of Fine Arts in Boston. The group received the grand prize at the International Exposition of Torino in 1911, for what was proclaimed as the finest porcelain in the world.

Despite the pottery's success, Edward Lewis's empire, including the American Women's League, ran into trouble with the government due to Lewis' other activities, including mail fraud. In 1911 Rhead left for Arequipa in California and the Robineaus returned to their studio in Syracuse. Edward Lewis moved to California where he founded the town of Atascadero, about twenty miles north of San Luis Obispo, as an utopian community for the "American Women's Republic."

In 1912 the University City Pottery was reorganized as the University City Porcelain Works, operating in a much more frugal fashion. Taxile Doat remained until 1915, when he returned to France. All production at University City stopped at that time.

OZARK POTTERY

c. 1910–c. 1940

THESE WELL-EXECUTED, MOLDED TILES ARE MARKED "OZARK TILE," and must have been produced in a pottery with considerable production. They were probably made in Missouri or Arkansas in the 1920s or 1930s.

Though the names are similar, there is probably no connection between Ozark Tile and the Ozark Pottery of St. Louis, Missouri (1906 to c. 1920), which used the mark "Zark."

SHAWSHEEN POTTERY

Billerica, Massachusetts; Mason City, Iowa 1906–1911

THE SHAWSHEEN POTTERY WAS ESTABLISHED IN 1906 BY EDWARD AND ELIZABETH BURNAP DAHLQUIST AND GERTRUDE Singleton Mathews in Billerica, Massachusetts. Named after a brook that ran through the town, "Shawsheen" is an Indian word which means "meandering." In 1907 the Dahlquists moved to Mason City, Iowa and, although they continued the pottery, the couple began to focus more on teaching. Much of the Shawsheen output from this time was by students.

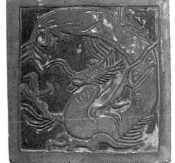

At the same time, the Dahlquists studied at the Minneapolis School of Art and the Chicago Art Institute and taught at the Handcraft Guild of Minneapolis, Minnesota. In 1910 Edward taught at the University City Pottery. Upon his return to Iowa in 1911, the couple closed their pottery and moved to Chicago. The Dahlquists continued teaching, however, and, in 1915 Elizabeth opened the Ho Ho Shop, which sold art pieces including much of the Shawsheen Pottery's best work. Elizabeth Burnap Dahlquist died in 1963. Edward died in 1972 at age ninety-four.

IOWA STATE COLLEGE

Ames, Iowa 1920–1939

THE POTTERY AT IOWA STATE COLLEGE BEGAN IN 1920 WHEN PAUL COX WAS HIRED TO HEAD THE CERAMIC ENGINEERING Department. A graduate of Alfred University, Cox had worked at Newcomb College where he was employed in a similar capacity from 1910–1918.

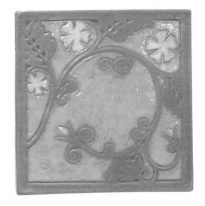

In 1924 Cox hired Mary Lanier Yancey, a 1922 graduate of Newcomb College, as instructor of decorative ceramics. The following year, Cox became the official head of the Ceramic Engineering Department, and they held a pottery sale to benefit the college. Most of the pieces sold were produced by Cox and Yancey, as the student work was often not of professional quality. Cox threw the pottery and Yancey applied the decoration, using Iowan motifs—maple seedlings, pine cones and needles, clover, lilies, and poppies. Cox wanted to avoid the matte green and blue glazes popular at the time, adopting tin glazes that produced brighter, livelier colors. As could be expected, the pottery was similar to that from Newcomb College. Students produced tiles as gift items and souvenirs for their annual student celebration, called "Veishea."

In 1930 Mary Yancey married Frank Hodgdon, a graduate of the Ceramic Engineering Department, and left Iowa.

The loss of Mary Yancey, coupled with the high production costs at the beginning of the Depression, ended art pottery sales in 1930. In 1939, after nineteen years at Iowa, Cox left to open his own pottery in Baton Rouge, Louisiana. Art pottery was subsequently eliminated from the curriculum of the Engineering Department. Cox operated his own pottery until 1942, and died in Baton Rouge at the age of eighty-nine.

THE HANDCRAFT GUILD OF MINNEAPOLIS

Minneapolis, Minnesota 1904–1919

THE HANDCRAFT GUILD WAS FOUNDED IN 1904 IN MINNEAPOLIS TO TEACH HANDICRAFTS, SUCH AS POTTERY, METALWORK, leatherwork, and woodwork. Under the direction of Margaret Kiess, the Guild's intent was to provide complete design and production instruction to members, who, in turn, would teach new students.

In 1905 the Guild moved to the King House on 2nd Avenue and 10th Street. The Guild moved again in 1907, to 89 South 10th Street, where it remained until 1919 when it was incorporated into the Department of Art Education at the University of Minnesota College of Education.

Both pottery and tiles were produced by the Guild. Decorative tiles for fireplaces were listed in the Guild's brochure as a special feature of the ceramic course. Because many of the pieces were made by short-term students, quality and style were not always consistent. There were, however, many museum-quality pieces produced. The Guild had a shop where members' work was sold, and many tiles found their way into Minneapolis homes.

Several notable students and instructors participated in the Guild: Elizabeth and Edward Dalquist of the Shawsheen Pottery were instructors; Margaret Cable of the North Dakota School of Mines was a student, and then a teacher there from 1906–10; and Ernest A. Batchelder was a teacher during the first half of 1909, prior to establishing the Batchelder Tile Company in California.

UNIVERSITY OF NORTH DAKOTA SCHOOL OF MINES

Grand Forks, North Dakota 1910–1967

THE SCHOOL OF MINES WAS ESTABLISHED AT THE UNIVERSITY OF NORTH DAKOTA IN GRAND FORKS, NORTH DAKOTA, IN 1890. The previous year, Earle J. Babcock had been hired as an instructor of chemistry, and in his research of the state's mineral resources he discovered large deposits of a high-grade potter's clay. After years of pressure from the University, backed by a report describing Babcock's findings, the state appropriated funds to open the School of Mines in 1898. Babcock was appointed the school's director.

In order to promote North Dakota clay, Babcock sent samples to many potteries, such as Roseville and J. B. Owens, asking them to make pots with it labelled "Made With North Dakota Clay." Ceramics with these labels were exhibited at the School of Mines booth at the St. Louis Exposition in 1904. In 1910 the ceramic department was finally established at the University, headed by Margaret Cable.

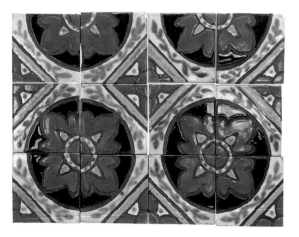

Margaret Kelly Cable was born in Minnesota and studied and taught at the Handcraft Guild of Minneapolis. Cable was made assistant professor at the School of Mines in 1921, and an associate professor in 1934. She insisted on using motifs native to North Dakota, such as buffaloes and coyotes, cowboys, Indians, and covered wagons. At the 1933 "Century of Progress" in Chicago the School exhibited 186 pieces of pottery and eleven tile panels depicting various occupations (nine of which are now on display at Bonanzaville in West Fargo, North Dakota). The School of Mines display was pronounced the outstanding exhibit of U.S. pottery by the University of Chicago.

Margaret Cable's sister, Flora Cable Huckfield, started working at the School of Mines as an assistant in ceramics in 1924. Julia Edna Mattson, an artist, also joined the staff in 1924, immediately after graduating from the School of Mines.

The Cable sisters retired in 1949 and moved to California (where they died within six months of each other, in 1960). The Cables were replaced at U.N.D. by William H. McKenney in 1949, who continued as head of the Ceramics Department until 1952. Margaret Pachl, an artist, also came to the School of Mines in 1949. She was appointed assistant professor of ceramics and continued there until 1970.

A round postmark-like seal was used on all pottery from 1916 to 1963. At first, the pottery was only sold at the school, though later it was sold through a network of shops. There were always some pieces available when Margaret Cable gave lectures. Promotional pieces were also produced for sale. The pottery hired a traveling salesman in 1938, who sold to neighboring towns until Margaret Cable retired. Production of pottery slowed thereafter.

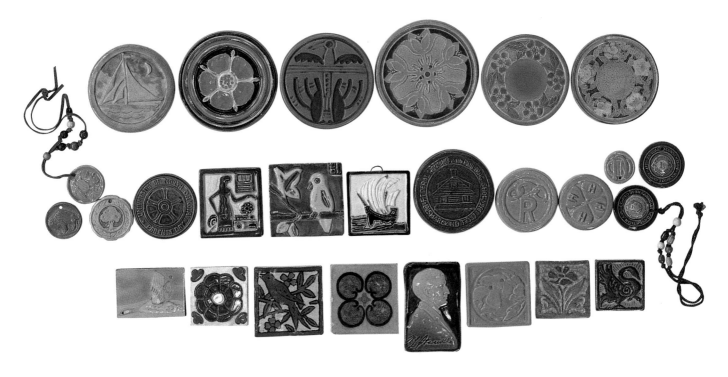

RUSHMORE POTTERY
Keystone, South Dakota 1933–1942

THE RUSHMORE POTTERY WAS ESTABLISHED IN KEYSTONE, SOUTH DAKOTA, IN 1933 BY IVAN HOUSER AND W. S. TALLMAN, A New York-trained sculptor. Houser was born on a ranch in Oregon and studied sculpture and fine arts under Avard Fairbanks at the University of Oregon. Houser then worked for architectural terra cotta makers on the West Coast and, later, studied sculpture with Arthur Lee and William Zorach in New York.

Houser then went to San Antonio, Texas, to assist Gutzon Borglum, the sculptor of Mount Rushmore, making model parts for the stone carvers to follow in creating the famous monument. During this work, Houser found a clay deposit between Mount Rushmore and Rapid City, which he said contained the finest clay he had ever seen as it required no additives. Houser purchased

thirteen acres of the clay deposit and opened the Rushmore Pottery in 1933.

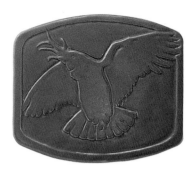

Houser and Tallman conferred with Margaret Cable at the University of North Dakota about Dakota clays, and they remained in touch with her during their years at the Rushmore Pottery. In 1935 Houser quit his job with Borglum to work in the pottery full time. Tallman, who also worked on the Mount Rushmore project, followed Houser at the end of the year. Rushmore Pottery produced large quantities of pottery and tiles. Tallman, who created most of the early tiles, also sold the ware to several stores, while the partners' wives, Mildred Houser and Peggy Tallman, sold pottery in a little shop below Mount Rushmore.

In 1940 Tallman sold his share of the pottery to Houser, who in turn sold the pottery's inventory in 1942 to Francis "Bud" Duhamel, owner of "Duhamel's Trading Post" in Rapid City. Houser then moved to Portland, Oregon, and taught sculpture at Lewis and Clark College. Duhamel closed his store in 1984.

VAN BRIGGLE POTTERY AND TILE CO.

Colorado Springs, Colorado

VAN BRIGGLE POTTERY CO. 1901–Present

VAN BRIGGLE CO.

VAN BRIGGLE ART POTTERY

ARTUS VAN BRIGGLE, BORN IN FELICITY, OHIO ON MARCH 21, 1869, WAS A DIRECT DESCENDANT OF SIXTEENTH CENTURY Flemish painter Pieter Bruegel. He worked as an apprentice with Karl Langenbeck at Avon and then for Rookwood Pottery in Cincinnati, Ohio. In 1893 Mrs. Maria Longworth Nichols Storer of Rookwood sent Van Briggle to France and Italy to study ceramics and painting. In Paris in 1894 he met Anne Lawrence Gregory, to whom he became engaged the following year. Van Briggle returned to Rookwood in 1896.

Stricken with tuberculosis, Van Briggle moved to Colorado Springs in 1899. In 1901, he established a small pottery in the backyard of his studio at 615 North Nevada Avenue. He sent pieces of his first production to his patron, Mrs. Storer of Rookwood, who was then living in Spain with her diplomat husband. Upon seeing the new pieces, she financed Van Briggle's new pottery. In 1901 Artus produced 300 pieces with the aid of an assistant and his fiancée Anne Gregory. These pieces were exhibited at the pottery and all were sold. The following year the Van Briggle Pottery Company was formed with several

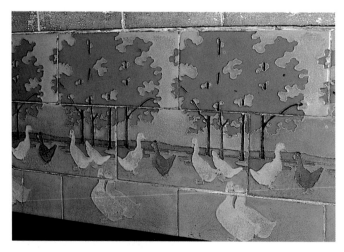

stockholders, including Mrs. Storer. The staff increased to fourteen, including Anne (who married Artus that year).

The Van Briggles worked long hours at their pottery, producing a large quantity of exceptional pieces. However, because of his failing health, Artus spent the winters of 1902 to 1904 in Arizona, and, on July 4, 1904, Artus Van Briggle died at the age of thirty-five.

Anne Gregory Van Briggle was a talented artist in her own right. Born on July 11, 1868, she studied art in Germany and France. Anne moved to Colorado Springs in 1900, and taught in a local high school prior to her marriage. After Artus died, the pottery was reorganized and called the Van Briggle Company, with Anne as president.

In 1907 a new Memorial Pottery was constructed at 300 W. Uintah Street. Beautifully designed by architect Nicholas Van Den Arend, it was embellished with thousands of decorated tiles and terra cotta chimney ornaments produced at the old factory. Tile production started in 1907 for this project, although some tiles may have been produced as early as 1905. In addition to tile production, architectural faience was among the new products made at the Memorial Pottery, which opened in 1908.

Van Briggle tiles are perhaps the most distinctive of this period. The tiles are rustic, handmade, and glazed in somber matte colors, such as deep browns, blues, and greens, often on black backgrounds. Decorative subjects include trees, plants, leaves, flowers, and geese. These tiles come to life when viewed in installations on brick exteriors, as do the multitude of tiles ornamenting the Memorial Pottery.

In 1908 the staff numbered thirty-eight, including superintendent Frank Riddle, and Emma Kinkead, who started working at the pottery after school. Born in 1890 (her family had come to Colorado Springs in two covered wagons), Kinkead designed tiles used to decorate the new pottery. She died in Colorado Springs in 1982 at the age of ninety-two.

Van Briggle's art nouveau pieces received great acclaim. In 1903 the pottery exhibited twenty-four pieces in the Paris Salon and was awarded fifteen medals, including two gold. One hundred pieces were exhibited at the Louisiana Purchase Centennial Exhibition in St. Louis in 1904, and five medals were awarded, two of which were gold. The pottery received a gold medal at

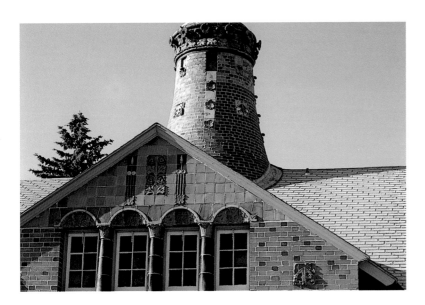

the Lewis and Clark Exhibition in Portland, Oregon in 1905, and received the highest award at the 1906-1907 Boston Arts and Crafts Society Exhibition. Anne was also awarded a master's degree from the Society.

In 1908 Anne married a Swiss mining engineer, Etienne A. Ritter, who persuaded her to leave the pottery to pursue painting. The pottery was then reorganized as the Van Briggle Pottery and Tile Company in 1910. Anne Gregory Van Briggle died of cancer on November 15, 1929, at the age of sixty-one.

In 1912 the pottery was leased to Edwin DeForest (Ned) Curtiss. The following year it was sold at

an auction to H. G. Lunt and George Krause. Lunt and Krause sold the pottery back to Curtiss. In 1915 Curtiss sold it to Charles Lansing, and moved east to manage the Enfield Pottery in Pennsylvania. No decorated tiles were made after this period. Lansing sold it to Ira F. and Jesse H. Lewis in 1920.

In 1935 a tremendous flood in Colorado Springs inundated the pottery and undermined its foundation. Many of the molds were destroyed and some pieces of pottery were found intact fifteen miles downstream.

In 1953 the owners purchased the Midland Railroad Roundhouse at 600 S. 21st and Cimarron Streets, and renovated it as an auxiliary to the Memorial Pottery. It was in full operation by 1955. In 1968 the Memorial Pottery building was sold to Colorado College, and all pottery operations were moved to the roundhouse. Ira Lewis operated the pottery until 1969, when controlling interest was transferred to Kenneth W. Stevenson.

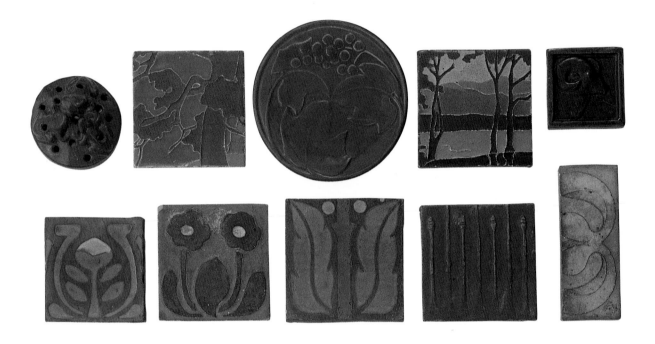

BROADMOOR ART POTTERY AND TILE COMPANY

Colorado Springs, Colorado 1933–1939

BROADMOOR POTTERY

IN EARLY 1933 COLONEL PAUL H. GENTER AND CECIL JONES BEGAN TO EXPERIMENT WITH THE CLAYS AROUND COLORADO Springs, Colorado. The resulting ceramics were exhibited that summer at the Broadmoor Hotel in Colorado Springs, and later at such places as the Metropolitan Museum of Art in New York and the Royal Museum in London. In October of that year Genter leased the Old Grace Episcopal Church building at 217 East Pike's Peak Avenue and established the Broadmoor Art Pottery and Tile Company.

Genter was owner, president, and general manager; Jones was the ceramist. The plant's production manager was Danish-born Erik Hellman, who had trained at Royal Copenhagen and Meissen in Denmark. Hellman had emigrated to the U.S. in 1929 and worked for Van Briggle in 1931.

Although known primarily for tourist-oriented items such as vases, candle holders, and paperweights, Broadmoor also produced faience tile and decorative pieces for exterior and interior use. Some Broadmoor tiles were glazed with bright high-gloss colors and very simple architectural motifs.

In 1937, Genter moved the plant to Speer Boulevard and 9th Avenue in Denver. Hellman left to teach at the University of Minnesota, but returned to Denver in September 1938 to help reopen the factory. The attempt met with limited success, and Broadmoor closed permanently on April 1, 1939.

Following World War II, Hellman established the Garden of the Gods pottery, listed in the 1946 Colorado Springs directory at 1202 W. Colorado Avenue. Erik Hellman died in 1986. The Broadmoor Pottery plant in Colorado Springs became The Village Inn Restaurant in 1937.

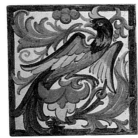
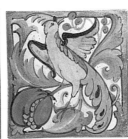
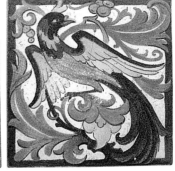

WACO TILE

Clayton, Washington c. 1900–1958

WASHINGTON BRICK, LIME AND SEWER PIPE CO.
WASHINGTON BRICK & LIME CO.

WACO TILE (PRONOUNCED "WACKO") WAS PRODUCED BY THE WASHINGTON Brick & Lime Co. in Clayton, Washington, from local clay. The company was in business from the late 1890s until 1957, when they sold out to Gladding McBean. "Sewer Pipe" was dropped from the company name in the 1930s.

The tiles were made from the mid-1920s to the mid-1930s, when the company was reorganized. Edward Burkhalter was the tile designer. Glazed and plain terra cotta tiles were made for framing as well as for fireplaces, walls, and floors in sizes up to eight-by-eight inches.

A prominent installation of the company's tiles is the floor of St. John's Cathedral in Spokane, Washington.

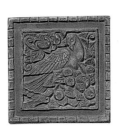
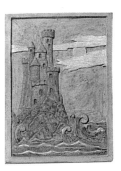

STEIGER TERRA COTTA AND POTTERY WORKS

South San Francisco, California 1896–1917

ORIGINALLY A SAN JOSE BRICK AND POTTERY FACTORY THAT WAS DESTROYED BY FIRE, STEIGER TERRA COTTA AND POTTERY Works was organized on the bay shore in South San Francisco on November 28, 1896, by members of the City Street Improvement Company (which was one of the largest contracting firms in California at the time).

Steiger's products were bricks, tiles, hollow tile, sewer pipe, architectural terra cotta, flower pots, ornamental vases, and mantels. Walter E. Dennison, the owner, was president and superintendent, and Giovanni Casagrande was assistant superintendent. Albert Solon's first American job was with Steiger in 1909. Frederick Rhead came to Steiger for a short time after he left Arequipa in 1913, and left the following year to establish Rhead pottery in Santa Barbara.

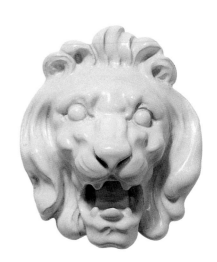

Steiger produced terra cotta for the Grant, Monadnock, and Rialto Buildings in San Francisco. The firm also supplied the terra cotta for the Humbolt Savings Bank, which was the first terra cotta structure to be built in San Francisco after the earthquake and fire of 1906. Steiger was a successful and growing company but on March 8, 1917, the plant was again consumed by fire. With the United States in the midst of World War I, the plant was not rebuilt. In 1922 the land that the plant occupied was sold to W.P. Fuller.

ROBLIN ART POTTERY

South San Francisco, California 1898–1906

IN 1884, ALEXANDER ROBERTSON OF THE CHELSEA KERAMIC ART WORKS IN MASSACHUSETTS MOVED TO CALIFORNIA. IN 1891, he met Linna Vogel Irelan, who was born in Leipzig, Germany in 1846. Irelan had moved to California in 1870 and married the State Mineralogist.

Robertson and Irelan shared an interest in ceramics; both were talented ceramic artists. In 1898, seven years after their meeting, the two established the Roblin Art Pottery in a very small building at 3244 20th Street at Treat Avenue in the Mission District of San Francisco. "Roblin" was an amalgam of their names.

Robertson was in charge of throwing and firing the pottery, and Irelan was mainly occupied with the elaborate modeling. The pieces were decorated with flowers, foliage, birds, and lizard-like animals. How many different tiles the pottery produced will probably never be known. The two tiles pictured here are among the few known to exist. Robertson and Irelan produced quality pottery on a small scale and continually planned on expansion. In 1903 Robertson's son, Fred H. Robertson, joined them.

The April 1906 San Francisco earthquake and fire completely destroyed the factory and a wealth of fine pottery with it. At age sixty-six, Alexander Robertson could not envisage rebuilding, so he left for Los Angeles with his son, his potter's wheel, and a few precious pieces of pottery that he salvaged from the ruins of the factory. Fred went to work at Los Angeles Pressed Brick, where Alexander was also given a place to work until he left for the Halcyon Pottery in 1909. Linna Irelan, however, never returned to ceramics.

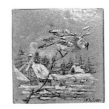

HALCYON ART POTTERY

Halcyon, California 1910–1940

HALCYON WAS A SMALL UTOPIAN COMMUNITY SITUATED ON THE CALIFORNIA COAST ABOUT TEN MILES SOUTH OF SAN LUIS Obispo. Incorporated as the Temple Home Association, the community was founded in 1903 by a Theosophist group headed by William H. Dower and Francia LaDue. In 1910, the group started a pottery with Leon Awerdick as manager and Alexander W. Robertson, previously of the Roblin Pottery, as director and instructor.

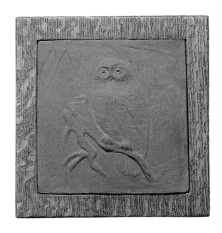

Using coarse local red clay, the pottery produced ceramics with great success. Nevertheless, it closed in 1913. Eighteen years later, in 1931, the plant was put back into operation by Gertrude Rupel Wall, co-founder of the Walrich pottery in Berkeley. Then a ceramics instructor at the University of California, Wall taught pottery at Halcyon for two summers. She used primarily white clay and Walrich glazes.

The pottery was finally dismantled about 1940, followed by the dissolution of the Temple Home Association in 1949.

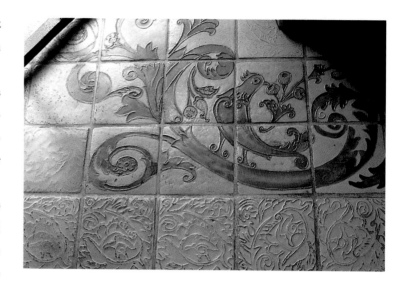

IN 1911 DR. PHILIP KING BROWN ESTABLISHED THE Arequipa Tuberculosis Sanitarium at Fairfax, Marin County, California.

That same year, Frederick Hurten Rhead and his wife Agnes were engaged by Dr. Brown to set up a pottery on the site. The intent was to teach ceramics as therapy, and to allow some of the patients to finance their stay through the sale of the wares.

The pottery was incorporated in February 1913 to separate it from the sanitarium. Unfortunately, sound business techniques were not Rhead's forte. To produce enough pots to make a profit, he allowed the quality to slip, and many of the wares had to be sold as seconds. In addition, his accounting was hopeless. The inevitable result was Rhead's resignation in 1913. Albert Solon, a young ceramic engineer recently arrived from England, took over.

Under Solon's direction, the number of patient-students doubled, and Arequipa wares were sold in the finest department stores across the country. Much of the pottery was of excellent quality. The pottery received a gold medal at the Panama Pacific Exposition in San Francisco in 1915.

Solon left Arequipa in 1916 to teach at the San Jose State Normal School. Fred H. Wilde replaced Solon as director, coming from California China Products in National City, California. Wilde expanded into tile production using the raised-line technique with Spanish motifs. One of the most interesting installations was designed by Frank Ingersol and George Dennison of Cathedral Oaks, made for Mrs. William Henry Bliss for her eighty-five room mansion, Casa Dorinda, in Montecito, California, completed in 1918. The building is now the Casa Dorinda retirement community.

The average patient's stay at Arequipa was less than six months. Due to the patients' short stays, skill levels varied. However, the program proved successful.

In 1918, the pottery temporarily closed. The sanitarium reopened after the war, and the pottery resumed production. By 1957 tuberculosis had been all but conquered as a life-threatening disease, and the sanitarium was closed. The buildings were razed in 1984.

In 1930, Dr. Brown wrote to Albert Solon, asking if he would like to buy some of the Arequipa molds. Solon replied, "There is no more market for old tiles than for diseased tonsils." He also composed this passage:

All is ruin — wreck and rack *Vanished from this mortal screen*

Persian Blue and Mirror Black *Flanders Gray and Blanc-de-Chine*

See the specters of the dead *But wearing still the thorny crown*

Aubergine and Chinese Red *Is Philip-King-Burnt-Umber-Brown.*

Ceramically yours, A.L. Solon

CATHEDRAL OAKS WAS AN ORGANIZATION ORIGINALLY ENVISIONED AS A SCHOOL OF ARTS AND CRAFTS. IT WAS FOUNDED IN 1911 by George Dennison and Frank Ingersol, and located above the small town of Alma, California, south of Los Gatos and San Jose. Dennison was born in New Boston, Illinois, on November 20, 1872; Ingersol in Victory Mills, New York around 1880. The two men met in San Francisco where Ingersol taught decorative design at the California School of Design and the San Francisco Institute of Art. Together, they built a house and studio at Alma, which they called Cathedral Oaks, a gathering place for artists, poets, musicians, and other local celebrities.

Besides being highly creative and prolific themselves, they held classes in painting, jewelry, sculpting, weaving, cabinetmaking, horticulture, interior design, and ceramics. Many of their other crafts coordinated with their interior design jobs. They designed homes for movie stars, as well as the Bliss Mansion, the Samarkand Hotel in Santa Barbara, and the famous Coconut Grove nightclub in Los Angeles.

Dennison and Ingersol experimented with several styles of tiles in the years before World War I, the most notable being large tiles portraying regional landscapes in a stylized arts and crafts mode, many of which closely resemble California Art Tiles, both in design and glaze. The Persian flying birds resemble those of California Faience. There were numerous installations in the Bay Area. Installed in their own home were many Cathedral Oaks tiles, but unfortunately these were destroyed when the house was razed.

Dennison and Ingersol had some very famous friends. Olivia De Havilland was born in nearby Los Gatos, and the two helped launch her career. Yehudi Menuhin, the famous violinist, grew up in Cathedral Oaks, and became a close friend of the two men. When they were getting older and needed financial assistance, Menuhin purchased Denison and Ingersol's home and allowed them to live out their lives there. George Dennison died in 1966 at age ninety three, and Frank Ingersol died in 1968 at age eighty eight.

CALIFORNIA FAIENCE

Berkeley, California 1924–1950

THOMAS AND BRAGDON 1916–1922

THE TILE SHOP 1922–1924

THOMAS AND BRAGDON WAS ESTABLISHED IN 1916 BY CHAUNCEY R. Thomas and William Victor Bragdon in a very small shed at 2336 San Pablo Avenue, Berkeley, California. "California Faience," as their ware was labeled, was exhibited at the San Diego Panama Pacific Exposition in 1915, which indicates that Thomas and Bragdon actually produced material in 1915 or earlier.

Thomas was born in New York in 1877, and taught at the California School of Arts and Crafts in Oakland. Bragdon, born in Pittsburgh in 1885, trained as a ceramic engineer at Alfred University and then taught at the University of Chicago, the University City Pottery of St. Louis, and the California School of Arts and Crafts.

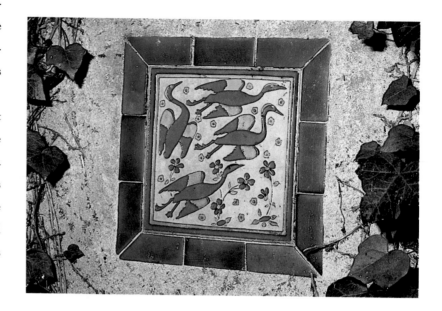

In 1922, the pottery moved to 1335 Hearst Avenue, and the name was changed to The Tile Shop. In 1924 the company adopted California Faience, previously a product name, as the firm's name. The pottery was small, employing no more than four workers in addition to Thomas and Bragdon, but was very successful, selling across the United States to a very high-end market.

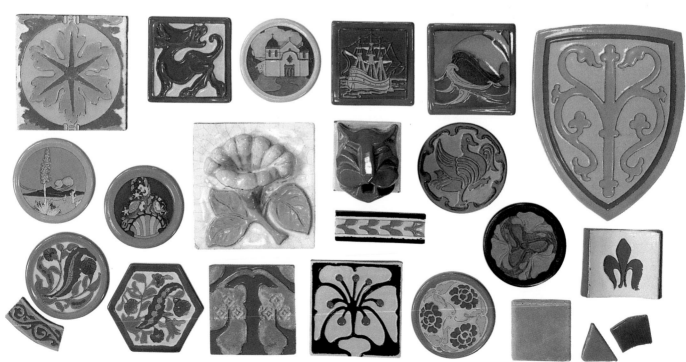

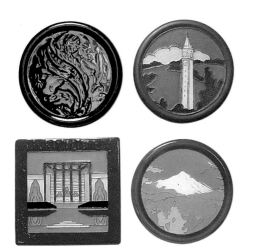

The pottery ware was generally one color, and the tiles were hand pressed in plaster molds with bright, multicolored patterns applied to a raised-line bisque. Bragdon was the technician in charge of mold making, and Thomas was in charge of the glazes.

Although Thomas and Bragdon produced most of the designs at California Faience, some tiles were the work of other designers. The most notable of these was Stella Loveland Towne, a former student of the partners. The firm's biggest project came in 1927, when the company was commissioned to produce tiles for Hearst's Castle at San Simeon. Several of these tiles were designed by Julia Morgan and can be seen on the front façade and bell towers of the main building.

With the exception of a large order for the Chicago World's Fair in 1932, business all but stopped during the Depression years. In the late 1930s, Bragdon bought out Thomas and continued to operate the pottery, allowing local artists and amateurs to use the plant to create their own projects. In 1950 he sold the business to a Mr. Stevenson, but stayed on a few years to assist. Chauncey R. Thomas died on August 21, 1950, and William Victor Bragdon died on October 26, 1959.

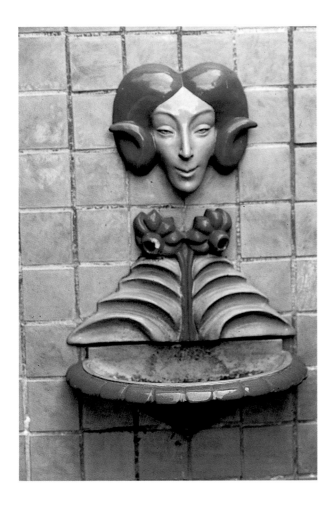

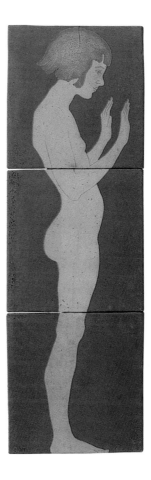

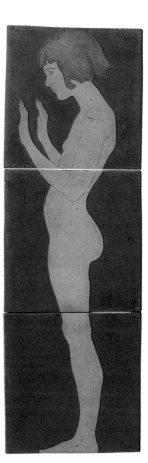

SOLON AND SCHEMMEL, "S & S"
SOLON AND LARKIN

San Jose, California 1920–1953

LARKIN TILE CO. 1936–1947

ALBERT LOUIS SOLON 1947–1953

THE TILE SHOP 1922–1924

ALBERT LOUIS SOLON WAS BORN IN STOKE-ON-TRENT, ENGLAND, IN 1887, INTO A FAMILY OF CERAMISTS DATING BACK TO THE seventeenth century in Toulouse, France. When his grandfather, Louis M. Solon, emigrated to England, his son worked at the Minton China Works. Young Albert, one of nine children, studied at the Victoria Institute in Stoke-on-Trent, and then worked as an apprentice at Minton with his father. Albert emigrated to the United States in 1908.

In 1913 Solon replaced Frederick Hurten Rhead as director of the Arequipa Pottery, where he perfected his Persian Faience glaze in transparent turquoise. He left Arequipa in 1916 to teach at the San Jose Normal School in California, which later became San Jose State University. In 1920 Solon teamed up with Frank Schemmel to establish Solon and Schemmel at 4th and Carrie Streets in San Jose. The company was also known as "S & S," as many of the tiles were marked.

Frank Schemmel was born in San Jose. His father, born in Germany, was a musician who had a music and piano store in San Jose. Frank had served with the United States Army Air Corps in England during World War I.

Solon and Schemmel was a well-balanced partnership. Solon was an accomplished ceramist, Schemmel a good businessman, and together they became successful and the company a prolific producer of ceramics. The two men alternated the duties of attending to the firing of the kilns. In 1925 the company moved to larger quarters at 1881 South 1st Street, west of Monterey Road, south of Cottage Grove.

The S & S tiles are distinct from those of other producers: the designs are less rigid, and not drawn from traditional motifs. S & S was responsible for many installations, including the Steinhart Aquarium in San Francisco's Golden Gate Park; San Jose Normal School; the kitchen tiles at San Simeon, Hearst's country home; and the Loews, State, and Orpheum Theatres in Los Angeles. Solon and Schemmel never tried to become a national company, but remained a regional supplier with an agent in Los Angeles. However, Bay Area designers and architects specified S & S tiles in some installations around the country.

In 1936 Frank Schemmel retired due to ill health and Solon took on a new partner, Paul Gifford Larkin, a gifted ceramic engineer and graduate of Ohio State University, who had worked for Denver Terra Cotta Company. In 1919 he went to Gladding, McBean in Lincoln, California, where

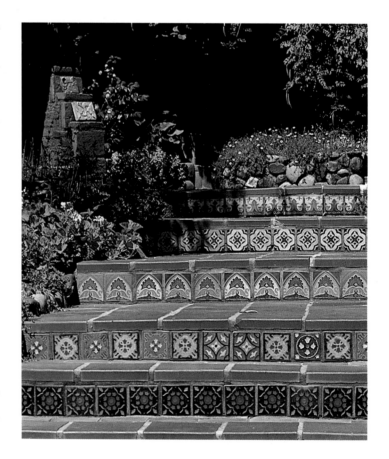

he was in charge of developing glazes. In 1931 he went to Pacific Clay Products in Los Angeles. Then he moved to San Jose with the Garden City Pottery.

Larkin purchased a one-half interest in S & S in 1936 and the name was changed to Solon and Larkin. Larkin was in charge of the plant, and Solon went on the road selling tiles. They sold to many important architectural firms in the Bay Area, primarily in Palo Alto, Sacramento, and San Francisco. Some installations included Yehudi Menuhin's home in Los Gatos; Campbell High School in Campbell; Fremont High School in Sunnyvale; and the Municipal Auditorium, in San Jose. During the Solon and Schemmel years, a coarse, dark brick-red clay was used (top two rows below), and, during the Solon and Larkin years, the clay was a smoother buff-colored terra cotta (bottom three rows below).

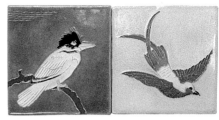

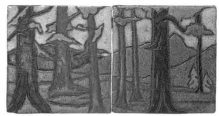

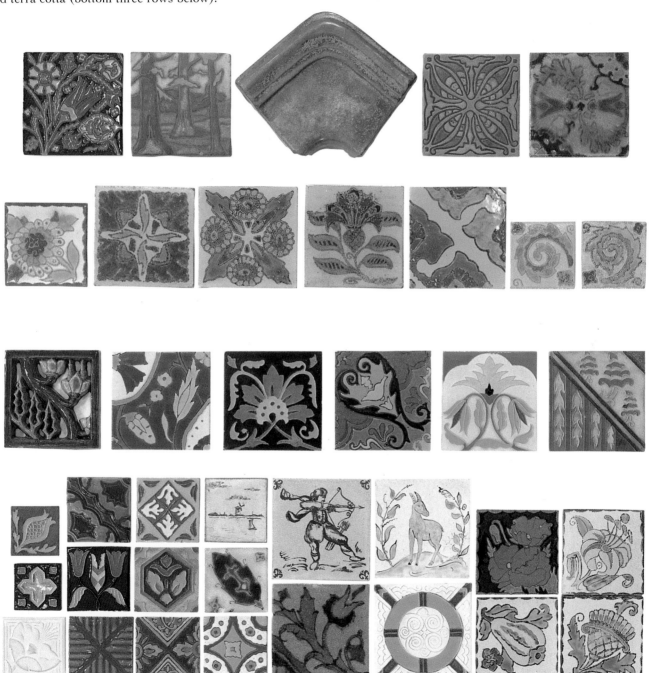

After World War II, Solon decided to retire. In settling his affairs, he offered for sale all the rejected tiles that had been stored in the factory at one cent each. Thousands of customers waited in line to purchase them. (Solon probably could have increased his retirement fund by a more judicious method of disposing of the tiles.) In 1947, with Solon no longer involved, the firm became the Larkin Tile Company, located at 1651 Pomona Avenue. Albert Solon continued to be listed in the city directory as a tile maker at the 1881 South 1st Street address until he died on August 2, 1949, age sixty one. Frank Schemmel died the following year.

Suffering from financial difficulties, Paul Larkin took on a new partner, Charles Welch. In 1953, still burdened with financial problems, Larkin sold the company to Ross Chichester, Paul Chamberlain, David Kasavan, and Nicholas Lafkas, who established the Stonelight Tile Company. Larkin remained at the factory for a year as a consultant. He died on July 12, 1965. An Australian, David Arson, purchased the company in 1989.

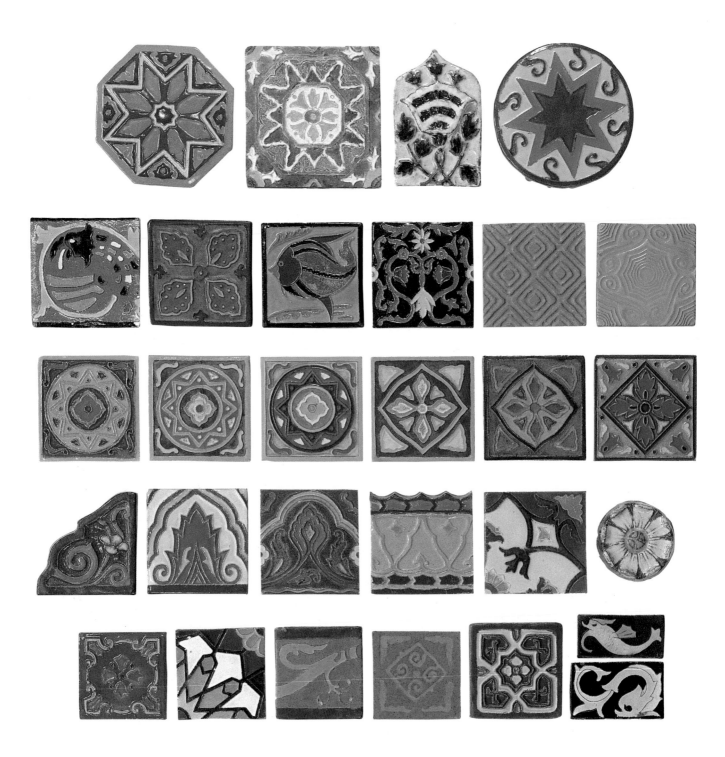

CALIFORNIA ART TILE COMPANY

Richmond, California 1923–1956

CLAY GLOW TILE COMPANY 1922–1923

JAMES WHITE HISLOP, A THIRD GENERATION BRICK MAKER, WAS BORN IN SCOTLAND IN 1860. AFTER EMIGRATING TO THE United States, he was employed by several clay working companies, including the Gladding, McBean plant in Lincoln and a company in Tropico, California.

In 1922 Hislop organized the Clay Glow Tile Company, in partnership with two of his sons, William Ahart Hislop and Lewis James Hislop. Also involved in this partnership were A.Clay Meyers and C.E. Cummings, who was the factory superintendent. In 1923 the company incorporated and the name changed to California Art Tile Company. The company experienced a growth explosion in 1928, with sales doubling those of the previous year. The firm was now called California Art Tile Corporation.

The factory used several different decorating techniques. Some of the tiles were sprayed one color after molding and single-fired. Others were molded in the raised-line method and glazed with eye droppers. Another method was oil painting on a fired bisque, which was then lacquered for interior use. Some tiles were antiqued with a lambswool brush. The decorative subjects were scenic views, birds, knights, and ships. These images were used on single tiles from two inches square to as large as eight by thirty-two inches. Panels as large as twenty-four by forty-eight inches were produced from a field of six-inch tiles. Scenes were carefully carved and molded.

In early 1942, just after the war began, the plant was closed and used as a warehouse for nearby Kaiser Shipyards. The tile plant reopened in 1945 or 1946.

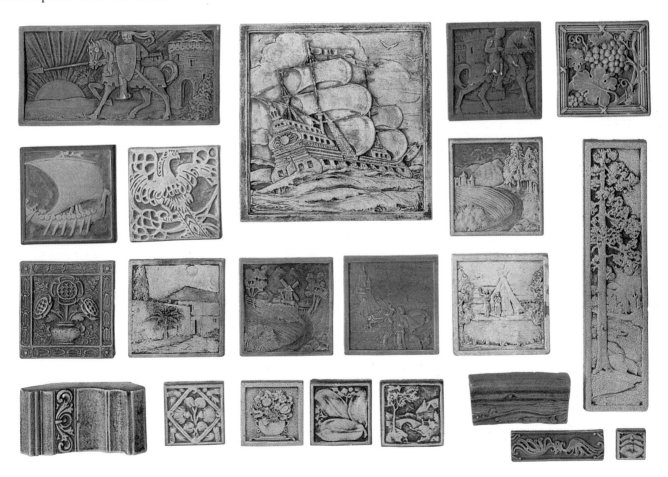

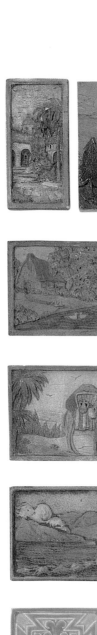
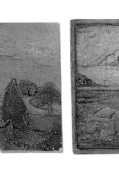
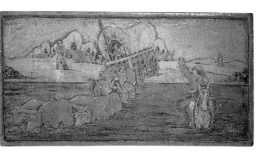
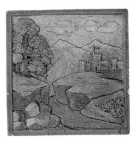

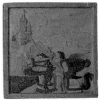
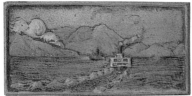
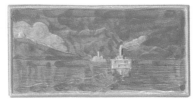
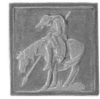
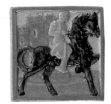

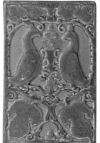

Initially, the factory's post-war products were the same faience as before, until 1949, when it began to produce whiteware. Over the next six years, production of faience tiles steadily decreased in favor of whiteware. By 1953, the one-hundred thousand square-foot factory had one-hundred and thirty employees.

The city directory last listed the company in 1956. Workers were moving to the nearby shipyards where the longshoreman's labor union demanded a twenty-two percent wage increase for the workers. The management of the factory felt labor costs would be prohibitive and closed the plant. Ten years later, in 1966, the idle factory burned to the ground in a spectacular fire.

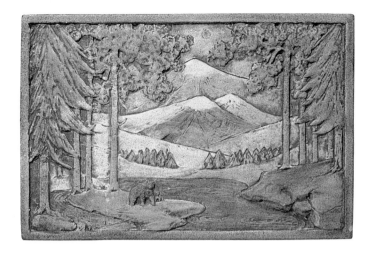

WALRICH POTTERY

Berkeley, California 1922–1930

THE WALRICH POTTERY WAS ESTABLISHED BY GERTRUDE AND JAMES WALL IN 1922 AT 2330 BROWNING STREET, BERKELEY, California. Born in Burslem, England in 1877, James had gained a strong technical knowledge of ceramics at Royal Doulton before emigrating to America. Gertrude was born in Greenville, Ohio, in 1881, and studied art at a number of midwestern institutions. The pottery was named after the Walls' son, Richard.

In 1924 the Walrich Pottery moved to 1285 Hearst Avenue, quite close to a local competitor, California Faience Company. Walrich produced cast vases, lamp bases, bookends, and decorative mantel tiles. The tiles were most often molded land and seascapes with two or three bright color glazes applied. Many were round or square with glazed edges, used as hot plates or trivets. The Walrich Pottery closed during the early years of the Depression.

Following the closing of the factory, Gertrude taught pottery at the University of California extension department at Halcyon Art Pottery, and also at San Quentin Penitentiary. James worked at Westinghouse's Emeryville, California high-voltage porcelain insulator factory, as well as in the San Francisco school system. James died in 1952, followed by Gertrude in 1971.

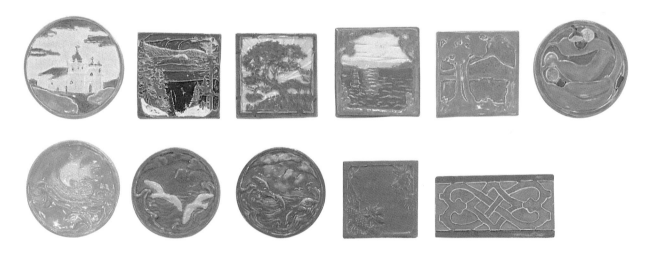

WILLIAM F. MUIR WAS BORN ON JANUARY 3, 1886, IN SCOTLAND, ONE OF THREE BROTHERS AND FOUR SISTERS. HE SERVED seven years as an apprentice tile setter in Glasgow. When his father died and the family's fish shop failed, the family emigrated to Winnipeg, Canada. William Muir was the only member of his family to move from Canada to the United States, arriving in Fresno, California, in 1913.

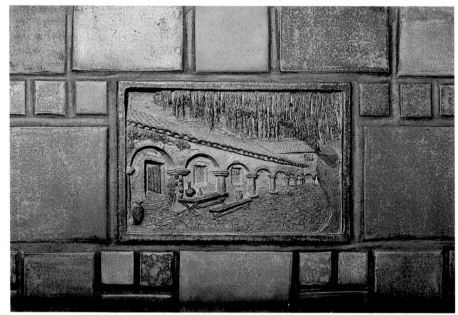

Vesta Powellson was born in 1898 in Oklahoma and moved to Modesto, California, in 1911, where she met Muir. They were married in 1918.

Muir was an avid pianist and active in the Masonic Lodge. He became a partner in a tile contracting company, Fresno Marble and Tile, at 8th Avenue and Palm. He later sold his share in the company and moved to Oakland where he and Vesta started Muresque Tiles in 1925 at 1001 22nd Avenue.

The tiles Muresque produced were hand-pressed, deep-relief wall and mantel tiles decorated with many subjects, especially scenic views that were painted with several colors of engobe. Muresque tiles were similar in style to those of California Art Tile, Claycraft, and Batchelder. The tiles were up to twenty-by-eight inches in size, and colored with pigmented slips, which were sometimes partially removed by buffing. Some of the tiles were then lacquered.

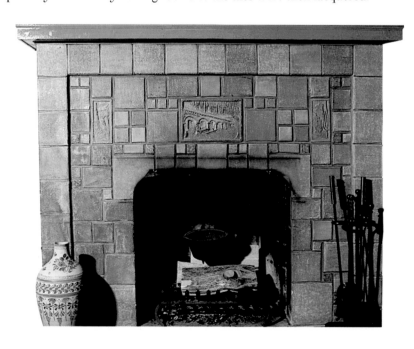

Business flourished under Muir's direction, although he had no formal training or experience in the manufacture of tiles. In 1930 the company published a seventy-page catalog of their products. Unfortunately, due to the Depression, the company failed and was last listed in the 1934 Oakland directory.

Muir moved back to Fresno in 1935, taking with him a large collection of his tiles. He went to work for W. T. Maxwell as a tile installer and soon started his own company called Fresno Tile. Muir both installed and sold tiles. He became sole Fresno distributor of Santa Monica Tiles through his friend, Donald A. Holm. Muir died in 1952 at the age of sixty-six.

Muresque Tile (without the "s") reappears in Denver, Colorado, listed in the 1936 city directory at 224 West 10th Street, with David Heany as manager. F. J. Goldsmith became manager in 1937, and that same year the company reproduced its 1930 tile catalog. In 1939 the factory moved to 3220 Mariposa Street. Some residents of the neighborhood recall that there were three or four employees who molded, fired, sanded, and lacquered the tiles.

Muresque Tile was last listed in the 1942 Denver directory, with Emily Goldsmith as manager. In 1952, Highway 25 was constructed over the site of the 3220 Mariposa Street factory.

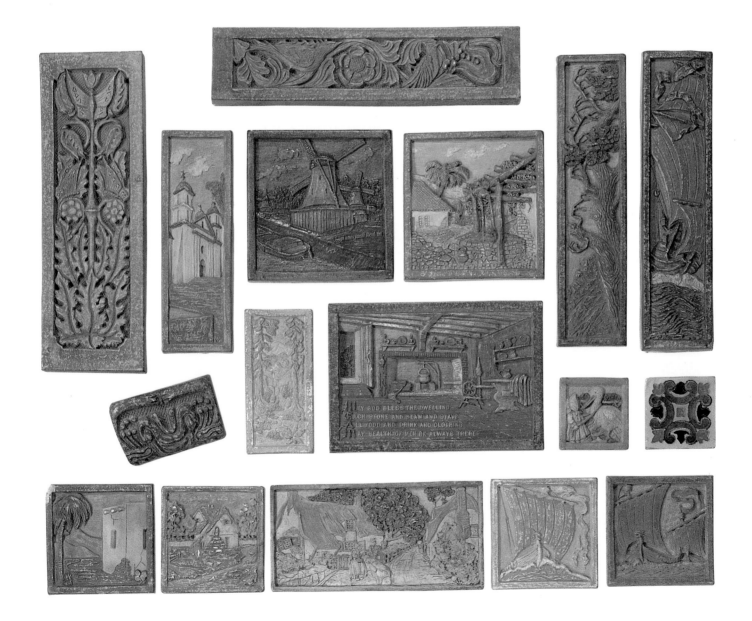

HANDCRAFT TILE WAS ESTABLISHED IN 1926, AT 333 SOUTH 18TH Street on Coyote Creek in San Jose, California. The founding partners were L. W. Austin, D. W. Wallace, L. F. Wallace, W. D. Rice, and L. H. Bruns. In 1931 the company moved five miles north on the Oakland Road to an unincorporated area, now addressed as 1695 S. Main Street, Milpitas.

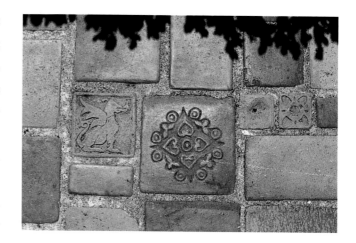

The company's tiles were rustic, matte terra cotta, with an engobe glaze coloration. Many sizes of squares and rectangles, with irregular surfaces, were often combined in installations with irregularly placed inserts with relief decorations. The company also produced tiles having continuous borders with decorated relief designs.

The factory was purchased in 1960 by Clayton Scott. Scott has attempted to reproduce all of the old tiles and patterns with the original molds. The factory was sold in 1997 to Shirley Dinkens and Frank Patitucci who are continuing production.

Some installations of Handcraft tile are: the exterior walkways at 1960 The Alameda, San Jose; the storefront facade at 2619 Domingo, Berkeley; and the entry floor and base at Sequoia High School, Redwood City, California.

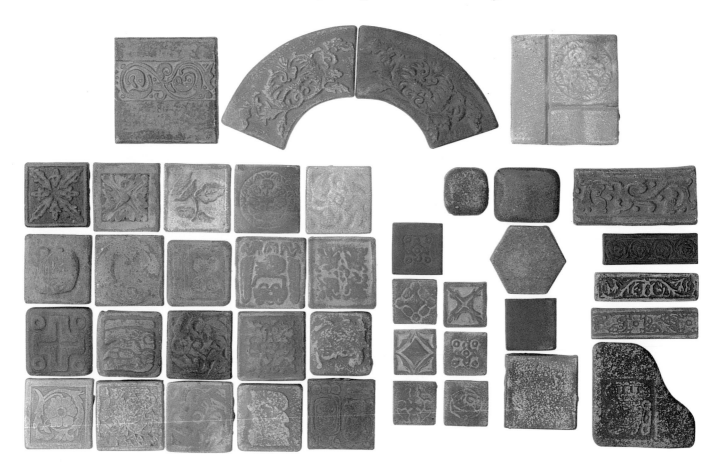

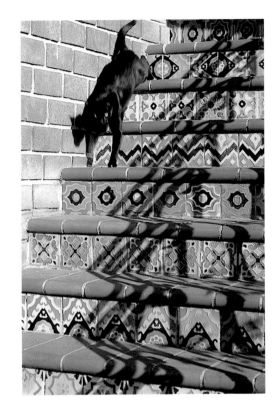

CHARLES A. ELSENIUS WAS BORN IN ILLINOIS ON SEPTEMBER 21, 1883. HE BECAME A tile-setter and bricklayer, and moved to California following the 1906 San Francisco earthquake, knowing there would be a lot of work for him.

Elsenius Tile and Mantel Company was first listed in the 1927 Berkeley city directory at 1631 Woolsey, Elsenius's Berkeley residence. In 1930 Elsenius Tile was listed under tile manufacturing at 1315 2nd Street, at the corner of Gilman. From 1933 through 1938 the company remained at the same location, although the name changed to Woolenius Tile Company (an acronym made from "Woolsey Street" and "Elsenius").

Woolenius tiles were similar to those produced at California Art Tile and Muresque Tiles, except a bit more rustic. The company made decorative and ornamental tile, inserts, terra cotta, custom fireplaces, and mantel pieces. Special designs were hand-pressed. A thin, matte glaze was fired with the body, and partly removed afterward by buffing. Other Elsenius tiles appear to have had a lacquer finish.

Some interesting installations of Woolenius tile include: the exterior of the A La Carte Restaurant at 1453 Dwight Way, Berkeley; the storefront and columns at Grand and Cypress, in South San Francisco; the exterior below the dome of a building at East 14th and Best, in San Leandro; the exterior of the City Hall, Colma, California; and the interior stair risers at the Paso Robles Inn, Paso Robles, California. The company produced a forty-page catalog with hand-drawn illustrations of its fireplaces and individual tiles. Price lists exist dated January 1, 1936, and May 1, 1939.

The factory shut down around the beginning of World War II, although the company was still listed in the directories from 1939 through 1943 as C. A. Elsenius, at the 2nd Street address. It appears likely that Elsenius hoped to revive the business after

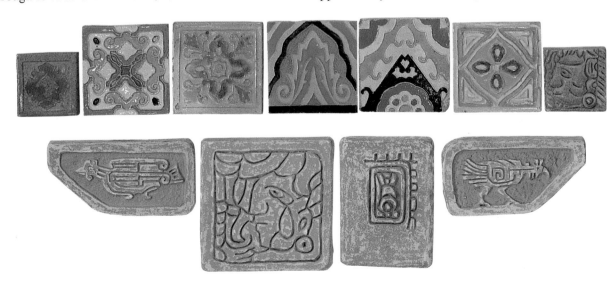

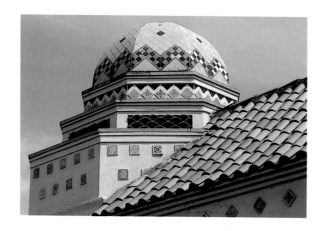

the war. During the war years, the plant, adjacent to a rail siding, was used to package food products to be shipped to American troops.

At the end of the war, however, Elsenius sold the factory to finance the building of a new family home on Andrews Street in Oakland. Charles Elsenius died in Piedmont, California, on May 31, 1963.

KRAFTILE CO.
Niles, California 1926–1997

IN 1903, CHARLES H. KRAFT AND HIS FOUR BROTHERS ESTABLISHED the Kraft Cheese Company in Chicago. In 1924, the K & L Box and Lumber Co. ("K" was C. H. Kraft and "L" was H. E. Leash) was founded in Niles, California, to produce boxes for Kraft Cheese. With the leftover scraps of wood and sawdust for fuel, and an excellent red clay supply, the company produced roof tiles on the side. This sideline proved successful, and in 1926 Kraftile was founded to produce glazed wall, floor, and decorative tiles.

K & L dropped out of the roof tile business and continued with wood boxes, operating alongside Kraftile. In 1936 K & L moved to Oregon and Kraftile took over the entire Niles property. C. H. Kraft acted as interim president for one year while the company groomed another person for the job. A. Clay Meyers, formerly with California Art Tile, became president and superintendent for the next five years. During this time the company made its most artistic tiles.

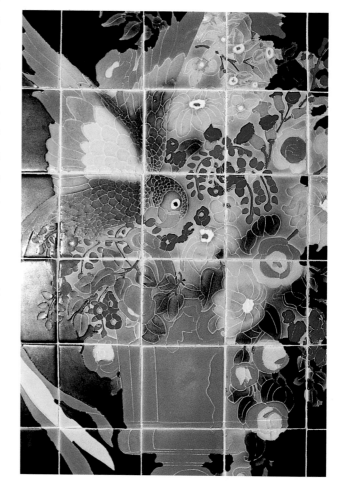

The Kraftile product was advertised as "high-fired" faience tile. It was offered in hundreds of patterns, based on Arabian, Persian, Moorish, and Tunisian designs. Many tiles were kept in stock, but others could be custom-made to suit any color scheme. The company also produced murals and huge panels to order. The company became prolific, producing 1,000 square feet a day by mid-1927. Kraftile's success is evident from the number of extant installations, especially around San Francisco. These include: the exterior walls and fountain at 798 South 2nd Street, San Jose; the exterior of the Sunshine School, 2730 Bryant Street, San Francisco; the stair risers at 1770 Pine Street and 719 Bay Street, both in San Francisco.

Decorated tile production continued until at least 1937, when the company produced the large order of tile for the Sunshine School. Kraftile's product line was supplemented by production of glazed, hollow building brick. During the years from 1932 onward, there was a succession of presidents: E. Ridgeway, H. E. Leash, J. L. Kraft, Chuck W. Kraft, and James Kraft. The company closed in 1997.

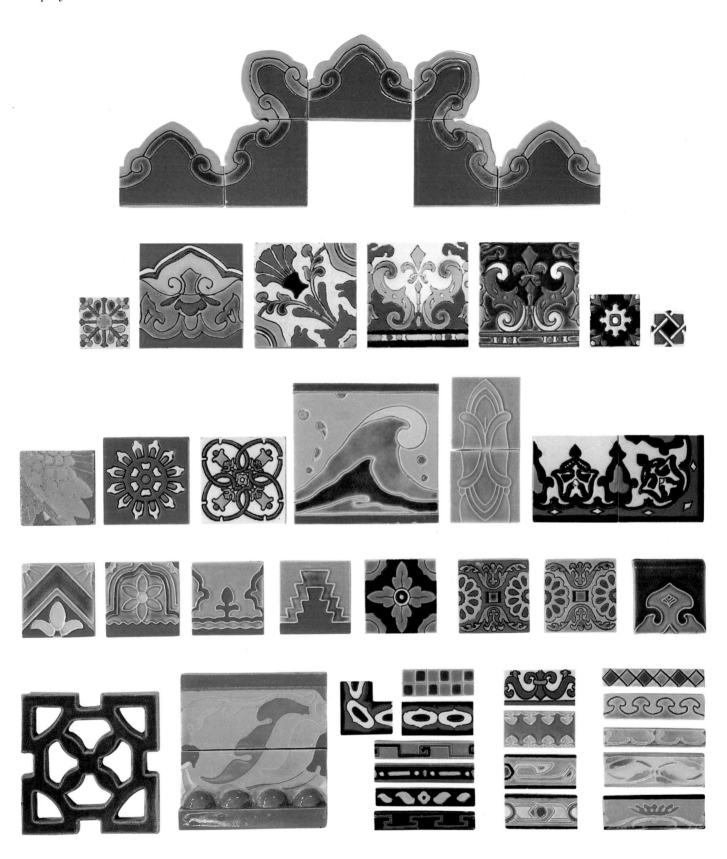

PACIFIC CLAY PRODUCTS

Los Angeles, California 1881–c. 1940s

PACIFIC CLAY PRODUCTS WAS ESTABLISHED IN 1881. THE EARLIEST PLANT, CONSTRUCTED IN 1885, WAS LOCATED AT SLAUSON and McKinley Avenues, Los Angeles. A second location, known as the Lincoln Heights plant, was located at 306 W. Avenue 26 at Humbolt Avenue. Here pottery and glazed tiles were manufactured, as well as sewer pipe and brick. A third location was the Los Nietos Plant in the Los Angeles suburb of Santa Fe Springs.

Pacific Clay Products is listed in the 1920 city directory as Pacific Sewer Pipe Co.; however, the 1921 directory again lists Pacific Clay Products.

In 1926, the firm began dinnerware production. The company appears in city directories until 1940. Glazed tile production was then limited by governmental restrictions at the start of World War II. A Pacific Clay Products' price list from 1941 indicates that the company produced a commercial tile called "Trophy Tile," which it continued to produce after the war.

LOS ANGELES PRESSED BRICK CO.

Los Angeles, Santa Monica, Richmond, and Alberhill, California 1887–1926

THE LOS ANGELES PRESSED BRICK COMPANY WAS ESTABLISHED BY CHARLES H. FROST IN 1887 AT DATE STREET AND Alhambra Avenue, near the present Union Station. In 1906 the firm hired Fred H. Robertson, who had just left the Roblin Pottery following its destruction by the San Francisco earthquake. Robertson left Los Angeles Pressed Brick and joined Claycraft Potteries in 1921.

Although the Los Angeles Pressed Brick's main production was brick, hollow brick, and architectural terra cotta, it began to produce decorative tiles in 1907. The company's 1917 catalog featured illustrations of embossed faience tile, decorated tile, and smooth, mottled tile. The catalog states that the company could produce any design or color scheme.

The company experienced dramatic growth during its history, coinciding with the development and growth of the city of Los Angeles. A second plant was added in 1906 at Colorado Avenue and 25th Street in Santa Monica, followed by a third at Point Richmond, called the Richmond Pressed Brick Works. A fourth plant was later opened in Alberhill, at which point the

Los Angeles Pressed Brick Company became the largest works of its kind in the world. In 1926, the company merged with Gladding, McBean.

Los Angeles Pressed Brick won several awards for its tile. The company garnered first prize at the Alaska-Yukon Exposition in Seattle in 1910; a gold medal at the Lewis and Clark Exposition in Portland, Oregon in 1905; a silver medal at the Louisiana Purchase Exposition in St. Louis in 1904; and first prize in the California State Fairs of 1903, 1907, and 1909.

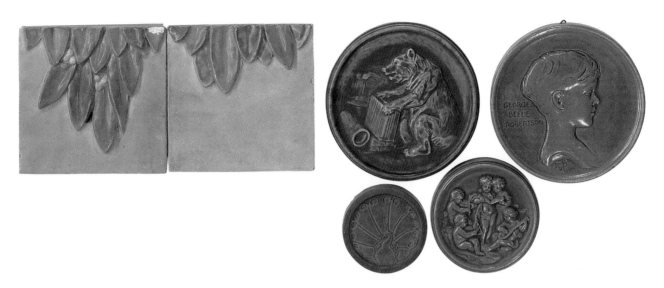

KIRKHAM TILE & POTTERY COMPANY
PACIFIC ART TILE COMPANY

Tropico (Glendale), California 1900–c. 1904

WESTERN ART TILE COMPANY

1904–1910

TROPICO POTTERIES

1920–1923

CALIFORNIA TILE & TERRA COTTA COMPANY 1910–1912

FIVE ART TILE COMPANIES PRIOR TO GLADDING, McBEAN EXISTED AT 2901 LOS FELIZ BOULEVARD IN TROPICO (NOW Glendale), California.

Kirkham Tile and Pottery Company: Professor Joseph Kirkham came to California after his well-equipped tile factory in Barberton, Ohio, was razed by fire in 1895—after less than two years of operation. He was given land in Tropico by local philanthropist and businessman, William Carr Belding Richardson. Records do not indicate, however, whether any tiles were produced under this name on the site.

Pacific Art Tile Company: Joseph Kirkham and Colonel Griffith founded Pacific Art Tile in 1900. On December 1, 1902, they incorporated along with C. C. Chandler, H. C. Goodell, John A. Merrill, and Warren J. Thomas. Fred Wilde, an expert

ceramist formerly in the employ of Maywood Tile Company of Maywood, New Jersey, and Robertson Art Tile Company of Morrisville, Pennsylvania, was hired as general manager.

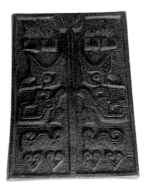

Western Art Tile Company: Fred Wilde continued as general manager of this new corporation, established June 4, 1904, with E. M. Durrant as owner and president. The company produced art tiles, floor, wall and mantel tiles, as well as vitreous china, sanitary ware, and terra cotta pipes. Wilde soon quit the company, however, blaming mismanagement. In 1907, Lycurgus Lindsay became owner.

In 1909, Lindsay lured Adolf Metzner away from Perth Amboy Tile Works to manage Western Art Tile. Lindsay misrepresented Western Art Tile's actual sales and profits to Metzner, promising him $550 per month plus ten percent of a projected $2,000-per-month profit. When Metzner arrived in July, 1907, he found the company operating at a loss that had grown—after four months—to $37,000. With operations paralyzed after just ninety days, Metzner sued for $20,000 in damages. The plant closed in 1910.

California Tile and Terra Cotta Company: Reorganized and renamed, but still with Lycurgus Lindsay as owner, the new company enlarged the plant. In May, 1912, however, the company's charter was forfeited for non-payment of taxes. Both Western Art Tile and California Tile and Terra Cotta were listed in the complaint. After a year of litigation, three companies on the Tropico site succeeded one another, but none produced tile. These were: Independent Sewer Pipe Company (1912-1914); Pacific Tile and Terra Cotta Company (1917); and Pacific Minerals and Chemical Company (1918-1920). On January 9, 1918, the town of Tropico became part of Glendale.

Tropico Potteries: This firm established in 1920 by Stephens and Company, a Los Angeles investment and security brokerage, with B. M. Wotkyns as president. F. B. Ortman, a ceramics engineer formerly with New York Architectural Terra Cotta Company and Northwestern Terra Cotta Company of Chicago, was hired as vice president and general manager. The plant's production soon doubled.

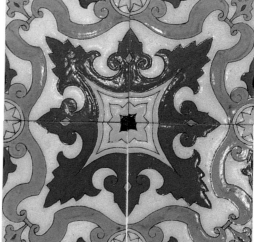
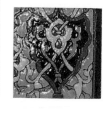

The factory produced interior and exterior faience tiles for storefronts, wainscotting, counters, soda fountains, and fireplaces. The staple products were architectural terra cotta and sewer pipes. By the time Tropico Potteries was purchased by Gladding, McBean in 1923, the company had become successful with its entire product line.

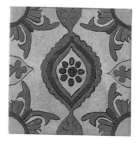
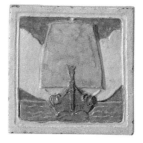

BATCHELDER TILE COMPANY

Pasadena, California; Los Angeles, California 1909–1912

BATCHELDER & BROWN 1912–1920

BATCHELDER-WILSON 1920–1932

ERNEST ALLAN BATCHELDER WAS BORN ON JANUARY 22, 1875, in Francestown, New Hampshire. He graduated from the Massachusetts Normal Art School in Boston in 1899, and studied at the Harvard Summer School of Design under Denman Ross, a designer for Dedham Pottery. He later studied at the Central School of Arts and Crafts in Birmingham, England.

Batchelder taught at the Handcraft Guild in Minneapolis in 1905, where he continued to teach during the summer until 1908 (one of his most promising pupils was the young Grant Wood). In 1901 he moved to Pasadena, California, to become a manual arts instructor at Throop Polytechnic Institute, now Caltech. He taught there during the winters until 1909, when he became Director of Art.

In 1909 Batchelder bought a piece of property in Pasadena along the Arroyo. He built a house and studio where he taught

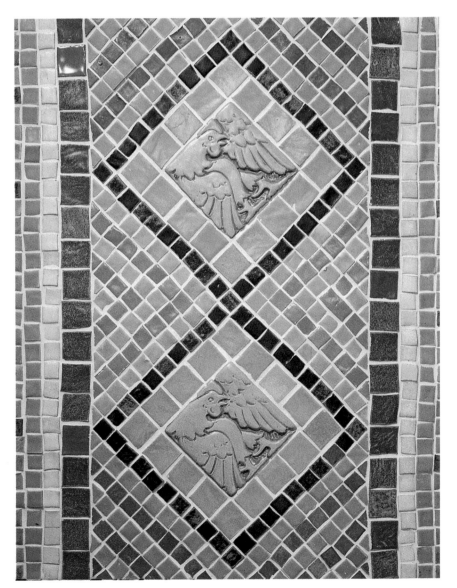

and began to make tiles. Although his kiln could fire no more than fifty pieces per day, Batchelder's tiles proved popular, and orders increased. In 1912 he entered into a partnership with Frederick L. Brown and moved the pottery to 769 S. Broadway (now Arroyo Parkway) in South Pasadena. The firm was then called Batchelder & Brown.

In 1912 Batchelder married Alice Coleman, an accomplished pianist who founded the Coleman Chamber Music Association (today the oldest society in the United States devoted solely to chamber music). The couple had a son, Alan C. Batchelder.

As the pottery's fortunes continued to improve, Batchelder found a new partner, Lucien H. Wilson, in 1920. Wilson became general manager, and the company became Batchelder-Wilson. By 1925 the firm employed 175 workers and produced six tons of tile per day. In 1928 it moved to new, much larger quarters at 2633 Artesian Street in Los Angeles.

Batchelder's products were hand-molded tiles on which a colored slip or engobe was applied, producing a matte, dusty-look-

ing surface. The decorative subjects included animals, birds (especially peacocks), flowers, vines, trees, fruit, castles, and country scenes, together with Mayan, Byzantine, and medieval motifs. The tiles were used for fireplaces, walls, floors, fountains, pools, and storefronts, and were sold throughout the country. A few significant installations were: Finney's Cafeteria, 216 W. 6th Street, Los Angeles (a Los Angeles Historical Landmark); the Fine Arts Building, 811 W. 7th Street, Los Angeles; All Saint's Church, Pasadena; the Christian Science Church, St. Petersburg, Florida; the Chapel at St. Catherine's College, St. Paul, Minnesota; and Union Station, Chicago.

In 1932 Batchelder-Wilson faced financial trouble, and the company was liquidated. The factory was sold to the Bauer Pottery Company, which owned a plant nearby. Batchelder-Wilson's tile stock was sold to the Pomona Tile Company.

Ernest Batchelder established a new pottery in 1936, called the Kinneloa Kiln, at 158 Kinneloa Street, Pasadena. Here he made delicate slip cast pottery, but not tile. He had some success with the pottery, primarily with Gumps department store, which purchased in quantity. Batchelder sold Kinneloa Kiln in 1949. He died August 6, 1957.

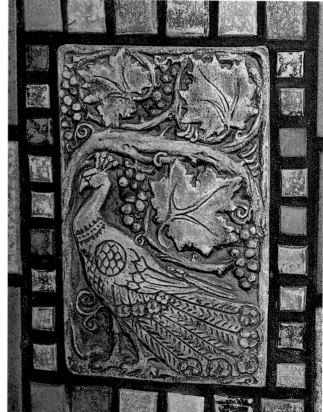

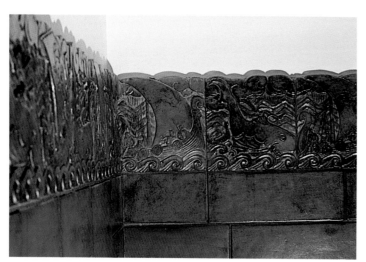

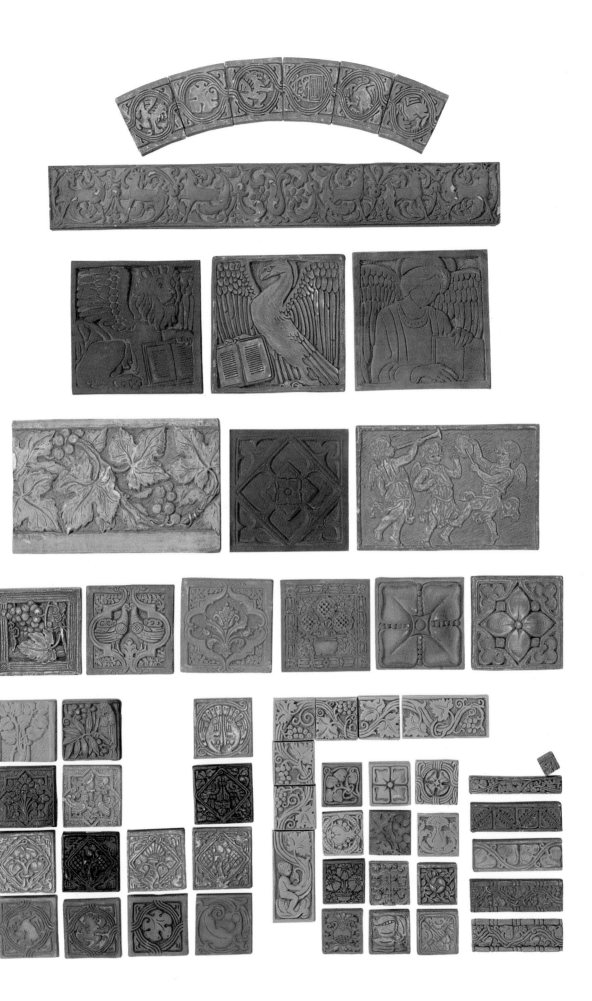

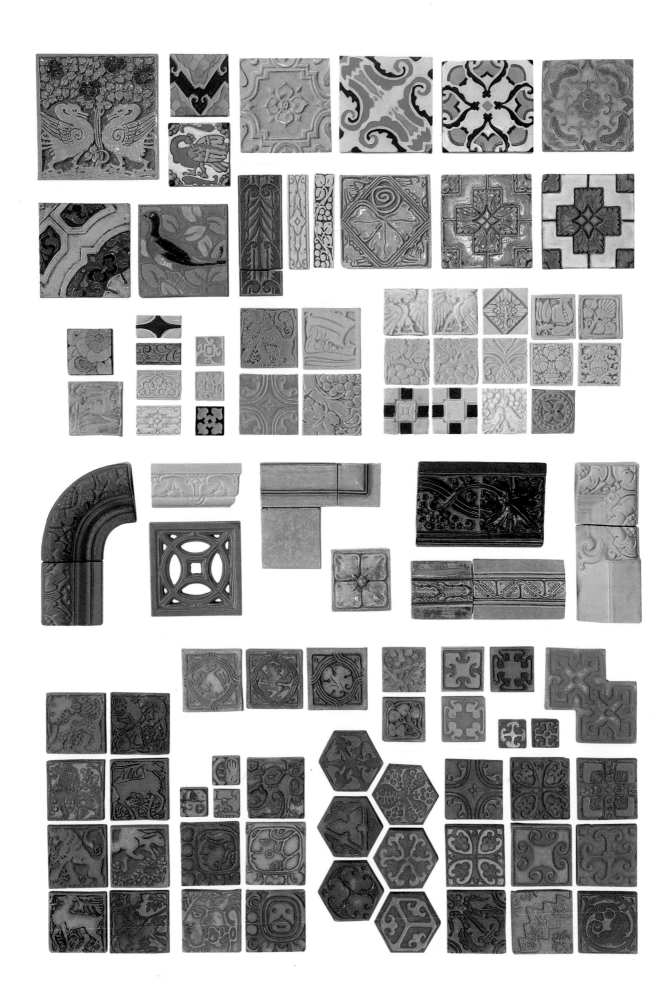

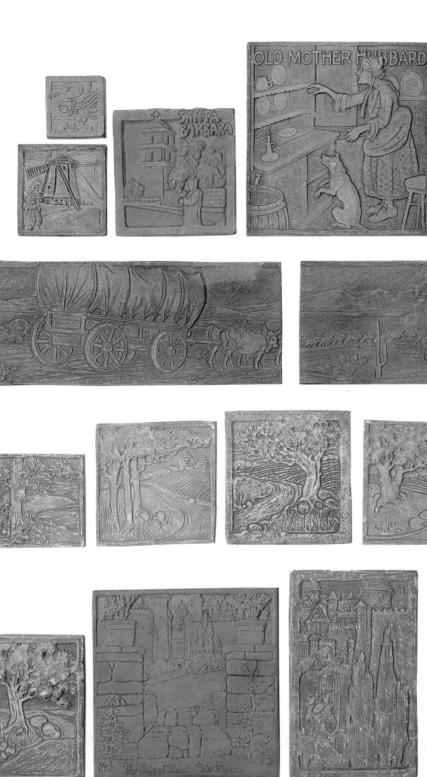
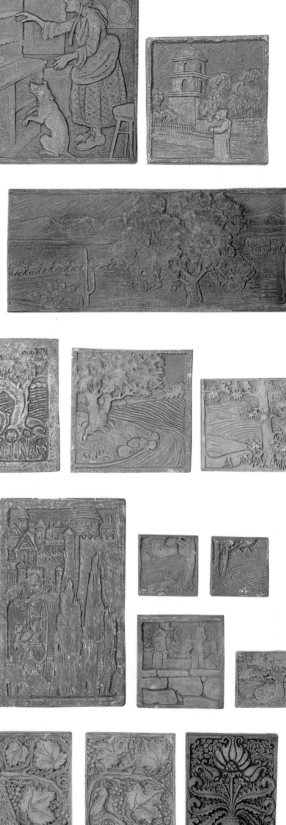

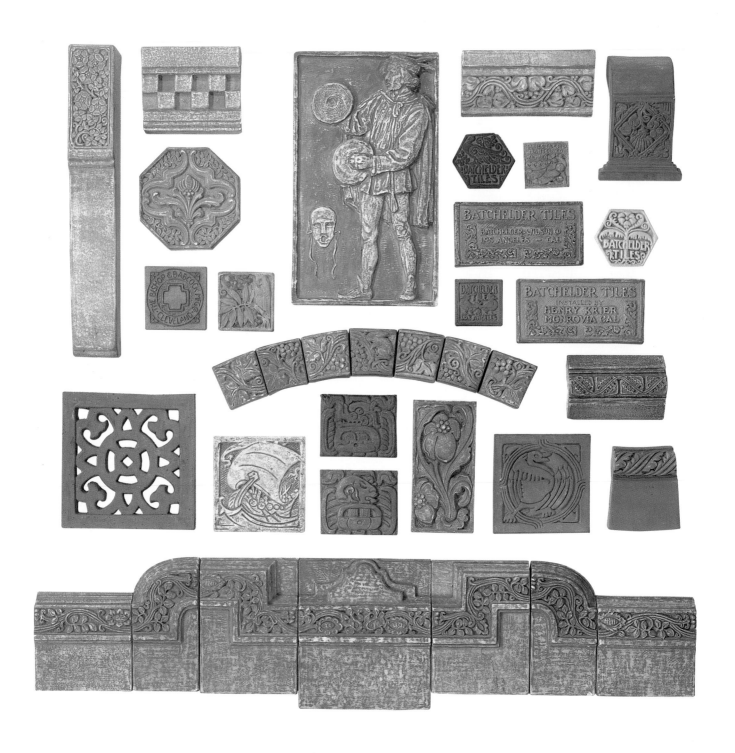

CALIFORNIA CHINA PRODUCTS COMPANY

National City, California 1911–1917

WALTER NORDHOFF, HIS SON CHARLES, AND JOHN B. MCKNIGHT INCORPORATED THE CALIFORNIA CHINA PRODUCTS Company in 1911 at 7th Avenue and 12th Street, National City, just south of San Diego. A sizable kaolin deposit on El Cajon Mountain assured the company of a reliable source of clay. California China's first products were porcelain insulators, tableware,

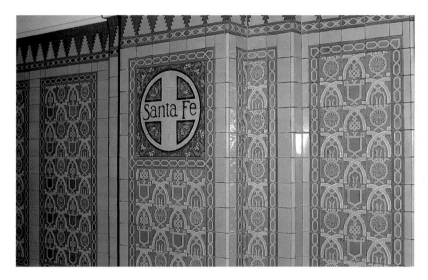

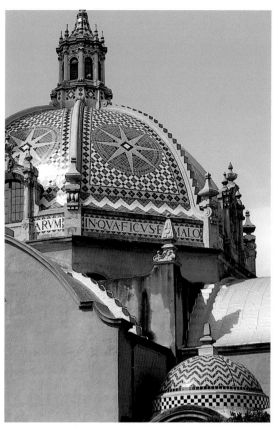

and faience tiles. The tiles (particularly one type called "kaospar," mined from a hard feldspathic rock found in the company's clay deposit) soon became the firm's most important product.

In 1912, California China Products hired Fred H. Wilde from the Western Art Tile Company in Tropico to develop and oversee tile production for the upcoming Panama California Exposition of 1915. Wilde, a very skilled, experienced ceramist, was hired with the understanding that he would be in complete charge of production—including hiring workmen—and would be responsible for seeing that the company turned a profit. Wilde produced tiles for the California Building in Balboa Park and the interior of the Santa Fe Railroad Station in San Diego. In 1915 Charles Nordhoff left the firm and moved to Tahiti, where he co-authored *Mutiny on the Bounty, Pitcairn's Island,* and *Men Against the Sea* with James Norman Hall. In 1916, Wilde also left the pottery, to replace Albert Solon at the Arequipa Pottery in Fairfax, California.

California China Products was last listed in the 1917 National City directory. Walter Nordhoff moved to Santa Barbara, where he became a writer of political satire. The company sold its machinery, molds, and the name "kaospar" to West Coast Tile in Vernon, California, which continued to produce many of the same tile products as California China.

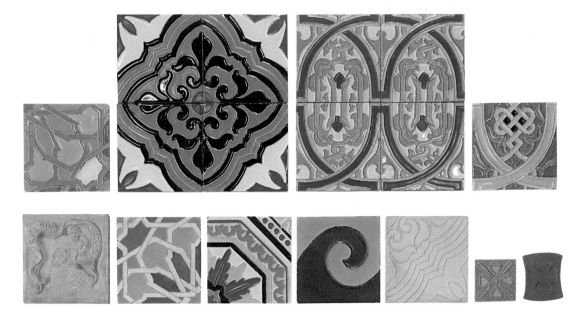

WHEN THE J. & W. WADE COMPANY OF BURSLEM, ENGLAND, DECIDED TO OPEN AN AMERICAN OPERATION, WILLIAM WADE, the firm's senior member , chose Los Angeles to be the site. Wade and his nephew, George J. Wade Poxon—who had been the general manager of the Burslem plant—took up permanent residence in California and established the Wade Encaustic Tile and Pottery Company. The company was incorporated in 1912, at 52nd Street and Alameda in Vernon, a suburb of Los Angeles. This site would later be home to two of the largest tile manufacturers in the United States.

Wade Encaustic had use of all the patents and designs of the English parent company, which had been in business since 1867. Production had just begun on a talc body tile—commonly used in England—when, on February 26, 1914, William Wade was killed in an automobile accident, which forced the closure of the factory that year.

On the site of the ill-fated Wade Encaustic Tile Company, George S. Pelton and his brother Herbert E. Pelton organized the West Coast Tile Company in 1914. Abandoning talc-body production, the former Wade Encaustic factory was then converted to produce a two-fire clay body tile. West Coast Tile manufactured wall tile, trim, mosaics, and floor tile.

Around 1917, West Coast Tile purchased the machinery, molds, and "kaospar" name from the California China Products Company of San Diego. This allowed West Coast Tile to produce faience tiles similar to those of California China, as well as the latter's noted "kaospar" tiles, manufactured from a hard, feldspathic clay mined in San Diego County. The company continued until 1919, when its plant was purchased by the American Encaustic Tiling Company.

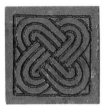
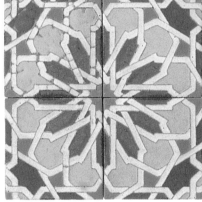

FREDERICK HURTEN RHEAD POTTERY

Santa Barbara, California 1913–1917

RHEAD POTTERY IN SANTA BARBARA, CALIFORNIA, IN BUSINESS FROM 1913 TO 1917, REPRESENTS ONLY ONE-TENTH OF Frederick Hurten Rhead's ceramic career in America.

Rhead was born in Hanley, Staffordshire, England, eldest son of a family of artists and ceramists. He studied first at the Wedgwood Institute at Burslem and, later, at various art schools including the Fenton Government Art School. He apprenticed with his father, Frederick Alfred Rhead, a noted ceramist, at Brownfield's Guild Pottery.

Rhead came to the United States in 1902 and worked with another Englishman, William P. Jervis, at Vance/Avon Faience. Rhead moved to Weller in Zanesville, Ohio, in 1904 where he also designed pottery. The same year he went on to Roseville Pottery where he remained until 1908. Then he moved to Jervis Pottery at Oyster Bay, New York, working again for William Jervis.

In 1909, Rhead moved to University City, a suburb of St. Louis. Here he taught and worked with other brilliant ceramists such as Taxile Doat and Adelaide Robineau, and created some of his most extraordinary ceramic tiles. One of a series of four tile panels of peacocks from this period is in the Los Angeles County Museum of Art collection.

One of the characteristics of Rhead's pottery was his use of tube lining to create a high-relief line to separate glazes. Another was his usage of sgraffito—scratching into the glaze to create an incised line of a different color.

In 1911 Rhead left University City and went on a lecture tour of California. In San Francisco, Rhead met Dr. Philip King Brown, the founder of Arequipa, a tuberculosis sanitarium in Marin County. Brown wished to introduce a craft to patients as therapy, and also as a way for the patients to earn some money during their long stay. Rhead started a pottery at Arequipa that became almost self-supporting within a year. Rhead's first wife, Agnes, helped with the teaching. Rhead made some fine pottery at Arequipa, and was able to teach, which he loved. Soon the operation proved to be over budget, because of mismanagement from which the quality of the products suffered.

In 1913 Rhead left Arequipa and went briefly to Steiger Terra Cotta in south San Francisco. In 1914, he started the Pottery of the Camarata in Santa Barbara's Mission Canyon. The pottery was later incorporated as Rhead Pottery. Rhead finally had his own pottery where he could do as he pleased. He won a gold medal in 1915 at the San Diego Exposition. He also taught, sold ceramic supplies, and edited and published a paper called *The Potter*. (After the first monthly issue was published in December 1916, however, only two more issues followed.) Rhead found that doing what he wished did not pay his bills so in 1917 he closed the pottery, but not before marrying his assistant, Loiz Whitcomb.

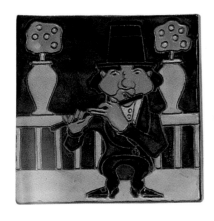
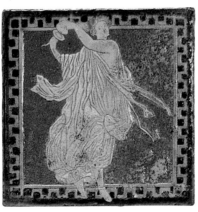

Rhead moved to Zanesville, Ohio, and became the Director of Research at the American Encaustic Tiling Company, where he worked on glazes and clay bodies. He designed many of A.E.T.'s most unique tile designs and helped the company become the world's largest tile producer.

In 1927 Rhead was hired by the Homer Laughlin China Company in Newell, West Virginia, where he continued until his death in 1942.

CALIFORNIA CLAY PRODUCTS (CALCO)

South Gate, California 1923–1933

SOUTHERN CALIFORNIA CLAY PRODUCTS *Vernon, California* c. 1918–1923

RUFUS BRADLEY KEELER WAS BORN IN BELLINGHAM, WASHINGTON, ON OCTOBER 2, 1885, AND RAISED IN SANTA CRUZ, California, before he moved to San Francisco. In 1905 he worked for the Carnegie Brick and Pottery Company in Tesla, California, which produced bricks and architectural terra cotta. (The building boom after the 1906 San Francisco earthquake kept the company quite busy.) Keeler then studied ceramic engineering at the University of Illinois, and in November 1909 went to Gladding, McBean in Lincoln, California. Initially employed as a draftsman, Keeler then developed glazes to suit the company's clay bodies.

Keeler left Gladding, McBean in September 1916 and went to California China Products in National City, near San Diego. Next he formed his own company, Southern California Clay Products, at 2298 E. 52nd Street in Vernon, where he made chemical stoneware, architectural terra cotta, and tiles. In 1923, he incorporated as California Clay Products, with "CALCO" as a trademark, and built a new factory at 4240 Santa Ana Street in South Gate, a Los Angeles suburb. At this plant Keeler produced many varieties of decorative tile for floors, walls, and mantels. Although this endeavor was very successful, an offer by May Knight Rindge to establish and manage a new factory in Malibu was so tempting that he sold his interest in California Clay Products in 1926. (Rufus Keeler's story is continued under Malibu Potteries.)

California Clay Products continued to be listed in the South Gate city directories from 1926 through 1932. In 1928, Victor Kremer of Victor Kremer Enterprises, Incorporated, was president. In 1929, R. F. Ingold is listed as president. The Clay-Worker cited W. A. Savage as head of the new California Clay Products. An undated catalog cover states "Whittier Terra Cotta Works changes its name and incorporation to California Clay Products Co."

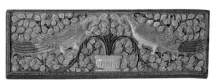

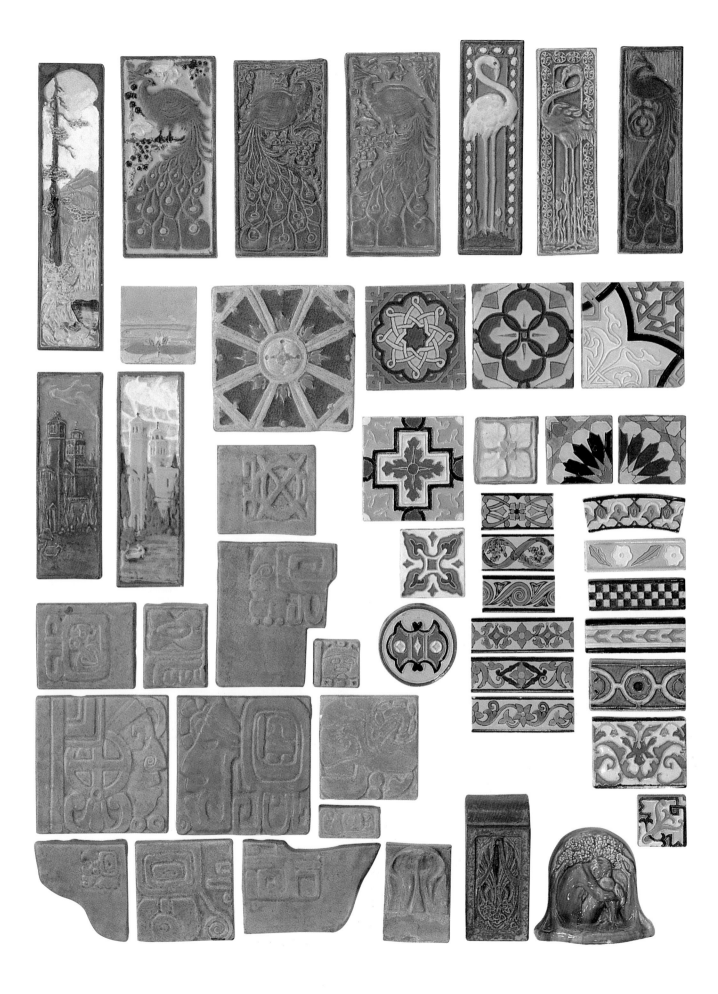

PACIFIC TILE AND PORCELAIN CO.

Los Angeles, California 1936–c.1960

THE PACIFIC TILE AND PORCELAIN COMPANY WAS FIRST LISTED IN THE LOS Angeles city directory in 1936, at 3428 West Pico Boulevard, and continued at the same address until 1960. The company used the trade names "Ramona Tile" and "Ceratile." These products were distributed nationwide by the Cambridge Tile Manufacturing Company of Cincinnati. Thirty-four stock patterns—from simple stripes and checks to loosely rendered abstracts and crisp, stencil-like motifs—were produced in sizes ranging from 4 1/4-inch squares to 6-by-9-inch rectangles.

AMERICAN ENCAUSTIC TILING CO.
(A.E.T.)

Hermosa Beach, and Los Angeles, California 1919–1933

IN 1919, THE AMERICAN ENCAUSTIC TILING COMPANY OF ZANESVILLE, OHIO, PURCHASED THE WEST COAST TILE COMPANY plant at 2030 E. 52nd Street in Vernon. Frank A. Philo of West Coast Tile was retained as general manager. The factory produced a wide range of tiles, from handmade faience to mechanically-fabricated and decorated tiles. In addition to the same clay bisque that was produced in Zanesville, this plant also produced a vitrified tile known under the trade name "kaospar," which was made from the clay found at a feldspathic clay deposit in San Diego County.

In 1926 A.E.T. purchased Theodore Prouty's Proutyline Products Company plant in Hermosa Beach. The purchase included the patent for Prouty's talc-bodied tile. Prouty stayed on for some time as local manager, and A.E.T. immediately enlarged the plant to ten times its original size, continuing the production of Hermosa talc-bodied tile in many new designs. The Vernon plant concentrated on the production of faience tiles.

A.E.T.'s Southern California staff grew from 60 employees in 1919 to 400 in 1930, when A.E.T. was the largest tile-maker

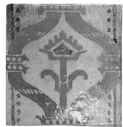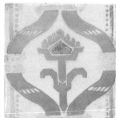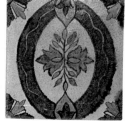

in the world. The total production of all A.E.T. branches including Zanesville represented one quarter of all of the tiles made in the United States. However, as the Depression continued, the main plant in Zanesville suffered from increasing financial difficulties. In 1933, the Vernon and Hermosa Beach plants were sold to Gladding, McBean. A.E.T. Zanesville closed in 1935.

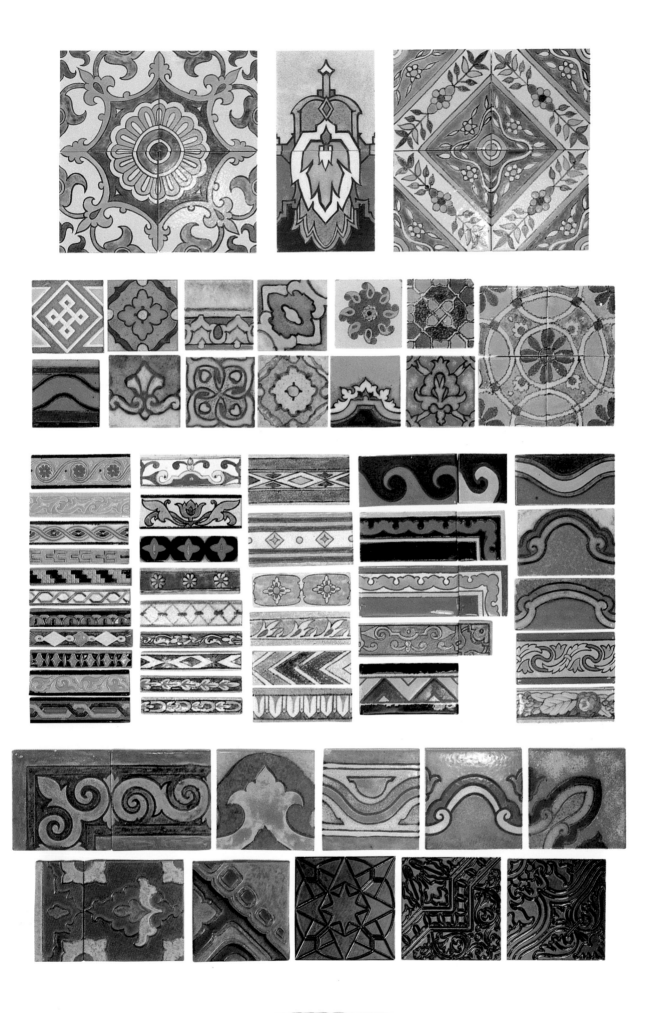

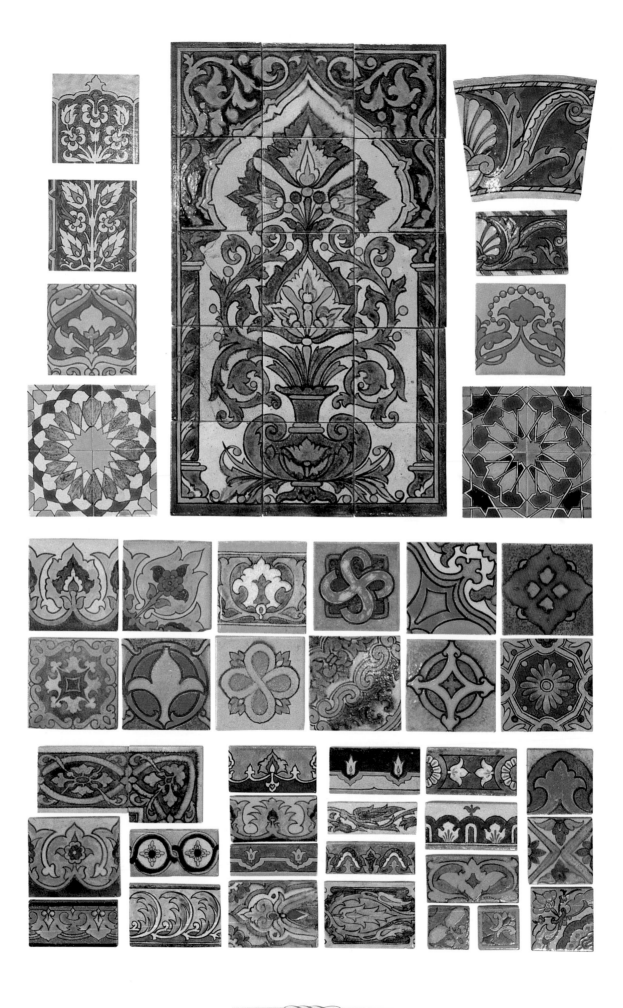

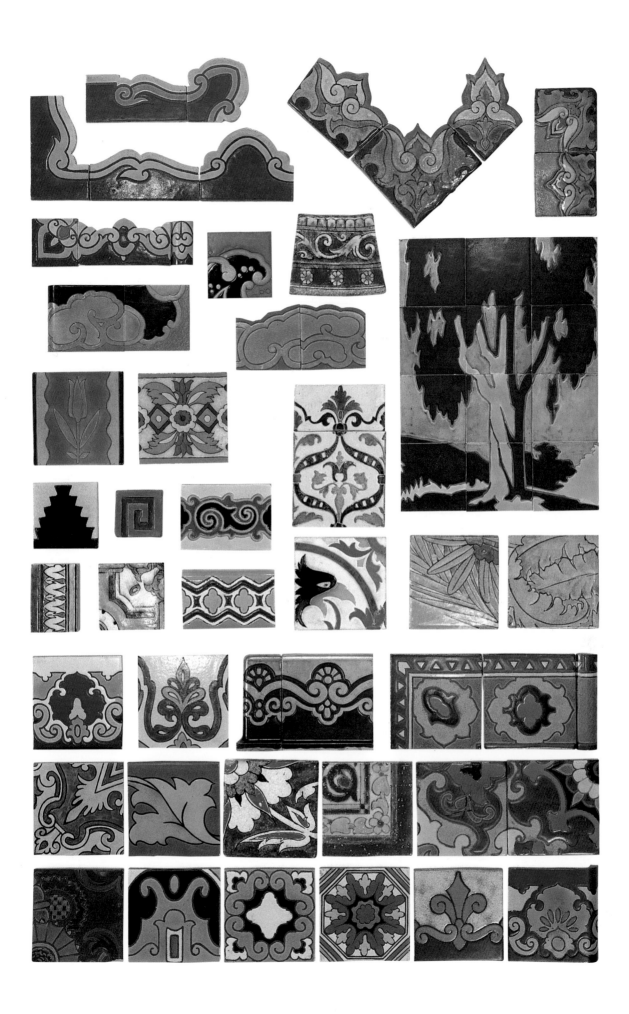

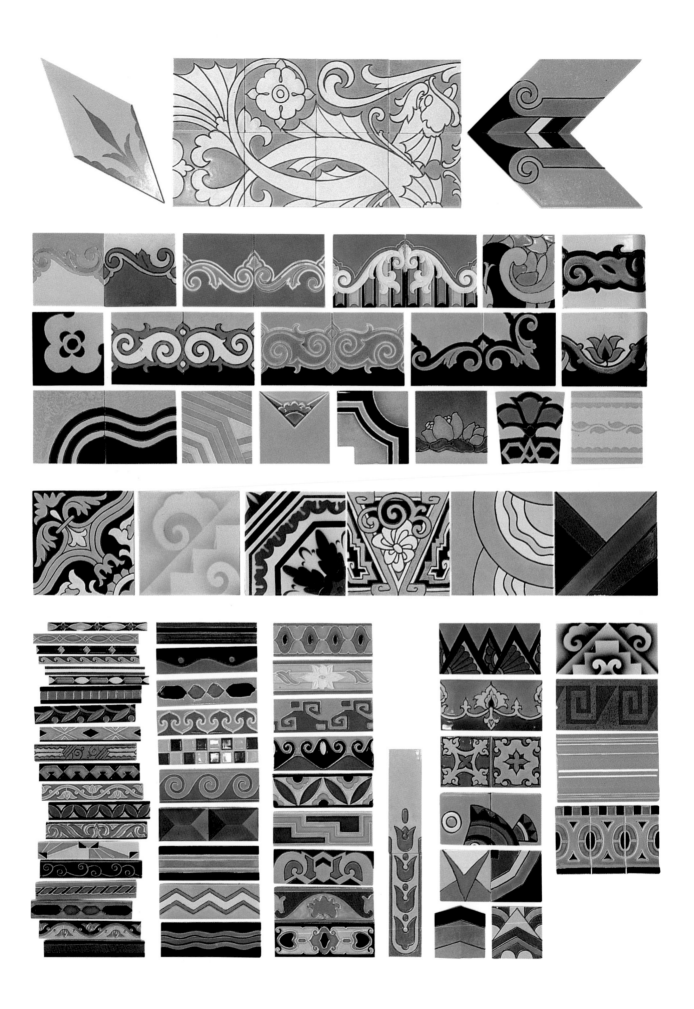

HELEN GREENLEAF LANE

Upland, San Bernardino County, California c. 1920–c. 1930

HELEN GREENLEAF LANE WAS BORN ON APRIL 12, 1874, IN GREENCASTLE, INDIANA. SHE WAS THE DAUGHTER OF CLEMENT Allen Greenleaf, a prominent mechanical engineer and inventor of the Greenleaf Railroad Ball Bearing Turntable, which is still in use worldwide. In 1903, Clement Greenleaf relocated with his family to Upland, California.

Helen and her three sisters—Mary, May, and Grace—all became accomplished portrait artists. Helen studied at the University of Southern California with acclaimed artist and potter Glen Lukens. She became well known for her weaving, jewelry, and pottery.

Helen was married to the Rev. Henry P. Lane, pastor of the First Presbyterian Church of Upland. She actively pursued her interest in pottery and tiles between 1920 and 1929. Helen Greenleaf Lane died December 3, 1962, at the age of eighty-nine.

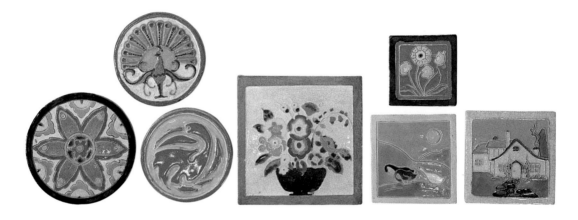

CLAYCRAFT POTTERIES

Los Angeles, California 1921–c. 1939

ROBERTSON POTTERY

Los Angeles, California 1934–1952

CLAYCRAFT POTTERIES WAS INCORPORATED AT 3101 SAN FERNANDO ROAD, LOS ANGELES, IN 1921. THE GROUP OF INVESTORS included Gus Larson, former superintendent of the Los Angeles Pressed Brick Company. Shortly after incorporation, Fred H. Robertson, also of the Los Angeles Pressed Brick Company, joined the firm as general superintendent. In 1925, at age eighteen, Robertson's son George B. was hired as assistant superintendent. English ceramist Cecil Jones left A.E.T.'s Los Angeles branch and joined Claycraft in 1930. In 1933, George Robertson married Dora Jones, Cecil Jones's daughter, and Cecil Jones left Claycraft for the Van Briggle Pottery.

Claycraft advertised three different product lines. The first was Claycraft tiles. According to their catalog, the surface color and tile body of the Claycraft tiles were matured in the same firing. The tiles were then buffed and sanded and given a linseed oil treatment. The second product was faience tiles, which had bright and vellum finished glazes. The bisque was machine made,

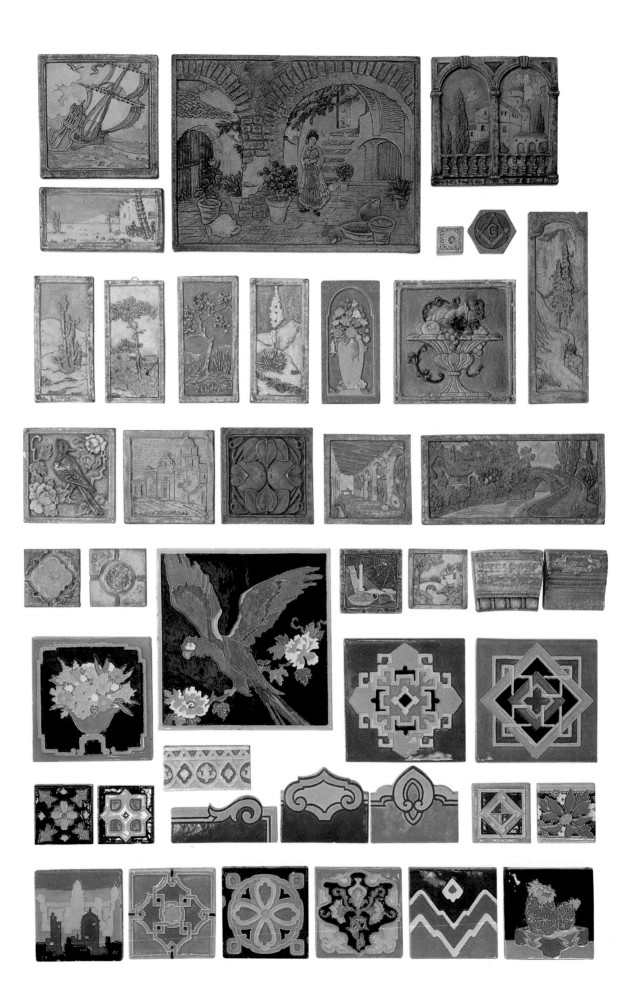

with very slight irregularities in surface and form. The third product was handmade tiles which were produced for building fronts, wainscots, mantels, counters, and pavements.

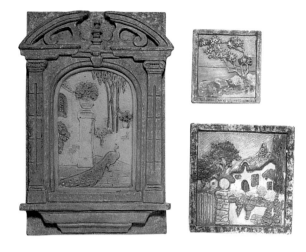

Claycraft moved to 3025-27 Fletcher Drive in 1936 or 37, and was last listed in the Los Angeles city directory in 1939.

In 1934 George Robertson and his father left Claycraft, after nine years of employment, and established the Robertson Pottery. Originally located at 3321 San Fernando Road, Los Angeles, the pottery moved to 18846-48 Ventura Boulevard in North Hollywood the following year. In 1940, the Robertsons moved back to Los Angeles, on Riverside Drive, and finally, in 1943, to 6809 Hawthorne Avenue, Hollywood.

Pottery and tiles have been accredited to the Robertsons as early as 1906, when Fred worked at the Los Angeles Pressed Brick Company and then Claycraft. It is not known whether tiles were produced at Robertson Pottery. The plaque illustrated was a portrait of George at age seven, made by his father in 1914.

Robertson Pottery closed in 1952, and Fred Robertson died December 23 the same year. George Robertson died in 1966.

PROUTYLINE PRODUCTS CO.

Hermosa Beach, California c. 1921–1926

THEODORE CHESTER PROUTY AND HIS SONS, WILLIS AND KENNETH, FOUNDED THE PROUTYLINE PRODUCTS COMPANY IN 1921 or 1922. Prouty, an inventor, developed an eighty-percent-talc body that produced a craze-proof tile, which he called "Hermosa Tile." The talc was obtained from Death Valley, which Prouty believed to be far superior to ordinary clay. Prouty's son Willis invented a tunnel kiln used to fire this new talc-bodied tile.

In 1924, the company incorporated and built a two-story factory with a railroad siding at 700 15th Street, Hermosa Beach, west of the Pacific Coast Highway. In 1925, Prouty applied for a patent on his process. The tiles were commonly six inches square, with a white body and bright colored glazes. Often, one design was made in twenty different color combinations.

Early in 1926, Prouty sold his plant and the patent to the American Encaustic Tiling Company for $1 million, remaining at the factory for a while as local manager. A.E.T. continued to produce Hermosa Tile at this plant until 1933, when the plant was sold to Gladding, McBean. Gladding, McBean continued to use the Hermosa Tile trade name at the Glendale plant after the Hermosa Beach plant was demolished. The Hermosa Beach site is now occupied by Von's Plaza shopping complex.

In 1927 Theodore Prouty started Metlox Potteries, which made ceramic advertising signs, in a new factory in Manhattan Beach. The new pottery was soon making small ceramic figurines and "Poppytrail" dinnerware, as well, but not tiles.

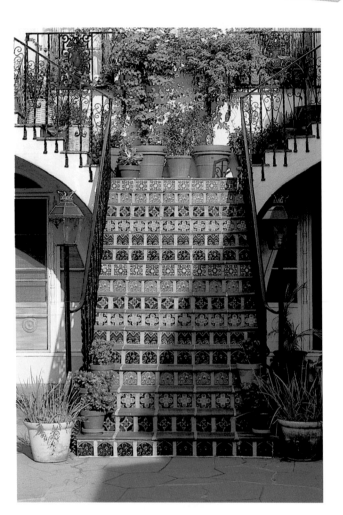

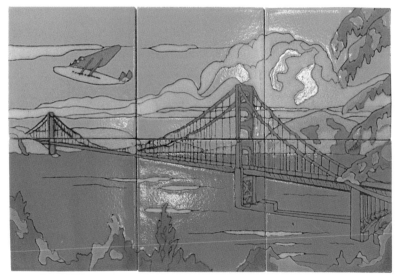

THE TAYLOR TILERY WAS ESTABLISHED BY TWO BROTHERS named Taylor as a subsidiary of the Santa Monica Brick Company. This factory produced tile under several different names, including Santa Monica Brick Company, Monaco, and Santa Monica Tiles.

Santa Monica directories from 1923 through 1940 place the brick company at 1741 Cloverdale Boulevard. E. A. Douglas is listed as president and F. M. Taylor as secretary and vice president. The Taylor Tilery was open from at least 1934 to 1938, and the 1938 city directory lists the company at the same address as the Santa Monica Brick Company, with the same officers.

The Santa Monica Brick Company made five-inch tiles in the raised-line and black-line methods. The thick, red clay tiles were typically decorated with bright yellow and orange glazes, and had the trade name "Monaco" impressed on the back. Taylor Tilery tiles were similar six-inch tiles made with the same rough clay. Often used for table tops, these tiles featured soft-edged designs glazed in bright yellow, orange, green, and turquoise, often on a black background.

Bill Handley came to Taylor Tilery as a designer from the Malibu Potteries after that factory closed in 1932. He brought with him some of the designs and glazes he had developed at Malibu. After his arrival, some of the tiles produced were of a much finer black-line painting style, on a smooth white bisque. One typical tile series was called "El Monico, a Day in the Life of a Mexican Peon."

Records indicate that in 1938 the Taylor Tilery employed about fifteen workers. Among these were Jose Morales and Simon Rodia. Morales, who was in charge of the glaze room, was fondly remembered for his violin playing during lunch. Rodia was the self-styled architect of Watts Towers.

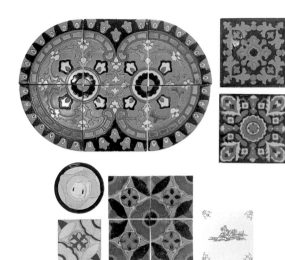

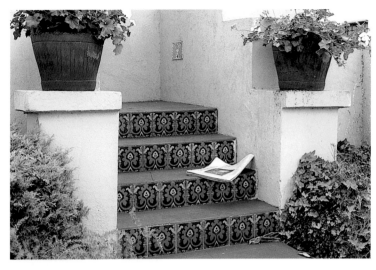

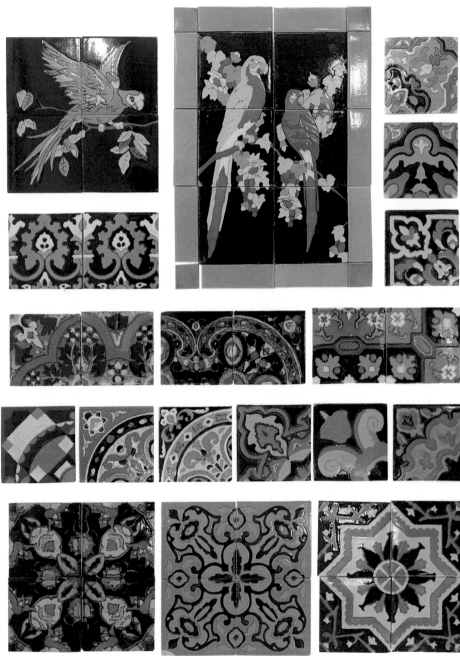

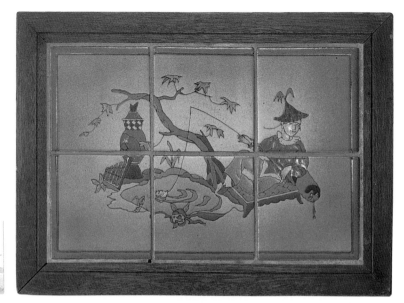

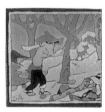
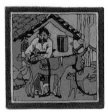
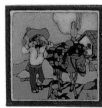

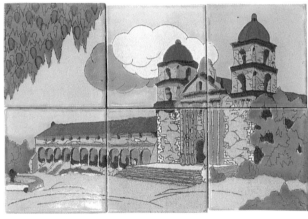
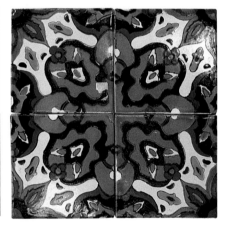

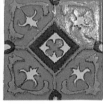
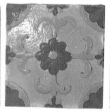
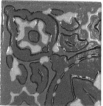
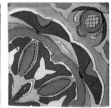
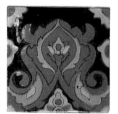

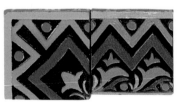
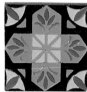

POMONA TILE MANUFACTURING CO.

Pomona, California 1923–1966

POMONA TILE MANUFACTURING COMPANY WAS INCORPORATED IN SEPTEMBER, 1923, AT THIRD AND RESERVOIR STREETS, Pomona, by Judson F. Clark. Other staff members included Fred H. Wilde who was ceramic engineer from the company's inauguration until 1940, when he retired at age eighty-three. Cecil Sanders became head of the decorating department after the owners saw a bird tile panel he had made on his own time.

Pomona Tile was capable of producing 5,000 square feet of tile per day. Although the majority of Pomona's production was plain, solid-color utilitarian tile and trim, the company did produce some very attractive polychrome tile with high-line relief decoration, deeply-sculpted modern decorative tile, and handmade faience.

The Pomona Tile showroom sold the Batchelder stock tiles that were left after the Batchelder factory closed. Pomona Tile also distributed terra cotta tiles, Taylor Tiles, and decorative Spanish and Oriental tiles.

Pomona Tile was taken over by American Olean in 1966, though it continued to produce tile under the Pomona name. Huntington Tile purchased the company from American Olean in 1976, and the tiles made there were no longer called "Pomona." Huntington closed the plant in 1988.

GLADDING, McBEAN & CO.

Glendale, Hermosa Beach, California 1923–1979

IN 1874 CHARLES GLADDING, WHILE VISITING CALIFORNIA, LEARNED OF LARGE, RICH CLAY DEPOSITS IN LINCOLN, IN PLACER County. In Chicago on May 1, 1875, Gladding signed a partnership with Peter McGill McBean and George Chambers to build a plant for making terra cotta in California, with Gladding as president. By the fall of that same year the company was producing terra cotta sewer pipe.

In 1884 architectural terra cotta was added as a product line. In that same year Gladding, McBean constructed its own showroom and office building in San Francisco. The building's facade emphasized the company's new architectural terra cotta products. Charles Gladding died in 1894 at age sixty-six, and Peter McBean became president.

Gladding, McBean purchased controlling interest of Tropico Potteries in 1923. Tropico, located in Glendale, was established in 1920 and produced sewer pipe, architectural terra cotta, and ceramic tiles. In 1926, Tropico merged with the Los Angeles Pressed Brick Company (which also produced tiles). This made Gladding, McBean the largest producer of terra cotta in California.

Atholl McBean became president. Then, in 1933 Gladding, McBean purchased the American Encaustic Tiling Company plants in Vernon and Hermosa Beach, California. With this purchase, the firm received the patent to the talc-bodied, dust-pressed

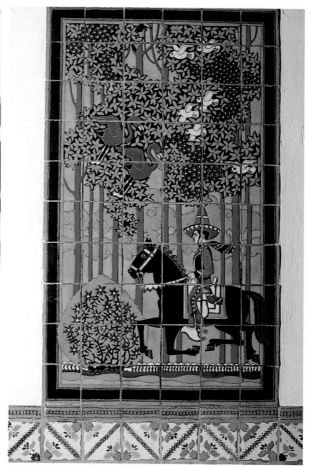

"Hermosa Tile" invented by Theodore Prouty. The "Tropico" name for tiles was dropped and the trade names "Hermosa Tile" or "Gladding, McBean Tile" were used.

In 1937, Gladding, McBean purchased the Catalina Pottery. The company moved Catalina's pottery and dinnerware production from Catalina Island to the mainland, but discontinued Catalina's tile line. A.E.T.'s Vernon plant was disposed of, and most of the Hermosa Beach plant production was shifted to Glendale—the Hermosa plant was now used only when production needs dictated. (The Hermosa Tile name was still continued for many tiles that were made in Glendale.)

Gladding, McBean was now the largest producer of tile in the west. As well as simple production tiles, the company produced a wide variety of art tile. Advertisements described "stock decorative designs," which meant that the unglazed tiles were in stock, and could be decorated specifically for a customer. The decorative motifs used were Moorish, Spanish, Persian, and abstract, in raised-line and wax-resist designs. Gladding, McBean produced many made-to-order murals with intricate designs. Important commissions included the Santa Fe Railroad Station in Los Angeles, the Biltmore Hotel in Santa Barbara, and the Los Angeles City Hall.

In 1962 Gladding, McBean merged with the Lock Joint Pipe Company to form the International Pipe and Ceramics Corporation. The following year the company name was changed to Interpace. At this time, the Glendale plant primarily produced dinnerware under the trade name "Franciscan." In 1976 Interpace announced the closing of the original Lincoln plant, but Pacific Coast Building Products of Sacramento came to the rescue and purchased it. The name Gladding, McBean was reclaimed by the Sacramento company, and the plant is still in operation as of this writing, producing architectural terra cotta.

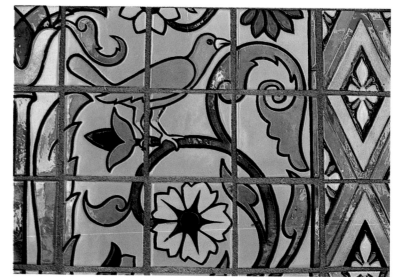

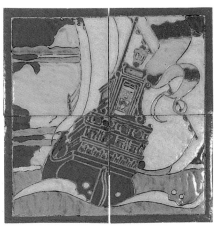

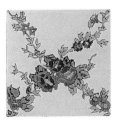

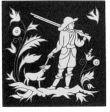

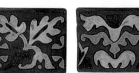
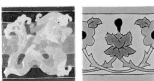

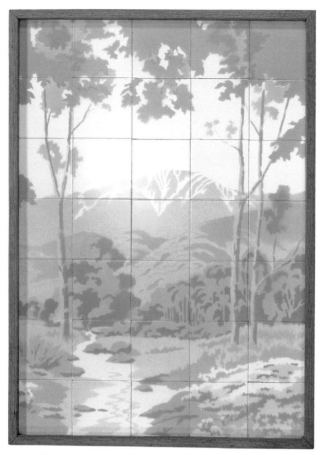

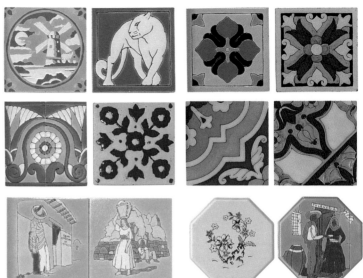

In 1979 Interpace, operating out of the Glendale plant, was sold to Josiah Wedgwood of England, which was interested in the Franciscan dinnerware production. Wedgwood continued to operate the plant until finally closing it in July 1984, ending an eighty-six year history of ceramic production at that site. The Interpace assets and land were sold, and the buildings were bulldozed.

ACME TILE COMPANY

Los Angeles, California 1925–1932

NOT MUCH IS KNOWN ABOUT THE ACME TILE COMPANY. THE LOS ANGELES CITY directories list it at 4938 W. Pico Boulevard from 1925 to 1928, and at 5166 Pico Boulevard from 1929 to 1932.

Acme Tile Company produced tile similar to that of other California companies such as Claycraft Potteries, California Art Tile, and Muresque Tile.

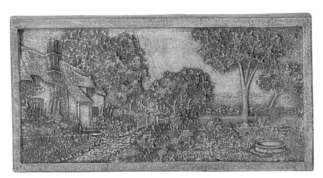

ALHAMBRA KILNS, INC.

Alhambra, Santa Monica, California 1926–1937

CITY DIRECTORIES PROVIDE SOME RUDIMENTARY INFORMATION on Alhambra Kilns, Incorporated. The company had two plants: one in Alhambra, the other in Santa Monica, California. The Alhambra facility was under construction in September 1926, and a 1930 advertisement lists its address as 1024 Westminster Avenue. From 1927 to 1933, Santa Monica city directories list the company at 2632 Colorado Avenue. Three years later, the Santa Monica plant moved a block away, to 2526 Colorado Avenue.

The California Clay Reserves and the Ceramic Industry of California Bulletin No. 90 identifies E. H. Ockerman as principal of the company in 1928. In 1929, the Ceramic Trade Directory cites L. B. Merwin as superintendent.

The Alhambra Kilns manufactured unglazed terra-cotta floor tiles, embossed stair and ceiling tiles, and terra-cotta inserts in relief. The tiles illustrated are miniature copies of eight-inch ecclesiastical emblems designed by Herman Mueller.

MALIBU POTTERIES

Malibu, California 1926–1932

MALIBU POTTERIES WAS ESTABLISHED IN 1926 BY MAY KNIGHT RINDGE on the Roosevelt Highway (now the Pacific Coast Highway) in Malibu, twelve miles west of Santa Monica. The pottery was built to supply tiles for the "American Riviera," a real estate developement planned by May's late husband, Frederick Hastings Rindge, to be built in the Malibu hills overlooking the ocean, as well as for the Rindges' new family mansion.

Rufus B. Keeler, formerly with California Clay Products Company, was hired to construct the factory and to be its general manager. The pottery produced wonderful tiles similar to those produced by Keeler at CALCO—in some cases, the tiles are indistinguishable. The venture proved successful and by 1927, the pottery employed 127 workers.

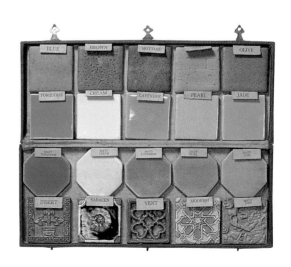

The town of Malibu was quite remote at the time, with no telephone service, gas, or electricity. Fuel oil to run the plant's electric generator had to be trucked in over a small road from Santa Monica that ended in Malibu. Keeler slept in a tent on the beach during the week and, on weekends, returned to his family in South Gate, forty miles away.

In 1929 Rindge began construction of a fifty-room mansion on an adjacent hill, and her daughter, Rhoda Rindge Adamson, started a house on the beach less than a mile northwest of the factory. With the Depression, construction on the more ambitious house on the hill came to a halt. Rhoda Adamson's house, however, was completed in 1930, and contains an extensive installation of Malibu tiles. Today, the building houses the Malibu Lagoon Museum. Malibu tiles were also used extensively in the Los Angeles City Hall and the Mayan Theatre, both located in downtown Los Angeles.

In November 1931, most of the pottery was destroyed by fire. The plant was partially rebuilt and operated on a greatly reduced scale until its closure in 1932. The factory, no longer standing, was situated on the ocean side of what is now the Pacific Coast Highway. Adjacent to the sandy beach east of the Malibu pier, it was probably the most pleasantly located tile factory in the world.

When a tile batch did not fire properly, it was buried deep in the beach sand, presumably so Mrs. Rindge would not see it. Over the years, after heavy storms, some of these tiles have surfaced. Once, a huge tiled concrete slab that was part of the factory floor appeared on the beach.

In 1942, the unfinished fifty-room mansion full of Malibu tiles was sold to the Order of Franciscan Friars of California, who converted it into the Serra Retreat. In 1970, it was destroyed in one of California's notorious brush fires. The building has been rebuilt and contains many of the original tiles. A few years later, Dan Reinhart, a tile setter, discovered boxes of tiles left in the fire rubble. He was using the tiles in installations when architectural historian David Greenberg saw them and, realizing their merit, placed them on exhibition at the Los Angeles Craft and Folk Art Museum in 1980.

MARKOFF MOSAIC TILE CORP.

THE MARKOFF MOSAIC TILE CORPORATION WAS INCORPORATED JULY 14, 1926, AND DISSOLVED IN 1945. THE DIRECTORS WERE

Harold Swenson, Aron S. Nelson, Robert C. Solomon, Axel Lindborg, and Ernest Hanson. Inglewood city directories locate the company at 1105-7 East Redondo Boulevard. The 1927 listing records Harold Swenson as president. From 1929 to 1942 the directories list Harold Markoff as president.

Markoff Mosaic advertised handmade tiles for interior uses, such as fireplaces, hallway wainscotting, stair risers, lobbies, and counter fronts. The company produced a twenty-two page, hand-drawn catalog illustrating fifteen fireplaces with tiles of assorted decorations and irregular sizes, some over twelve inches square. The decorative motifs included portraits, as well as abstract and geometric designs.

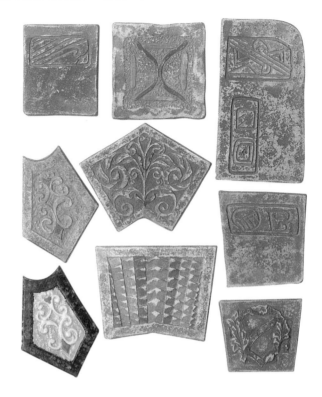

BRAYTON LAGUNA POTTERY

IN 1926 DURLIN E. BRAYTON PURCHASED A SMALL PARCEL OF LAND IN LAGUNA BEACH ALONG A DESERTED STRETCH OF THE Pacific Coast Highway, then a two-lane road. A carpenter with a background in architecture and design, Brayton built a home there the following year and began to make colorful pottery and dinnerware.

In 1936 Brayton married Ellen Webster Grieve (known by her friends as Webb), and the couple worked together in the pottery. Sales grew rapidly, prompting the Braytons to enlarge the pottery to accommodate up to thirty employees. Soon, Laguna Beach began sprouting potteries, some operated by former employees of the Braytons.

In 1938 Brayton Laguna Pottery began work on one of its largest commissions, producing figures for Walt Disney Studios. The pottery also developed an excellent reputation as makers of ceramic tiles. These were individually created, many in the raised-line method, and in a wide assortment of glazes. The tiles were decorated with images that resembled cartoon drawings.

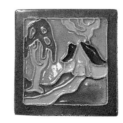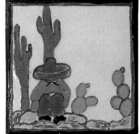

Webb died in 1948, followed by Durlin in 1952, which left a serious creative void at the pottery. Later, business dwindled as new Japanese potteries offering lower priced wares entered the market. Still, the pottery continued on until 1968. The buildings were demolished the following year.

 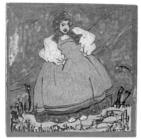 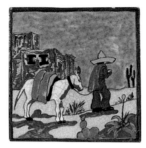 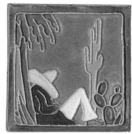 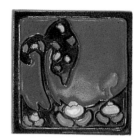

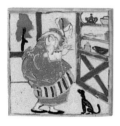

CATALINA POTTERY

Avalon, Santa Catalina Island, California c. 1927–1937

CHEWING GUM MAGNATE WILLIAM WRIGLEY JR. PURCHASED SANTA CATALINA ISLAND IN 1919. WISHING TO DEVELOP A resort, yet maintain the charm and integrity of the island, he instigated improvements to increase tourism and create jobs for Catalina's residents. One day, while driving with his general manager, David Renton, Wrigley's car became mired in mud. Hoping the mud might have useful properties, Wrigley had it analyzed and found that it was suitable for use in ceramics.

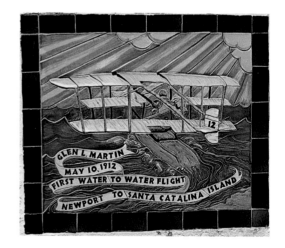

In the early 1920s Wrigley build a plant on Pebbly Beach to make bricks from the local clay. The plant also produced plain and cuenca-decorated pavers, as well as roof tiles. These were used primarily in construction projects on the island, although some were also sold on the mainland. In the late 1920s, the company began to produce decorative glazed tile. In addition to bright, stylized Moorish designs, tile panels were produced with images of birds, sea creatures, and airplanes. The most impressive designs were seascapes to be installed in the portico of the island's Casino—now a national historic landmark. Ironically, time constraints in the Casino's construction did not allow for the tile panels to be installed. Instead, the designs were painted onto the walls of the building. Finally, tile panels made to the original designs were executed in the 1980s by California tile-maker Richard Keit in conjunction with the Dal-Tile Corporation and the Casino's original designer, John Gabriel Beckman.

Harold Johnson, the pottery's first ceramic engineer, was replaced by Virgil Haldeman in 1930. John Wilde (the son of Fred Wilde), was plant supervisor in charge of production, and helped improve Catalina's glazes. Unfortunately, glazes were the least of the pottery's woes. Although Wrigley preferred that only native Catalina clays be used in the pottery's production, the factory began to look for other clay sources following his death in 1932. Although the quality of Catalina clay had been heavily promoted, the pottery's products were prone to chipping. The factory decided to use white clay from Lincoln, California, which was quite costly, and contributed to the pottery's eventual demise.

The company's name changed during the 1930s to Catalina Clay Products. By 1934, a showroom had been established in Los Angeles at 618 N. Main Street. Tableware, introduced in 1930, sold on the island, at Catalina shops on Los Angeles's historic Olvera Street, at the Wrigley-owned Arizona Biltmore in Phoenix, and through fine stores across the country. The best Catalina tile installations are on the island itself, at the old Bird Park, the Casino, the Country Club, the airport, and along Crescent Avenue. Numerous buildings in the town of Avalon display Catalina tile door surrounds, stair risers, and patios.

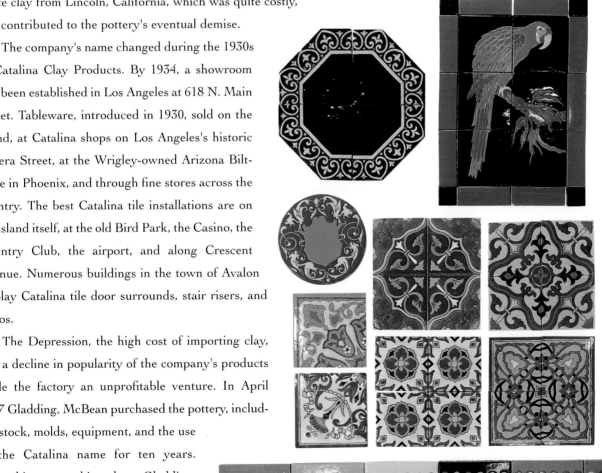

The Depression, the high cost of importing clay, and a decline in popularity of the company's products made the factory an unprofitable venture. In April 1937 Gladding, McBean purchased the pottery, including stock, molds, equipment, and the use of the Catalina name for ten years. Everything was shipped to Gladding, McBean's Glendale plant, where production of Catalina pottery—but not Catalina tile—continued.

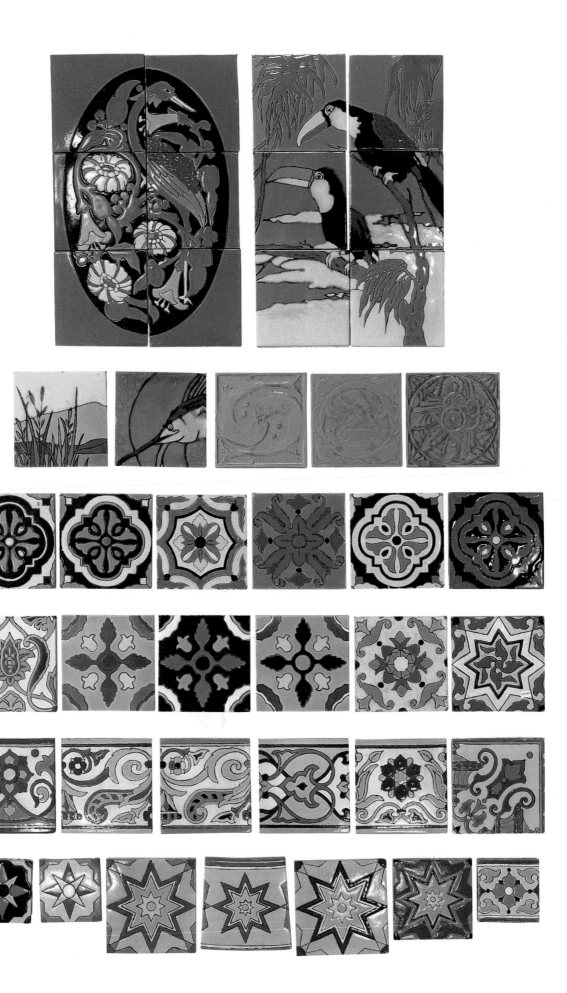

DECORATIVE ARTS INC.
(DEC ART TILES)
Hawthorne, California 1927–1933

DECORATIVE ARTS INCORPORATED WAS INCORPO-
rated on December 5, 1927.

Perhaps the best record of this little-known
enterprise, which operated between 1927 and 1933,
is a fifty-eight-page color catalog of decals that the
company published in 1928. The motifs (geometric,
floral, and scenic) covered the widest range of styles,
such as art nouveau, art deco, Native American, and
cartoon, to name a few. In addition, the company
made tiles for use as advertising.

The tiles had decals applied to a thin white
bisque, in a variety of sizes, including 8-, 6-, 4 ¼-, and
2-inch squares.

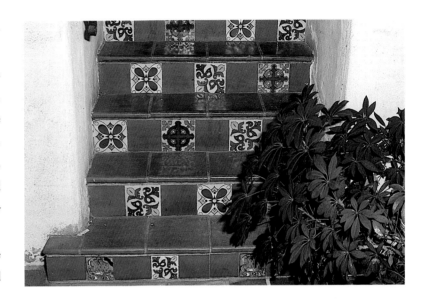

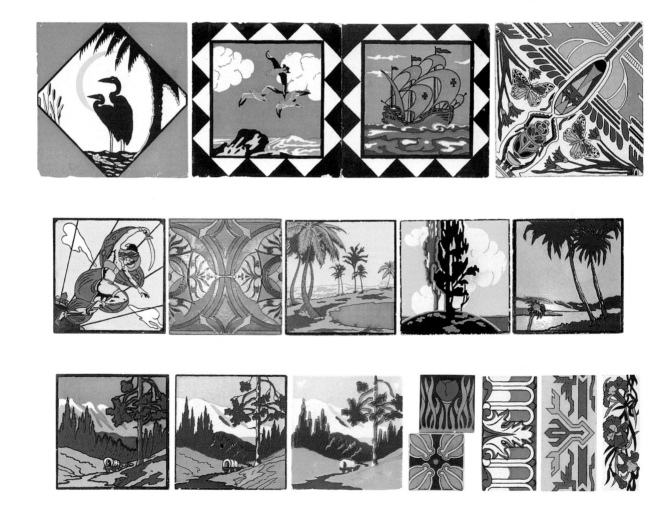

HISPANO MORESQUE TILE CO.

Los Angeles, California 1927–1932

HARRY C. HICKS STUDIO

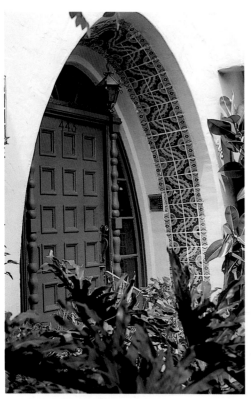

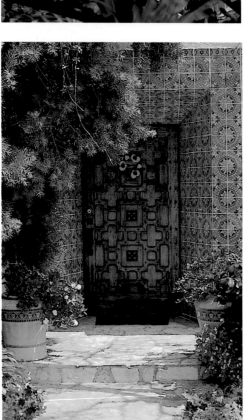

ALTHOUGH THE COMPANY'S PRODUCTION WAS QUITE PROLIFIC, LITTLE IS RECORDed about the Hispano Moresque Tile Company. Los Angeles directories list Harry C. Hicks under tile manufacturers from 1927 to 1929, at 4283 Beverly Boulevard. An undated catalog lists both Hispano Moresque and Hicks at the same address. Prior to coming to California, Hicks had manufactured stained-glass windows in England and then worked in New York.

Hicks and Hispano Moresque moved to 173 N. La Brea Avenue in 1929, next door to the Building Arts and Crafts showrooms. Hispano Moresque is listed here through 1932, with individual listings for Hicks as well in 1933 and 1934. As this address is located in a non-industrial business district, it was probably only a showroom and studio. It is unlikely that Hispano Moresque's factory, whose output must have been quite high, could have been located in this neighborhood. It is possible that the tiles were manufactured by the D. & M. Tile Company of Los Angeles, as many of D. & M.'s tiles are very similar in decoration, clay body, and shape (having tapered sides), to the tiles marked "Hispano Moresque" or "Harry Hicks." The majority of these well-executed tiles were six inches square, with Moorish designs in the "California" colors of yellow, orange, and turquoise green. There is a Hispano Moresque fountain in the entrance court of the Campanile restaurant at 624 S. La Brea Avenue, originally built to house Charlie Chaplin's offices.

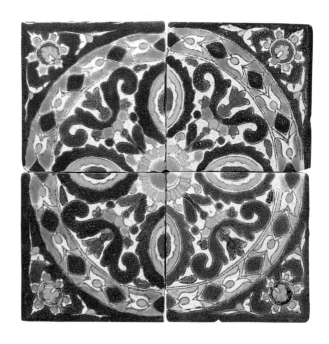

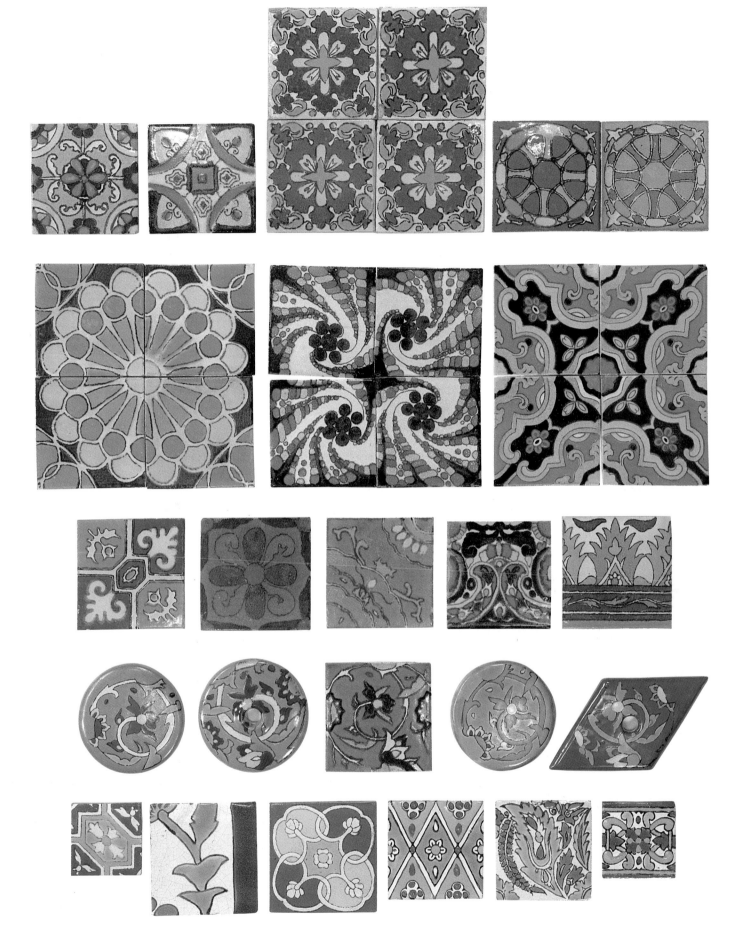

TUDOR POTTERIES, INC.

Los Angeles, California 1927–1931
TUDOR ART TILE CO.

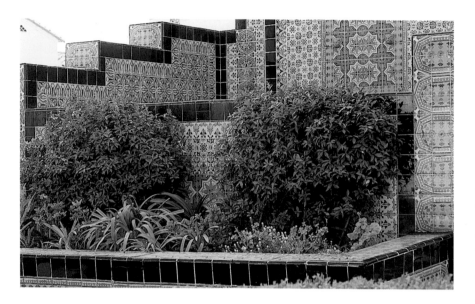

ORGANIZED IN 1927, AND LISTED IN local directories until 1931, Tudor Potteries was located at 5848 ½ Santa Fe Avenue in Los Angeles. The owners were H. C. Hill, C. J. Biddle, T. P. Cook, and George Skee (who also served as superintendent).

The Tudor Potteries produced hand-molded faience tiles and specialized in border, corner, and field tile combinations from which any size panel could be assembled. The company also manufactured tiles for fountains and store counters, as well as a wide variety of trim pieces. Tudor favored the colors popular in Southern California at the time: yellow, orange, turquoise, and green. Colors were often mixed to create a soft, blurred effect. Tudor's advertisements also boasted high-fired tiles for use on bulkheads, storefronts, and other exposed areas.

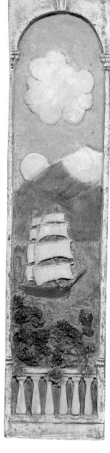
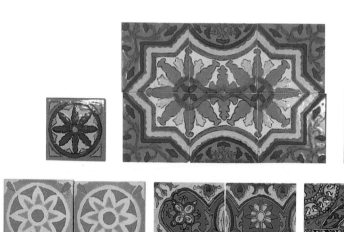

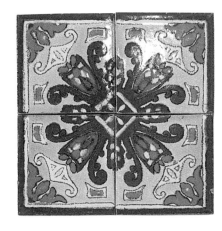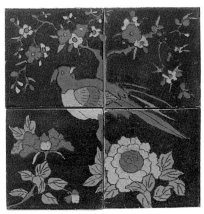

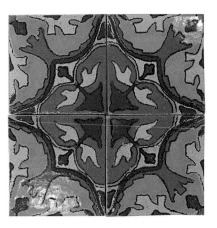

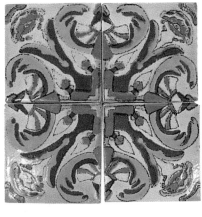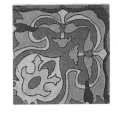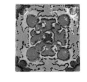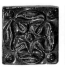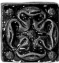

HALDEMAN TILE MANUFACTURING CO.

Hollydale, California 1928–1930

HOLLYDALE TILE

VIRGIL K. HALDEMAN, A CERAMICS ENGINEER, HAD A LONG AND DIVERSE CAREER IN THE CERAMIC TILE INDUSTRY. BORN IN Morrill, Kansas, Haldeman received a degree in ceramic engineering from the University of Illinois in 1923. He worked for the Beaver Falls Art Tile Company in Pennsylvania, conducting research on tile bodies and glazes before he moved to California in 1926. In California Haldeman was employed by Rufus Keeler at California Clay Products Company in South Gate, a suburb of Los Angeles.

Around 1928 Haldeman formed a partnership, called the Haldeman Tile Manufacturing Company, with the Cedarquist Showcase and Cabinet Company of Los Angeles, makers of cabinets and showcases used in stores and restaurants. The tile company was also known as Hollydale Tile. Its owners were Haldeman, Max Gunnerson, and N. H. Cedarquist. Some of the tiles produced at this factory were handmade four-inch pillow tiles similar to those made by Keeler at CALCO and the Malibu Potteries. After a short time, Haldeman Tile's production was absorbed exclusively by the Cedarquist Showcase and Cabinet Company, who used the tiles for soda fountain counters and butcher shop cases.

In December 1930 Virgil Haldeman left the Haldeman Tile Manufacturing Company and went to work at the Catalina Pottery. In 1933, with $300, Haldeman and his wife left Catalina, moved to Burbank, and started the Caliente Pottery at 41 E. San Jose Avenue. In 1951 the pottery moved to Calabassas, where it continued until 1953. Later Haldeman was hired by the Dallas Ceramic Company, where he

worked for two years on tile body and glaze research for wall tiles. He subsequently worked for Desert Ceramics in Albuquerque, New Mexico, and the Highland Tile Company in California. Virgil K. Haldeman died in 1979.

D. & M. TILE COMPANY

Los Angeles, California 1929–1933

D. & M. TILE WAS OWNED BY TWO MEN, JOHN L. DAVIES AND A MR. MC DONALD. LOS ANGELES CITY DIRECTORIES LOCATE the company from 1929 to 1933 at 707 Antonia, with a second 1933 listing at 425 N. Western Avenue.

Davies, who the directories list at the 707 Antonia address from 1934 to 1938, was an artist and ceramist. Born in Wales, Davies worked at Dalton on Staten Island, New York, and at Pacific Clay Products in Renton, Washington, before moving to Los Angeles. He died in 1937. Davies's partner Mc Donald was the salesman for the company.

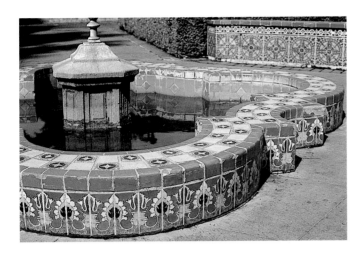

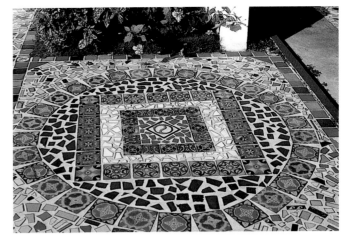

D. & M. Tile produced four-, five-, six-, and eight-inch tiles, as well as some circular tiles. The designs were mostly Moorish patterns in bright yellow, orange, turquoise, and blue. D. & M. tiles were used in The Mission Inn, Riverside, California; the Santa Barbara Biltmore, Santa Barbara, California; and on the Grace Line ocean liners *Santa Paula* and *Santa Rosa*.

It seems likely that there was some connection between D. & M. Tile and Hispano Moresque Tile Company, as many of the tiles have very similar characteristics, such as the decoration, bisque, and tapered sides of the tiles. Possibly D. & M. produced tiles for Hispano Moresque to sell.

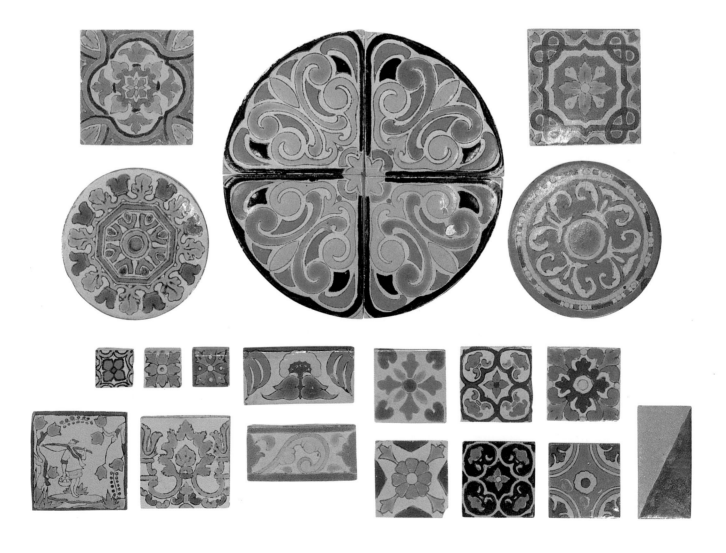

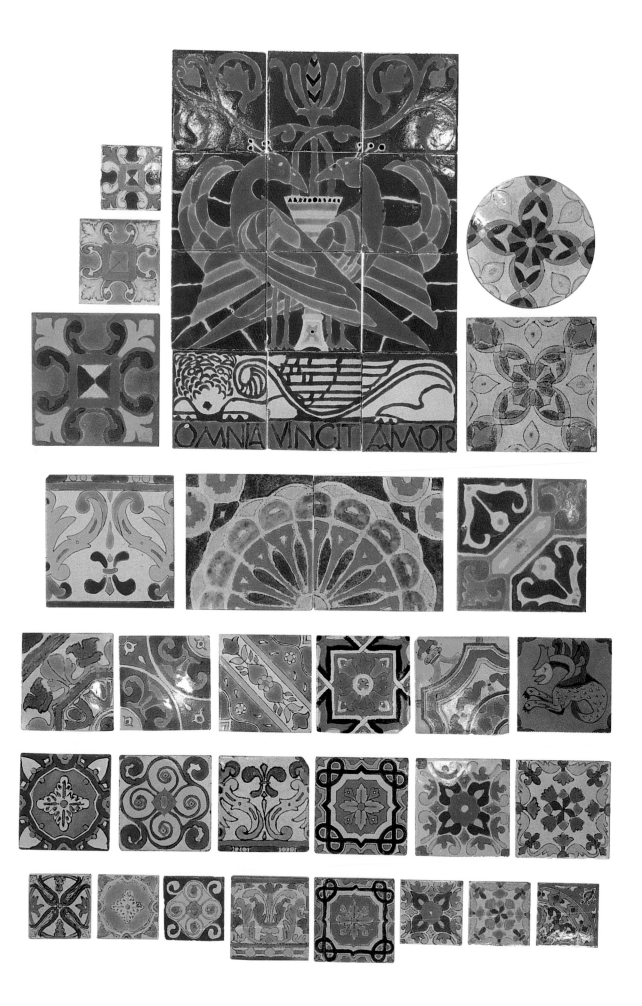

Biographical Profiles

The six profiles below represent the major ceramists and leaders of the American art tile industry. The foremost teacher, Charles Binns, exerted a profound influence on the industry as a whole, while the Robertson family is an example of a "dynasty" of potters whose work spans generations in both England and the United States. The works of these luminaries are woven through the history and production of fifty American art potteries.

Charles Fergus Binns

Charles Fergus Binns was born in Worcester, England, in 1857. His father, Richard William Binns, was the director of the Royal Worcester Porcelain Works. Charles studied chemistry and applied this knowledge to ceramics as an apprentice at Royal Worcester. He represented the pottery at the 1893 Chicago Exposition.

Binns emigrated to the United States in 1897 and became a consultant to the Ceramic Art Company in Trenton, New Jersey. In 1898 the Trenton School of Technical Science and Art opened, and Binns became principal.

In 1900 a school for ceramics was established at Alfred University in New York and Binns became its director. He developed the curriculum, which embodied a complete education on ceramic processes, including ceramic technology, the importance of craftsmanship, and design esthetics. In 1901 Binns established a summer school at the University, which taught painting and design as well as the technical aspects of ceramics.

Under Binns's direction Alfred University's ceramics program produced many of the most prominent figures in the American Arts and Crafts ceramics movement, including Arthur Baggs, William Victor Bragdon, Paul Cox, Elizabeth Overbeck, Mary Chase Perry, Adelaide Alsop Robineau, and Frederick Walrath. Recommendations by Binns were considered definitive. He was one of the most honored ceramists in the United States, even though his art pottery output was quite low. His knowledge of glaze technology was probably unequaled among his peers, and many leading ceramists often came to him for advice, which he gladly gave.

Binns was very active in ceramic and art organizations: he was a founding member of the American Ceramic Society, a fellow of the Boston Society of Arts and Crafts, and a member of the English Ceramic Society. He was a prolific writer, and in addition to many articles, Binns wrote three books, *Ceramic Technology* (1896), *The Story of a Potter* (1897), and *The Potter's Craft* (1909), all of which remained the definitive works on the subject for many years. Binns remained on Alfred's staff until his retirement in 1931. Charles Fergus Binns died in 1934.

Isaac Broome

Isaac Broome was born May 16, 1835, in Valcartier, Quebec. His parents, Isaac and Annie B. Broome, emigrated to Philadelphia, where the young Broome worked with Hugh Cannon, and attended the Pennsylvania Academy of Fine Arts. Broome was part of the team that carved the pediment of the dome of the Capitol Building in Washington, D.C. Following this engagement Broome lived in Rome for a year, studying classical sculptural styles and frescoes.

In the mid-1860s Broome established a short-lived studio in Philadelphia, where he produced decorative and architectural wares in terra cotta. Around 1871 he opened another studio in Brooklyn, but this was closed by the city's Board of Health, which felt his kilns would endanger the neighborhood. Broome continued to work on his paintings, frescoes, and sculpture.

Broome was hired by Ott & Brewer in 1875 to create pieces for the 1876 Centennial Exhibition in Philadelphia. For this commission Broome invented an innovative kiln that allowed for an even regulation and distribution of heat. In 1878, Broome was made special commissioner of ceramics for the United States Government and the State of New Jersey, and represented the U.S. at the Exposition Universelle in Paris that year.

In 1882 Broome, in partnership with M. S. Morgan, established the Dayton Porcelain Pottery in Dayton, Ohio, and produced vases. Broome moved into tile design and modeling in 1883 when he began working for the Trent Tile Company of Trenton, New Jersey. In 1886, he went to the new Providential Tile Works as its first modeler and designer. A prolific artist, during his tenures at both of these tile companies, Broome produced such a backlog of designs that the firms were able to produce "new" designs by Broome for years after he left. In 1890 Broome left Providential to work for the Beaver Falls Art Tile Company in Pennsylvania.

It is generally agreed that the best tiles from these three factories were Broome's work. Broome produced relief tiles and panels decorated with portrait heads, flowers and plants, or cultural scenes (artists painting, musicians playing instruments), modeled in meticulous detail and glazed in single-color, rich glazes that enhanced the depth of the modeling.

Broome spent the majority of his later years writing and lecturing. He occasionally modeled sculptural pieces on commission, such as a bust of John A. Roebling he sculpted for Lenox, Incorporated, in 1909. Isaac Broome died in Trenton, New Jersey, on May 4, 1922.

Cecil Jones

Born in England, Cecil Jones studied at the Government Art School in Coalbrookdale. In 1906, Jones worked as a designer and then art director at Godwin and Hewitt, a tile and architectural faience manufacturer in Hereford. Emigrating to the United States in 1913, Jones first worked for the American Encaustic Tiling Company in Zanesville, Ohio, as a modeler, and then became head of the company's research department. He was later transferred to A.E.T.'s Maurer, New Jersey, plant, and worked in conjunction with Leon Solon on the development of techniques and designs for architectural faience and tiles.

In 1919, Jones moved to California to work in the A.E.T. Los Angeles plant as head of the decorating department. In 1930, he left A.E.T. and worked with various potters in the Los Angeles area.

Jones worked for Fred and George Robertson at Claycraft Potteries for two years, during which time George married Jones's daughter, Dora. Jones then worked for Catalina Clay Products. In 1933 he moved to Colorado and worked at the Van Briggle Pottery and Broadmoor Art Pottery. Jones later returned to Los Angeles and worked for several other potteries.

Throughout his career Jones maintained his own studio work while working for others. While at A.E.T., Jones designed A.E.T.'s displays at the Metropolitan Museum of Art in New York, as well as the company's presentations for New York's Industrial and Architectural League exhibitions of 1921, 1922, and 1924. The Los Angeles County Museum showed Jones's work in conjunction with a lecture series he gave there in 1931.

Herman Carl Mueller

Herman Carl Mueller was born in 1854 in Rodach, Germany, the eldest of four sons born to Doretta and Elias Mueller. In 1868 Mueller was sent to the Nuremberg School of Industrial Arts, which his father, a master gunsmith, had also attended. He began to study sculpture in 1870 at the Munich Academy of Fine Arts, and spent four years apprenticing to several sculptors. After spending two years in the Honor Guard of the Army of Coburg, Mueller emigrated to the United States in 1878.

Mueller settled in Cincinnati, Ohio, which was known at the time both for its sizable German community and its reputation as a center of the arts. In 1882 Mueller joined the Matt Morgan Art Pottery as modeler. In 1885, Mueller began modeling for the Kensington Art Tile Company in Newport, Kentucky. The same year he received a commission to create nine figures for the portico and classical pediments of the Indiana State Capitol Building in Indianapolis.

Mueller took a job as modeler for the American Encaustic Tiling Company in Zanesville, Ohio, in 1887. At A.E.T. Mueller modeled individual relief tiles as well as multi-tile panels that were as large as twelve-by-twenty-four inches. These usually displayed figures in Italian Renaissance or classical Greek and Roman styles, as well as other portraits, landscapes, and abstract geometric designs. Karl Langenbeck, the noted ceramic chemist, joined A.E.T. in 1890, and the two men developed new ceramic processes.

In 1894 Mueller and Langenbeck left A.E.T. to establish the Mosaic Tile Company in Zanesville. The company began by producing utilitarian octagonal and hexagonal floor tiles as staple products, and then moved on to produce encaustic mosaics. Unlike standard mosaics, which used small, individual tiles, the system Mueller devised created six-inch square tiles comprised of one-eighth-inch encaustic tesserae were assembled in a mosaic pattern. The six-inch tiles were then installed to create murals. Designs were produced, in a myriad of historical styles, from Egyptian to Native American. In recognition of the system Mueller invented, he was awarded the John Scott Medal by the Franklin Institute.

Mueller was interested in education in the industrial arts. He lectured at Ohio State University in 1895 and was one of twenty charter members of the American Ceramic Society, founded in 1899.

Although Mueller and Langenbeck's supervision of the Mosaic Tile Company was quite successful, a management change intended to further industrialize the company discouraged these two great ceramists to such a degree that they left the firm. In 1903 Mueller was hired by National Tile to manage the design and estimating departments of their Robertson Art branch in Morrisville, Pennsylvania. During this time he began to plan his own company. In 1906, with the break-up of the National Tile conglomerate, Mueller and two brothers, James and George Grigsby, went back to work for Robertson Art Tile in Morrisville. The three men went on to establish the Mueller Mosaic Company in Trenton, New Jersey, in 1908.

At his new company, Mueller continued the development of his mosaic systems. The company proved quite successful, and Mueller was free again to turn his interests toward the support of education. He was appointed trustee for the Trenton Board of Industrial Arts in 1910, and served as president of the Trenton Board of Education from 1914 to 1919. Mueller wrote many widely-published articles, including several for the trade journal *The Clay Worker.*

When the Grigsby brothers died in 1916 and 1917, Mueller's sons Edward and William joined the company. Mueller Mosaic continued to produce decorative tiles, panels, and accessories, as well as a line of frost-proof tiles. During the 1920s Mueller developed a friendship with another great American ceramist, Henry Chapman Mercer. The two men had similar interests in history and art, the same initials, and similar artistic styles. The October Harvest mural in Mercer's Fonthill mansion bears marks from both Mueller and Mercer's Moravian Pottery. Why Mercer allowed Mueller to co-sign this piece remains a mystery. Mercer was not known to collaborate on projects. Possibly Mueller gave him technical advice on the creation of this panel, as the technique used appears to be different from any other Mercer installation.

The Depression, the move toward cheaper, industrialized materials for buildings, and the "moderne" decorative style that was popular in the 1930s, caused a great decline in demand for the company's products. Mueller would not give up his ideals concerning art, craft, and production. Herman Carl Mueller, remembered by many for his good-natured, lighthearted disposition, died in 1941 at age eighty-seven. The Mueller Mosaic Company closed shortly thereafter.

The Robertson Family

Four generations of Robertsons left their mark on American art tile and pottery history, beginning with James Robertson, who was born in Edinburgh, Scotland, in 1810. James himself came from four generations of Scottish and English potters. His father had been the head of the Fife Pottery in Dysart, Scotland, and it was there that James learned modeling and mold-making. James then worked for the Watsons of Prestonpans, Scotland, and various potteries throughout Scotland and England.

In 1853 James emigrated to the United States with his wife Isabelle Williamson, their daughter, and their three sons: Alexander William, Hugh Cornwall, and George W. Arriving in New Jer-

sey, James was employed by the ceramic manufacturer James Carr in South Amboy, and then by Speeler, Taylor and Bloor in Trenton. By 1860, most of the family had relocated to Boston. Hugh Cornwall Robertson (b. 1845) alone remained in New Jersey, apprenticing at the Jersey City Pottery.

In Boston James began producing crockery in partnership with Nathaniel Plympton, under the name Plympton & Robertson. In 1860, the firm was awarded third prize at the Massachusetts Charitable Mechanic Association Fair. Although the plant was sold two years later, James remained as manager of what was then known as the East Boston Pottery.

Alexander William Robertson (b. 1840) established a pottery in Chelsea, Massachusetts, in 1866. He was joined the following year by his brother Hugh. The factory eventually evolved into the Chelsea Keramic Art Works. The two brothers were joined by their father and another brother, George W., in 1872. James Robertson died in 1880, and in 1884 Alexander migrated west to California. Hugh remained at Chelsea, where he became obsessed with the development of new glazes. Though his experiments were successful, this preoccupation with developing new formulas to the exclusion of all else led to the pottery's closing in 1889. George then went on to establish another company, Robertson Art Tile, in Morrisville, Pennsylvania, in 1890, while the Chelsea works were reopened as Chelsea Pottery U.S., with Hugh continuing as manager. In 1891 the Chelsea factory was moved to Dedham, Massachusetts, and was renamed the Dedham Pottery. Upon Hugh Cornwall Robertson's death from lead poisoning in 1908, his son, William Augustin Robertson, ran the plant. And when William passed away, in 1929, his son, Joseph Milton Robertson, took over management of the factory until its closing in 1943.

Alexander had moved to the west to study the vast clay deposits in California. Realizing the potential of this great resource, he moved to Oakland. In 1891 Alexander met Linna Irelan. Together they founded the Roblin Art Pottery in San Francisco in 1898. In 1903 Alexander's son Fred H. (b. 1868) joined them. Unfortunately, the pottery was destroyed in the San Francisco earthquake of 1906 and was never rebuilt.

After the earthquake, Alexander and Fred moved to Los Angeles. Fred worked at the Los Angeles Pressed Brick Company and Alexander ran the Halcyon Art Pottery near San Luis Obispo, where he remained from 1909 until 1912. Alexander then went to the Alberhill Pottery in Alberhill, California, where he worked until 1914. Alexander William Robertson died in Glendale in 1925.

Fred left Los Angeles Pressed Brick in 1920, and joined Claycraft Potteries the following year. His son, George Beede Robertson, followed him to Claycroft in 1925. The noted ceramist Cecil Jones was also employed at Claycraft during this period, and it was at this time that George met Jones's daughter, Dora, whom he subsequently married.

Fred and George Robertson established the Robertson Pottery in Los Angeles in 1934. This firm remained in business in various locations in the Los Angeles area until 1952. Fred H. Robertson died on December 23 of that year.

George Beede Robertson and his cousin, Joseph Milton Robertson, who ran the Dedham Pottery until its closing, both died in 1966. This drew to a close an eight-generation history of Robertson family potters on both sides of the Atlantic.

Fred H. Wilde

Born on August 27, 1856, in Brosley, England, Frederick Harry Wilde was the son of John Wilde, a manufacturer of vitreous tiles. Fred Wilde worked at Maw and Company prior to his emigration to the United States in 1885.

Wilde's first job in the U.S. was as a ceramist with the English-backed firm of International Tile and Trim in Brooklyn, New York. In 1891 he began working for the Maywood Tile Company in Maywood, New Jersey, producing anchor-back tiles for stoves, hearths and mantels.

In 1900, Wilde went to work for the Providential Tile Company in Trenton, New Jersey, and by the end of the year he had changed jobs again and was working for Robertson Art Tile in Morrisville, Pennsylvania. At Robertson, Wilde was instrumental in creating a new line of glossy and matte colored glazes, as well as an excellent white wall tile.

When Robertson Art Tile joined the National Tile consortium in 1903, Wilde moved to California with his wife, Ellen, and their three children Possibly Wilde hoped to expand his creative horizons in the burgeoning California tile industry. He first worked as superintendent for the Pacific Art Tile Company in Tropico (now Glendale). The company's name changed the following year to Western Art Tile, and Wilde remained there until 1909. Many believe that Wilde may have operated his own pottery from 1909 to 1912, although there is no record of it. However, tiles with a bold imprint of "WILDE" on the back do exist.

In 1912 Wilde began to work for California China Products in National City, California. The firm had been commissioned to create tile installations for the Panama-California Exposition of 1915 in nearby San Diego. These installations, created under Wilde's direction, are now in the Museum of Man in Balboa Park and the Santa Fe (Amtrak) Railroad depot.

Wilde relocated in 1916 to Marin County in Northern California, where he was placed in charge of the pottery at the Arequipa Sanitarium. In a departure from his predecessors, Frederick Rhead and Albert Solon, Wilde switched the pottery's focus from vases to tiles. These tiles, primarily reproductions of Spanish designs, proved successful with local builders. Wilde remained at Arequipa until the discontinuation of the pottery in 1918.

The Wildes returned to Glendale that year. In 1923, at age sixty-seven, Fred was hired by the Pomona Tile Manufacturing Company in Pomona, California, as ceramic engineer. He remained at Pomona until he officially retired in 1940 at age eighty-four. Fred's son John, trained as a ceramic engineer at Ohio State University, also worked at Pomona and then at Catalina Clay Products. Frederick Harry Wilde died in Glendale on November 24, 1943, after a long and illustrious career.

GLOSSARY

Aerography, or Airbrush Decoration: Spraying of color or glaze.

Argile: French for clay.

Art Tiles: Decorated or solid color tiles fashioned with artistic creativity, as opposed to utilitarian production tiles.

Arts and Crafts Movement: A social and artistic movement that began in England in the latter part of the nineteenth century, it existed in America until about 1920. The movement was a rebellion against industrialization and a desire to return to the crafts tradition and the ideals of good design. Some of the best known tilemakers of this period were William Grueby, Rookwood, Newcomb, Henry Mercer, and the Van Briggle Pottery.

Azulejo: Portuguese or Spanish word for tile.

Back Stamp: The manufacturer's trademark or name pressed into the underside of a tile.

Ball Clay: A very plastic clay that fires to a white or pale cream color.

Barbotine: A mixing of different colors of slip clay by brush. One color is applied over another (Tarrytown Tile was known for using this process.)

Bas Relief: A shallow relief decoration, which is raised above the background without undercutting.

Bisque, or Biscuit: An unglazed but fired clay tile.

Body: The structure of a tile.

Burnt: Prior to 1930 it was common to use this term in place of "fired." This refers to the firing of tiles in a kiln.

Carreaux, Carrelages: French words for tile and tiles.

Cast: To pour liquid clay into a plaster mold.

Ceramic: From the Greek "keramos;" fired clay.

China: Ware made from a vitrified or semi-vitrified body.

China Painting: See "overglaze."

Clay: A plastic earth that becomes ceramic when fired. It is the result of decomposed feldspar, a mineral found in rock.

Crazing, Craquelee, Crackle: Fine cracks in a glaze caused by the uneven shrinking of the glaze and the body. Crazing is an unintentional occurance, while crackle is intentionally induced.

Crawling: The receding of glaze from the body during firing, caused by a dusty or greasy bisque.

Crystalline Glaze: A glaze that has microscopic or larger crystals.

Cuenca: Spanish word for basin (geographic). In this style, highline or raised-line ridges are formed in the tile bisque to separate different color areas. The colors are then often applied through a squeeze bag. This style of decoration originated in Spain, but is now in common use worldwide.

Cuerda Seca: Spanish for "dry string," this is a method of tile decoration that originated in Spain where a piece of string coated with wax was used to separate different color glazes. Today it is also referred to as "wax resist," as now a wax line is drawn on the tile to keep the different glaze colors apart.

Dado: A lower portion of a wall decorated differently from the top portion. Tiled dadoes are often either to the height of a chair rail or higher (see "wainscotting").

Decal Decoration, Decalcomania, Transfer: The French word "decalcomania" means to trace or copy. This is a process of decorating tiles with images printed on paper. The decoration is transferred from the paper to the already glazed and fired tile, which is then refired.

Delft: Originally, decoration that was painted in cobalt blue with a lead glaze in Delft, Holland. The name now generally refers to Dutch motifs or any decoration in blue and white.

Dry Line, or Black Line: Similar to wax resist except that instead of wax, an oil of fine tar or squeegee oil is applied to the tile, often with a silk screen, to keep the glaze colors apart.

Dust-pressed: Powdered clay with a small percentage of moisture pressed under great pressure into steel molds to form flat or heavy relief tiles.

Earthenware: Pottery made from common clay, usually fired no higher than 1,100 degrees centigrade.

Embossed: Relief tile.

Enamel Glaze: Finely ground vitreous materials used for overglaze painting on tiles that are already glazed. When fired the enamel fuses to the surface.

Encaustic Tile: A tile made up of two or more different colored clays to form a design. Now these are usually made with powdered clay, as opposed to plastic clay, which was used in medieval England.

Engobe: A thin coating of slip (liquid clay) applied to a tile to change the color, or give a finer surface than the clay body beneath.

Extruded: A form of tile or molding that has been forced through a cut-out metal die to form its shape, then usually wire-cut to length.

Faience: Originally, tin-glazed ware or majolica. In the United States in the 1920s it referred to glazed, decorated tiles on a rustic bisque.

Fayence: German for "faience."

Feldspar: Mineral that is found in granite and other rocks, which is an essential element in clay and glazes.

Field Tile: An area of plain, solid color tiles used with decorated inserts, panels, borders and trim.

Firing: The process of heating a kiln and its contents to the correct temperature.

Flashing: The process of permitting flames in a kiln to touch the ware, causing variegated effects. This is commonly used with terra-cotta tiles.

Glaze: A mixture of silica sand and other chemicals, which, when fired, becomes a glass coating. Applied to a tile bisque, it decorates, colors, or renders a tile non-porous.

Glost Firing: The process of firing bisque tiles to which glaze has been applied.

Graffito: (Italian, *sgraffito*): The process of scraping through a layer of slip for decoration.

Greenware: Ware that is dry but not yet fired.

Grout: The material used to fill the surface spaces between installed tiles. It is most commonly a mixture of cement, fine sand, and water.

Hand Thrown: Objects of clay formed by hand on a potter's wheel.

High-line, Raised-line: Ridges in a tile bisque that are formed to separate the different colors of glaze. The glaze is then applied with a squeeze bag. (See "Cuenca.")

Hispano-Moresque: A style of decoration from southern Spain in the fourteenth and fifteenth centuries, still very popular today.

Incise: To cut into the surface. Often, lines are cut to separate different color glazes; the work of Herman Mueller is a good example.

In glaze: Usually denotes a stain or colorant added to change the color of the base glaze.

Inlaid Tile Decoration: See "encaustic."

Intaglio: An indented pattern, the opposite of a relief pattern, usually filled with a dark colored glaze or underglaze slip.

Kaolin: A non-plastic type of clay, which is necessary in the making of porcelain. It fires to a white or nearly white color. Its name, spelled backward, was used by a well-known pottery in Benton, Arkansas.

Keramic: An old spelling for ceramic, from the German. This spelling fell out of favor around World War I.

Kiln: Oven, usually constructed of brick, designed specifically for high temperature firing of ceramic products. There are two basic types: periodic kilns, which are loaded, closed, fired, cooled and then opened; and tunnel kilns, in which tiles go in one end, pass through a heat zone, and come out the other end. This type can be in continuous operation twenty-four hours a day.

Lead Glaze: An ancient method using lead oxide, which produces brighter colors and is more forgiving in the glazing process. In recent years lead glazes have been outlawed on food containers and dinnerware, and will probably be banned in all ceramic production in the future.

Line Impressed: See "Incised."

Liner: A small tile used to create a line of color or decoration through a field of solid tiles. These tiles are generally ½ to 2 inches wide.

Luster: A tile decoration in which a thin metal layer is deposited on the surface of a glaze, giving iridescent color. It was first developed in tenth century Persia and later in fifteenth century Spain.

Maiolica: Italian spelling of "majolica," denoting Italian tin-glazed pottery.

Majolica: From the Spanish island of Majorca, where fine tin-glazed pottery was made in the fifteenth to eighteenth century, majolica refers to an opaque luster glaze and overglaze colored decoration. The English and American potteries of the Victorian era used the name for richly colored, opaque-glazed, embossed ceramics.

Matte, Matt, Mat: A non-glossy finish on a tile.

Modeling: Process of sculpting an original tile from which molds would be made for production tiles.

Mold: A negative form usually made of plaster of Paris into which plastic clay is pressed by hand or machine, or into which liquid clay is poured to form a tile.

Molded Decoration: A form of decoration that is in relief and formed in a mold.

Mosaic: Small tiles that are assembled and installed together, forming a design with variations of color or shape.

Olambrilla: Spanish word for small decorated tile, which is often used as an insert in a terra cotta or solid color floor. These are often two or three inches square.

On Glaze: See "Overglaze."

Oven: Another term for "kiln."

Overglaze, China Painting: Decoration that is painted over an already glazed and fired tile. This method is used to add brighter colors that will be refired at lower temperatures. It also makes it possible to have some decorated tiles to use in an installation of solid colored commercial tiles.

Piastrella: Italian word for tile.

Plastic Clay: Clay that has a high water content and can be shaped by hand. This type of clay is usually well aged, containing fine-grained clay particles.

Plastic Sketches: A term applied to hand-molded tiles that were made in limited editions by Arthur Osborne of the J. & J. G. Low Art Tile Works.

Porcelain: A hard, white, vitrified, translucent ceramic body originally produced in China. It is often called china. It is usually made of equal parts of feldspar, kaolin, and silica, and fired above 1,300 degrees centigrade. There are distinctions referred to as hard and soft porcelain.

Pottery: Term denoting ceramics of fired earthenware, glazed or unglazed, terra cotta or whiteware.

Pouncing: A method of transferring a design onto tiles by carbon-dusting through a perforated pattern sheet. The design is then painted over the carbon-dotted lines. When fired, the carbon marks disappear.

Press: A method of molding tiles by hand or machine.

Raised-line, High-line, Cuenca: Ridges produced on a molded tile bisque that are formed to separate the different colored glazes, which may then be applied with a squeeze bag.

Ram Press: An automated machine used for mass-producing tiles.

Reduction: A method of firing in which the oxygen in the kiln atmosphere is reduced so that the coloring oxides in the glazes give up oxygen, producing interesting effects in the resulting glaze colors. This method is commonly used with celadon, copper red, and luster glazes.

Refractory Tiles: Tiles that can withstand great heat. These tiles are used in fireplaces and cooking areas, and also as kiln furniture for making tiles.

Saggar: A protective case of fire clay used to fire other ceramics placed inside.

Salt Glaze: A glaze produced by the reaction at a high temperature of a ceramic body surface and salt fumes produced in the kiln atmosphere.

Sgraffito: Italian for "graffito."

Silk Screen: A method of applying decoration to tile. A screen of silk is blocked out except where the color is to be applied. A colorant is squeezed through to the tile. One design can use as many as six screens—one for each color.

Slip: A thin solution of clay and water used for decorating. This is sometimes colored, as in medieval English tiles.

Slip Decoration: Underglaze decorative process using slip.

Stencil Decoration: Decoration of color or slip that is applied with a brush or sprayed through a stencil.

Stoneware: A very hard, vitreous, opaque ware fired at a temperature between 1,200 and 1,300 degrees centigrade.

Talc: A fine grained mineral found in Death Valley, California. It is used to produce dust-pressed tiles for commercial production.

Tegel: Dutch word for tile.

Terra Cotta: Any low fired, unglazed, porous ware, often used for floors, garden pottery, and architectural building pieces.

Terre Cuite: French term for terra cotta, or "cooked earth."

Tesserae: Small mosaic tiles that are assembled together. The term often refers to small geometric shapes composed into areas and also often combined with encaustic tiles.

Tile: Taken from the Latin "tegula," or cover, which is also the Italian word for roof tiles. A flat, fired, clay product used for cladding on walls, floors, and roofs.

Tin Glaze: An opaque white glaze resulting from the presence of tin oxide, used as a basis for maiolica, faience, and delftware.

Transfer Decoration: See "decalcomania."

Trim: All of the additional tile pieces needed to complete an installation. Some examples of these pieces are bead, bullnose, cove, cap, chair rail, angle, ogee, and liner.

Tube Lining Decoration: This method achieves the same result as high-line. High-line is generally used for large quantities of tile, with the line produced in the molding of the tile. Tube lining, a hand process which uses a squeeze bag to form the line, is used for small amounts of tile. In this process, a thin, spaghetti-like line of clay slip is applied to the bisque which is used to separate the different colored glazes applied afterwards.

Under Glaze Decoration: An application of decoration applied to the bisque prior to the application of glaze. (See also "slip decoration.")

Vellum Glaze: A semi-matte glaze with a satin-like surface.

Vitreous: From the Latin "vitreus," meaning glassy. A body that has been high-fired, resulting in chemical changes that produce a body impervious to liquid absorption.

Wainscotting: The area of a tiled wall that is installed from the floor to chair rail height, or slightly higher, with a border or cap finishing the area.

Wax Resist: See "Cuerda Seca."

SOME NOTES ON THE PHOTOGRAPHS

TILE BACKS

The following photographs show the backs of tiles that have makers' identifying emblems. Machine-made bisque tiles with factory names in relief or rustic tiles with clear imprints of makers are not included.

Many rustic hand molded tiles exist with no marks at all. Sometimes experts can identify unmarked tiles by gauging the clay composition by color or texture, or by examining the impressions on the back surface produced by screeding during the molding of the tile.

Acme Tile Co.,
South California

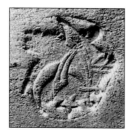

Alhambra Tile Co.,
Kentucky

American Encaustic
Tiling Co.,
Ohio

Atlantic Tile & Faience or
Atlantic Tile Mfg. Co.,
New Jersey

Broadmoor
Art Pottery,
Colorado

Byrdcliffe,
New York

California China
Prod. Co.,
California

Cathedral Oaks,
North California

Dedham Pottery,
Massachusetts

Flint Faience
and Tile Co.,
Michigan

Susan Frackelton,
Wisconsin

G.E.T.,
Ohio

Gladding McBean,
South California

Handcraft Guild
of Minneapolis,
Minnesota

International
Tile and Trim,
New York

Kensington,
Kentucky

Helen Lane,
South California

Marblehead Pottery,
Massachusetts

Mosaic Tile Co.,
Ohio

National Tile Co.,
Indiana

Newburgh
Tile Works,
New York

Newcomb Pottery,
Louisiana

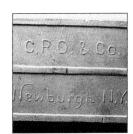

New York Architec-
tural Terra Cotta Co.,
New York

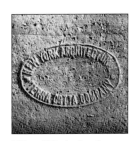

Charles R.
Owens Co.,
New York

Overbeck Pottery,
Indiana

Ozark Tile,
Unknown

Raritan Art
Tile Works,
New Jersey

Robert Rossman,
Pennsylvania

Rookwood Pottery,
Ohio

San Jose Pottery,
Texas

Shawsheen Pottery,
Iowa

Solon and Schemmel,
North California

Strobl Tile Co.,
Ohio

TECO,
Illinios

Unitile,
Ohio

Van Briggle Pottery,
Colorado

Walrich Pottery,
North California

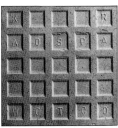

West Coast
Tile Co.,
North California

Wheatley Pottery,
Ohio

WACO,
Washington

SELECTED READING

American Art Pottery. Cooper-Hewitt Museum, Watkins Glen, NY, 1987.

Barber, Edwin Atlee. *Pottery & Porcelain of the U.S.* Revised edition. Watkins Glen, NY: Century House Americana, 1971.

Bowman, Leslie Green. *American Arts & Crafts, Virtue in Design.* Boston: Little, Brown & Co., 1991.

Bray, Hazel B. *The Potter's Art in California 1885–1955.* Oakland Museum, Oakland, CA, 1978.

Bruhn, Thomas P. *American Decorative Tiles, 1870–1930.* Univ. of Conn., Storrs, CN: The William Benton Museum, 1979.

California State Division of Mines & Mining Bulletin No. 99, January 1928.

Cameron, Elisabeth. *Encyclopedia of Pottery & Porcelain, 1800–1960.* New York: Facts on File Publications, 1986.

Chipman, Jack. *Collector's Encyclopedia of California Pottery.* Paducah, KY: Collector Books, 1992.

Clark, Garth. *American Ceramics, 1876 to the Present.* New York: Abbeville Press, 1987.

Clark, Robert Judson. *The Arts and Crafts Movement in America, 1876–1916,* The Art Museum, Princeton University, Princeton, NJ, 1972.

The Clay Industry in California, California State Mining Bureau Preliminary Report No. 7 (January, 1920).

Derwich, Jenny B. and Dr. Mary Latos. *Directory Guide to U.S. Pottery & Porcelain.* Franklin, MI: Jenstan, 1984.

Evans, Paul. *Art Pottery of the United States.* New York: Feingold & Lewis Publishing Corp., 1987

Frelinghuysen, Alice Cooney. *American Porcelain 1770–1920.* New York: The Metropolitan Museum of Art, 1989.

Furnival, William James. *Leadless Decorative Tiles: Faience and Mosaic.* W. J. Furnival Stone, Staffordshire, 1904.

Henzke, Lucile. *Art Pottery of America,* Exton, PA: Schiffer Publishing Co., 1982.

Herr, Jeffrey. *California Art Pottery 1895–1920,* California State University-Northridge, 1988.

In Pursuit of Beauty, Americans and the Aesthetic Movement. The Metropolitan Museum of Art, New York, 1986.

Kaplan, Wendy. *The Art That Is Life: The Arts & Crafts Movement in America ,1875–1920.* Boston: Little, Brown & Co., 1987.

Ketchum, William C. *Potters and Potteries of New York State, 1650–1900.* Syrause, NY: Syracuse University Press, 1987.

Kovel, Ralph and Terry. *Kovel's Collectors Guide to American Art Pottery.* New York: Crown, 1974.

The Ladies, God Bless 'Em. Cincinnati Art Museum, 1976.

Lehner, Louis. *Lehner's Encyclopedia of U.S. Marks on Pottery & Porcelain & Clay.* Paducah, KY: Collector Books, 1988.

Nelson, Marion John. *Art Pottery of the Midwest.* University Art Museum, University of Minnesota, Minneapolis, 1988.

Perry, Barbara. *American Ceramics: The Collection of the Everson Museum of Art,* New York: Rizzoli Publications, 1989.

Purviance, Louise and Evan. *Zanesville Art Tile in Color.* Des Moines, IA: Wallace Homestead Book Co., 1972.

The Structural and Industrial Materials of California. California State Mining Bureau Bulletin No. 38 (January, 1906).

Townsend, Everett. "Ceramic History." *Bulletin of the American Ceramic Society,* Vol. 22 No. 5, May 15, 1943.

Trapp, Kenneth R. *The Arts & Crafts Movement in California: Living the Good Life.* New York: Abbeville, 1993.

Tunick, Susan. *Sites 18.* Lumen, Inc., 1986.

Volpe, Tod M. and Beth Cathers. *Treasures of the American Arts & Crafts Movement 1890-1920.* New York: Harry Abrams, Inc., 1988.

Wires, Stanley, Norris F. Schneider, and Moses Mesre. *Zanesville Decorative Tiles,* Zanesville, OH.: Zane Antiques, 1972.

Wires, Stanley. "Decorative Tiles." Technology Review, M.I.T. Cambridge, MA: Jan.-Feb. 1954.

Periodicals

Arts & Crafts Quarterly magazine (1986–Present).

Brickbuilder (ca. 1905–1912).

Clay Record (ca. 1893–1902).

Clay-Worker (ca. 1902–1931).

Flash Point: Quarterly Bulletin of the Tile Heritage Foundation (Joseph Taylor, President; January 1988–Present).

Journal of the American Art Pottery Association (1986–Present).

The Mantel, Tile, and Grate Monthly (ca. 1907-1918).

SOURCES OF INFORMATION

This book represents more than ten years of tile collecting, fieldwork, and research, during which I have pored over numerous old books, documents, newspaper clippings, catalogs, city directories, and the like; spoken with fellow tile enthusiasts, descendants of tile makers, town historians, and other people who were able to shed some light on the history of often obscure potteries; and scoured the archives of potteries and local libraries for information. Many of the sources I used are listed below; unfortunately, space considerations prevent me from including an exhaustive list. As many of the sources were old, incomplete, or self-published, full bibliographical information was not always available. In order to fit in as much source information as possible, I have abbreviated many of the references after the first mention; I apologize for any difficulty readers may have in deciphering this list.

NEW ENGLAND

United States Pottery

The Potters and Potteries of Bennington, John Spargo, 1926.

Our Pioneer Potters, Arthur W. Clement, 1947.

American Clay Exchange, "The Bennington Potteries," Mel Tharp, June 1987.

American Clay Exchange, "Bennington Pottery Lore," Anne Raisch, January 1983.

Chelsea Keramic Art Works

Untitled article, J. Milton Robertson, January 1, 1938.

Antiques Magazine, Lloyd E. Hawes, March 1966.

A museum brochure, "Yesterday and Tomorrow," The Story of Robertson Ceramics, n.d.

J & J. G. Low Art Tile Works

Spinning Wheel, "The Low Family of Chelsea, Massachusetts and Their Pottery," Morse, September 1977.

Collectors News, June 1981.
"Some American Tiles," *Harper's Magazine,* April 1882.
Low Art Tile Catalog, 1884.

Grueby Faience and Tile Co.
House Beautiful, July 1916.
International Studio, March 1922.
Atwood & Grueby catalogue, n.d.
Grueby, Everson Museum of Art, 1981.
Ceramic Ornament in the New York Subway System, Susan Tunick.

Hartford/Faience Co.
The Brickbuilder, February, June, July, August, October, 1904; March, October, 1905; January, March, July 1909; March, May, August, 1910.
Ceramic Trade Directory, 1929.
Letter from the Connecticut Historical Society, 1990.
The Wolfsonian Foundation, Miami, letter April 2, 1991.

Dedham Pottery
Dedham Pottery catalogue, 1938.
The Dedham Pottery, Lloyd E. Hawes, M.D., 1968.

Merrimac Pottery
Exhibition catalogue, Society of Arts and Crafts, Copley Hall, Boston, 1899.

Marblehead Pottery
Keramic Studio, June 1908.
Marblehead Magazine, Gail Pike Herscher, Fall 1980.
American Art Pottery Monthly, March 1981.
Journal of the American Art Pottery Association, February 1989.

Saturday Evening Girls' Club
House Beautiful, August 1914; January 1922.

New York

Union Porcelain Works
Pennsylvania Museum Exhibition of Tiles, 1915.
Our Pioneer Potters, Clement, 1947.
American Potters and Pottery, John Ramsay, 1976.

The Tile Club
"A Catalogue of Work in Many Media by Men of the Tile Club," Lyman Allan Museum, Mahonri Sharp Young, 1945.
The American Art Journal, "The Tile Club Revisited," Mahonri Sharp Young, Fall 1970.
Scribner's Monthly, "The Tile Club at Play," February 1879.
The Century Magazine, "The Tile Club Ashore," February 1882.

Charles Volkmar
International Studio, March 1905; January 1909.
Journal of the American Art Pottery Association, David Rago, November, December, 1984.
Journal of the American Arts & Crafts Quarterly, Dr. Arthur Goldberg, Spring 1988.

Odell & Booth Bothers
Tarrytown Pottery/Odell & Booth Brothers catalogue, n.d.
The Daily News, Tarrytown, July 2, 1957; September 10, 1978.

Art & Antiques, "Odell & Booth Brothers, Art Potters of Tarrytown," Leigh Keno, March/April 1980.
Tarrytown Sunnyside Press, September 18, 1880.

International Tile & Trim
Bulletin of the American Ceramic Society, 1943, Vol. 22, No. 5.
Victorian Ceramic Tiles, Julian Barnard, 1972.

Newburgh Tile Works
Newburgh, N.Y., City Directories, 1883 to 1892.
Tarrytown, N.Y., City Directories, 1891-1892.
State of New Jersey, Certificate of Full Incorporation of the Owen Tile Manufacturing Co. Ltd., May 25, 1891.
The Daily News, Tarrytown, July 2, 1957.
Stephen Davis, M.D., letter of May 5, 1992.

New York Architectural Terra Cotta Co.
Popular Science Monthly, January 1892.
New York Times, March 29, 1987.

Atlantic Terra Cotta Co.
The Mantel, Tile, and Grate Monthly, August 1913; May 1915.
Ceramic Trade Directory, 1929.
History of Perth Amboy, New Jersey, 1651–1962, William C. McGinnis.

Robineau Pottery
Good Housekeeping, January 1910.
House Beautiful, April 1913.

Tiffany Pottery
The Arts & Crafts Movement in New York State, Coy Ludwig, 1983.

Byrdcliffe Notes
Woodstock: History of an American Town, Alf Evers, 1987.
Art Pottery of the United States, Evans, 1987.
The Art That Is Life, The Arts & Crafts Movement in America 1875–1920, Robert Edwards, "The Art of Work," 1987.
The Official Identification and Price Guide to Arts and Crafts, Bruce Johnson, 1988.

New Jersey

Fulper Pottery
The Clay-Worker, October 1928.
Fulper Glazes, Inc., tile brochure, 1990.
Arts & Crafts Quarterly, "John Kunsman, Fulper's Master Potter," Thomas C. Folk, November 15, 1991.

Burroughs Mountford & Co.
The Potter's Wheel & How It Goes Around, Burroughs & Mountford, date unknown.
Popular Science Monthly, January 1892.

J. L. Rue Pottery
The Pottery and Porcelain of New Jersey, 1688–1900.
American Decorative Tiles 1870–1930, University of Connecticut, 1979.
Monmouth County, A Pictorial History, Robert F. Van Benthuysen, 1983.
Letter from New Jersey State Museum, May 22, 1992.

Trent Tile Co.
The Popular Science Monthly, January 1892.

Trent Tile Co. brochure, Alfred Wilson Lawshe, January 1905.
Bulletin of the American Ceramic Society, Vol. 22, No. 5., 1943.
Kovel's Collection Guide, 1974.
Trent Decorative Tiles, Michael A. Zacconia, 1988.

Raritan Art Tile Works
New Jersey State Museum, Susan Finkel, 1994.

Providential Tile Works
The Popular Science Monthly, January 1892.
The Mantel, Tile, and Grate Monthly, January 1914.
Bulletin of the American Ceramic Society, Vol. 22, No. 5, 1943.
Victorian Ceramic Tiles, Julian Barnard, 1972.

The Old Bridge Enameled Brick & Tile Co.
The Mantel, Tile, and Grate Monthly, May 1909; June 1910; October
 1910; January 1911; February 1913; May 1913; November
 1914; September 1917.
The Clay-Worker, July 1927.
Bulletin of the American Ceramic Society, Vol. 22, No. 5, 1943.

C. Pardee Works
C. Pardee Works, Catalogue of Delft Faience & Tile, 1924.
Pardee Tile catalogue, 1928.
The Clay-Worker, August 1930; September 1930.
Bulletin of the American Ceramic Society, Vol. 22, No. 5, 1943.
Sites 18, 1986.

Maywood Art Tile Co.
Bulletin of the American Ceramic Society, 1943.

Architectural Tiling Co. (ATCO)
Keyport Weekly, April 28, 1911.
Matawan Journal, August 10, 1916.
Ceramic Trade Directory, 1929.
ATCO advertisements, April 1929, September 1930.
Bulletin of the American Ceramic Society, Vol. 22, No. 5, 1943.
Letter from Jack Jeandron, February 3, 1990.

Matawan Tile Co.
The Mantel, Tile, and Grate Monthly, December 1904; March 1916.
Ceramic Trade Directory, 1929.
Matawan Journal, October 20, 1931; September 10, 1936.
*The Early Makers of Handcrafted Earthenware and Stoneware in Central
 and Southern New Jersey,* M. Lelyn Branin, n.d.
Matawan 1686–1936, Alexander L. Crosby, 1936.
Bulletin of the American Ceramic Society, 1943.
Matawan Historical Society, briefing for exhibition, "The Clay
 Industries of Middletown Point," 1990.
Matawan Historical Society Newsletter, Spring 1990.

Clifton Art Pottery
The Mantel, Tile, and Grate Monthly, October 1914.

M.A. Metzner Manufacturing Co.
The Mantel, Tile, and Grate Monthly, March 1901; January 1915.
The Clay-Worker, July 1927; May 1928.
Bulletin of the American Ceramic Society, Vol. 22, No. 5, 1943.

Mueller Mosaic Co.
Mueller Tile catalogue, n.d.
The Clay-Worker, January 1901; July 1921; September 1921.
Art & Decoration, March 1927.

Sunday Times Advertiser, June 5, 1927.
Trenton Times, February 2, 1979.
*Herman Karl Mueller: Architectural Ceramics and the Art & Crafts
 Movement,* Lisa Factor Taft, 1979.

Atlantic Tile & Faience
The Mantel, Tile, and Grate Monthly, November 1909; October 1911;
 December 1913.
Bulletin of the American Ceramic Society, Vol. 22, No. 5, 1943.

Atlantic Tile Manufacturing. Co.
The Mantel, Tile, and Grate Monthly, June 1910; October 1910.
The Clay-Worker, March 1931.
Matawan Journal, September 10,1930; February 28, 1936.
Bulletin of American Ceramic Society, 1943.
Matawan Historical Society, "The Clay Industries of Middletown
 Point" exhibition, 1990.

Harikan Art Products
Tile Products Co., Inc., advertisement in *Matawan Journal,* Septem-
 ber 10, 1936, and in *Keyport Journal,* October 17, 1940.
Letter from Sarah H. Ellison, May 22, 1992.

Pennsylvania

Hyzer & Lewellen
Exhibition of Tiles, Pennsylvania Museum, 1915.
Smithsonian Studies in History and Technology, n.d.

Pittsburgh Encaustic Tile Co.
Pennsylvania Historical Reviews: Cities of Pittsburgh and Alleghe-
 ny, 1866.
*Industries of Pittsburgh: Trade, Commerce, and Manufactures for 1879 and
 1880,* Richard Edwards, 1879.
Allegheny County: Its Early History & Subsequent Development, Alleghe-
 ny County Centennial Committee, 1888.
Victorian Ceramic Tiles, Julian Barnard, 1972.
Tiles: A Collector's Guide, Hans Van Lemmen, 1979.

Park Porcelain Works
Exhibition of Tiles, Pennsylvania Museum, 1915.

Beaver Falls Art Tile Co.
History of Beaver County, Rev. Joseph H. Bausman, 1904.
Beaver Falls Tribune, "Beaver Falls Art Tile Co. Builds Large New
 Plant," August 25, 1923.
Bulletin of the American Ceramic Society, Vol. 18, No. 6, June 1939.
Bulletin of the American Ceramic Society, Vol. 22, No. 5, 1943.
"Beaver Falls Art Tile Co.," article by George C. Walker, 1984.

Robertson Art Tile Co.
The Mantel, Tile, and Grate Monthly, July 1907; October 1907.
Ceramic Trade Directory, 1929.
The Clay-Worker, April 1932.
Bulletin of the American Ceramic Society, Vol. 22, No. 5, 1943.
Victorian Ceramic Tiles, Barnard, 1972.

Moravian Pottery & Tile Works
House Beautiful, May 1915.
Philadelphia Inquirer, July 28, 1974.
American Art Pottery, Duke Coleman, No. 32, January 1979.

The Mercer Mile, Helen Hartman Gemmill, 1987.

Henry Chapman Mercer and the Moravian Pottery and Tile Works, Cleota Reed, 1987.

Mercer Mosaic (The Journal of the Bucks County Historical Society) Vol. 6, Nos. 2–3, "Henry Chapman Mercer, An Annotated Chronology," Linda F. Dyke, Spring/Summer 1989.

Enfield Pottery

Enfield Pottery & Tile Works catalogues of 1907, 1925, 1928.

"A Synopsis of the History, Raw Materials and Character of Products," Enfield Pottery & Tile Works, 1914.

The Bridge over the Delaware River: Final Report of the Board of Engineers, n.d. (ca.1922–1926).

Ceramic Trade Directory, 1929.

Montgomery County: The Second Hundred Years, Jean Barth Toll and Michael J. Schwager, 1983.

Franklin Tile Co.

The Clay-Worker, July 1930.

North Penn Reporter, Lansdale, February 7, 1936.

Bulletin of the American Ceramic Society, Vol. 22, 1943.

The Tile Times, Special Anniversary Issue, April 23, 1954,

American Olean Tile Co. brochures, 1923/1973, 1973.

Notes on a Fifty-year Revolution, Frederic Bell, 1973.

Roy W. Schweiker, family letter, "Very briefly....M. A. and R. W. Schweiker—Why Ceramic Tile?" June 21, 1990.

Interview with Roy A. Schweiker, April 16, 1991.

Robert Rossman Co.

The Mantel, Tile, and Grate Monthly, July 1908; October 1908; August 1909; November 1909; April 1910; March 1912; November 1914.

The Clay-Worker, July 1927.

Sweet's Catalogue, "Rossman Corp.," 1930.

Bulletin of the American Ceramic Society, 1943.

OHIO

Weller Pottery

S. A. Weller Co. Tile catalogues, n.d..

Weller Pottery advertisement, Keramic Journal, May 1930.

Zanesville Decorative Tiles, Stanley Wires, Norris Schneider, and Moses Mesre, 1972.

American Encaustic Tiling Co.

Biographical & Historical Memoirs of Muskingum County, Ohio, 1892.

Y Bridge City: The Story of Zanesville and Muskingum County, Ohio, Norris F. Schneider, 1950.

Zanesville Times Recorder, "A.E. Tile Company's First Plant Here Is Demolished," Schneider, October 27, 1963.

Zanesville Times Recorder, "Factories Here Pioneered In Decorative Tile," Schneider, 1972.

Zanesville Decorative Tiles, Wires, Schneider, and Mesre, 1972.

American Art Pottery: 1875-1930, Keen, 1978.

Antique Collector, November 1989.

Mary Louise McLaughlin

"Overture of Cincinnati Ceramics," a handwritten manuscript given to the Ohio Historical Society, 1890.

American Art Pottery: 1875-1930, Keen, 1978.

Rookwood Pottery

House Beautiful, John Valentine, Vol. IV, No. 4, 1897.

Architectural Record, April 1905.

Rookwood Pottery Co. Architectural Department catalogue, 1912.

Spinning Wheel, October 1969.

Zanesville Majolica Co.

Zanesville Courier, July 28,1883

The Zanesville Majolica Company, Michael Sims, 1991.

Ohio Encaustic Tile Co.

Michael Sims, essay on the Ohio Encaustic Tile Company, n.d..

"Ohio Encaustic Tile Co.," Michael Sims, *Flash Point*, Vol. 5, No. 2.

Hamilton Tile & Pottery Co.

The Centennial Anniversary of the City of Hamilton, Ohio, 1892.

Clay Record, August 29, 1893.

A Concise History of Hamilton, Ohio, Stephen D. Cone, 1901.

Hamilton City Directories, 1881–1910.

Hamilton Journal News, "Work of Hamilton Artist, Long Dormant, Hailed As Noted Civil War Documentary," Steven L. Beeler, June 21, 1961.

Interview with Michaela Dzurisin, April 3, 1991, great-grand-daughter of Adolf Metzner.

Letter from Sister Justine Apfeld, July 24, 1991.

Cambridge Art Tile Works

Covington, Kentucky, directories, 1880–1931.

Kentucky Post, December 7, 1899; November 3, 1904; March 2, 1912.

The Cambridge Wheatly Catalog A, 1928.

Cambridge Art Tile Works catalogue, Covington, date unknown.

"Suntile by Cambridge" catalogue, 1941.

Bulletin of the American Ceramic Society, Vol. 22, No. 5, 1943.

Antique Collector, November 1989.

Kirkham Art & Pottery Co.

Illustrated Summit County, Ohio, 1891.

Akron, Ohio, city directory, 1892–93.

Barberton Herald, March 21, 1955.

The Story of Barberton: 1891–1962, George Davis.

The Potters & Potteries of Summit Country: 1828–1915, C. Dean Blair, 1974.

Ohio Pottery and Glass Marks and Manufacturers, Lois Lehner, 1978.

J. B. Owens Floor and Wall Tile Co.

Tile Talk: An Owens Magazine, July 1928.

The Clay-Worker, March 1928, April 1928.

Bulletin of the American Ceramic Society, Vol. 22, No. 5, 1943.

Zanesville Art Pottery, Schneider, 1963.

Ohio Pottery and Glass Marks and Manufacturers, Lehner, 1978.

Mosaic Tile Co.

The Mosaic Tile Co. catalogue, 1897.

The Clay-Worker, March 1931.

Bulletin of the American Ceramic Society, Vol. 22, No. 5, 1943.

The Mosaic Tile Co. Fiftieth Anniversary Program, 1944.

Zanesville Decorative Tiles, Wires, Schneider, and Mesre, 1972.

Interview with Don Quick, former general manager of General Tile, January 9, 1993.

G.F. Brunt
The Mantel, Tile, and Grate Monthly, May 1914; August 1914; November 1914.
Columbus, Ohio, city directories, 1915 to 1917.
Geological Survey Bulletin 26, 1923.

Wheatly Pottery
The Mantel, Tile, and Grate Monthly, May 1910; September 1910; April 1911.
The Clay-Worker, March 25, 1921.
Cincinnati, Ohio, city directories, 1880–1924.

Strobl Tile Co.
Cincinnati, Ohio, city directories, 1899 to 1924.
The Mantel, Tile, and Grate Monthly, Stroble Tile Co. advertisements, December 1911; March 1912; April 1912.
Cincinnati, the Queen City: 1788–1912, Vol. 4, 1912.
Geological Survey of Ohio, 1923.
Telephone conversation with Robert E. Seery, June 2, 1992.

A. E. Hull Pottery Co.
Lovely Hull Pottery, Book 1, Sharon Loraine Felker.
Lovely Hull Pottery Book 2, 1977.
The Collectors Encyclopedia of Hull Pottery, Brenda Roberts, 1987.
Hull, the Heavenly Pottery, Joan Gray Hull, 1990.

Stark Ceramics
Autobiography of Enos A. Stewart, with H. T. O. Blue, 1974.
Telephone conversation with Carl Deimling, February 18, 1992.
Letter from Carl Deimling, February 27, 1992.
Telephone conversation with Dorothy Blosser, March 27, 1992.
Telephone conversation with Dean Dawson (son of Russell Dawson), January 6, 1993.

Cowan Pottery Studio Inc.
Spinning Wheel, "Cowan Pottery," John Brodbeck, March 1973.
Booklet from Cowan Pottery Museum, 1978.
The Bulletin of the Cleveland Museum of Art, September 1989.
Letter from Don Calkins, June 27, 1991.

Unitile
The Unitile Co. catalogue, 1917.
Geological Survey of Ohio, 1923.
Cleveland Plain Dealer, "Teenies Weenies Remembered," Becky Freligh, November 29, 1986.
Interview with James Harrison Donahey (son of Alvin Victor Donahey), July 20, 1991.

G.E.T.
Information from the back of tiles.

Sparta Ceramic Co.
United States Quarry Tile Co. and Romany Tiles catalogue, 1940, Sparta Ceramic Co., Tiles catalogue, 1940.
United States Ceramic Tile Co.: A Proud History of Innovations, Products and Progress, 1988.

Standard Tile Co.
Ceramic Trade Directory, 1929.
Bulletin of the American Ceramic Society, Vol. 22, No. 5, 1943.

CENTRAL-EAST

Newcomb Pottery
International Studio, September 1922.
Antiques Magazine, July 1968; August 1971.
American Art Pottery: 1875–1930, Keen, 1978.
Arts & Crafts Quarterly, Vol. 2 Issue 4.
Newcomb Pottery, Jessie Poesch, 1984.

George Edgar Ohr
The Biloxi Art Pottery of George Ohr, Mississippi State Historical Museum, 1978.
The Studio Potter, December 1983.
Antiques Magazine, September 1985.
The Mad Potter of Biloxi: The Art and Life of George Ohr, Garth Clark, Robert Ellison, Eugene Hecht, Abbeville Press,1989.

Bybee Pottery
Madison County Post, "Madison's Oldest Industry is Pottery," Fred Allen Engle, July 22, 1971.

Kensington Art Tile Co.
Newport, Kentucky, city directories, 1882–1894.
Clay Record, August 29, 1893.
Kentucky Post, March 9, 1895.
Bulletin of the American Ceramic Society, Vol. 22, No. 5, 1943.
Herman Carl Mueller: Architectural Ceramics and the Arts & Crafts Movement, Lisa Taft, 1979.

Paducah Tile & Pottery Co.
Memorial Record of Western Kentucky, 1904.
McCracken County, Kentucky, deeds, October 1905 and October 1935.
The Clay-Worker, July 1908; June 1909, December 1909.
Art Pottery Gazette, December 1909.
Tile Industry's Manual, F. K. Pense Tile Works advertisement, April 1929.
Bulletin of the American Ceramic Society, Vol. 22, No. 5, 1943.
Telephone conversation with Mrs. James Bauer, widow of George Bauer, December 30, 1990.
Letter from Gail Durnham, January 28, 1991.

Alhambra Tile Co.
Newport, Kentucky, city directories, 1882–1942.
Tile Industry's Manual, The Alhambra Tile Co., April 1929.
Bulletin of the American Ceramic Society, 1943.
Kentucky Post, "Alhambra Left Its Mark Set In Tile," Jim Reis, January 14, 1991.

Wheeling Tile Co.
Forward Wheeling brochure, November 1931.
The Wheeling Tile Co. catalogue, date unknown.
Wheeling, W.V., city directories, 1930–1960.
Bulletin of the American Ceramic Society, Vol. 22., No. 5, 1943.

United States Encaustic Tile Co.
History of Indianapolis and Marion County, Indiana, B. R. Sulgrove, 1884.
United States Encaustic Tile Works: Fifty Years Ago on Tinker Street In Indianapolis, 1927.
Bulletin of the American Ceramic Society, Vol. 22, No. 5, 1943.

Victorian Ceramic Tiles, Bernard, 1972.

Spinning Wheel, "High Art Maiolica Tiles of the United States Encaustic Tile Works," Barbara White Morse, March/April 1982.

Columbia Encaustic Notes

Pottery and Porcelain of the United States, Barber, 1893.

Clay Record, August 29, 1893.

The Clay-Worker, September 1903.

History of Madison County, John Forkner, 1914.

Ceramic Trade Directory, 1929.

Bulletin of the American Ceramic Society, Vol. 22, No. 5, 1943.

Anderson, Illinois newspaper article, "Tile Made Here Used All Over United States," June 3, 1959.

Overbeck Pottery

International Studio, September 1922.

The Chronicle of the Overbeck Pottery, Kathleen R. Postle, 1978.

American Art Clay Co.

Indianapolis Star, May 29, 1961.

Letter from Stephen E. Towne, June 4, 1992.

American Terra Cotta and Ceramic Co.

House Beautiful, April 1913.

Chicago Ceramics and Glass, Darling, 1979.

Treasures of the American Arts & Crafts Movement, Volpe & Cathers, 1988.

Teco Art Pottery of the Prairie School, Darling, 1989.

Northwestern Terra Cotta Co.

Ceramic Trade Directory, 1929.

Chicago Ceramics and Glass, Darling, 1979.

The Los Angeles Modernism and Architectural Terra Cotta: Ornament Comes of Age In Chicago (exhibition catalogues), Timothy Barton, 1992.

Pewabic Pottery

Spinning Wheel, October 1975.

Pewabic Pottery, Arts Ceramica Ltd., Michigan State University, 1977.

Historic Preservation, National Trust for Historic Preservation, March, April 1990.

Flint Faience

Sweet's Catalogue, c. 1926.

Action: Newsletter produced by AC spark plug division of General Motors, March, April, May 1984.

A History of A.C. Spark Plug Division: 1908–1984, General Motors, 1984.

Continental Faience and Tile Co.

South Milwaukee, Wisc., city directories, 1925–1945.

Continental Faience, catalogue, n.d..

Through the Years, South Milwaukee Centennial, Inc., 1935.

Bulletin of the American Ceramic Society, Vol. 22, No. 5, 1943.

Classified Directory of Wisconsin Manufacturers, 1941–1948.

CENTRAL-WEST

Niloak Pottery

Journal of the American Art Pottery Association, January & February 1993.

San Jose Pottery

San Antonio Express and News, December 2, 1962.

San Antonio Conversation Society Newsletter, August 1963.

San Antonio Light, February 26, 1956 & June 7, 1964.

Letters from Helen Harris Witte, January 18, 1990; February 2, 1990; August 2, 1993.

Telephone conversation with Helen Harris Witte, December 20, 1989; July 7, 1993.

Voices from San Antonio Missions, Texas Tech University Press, Austin, TX, Luis Torres, 1997.

Conversation with Donald W. Harris, October 25, 1997.

University City Pottery

The Art Academy of the People's University, c. 1912.

Hard Porcelains and Gres Flammes Made at University City, Mo., The University City Porcelain Works, n.d..

Friderichsen Floor & Wall Tile Co.

Jackson Examiner, March 28, 1924.

Independence Examiner, August 4, 1921; November 18, 1921; June 5, 1931; July 20, 1933; November 20, 1935.

Bulletin of the American Ceramic Society, Vol. 22, No. 5, 1943.

Independence and 20th Century Pioneers, Pearl G. Wilcox, 1979.

Shawsheen Pottery

American Art Pottery 1875-1930, Keen, 1978.

Iowa State College

American Art Pottery, "Iowa State College at Ames," Tom Turnquist, October 1982.

Brunnier Gallery and Museum, Iowa State College brochure, Iowa State College Art Pottery 1920–1939, 1986.

Letter from Dr. D. R. Wilder, February 4, 1991.

Handcraft Guild of Minneapolis

Minneapolis Journal, December 3, 1904; April 19, 1905; July 20, 1905; December 9, 1908.

Minneapolis Society of Fine Arts Bulletin, July 1906; March 1907; May 1907.

Brochure of the Handicraft Guild, date unknown (after 1907).

American Art Pottery, "The Handicraft Guild of Minneapolis 1904-1919." Tom Turnquist. April 1983.

Antiques & Collecting, "Pottery of the Handicraft Guild of Minneapolis," Darlene Dommel, November 1990.

University of North Dakota, School of Mines

University of North Dakota Pottery: The Cable Years, Margaret Libby Barr, Donald Miller, Robert Barr, 1977.

Journal of the American Art Pottery Association, January & February 1986.

Rushmore Pottery

Journal of the American Art Pottery Association, Vol. 6, No. 2, "Rushmore Pottery," Darlen Dommel, March/April 1991.

Van Briggle Pottery Co.

Journal of the American Art Pottery Association, "An Overview of Van Briggle Pottery," Scott H. Nelson, November-December 1984.

The Van Briggle Story, Dorothy McGraw Bogue, 1984.

A Collector's Guide to Van Briggle Pottery, Scott H. Nelson, Lois K. Crouch, Euphemia B. Demmin, Scott Wyman Newton, 1986.

Arts & Crafts Quarterly, Vol. 1, Issue 2, January 1987; Vol. 2., Issue 3; Vol. 3, Issue 1.

Broadmoor Art Pottery & Tile Co.

Sunday Gazette & Telegraph, "Region Clays Assure Fine Pottery for New Company," October 22, 1933.

Spinning Wheel, "Broadmoor Pottery," Chester Davis, January-February 1976.

Gazette Telegraph, May 1, 1982.

Antique Trader, "Broadmoor Pottery," Carol, Ann Carlton, April 1990.

Waco Tile

Conversation with Neal Fosseen (who worked at Waco in 1950s), July 15, 1996

NORTHERN CALIFORNIA

Steiger Terra Cotta & Pottery Works

The Mantel, Tile, and Grate Monthly, October 1910; April 1917.

South San Francisco Enterprise Journal, March 10, 1917; June 29, 1922.

Resumé of "Steiger Pottery Works," Isabel Casagrande, 1982.

South San Francisco History, Linda Kauffman, n.d..

Roblin Art Pottery

San Francisco Chronicle, May 21, 1905.

Arequipa Pottery

Arequipa Annual Report, First 1912, Second 1913, Third 1914, Fourth 1915.

San Francisco Chronicle, June 7, 1914.

History of Arequipa Pottery, Scrapbook #2, Helen Hillyer Brown, April, 1914.

Western Collector, "Arequipa Pottery," Robert Blasberg, October 1968.

Casa Dorinda, Historical Background and Cultural Heritage, James Frush, 1973.

Ceramics Monthly, "Arequipa Pottery," Lynn Downey, March 1985.

Journal of the American Pottery Association, January 1989.

Cathedral Oaks

San Jose Mercury, "Artist George Dennison Dies at 93," March 29, 1966.

Obituary of Frank Ingersol, source and date unknown.

Peninsula Open Space Trust Newsletter, Menlo Park, summer 1988.

Letter from Riley Doty, 11. April, 1991.

Letter from Olivia De Havilland to Joe Taylor, July 31, 1991.

Conversation with Barrie Coate, April 21, 1991.

California Faience

The Clay Resources and the Ceramic Industry of California, W.F. Dietrich, January 1928.

Death certificates of Chauncey R. Thomas and William Victor Bragdon.

American Art Pottery, Cooper-Hewitt Museum, 1987.

Exhibition at California State University, Jeffrey Herr, October 1988.

Solon and Schemmel

Garden of the World, or Santa Clara County, Ca., 1888.

The Clay-Worker, December 1929.

Riley Doty, draft on Frank Schemmel, n.d.

Conversation between Mrs. L. S. Moore (wife of Frank Schemmel and Joe Taylor), Riley Doty, and Joan Wilcox.

Conversation between Riley Doty, David Solon, and Mrs. Marie Martin (children of Albert Solon).

California Art Tile Co.

Contra Costa County Historical Record, 1926.

The Clay-Worker, January 1924; December 1928; August 1929; February 1929; November 1931.

Richmond Independent, "California Art Tile Is One of State's Top Producers," May 21, 1953.

History of James White Hislop, written in 1958 by his daughter, Alta.

The Independent, "Art Tile Co. Destroyed In Roaring Fire," March 22, 1966.

Conversation with Robert Maddox, January 1, 1991.

Two Generations of Claycraft, brochure, Cal. Art Tile Corp., n.d..

Walrich Pottery

The Clay-Worker, November 1931.

California Design 1910, Robert Winter, Timothy Anderson, Eudorah Moore, 1974.

Muresque Tiles

Oakland, California, city directories, 1925–1934.

Oakland Chamber of Commerce information sheet, February 25, 1925.

Muresque Tile catalogues, one n.d.; 1930; 1937, Denver.

Conversation with Irene Krops, 1991.

Handcraft Tile

The Clay Resources and the Ceramic Industry of California, January 1928.

San Jose Mercury News, "Brick and Tile Plans Here Famous," June 20, 1941.

San Jose Mercury News, "Handcraft Tile of 1926 Still Churns," March 25, 1981.

Letter from Riley Doty, March 10, 1991.

Woolenius Tile Co.

Woolenius Tile Co. catalogue, 1936.

Polk's Oakland, Calif., city directories, 1927–1943.

Alameda County, California, death records, 1960–1969.

Interview with Riley Doty, by Peter Van Deusen, December 21, 1991.

Letter from Riley Doty, December 21, 1991; January 3, 1992.

Kraftile Co.

The Clay Resources and Ceramic Industry of California, January 1928.

Kraftile Company catalogue, 1931.

Letters from C.W. Kraft to Al Alberts, October 7, 1983; October 18, 1984.

Telephone conversation with James F. Kraft, January 29, 1990.

SOUTHERN CALIFORNIA

Pacific Clay Products

The Clay Resources and The Ceramic Industry of California, January 1928.

The Clay-Worker, April & June 1929.

Ceramic Trade Directory, 1929.

Pacific Pottery, Pacific Clay Products booklet, 1934.

Downey Museum, "Pacific Clay Products Company," March 1988.

Los Angeles Pressed Brick Co.

The Clay Industry in California, California State Mining Bureau, January 1906 and January 1920.

Los Angeles Pressed Brick Co. catalogue, 4th edition, April 1917.

Kirkham, Pacific Art, Western Art, California Tile, Tropico Potteries

The Building Contractor, January 3, 1901; August 16, 1900.

The Clay-Worker, March 1902; August 1902; August 1903.

Articles of Incorporation for Pacific Art Tile Company.

Articles of Incorporation for Western Art Tile Company

Glendale: A Pictorial History, E. Caswell Perry and Shirley Catherine Berger.

The Architect and Engineer of California, July 1907.

Southwest Builder & Contractor, October 15, 1908; May 30, 1912.

The Mantel, Tile, and Grate Monthly, September 1909; May 1910.

The Clay-Worker, May 1921.

Newspaper from Atwater, California, June 14, 1923.

Bulletin of the American Ceramic Society, Vol. 22, No. 5, 1943.

Glendale Area History, E. Caswell Perry and Carroll W. Parcher, 1974.

Victorian Ceramic Tiles, Barnard, 1972.

Markham Pottery

"San Diego and the American Art Potter," San Diego Historical Society, n.d. pamphlet.

Batchelder Tile Co.

Pasadena Star-News, "Pioneer Civic Aide Dies," August 7, 1957.

"Batchelder Tiles," essay, Robert Winter, n.d. essay.

Spinning Wheel, November 1971.

Downey Museum, Ernest Batchelder, pamphlet, January 1978.

Westways, "Pasadena Draws A Pair," Alice Stone, March 1980.

West Coast Peddler, "Batchelder's Work: A Ceramic Cornerstone of American Manual Arts Design," Sylvia Palmer Mudrick, September 1986.

California China Products Co.

"San Diego and the American Art Pottery," San Diego Historical Society, n.d. pamphlet.

National City News, "To Manufacture Floor and Wall Tiling," June 24, 1911; July 22, 1911.

The Architect, June 1915.

Southwest Builder & Contractor, February 18, 1915; November 30, 1917.

The Mantel, Tile, and Grate Monthly, "A Western Factory Invades the East," March 1914; April 1915; May 1915; June 1915.

Wade Encaustic Tile, West Coast Tile Co.

Southwest Builder and Contractor, January 11, 1912; February 15, 1912; March 21, 1912; May 22, 1913; February 26, 1914; November 30, 1917.

The Mantel, Tile, and Grate Monthly, October 1914.

The Clay Industry in California, California State Mining Bureau, January 1920.

Bulletin of the American Ceramic Society, Vol. 22, No. 5., 1943.

Frederick Hurten Rhead

Arts & Crafts Quarterly, "Frederick Hurten Rhead: A Natural Offshoot of His Family," Bernard Bumdus.

Frederick Hurten Rhead: An English Potter in America, Erie Art Museum, Sharon Dale, 1986.

American Arts & Crafts, Virtue in Design, Bowman, 1987.

Noticias: Quarterly of the Santa Barbara Historical Society, Spring 1990.

Furlong Poxon Pottery Co.

Southwest Builder and Contractor, November 30, 1917.

The Clay Resources and The Ceramic Industry of California, January 1928.

Ceramic Trade Directory, 1929.

San Jose Mercury News, October 23, 1932.

Versatile Vernon Kilns, Maxine Feek Nelson, 1978.

California Clay Products Co. (CALCO)

Southwest Builder and Contractor, November 30, 1917.

The Clay Industry in California, California State Mining Bureau, January 1920.

The Clay-Worker, August 1923.

The Clay Resources and the Ceramic Industry of California, January 1928.

Whittier Terra Cotta Works Pottery catalogue, n.d.

Ceramic Art of the Malibu Potteries, Ronald L. Rindge, 1988.

American Encaustic Tiling Co., Los Angeles

American Encaustic Tiling Co., Hermosa Beach

Hermosa Beach Review, March 5, 1926.

The Clay Resources and The Ceramic Industry of California, January 1928.

Evening Express, "Growth of Los Angeles and Southern California Makes World's Largest Tile Company Here," 1930 yearbook.

Bulletin of the American Ceramic Society, Vol. 22, No. 5, 1943.

Helen Greenleaf Lane

Daily Sun, June 23, 1956.

Upland News, "Unique Art Show: Former Uplanders Get Attention," June 28, 1956.

"Three Generations of Greenleaf Family Represented By Works In Art Exhibit," source unknown, c.a. June 1956.

Letter from Barbara Jean Hayes, 1991.

Conversation with Barbara Jean Hayes, April 19, 1991.

Claycraft Pottery

Robertson Pottery

Claycraft Potteries catalogue, ca. 1925.

Death certificate of Fred H. Robertson, December 23, 1952.

Proutyline Products Co.

Hermosa Beach Review, "Big United States Tile Company Buys Local Plant," March 5, 1926.

Evening Express, "Growth of Los Angeles and Southern California Makes World's Largest Tile Company Here," 1930 yearbook.

Bulletin of the American Ceramic Society, Vol. 22, No. 5, 1943.

"The Prouty Palace," Hermosa Beach Historical Society, Patricia A. Gazin, 1991.

Taylor Tilery

Santa Monica Tiles/Taylor Tilery catalogue, n.d..

The Clay Resources and the Ceramic Industry of California, Bulletin No. 99, January 1928.

Interview with Jim Handley, March 20, 1990.

Interview with Margaret Curtis Smith, January 10, 1991.

Pomona Tile Mfg. Co.

The Clay Resources and The Ceramic Industry of California, January 1928.

California Arts and Architecture, Pomona Tile Mfg. Co., advertisement, May 1936.

Architectural Digest, Pomona Tile Mfg. Co., advertisement, date unknown.

Bulletin of the American Ceramic Society, Vol. 22, No. 5, 1943.

Pomona Tile Mfg. Co., annual report, 1955.

Gladding, McBean & Co.

The Clay-Worker, July 1923; December 1924.

California Business Roll of Honor, Nichols F. Wilson, 1943.

"Gladding, McBean's History, 1875–1957," Gladding, McBean & Co. employee handbook, July 1, 1957.

Glendale News-Press, "Gladding, McBean Grew Up Fast," August 26, 1958.

Feats of Clay: "The Pottery" and the City of Lincoln, Diane Youtsey, Jerry Logan, Bertha Newcomb, Lois Watts, and William L. Wyatt, 1989.

California Encaustic Tile, Co.

Articles of incorporation, California Encaustic Tile, Co.

The Clay-Worker, August 1923.

Acme Tile Co.

Marks on the back side of tiles.

Los Angeles city directories, 1929–1932.

Alhambra Kilns Inc.

The Clay Resources and the Ceramic Industry of California, January 1928.

Ceramic Trade Directory, 1929.

California Arts and Architecture, Alhambra Kilns, Inc., advertisement, March 1930.

Malibu Potteries

The Clay Resources & The Ceramic Industry of California, January 1928.

Malibu Tiles "Malibu Potteries," Kathryn Smith, (exhibition catalogue) 1980.

Ceramic Art of the Malibu Potteries 1926-1932, Rindge, 1988.

Angeles: The Art of Living in L.A., July 1989.

Flash Point, "Rufus B. Keeler: A Tile Wizard," Vol. 2., No. 1, Joseph A. Taylor, January-March 1989.

Conversation with Bill Handley, 10 January 1993.

Markoff Mosaic Tile Corp.

Articles of incorporation, Markoff Mosaic Tile Corporation.

Markoff Mosaic Tile Corp. catalogue, n.d.

Inglewood, Calif., city directories, 1926–1945.

Ceramic Trade Directory, 1929.

Brayton Laguna Pottery

"This Was Mission County, Orange County, California," Warren F. Morgan, 1973.

"The First One Hundred Years In Laguna Beach 1876–1976," Merle and Mabel Ramsey, 1976.

Catalina Pottery

The Clay-Worker, May & December 1927; January & August 1933.

Catalina Islander, "Museum Report" column, Patricia Anne Moore, May 23, 1974.

Catalina Pottery: The Early Years, 1927–1937, A.W. Fridely, 1977.

American Clay Exchange, "Catalina Island and Catalina Pottery," Delleen Enge, May 1983.

American Clay Exchange, "Considering Catalina," Chipman, Vol. 7, No. 10, August 1987.

Catalina Tile of the Magic Isle, Lee Rosenthal, 1992.

Decorative Arts Inc.

Articles of incorporation, Decorative Arts, Inc.

Decorative Arts, Inc. Catalog of Designs, 1928.

Hispano-Moresque Tile Co.

Harry C. Hicks Studio/Hispano-Moresque Tile catalogue, n.d..

Arts & Architecture, advertisement, April 1930.

Tiles and Tile Work, March 1931.

Los Angeles city directories, 1931–1932.

Tudor Potteries, Inc.

The Clay Resources and the Ceramic Industry in California, January 1928.

Los Angeles city directories, 1928–1931.

Tudor Tile catalogue, Tudor Potteries, Inc., 1931.

Haldeman Tile Mfg. Co.

The Clay-Worker, month unknown, 1929.

Conversation with Anna Dinkla Haldeman, February 14, 1995.

D & M Tile Co.

D & M Tile Co. catalogue, n.d..

List of members, Pacific Coast Association of Tile Manufacturers, 1936.

Interview with Mrs. Ben Davies (daughter-in-law of John L. Davies), November 23, 1992.

Pacific Tile and Porcelain Co.

Los Angeles city directories, 1936–1940.

Interiors, March 1952.

Charles Fergus Binns

Journal of the American Art Pottery Association, Vol. 7, No. 1, "An Issue of Style," Dorothy Lamoureux.

The Arts & Crafts Movement In New York State, 1983, Ludwig

"In Defense of Fire," *Craftsman,* Charles Fergus Binns.

Isaac Broome

"Tiles Made By Isaac Broome, Sculptor and Genius," *Spinning Wheel,* Barbara White Morse, January-February 1973.

Cecil Jones

Paul Evans's interview with Dora Jones Robertson and Helen Wellman, February 19, 1970.

Herman Mueller

Herman Karl Mueller: Architectural Ceramics and the Arts & Crafts Movement, Taft, 1979

Robertson Family

In Pursuit of Beauty, Metropolitan Museum of Art, 1986

Death certificate of Fred H. Robertson.

Frederick Harry Wilde

Victorian Ceramic Tiles, Barnard, 1972

Bulletin of the American Ceramic Society, Vol.22, No.5

Death certificate of Frederick Harry Wilde.

OTHER TILE COMPANIES

Following is a list of companies that may also have produced art tiles:

Maine
South Blue Hill Pottery, Blue Hill c. 1940

New Hampshire
Hampshire Pottery, Keene 1871-1953

New York
Celadon Terra Cotta, Co. Alfred 1889-1909
Durant Kilns (Leon Volkman), Bedford Village 1910-1918
Glen Falls Terra Cotta & Brick Co., Glen Falls 1886-
William H. Jackson Co. 1900-1930
Law Art Tile Works, Buffalo c. 1892
Olean Tile Co., Olean (Mosaic floor tile) (See Franklin) 1913-1957

New Jersey
American Enameled Brick & Tile Co., South River 1910-1920
Crescent Tile Co., Trenton 1925-1934
Lindenwold Ceramic Co., Lindenwold c. 1905
NATCO Tile Co., Union Beach c. 1935
New Brunswick Tile Co., New Brunswick 1906-1914
New Jersey Tile Co., Trenton 1900-c.1942
Perth Amboy Terra Cotta Co., Perth Amboy 1890-1896
New Jersey Terra Cotta Co.
South Amboy Terra Cotta Co.
Federal Terra Cotta Co.
Federal Seaboard Terra Cotta Co., Perth Amboy
Poillon Pottery, Woodbridge 1904-1936
South Amboy Tile Co., South Amboy c. 1900
Wenczel Tile Co., Trenton (Production tile) (See Trent) c. 1929-Present
Whitehead Pottery, Trenton c. 1929-1932

Pennsylvania
American Clay Product Co., Forty Fort 1902-1916
Galloway & Graff, Galloway Terra Cotta Co., Galloway 1868-c. 1940
Pottery, Philadelphia (pottery & garden ceramics)
McKeesport Tile Co., McKeesport c. 1895
Newtown Tile Co., Newtown c. 1936-1942
Penn Tile Works, Aspen (Mosaic floor tiles) c. 1893-1953
Sharpless and Watts, Philadelphia

Ohio
American Art Tile, Columbus, 1899-1905
Art Ceramic Works, Zanesville c. 1908
Belgian Wall Tile Co., Columbus c. 1926
Buckeye Tile Co. Chillicothe c. 1923-c. 1930
Burford Bros. Pottery Co., East Liverpool
The Ceramic Co., Toledo Art Tile and Fire Brick 1890-1896 Co., Toledo
Colonial Tile Co., Tiffen 1903-
East Liverpool Encaustic Tile Co., East Liverpool 1877-1879
Federal Tile Co., Columbus 1915-1932
Fisher Veneer Tiling Co., Zanesville c. 1907
General Tile Co., Zanesville 1956-1976

Harker, Taylor and Co., East Liverpool 1846-1851
Oxford Tile, Co., Cambridge (Universal Potteries)
Pittsburgh Tile Mfg. Co., East Liverpool c. 1913
Salem China Co., Salem
Summitville Tile Co., Summitville 1922-Present Wege Marble and Tile Co., Columbus c. 1927-c. 1978
Zanesville Tile & Decorating Co., Zanesville c. 1913

West Virginia
Kenilworth Tile Co. 1907

Florida
Cheney Art Tile Co., Orlando (4" x 4" pillow tiles) 1924-1929
Crescent Tile Co., St. Petersburg c. 1925

Georgia
Carling Tile Co., Macon (Wall tiles, mosaic floor tiles) c. 1930
Patch Inc., Atlanta

Alabama
The Art Tile Co., Mobile c. 1911
National Mosaic Flooring Co., Mobile c. 1913-1926

Kentucky
Latoria Tile Co., Covington

Indiana
American Tile & Pottery Co., American Tile 1928-1935 Corp., Rockport
Merit Tile Co., Rockport
Superior Ceramic Corp., Anderson 1935-1941

Illinois
Beggs, Chicago
Ceramic Tile Co., Chicago c. 1923
Chicago Terra Cotta Works, Chicago 1866-c. 1879
Howes & Dodd, Chicago c. 1906
Martin Tile, Co., Dwight
Morton Ceramic Tile Co., Morton

Michigan
Michigan Porcelain Tile Works, Ionia c. 1930

Wisconsin
Ceramic Products Mfg. Co., Milwaukee c. 1929-1936

Arkansas
Camden Art Tile & Pottery, Camden c. 1928

Texas
Hagy Ceramic Studio, San Antonio 1939-1953

Iowa
Swift Tile, Riverside (decorative brick tiles) 1870-1910

Minnesota
Mayerton Tile Works, St. Paul
Nemadji Earth Pottery Co., Kettle River 1922-1986

North Dakota
Dickota Pottery, Dickenson 1934-1937

Colorado
Colorado Springs Pressed Brick Co., Colorado Springs, c. 1911
Denver Art Pottery, Denver c. 1900-c. 1955

Denver Terra Cotta, Denver 1911-1957

Arizona

Gila Pottery McKusick Tile Studio, Globe 1947-Present

Oregon

Oregon Art Tile Co., Portland c. 1926 (may have been a shop)

Washington

Seattle Pottery & Tile Co., Seattle c. 1927-1929 (may have been a shop)

Northern California

The Art Tile Co., Redlands c. 1928

California Pottery Co., 1876-c. 1929

California Pressed Brick Co., Niles c. 1911 (Brick mantel & floor tile)

N. Clark & Sons Pottery, San Francisco 1889-c. 1942

Globe Tile and Porcelain Works, Hynes c. 1929

H & H Tile Co. (Hagerman & Halieman) (floor tiles) 1927

W.W. Montague, San Francisco, c. 1900-1920 (some tiles made by Providential)

Monterey Mission Tile Co., Seaside

Southern California

Alberhill Pottery, Alberhill California Pottery

Alberhill Coal & Clay Co., Alberhill 1912-1928

American China Co., Vernon 1923-1927

W.E. Bockmon Tile Co., Los Angeles 1927-1933

California Art Tile Mantel Works, San Diego c. 1927-1924

California Encaustic Tile Co., Ontario 1923-1924

Corona Tile Co., Riverside (Mission tile) c. 1925

Dohrmann Walker Co., Los Angeles c. 1922-1929

Hacienda Tiles, Glendale c. 1938-1945

Hodjo Tile

Metlox Potteries, Manhattan Beach 1927-1985

Spanish Tile Co. of L.A., Los Angeles (Los Angeles-made Mission tile & cement tile)

Sun Valley Tile Kilns, Los Angeles

Whittier Terra Cotta Works, So. Whittier c. 1928

Valentien Pottery, San Diego 1911-1913

About the Author

Norman Karlson was born and grew up in White Plains, New York. After World War II, he served as an electronic technician in the U.S. Navy aboard a patrol craft escort and the *U.S.S. Mount Olympus*. Karlson studied photography in New York City and then worked for Wilhela Cushman, fashion editor of *Ladies' Home Journal*, photographing throughout the U.S. and at the fashion shows in Paris, London, and Rome. Karlson subsequently assisted the renowned photographer, Irving Penn in photographing such notables as Willie Mays, Mies van der Rohe, Louis Armstrong, Gina Lollobrigida, Grace Kelly, and Ava Gardner for *Vogue* magazine. In his own studio, Karlson specialized in food photography, interiors and children. Aside from his advertising work, Karlson has done photo layouts for *Harper's Bazaar, Ladies' Home Journal, McCall's, House and Garden* and French *Elle*.

While still a photographer, Karlson became enamored of the old traditional tiles he saw on trips to France, Italy and Portugal. Disappointed that he could find no source for these tiles in the United States, he established Country Floors tile store in the basement of his photography studio on 26th Street in New York. Thirty years later, the store now has branches in most major cities in the United States, Canada, and Australia.

Karlson moved to Paris for a while, and began collecting antique European tiles. Returning to the United States, his collection expanded to include antique U.S. tiles as well. While amassing his vast collection, Karlson has uncovered tiles from many small artisan potteries in the U.S. that were practically lost to the world.

In this book, Karlson pulls together over ten years of fieldwork, collection, and research on the subject of U.S. art tiles.

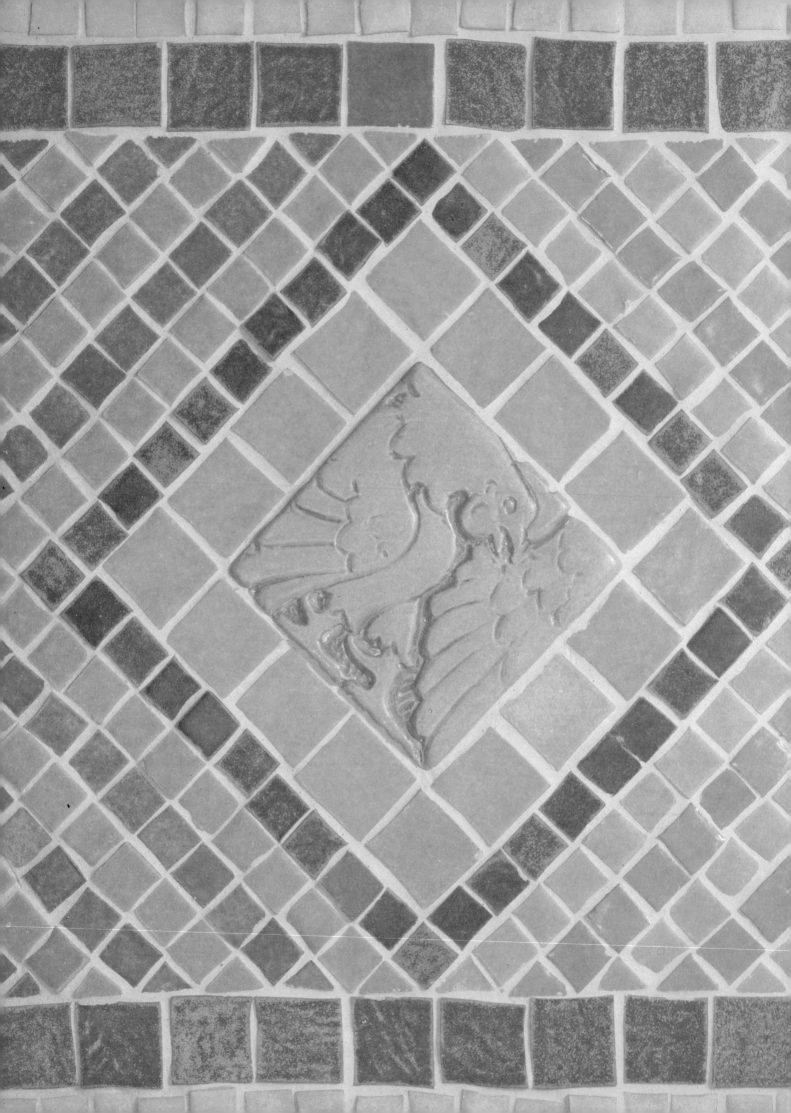